This study examines the narrative paintings of the Passion of Christ created in Italy during the thirteenth century. Demonstrating the radical changes that occurred in the depiction of the Passion cycle during the duecento, a period that has traditionally been dismissed as artistically stagnant, Anne Derbes analyzes the relationship between these new images and similar renderings found in Byzantine sources. She argues that the Franciscan order, which was active in the Levant very early in its history, played an important role in introducing these images into Italy. But Italian painters and their advisers did not always strive to reproduce Byzantine models. Rather, they often strategically reworked them to produce new images with a distinctly Franciscan cast. The Passion cycles produced for the Franciscans during the thirteenth century powerfully advanced the interests of the Order by promoting christocentric piety, asserting the Order's continuing allegiance to the vow of poverty, and proclaiming St. Francis as a second Christ.

PICTURING THE PASSION IN
LATE MEDIEVAL ITALY

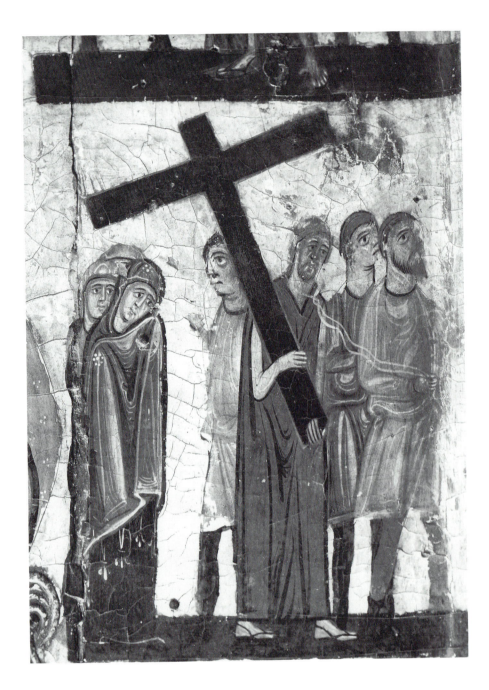

PICTURING THE PASSION IN LATE MEDIEVAL ITALY

Narrative Painting, Franciscan Ideologies, and the Levant

Anne Derbes
Hood College

CAMBRIDGE
UNIVERSITY PRESS

To my family, and to the memory of my father

Published by the Press Syndicate of the University of Cambridge
The Pitt Building, Trumpington Street, Cambridge CB2 1RP
40 West 20th Street, New York, NY 10011-4211, USA
10 Stamford Road, Oakleigh, Melbourne 3166, Australia

First published 1996

Printed in the United States of America

Library of Congress Cataloging–in–Publication Data

Derbes, Anne
 Picturing the passion in late Medieval Italy : narrative paint-
ing. Franciscan ideologies, and the Levant / Anne Derbes
 p. cm.
 Includes bibliographical references.
 ISBN 0-521-47481-7
 1. Painting, Italian. 2. Painting, Medieval—Italy. 3. Jesus
Christ—Passion—Art. 4. Art, Franciscan. I. Title.
ND613.D48 1996
755'.53'094509022—dc20
 95-10981
 CIP

A catalog record for this book is available from the British Library

ISBN 0-521-47481-7 Hardback

CONTENTS

LIST OF ILLUSTRATIONS

✠

ACKNOWLEDGMENTS

The beginnings of this book go back to my first semester as a graduate student at the University of Virginia, when I took John Yiannias's course on Byzantine art and the late Frederick Hartt's course on duecento and trecento painting. The interconnections between the material covered in the two courses intrigued me, and I am deeply grateful to both men for encouraging me to pursue the questions they raised. John Yiannias was an unfailingly generous and thoughtful adviser to the dissertation that eventually resulted, and others at Virginia, especially Paul Barolsky and Marion Roberts, offered valuable guidance along the way.

I am grateful, too, to many colleagues for advice, support, and assistance. Annemarie Weyl Carr, Rebecca Corrie, Anthony Cutler, Helen Evans, Jaroslav Folda, and Robert Nelson have done pioneering work on cultural exchange in the Mediterranean basin. The repeated references to their work in this book inadequately reflect my profound debts to them. I am much indebted as well to Leslie Brubaker and Robert Ousterhout, who prompted me to reconsider some of the questions I first raised in my dissertation, and whose critical acumen was a boon to my work. Thomas Mathews kindly discussed his research on the Ascent of the Cross with me, and this, too, was an important stimulus.

Julia Miller, good friend and indefatigable travel companion, has helped in countless ways over the years; her breadth of knowledge and insights about Italian painting have been invaluable. Many thanks also to the colleagues who gather annually at Kalamazoo. Louis Jordan, Genevra Kornbluth, Ellen Schwartz, and Diane Wolfthal have been generous sources of advice and support. Special thanks also to members of the Italian Art Soci-

ety, and in particular to Yael Even, Margaret Flansburg, Dorothy Glass, John Paoletti, Gary Radke, Paul Watson, and David Wilkins. My gratitude, too, to two other Kalamazoo regulars, both of whom have kindly shared their expertise with me: William Cook, whose research on Franciscan images in thirteenth-century Italy will be cited often here, and Richard Kieckhefer, who has done important work on devotion to the Passion in late medieval Europe.

I am especially indebted to the friends and colleagues who have been kind enough to read part or all of the manuscript and to offer astute advice: William Cook, Rebecca Corrie, James Czarnecki, Helen Evans, Smiljka Gabelić, Louis Jordan, Julia Miller, Amy Neff, Laurie Taylor-Kelly, and Jeryldene Wood. Their criticism has done much to improve the text; all remaining errors are, or course, my own. Profuse thanks especially to Sharon Gerstel not only for reading the text and commenting with much insight, but also for offering unstinting support with matters small and large. Adrian Hoch provided indispensable aid with many problems, and I am deeply grateful to her as well. Judy Feldman's incisive editing of a draft helped greatly to sharpen language and argument. For their assistance with the vexing problems of obtaining photos and permission to publish them, I am indebted to Luigi Artini, Miklós Boskovits, Annemarie Weyl Carr, John Cotsonis, Sharon Gerstel, Robert Ousterhout, Valentino Pace, Natalia Teteriatnikov, Jean-Guy Violette, Daniel Weiss, and especially to Smiljka Gabelić and Adrian Hoch, both of whom went to considerable trouble on my behalf. Many thanks also to Joanna Cannon for permission to cite her thesis and for the warm hospitality she and John Lowden offered in London. My gratitude as well to Liz Miller for her generous welcome in San Diego. And for their kindness in responding to my queries, I am obliged to Jeffrey Anderson, Brendan Cassidy, Alice Christ, Keith Christiansen, John Cotsonis, Elizabeth Fisher, Cynthia Hahn, Virginia Kaufmann, Kathleen Maxwell, Amy Neff, Elizabeth Teviotdale, and Lee Ann Turner.

Colleagues and students at Hood College have also helped in many ways. Fred Bohrer kindly agreed to take on the departmental chairmanship when I was on leave to pursue this project. Carol Kolmerten offered valuable advice about the publication process. Friends in the Hood College Center for the Humanities were a steady source of support and encouragement. I am grateful to Barbara Hetrick, former Vice-President and Dean of Academic Affairs, and to the Faculty Development Committee, for generously providing much financial support, including travel to conferences, research assistance, and funds to cover the cost of the photographs. A Beneficial-Hodson Faculty Fellowship granted me a semester away and made possible my research in Europe. Debbie Biddle-Wilson, Marcia Hall, Arthur Martin, and Nicole Martin in the Hood College library efficiently supplied interlibrary

loan material and reference assistance, and Sally DeBurgh and Doug Beasley offered essential technical support.

The research for this book was conducted at numerous libraries, and I am indebted to their directors and staff for facilitating my work: the University of Virginia, Johns Hopkins University, the University of Maryland, the Library of Congress, the National Gallery of Art, the British Library, the Courtauld Institute, and the Kunsthistorisches Institut in Florence. Special thanks to the directors and staff of Dumbarton Oaks in Washington, D.C., especially Irene Vaslef, Natalia Teteriatnikov, Mark Zapatka, and Joe Mills, for much-appreciated help.

I have benefited greatly from the expertise and support of Beatrice Rehl at Cambridge University Press and from the work of Jo Ellen Ackerman and Robin Hazard Ray. Thanks as well to Andrea Van Houtven, a resourceful research assistant in the last stages of the project.

My deepest gratitude goes to my family. My brother, David Derbes, took time from his own work to locate material for me in Europe and still scours the used bookstores of Chicago for useful volumes. My parents, Christine and Vincent J. Derbes, provided unflagging encouragement and help. My husband, Robert Schwab, and our children, Josh and Daniel, have supported me in more ways than I can acknowledge. I am grateful to them for everything from their expertise in solving computer problems to their loving tolerance of a wife and mother who at times is more engaged by the thirteenth century than by the twentieth. My warmest thanks to them all.

THE PASSION CYCLE IN THIRTEENTH-CENTURY PAINTING: CONTENT AND CONTEXT

✠

Profound changes took place in central Italian narrative painting in the course of the thirteenth century. The thirteenth century was an expansive age in central Italy: The population was surging; merchants, missionaries, and adventurers were plying the Mediterranean; mendicant orders and popular movements were transforming the religious landscape. It is not surprising that changes of a similar magnitude occurred in the visual arts. What is perhaps surprising is that the narrative expansion of duecento painting is so little known.

Unlike historians, art historians have traditionally characterized the duecento as stagnant, a kind of hiatus in the history of Italian art until the arrival of Giotto. The century is often still treated cursorily in histories of Italian painting.

The duecento's marginal position is felt in a discussion of Italian narrative painting by Hans Belting.[1] Belting's comments are both provocative and revealing. He states first that narrative "changed profoundly in the age of Giotto."[2] He then goes on to compare narrative prior to this point – about 1300 – with the text of the Bible, which is, as he notes, a spare and factual record of biblical events. Belting argues that narrative before the age of Giotto was similarly spare and had the same intention as the Bible: to instruct the viewer/reader. But in the time of Giotto, "the Bible was being retold in a novellike form that invited the reader's empathy and offered not only information on details but also stimuli to sympathetic and affective participation."[3] For Belting, the *Meditationes vitae Christi*, which enlarged the narrative beyond the terse biblical text and elicited emotional responses in readers, corresponds to the new pictorial cycles (at the Arena Chapel, or in

the Upper Church of San Francesco, Assisi) that similarly enrich the narrative and appeal to their viewers' emotions.

Much about this discussion of narrative, both visual and textual, rings true. However, neither the changes in pictorial narrative nor the concomitant changes in devotional texts, which Belting convincingly links, originated with the age of Giotto. The transformations that he describes are powerfully felt in art and devotional texts from around the year 1300, but they began more than half a century earlier. The transformation of narrative painting is especially pronounced in depictions of the Passion of Christ, which will be the specific focus of this study.[4]

Of the narrative cycles that survive in duecento panel painting – the Infancy of Christ, the Ministry of Christ, cycles of saints' lives, and so on – none is more common than the story of Christ's suffering and death on the cross. We have from this period a fairly large corpus of narrative cycles of saints' lives, by far the largest number representing St. Francis.[5] Of christological cycles, the Infancy of Christ is featured on surprisingly few extant panels and the Ministry is still less common.[6] But a much larger number of panels include narratives depicting the Passion; fairly often only the Passion appeared.[7] Relatively few duecento fresco programs in central Italy have escaped destruction, but of those that remain, several include Passion themes.[8] Thus, to judge from the available evidence, if a narrative cycle depicting the life of Christ was painted in thirteenth-century central Italy, it generally included Passion scenes, and not infrequently it depicted only the Passion.

The surviving panels with Passion cycles vary considerably in size, format, and program; indeed the theme is so common that it is impossible to point to a single representative example. The majority were large enough to have been destined for altars; among them are a Lucchese diptych in the Uffizi from Santa Chiara, Lucca (Fig. 1), circa 1255–65; a Pisan dossal in the Bargello, Florence (Fig. 2), circa 1260–70; or an Umbrian dossal in Perugia from the Convento dei Frati Minori del Farneto (Fig. 3), circa 1285–90.[9] Smaller panels, presumably intended for private devotion, also often included Passion themes.[10]

The altarpieces shown here depict three or four episodes of the Passion cycle; but at times, especially in the last decades of the century, the narrative program expands substantially. For instance, in a Florentine dossal from the late duecento in San Diego (Fig. 4), the Passion story is detailed in ten separate episodes.[11] This dossal, with two post-Passion scenes as well, offers an especially rich narrative program, and we will return to it in the Conclusion. Programs like this one anticipate the proliferation of narrative in the early trecento, as in Duccio's *Maestà* and Giotto's Arena Chapel.[12]

Until the densely illustrated cycles of the later duecento, some of the most extensive Passion cycles to survive in thirteenth-century painting are

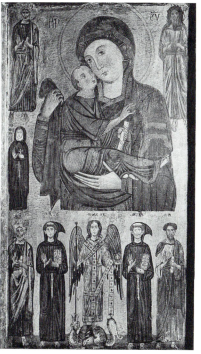

Figure 1 Diptych from Sta. Chiara, Lucca, c. 1255–65. Florence, Uffizi. Photo: Alinari/Art Resource.

Figure 2 Madonna and Child with Passion Scenes, c. 1260–70. Florence, Museo Nazionale del Bargello. Photo: The Conway Library, Courtauld Institute of Art.

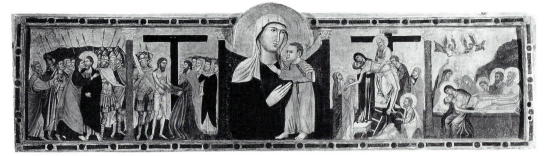

Figure 3 Madonna and Child with Passion Scenes, from the Convento dei Frati Minori del Farneto, c. 1285–90. Perugia, Galleria Nazionale dell'Umbria. Photo: Alinari/Art Resource.

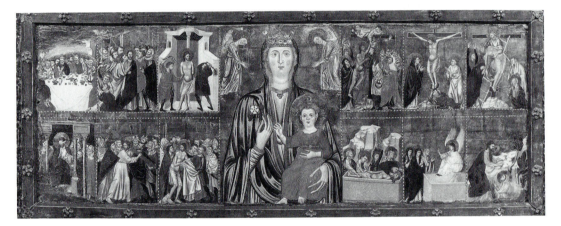

Figure 4 Magdalen Master and San Gaggio Master. Madonna and Child with Passion Scenes, from Sta. Maria dei Candeli, Florence(?). Madonna and Child by Magdalen Master, 1280s; narratives by San Gaggio Master, 1290s. San Diego, Calif., Timken Museum of Art, The Putnam Foundation. Photo: museum.

found on historiated painted crosses. Painted crosses must have been found in most Italian churches during the thirteenth century.[13] These crosses were placed on altars, hung over them, suspended in apses, and attached to rood beams. They predate the duecento: The earliest dated example is from 1138, and they continue throughout the thirteenth century and into the early trecento. Of the surviving crosses, some twenty-five, all of which are Tuscan, include narratives of the Passion in the side panels, also known as apron panels, flanking the central image of Christ.[14] Like other historiated panels, such as the Marian altarpieces cited above and the hagiographic panels so common in duecento painting, these crosses fuse icon and narrative; here the viewer at once contemplates the body of Christ and reads the events leading to his death on the cross.[15] Illustrated here are two particularly detailed examples, both Pisan: a late twelfth-century work from the church of San Sepolcro, Pisa (Fig. 5) and a mid-thirteenth-century example in San

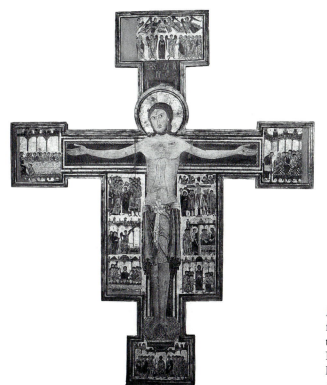

Figure 5 Painted cross from S. Sepolcro, Pisa, late twelfth century. Museo Nazionale di San Matteo, Pisa, no. 15. Photo: Alinari/Art Resource.

Martino, Pisa (Fig. 6).[16] Historiated crosses like these were probably intended for altars or rood screens; the small scenes would not have been visible if the cross were suspended high above the apse.[17] Historiated apron panels occur in the earliest painted crosses and continue well into the thirteenth century; an occasional archaizing example dates from the trecento. But they gradually fell from favor as the narratives were increasingly replaced with decorative patterns, a scheme apparently introduced by Giunta Pisano in the fourth decade of the thirteenth century.[18]

The earlier crosses, whether historiated or not, are consistent in their representation of the central Christ: Like the San Sepolcro cross (Fig. 5), they depict the traditional *Christus Triumphans*, a Christ who transcends suffering and is victorious over death, gazing out with head held erect. In the early decades of the thirteenth century, this type was gradually displaced by a new type, the suffering Christ or *Christus Patiens*. The San Martino cross (Fig. 6) is typical of this type, in which Christ as suffering human replaces the triumphant savior: His eyes are closed, his head bowed, and his body begins to lose its upright stance, sagging to the left. Though long familiar to modern scholars, these are remarkable changes. The new images must have seemed almost unbearably graphic to the first observers.

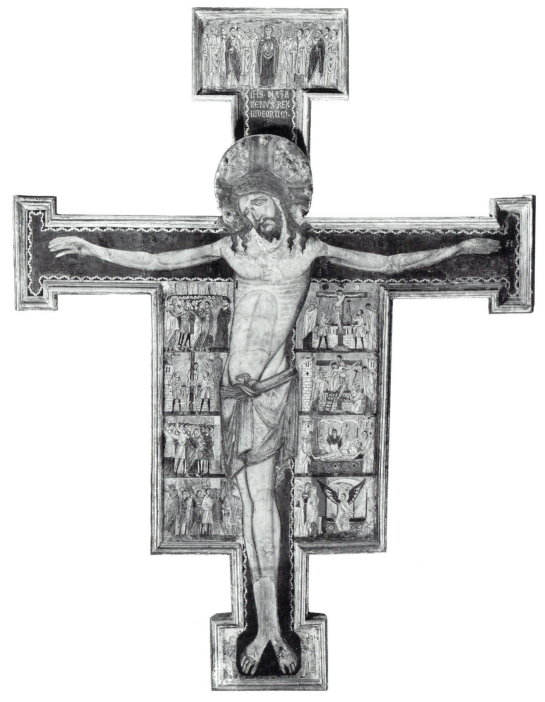

Figure 6 Enrico di Tedice. Painted cross, c. 1245–55. Pisa, S. Martino. Photo: Alinari/Art Resource.

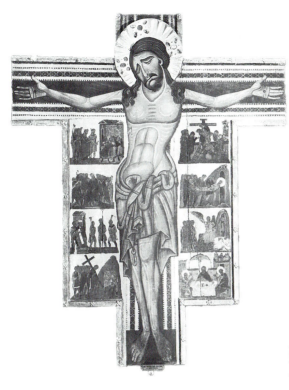

Figure 7 Painted cross, c. 1240–5. Florence, Uffizi, no. 434. Photo: Alinari/Art Resource.

The fact that the *Christus Patiens* gradually displaced the *Christus Triumphans* is well known to students of Italian art.[19] But the image of the crucified Christ is not the only indication of the radical revision in the understanding and depiction of Passion; rather, it is merely one symptom of an extraordinary transformation. Another symptom is the changing narrative program; the choice of narratives typically depicted on earlier crosses often differs considerably from those seen in later examples. The two Pisan works represented here offer an instructive example. In the earlier work, the San Sepolcro cross (Fig. 5), the small scenes (both in the aprons and in the terminals) reveal an approximate balance between the events of the Passion (the Last Supper, the Washing of the Feet, the Mocking of Christ, the Crucifixion) and the events that followed the Resurrection (the Marys at the Tomb, the Road to Emmaus, the Supper at Emmaus, the Apparition at the Closed Gates, Pentecost).[20] In fact, only two of the nine scenes – the Mocking and the Crucifixion itself, both at the top of the apron and thus least visible to the viewer of all the apron scenes – depict Christ in the hands of his captors.[21] It was clearly the intention of the painter and his patron to minimize references to Christ's suffering and to stress instead his triumphant resurrection from the dead, an intention reinforced by the central image.

In the San Martino cross (Fig. 6), by contrast, we find instead the Betrayal, the Flagellation, the Mocking, the Way to Calvary, the Crucifixion, the

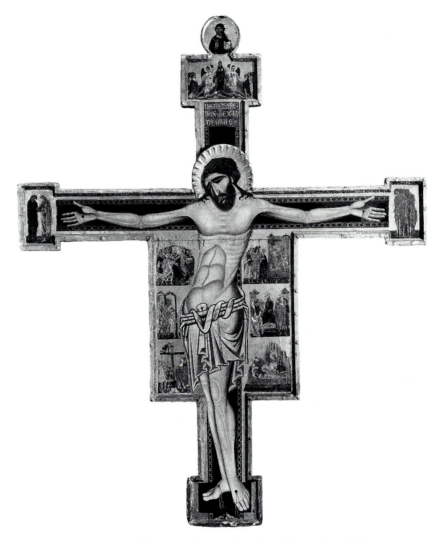

Figure 8 Coppo di Marcovaldo. Painted cross from Sta. Chiara, San Gimignano, c. 1261. San Gimignano, Museo Civico. Photo: Alinari/Art Resource.

Deposition, the Entombment, and the Marys at the Tomb. Only the final scene promises Christ's triumph over death; the other seven record in considerable detail the torments to which he was subjected, and the ultimate result. Again, the emphasis of the narratives is consistent with the *Christus Patiens*, now featured in the center. Almost all historiated crosses representing the *Patiens* similarly emphasize the Passion cycle in the apron panels. They typically limit the post-Passion images to one or two scenes, as in a cross of about 1240–5 in the Uffizi, one of the first extant Florentine crosses to depict Christ as *Patiens* (Fig. 7). Another example – a cross of c. 1261 by another Florentine painter, Coppo di Marcovaldo, in San Gimignano (Fig. 8) – eliminates them altogether.[22] Coppo's cross differs from most other ver-

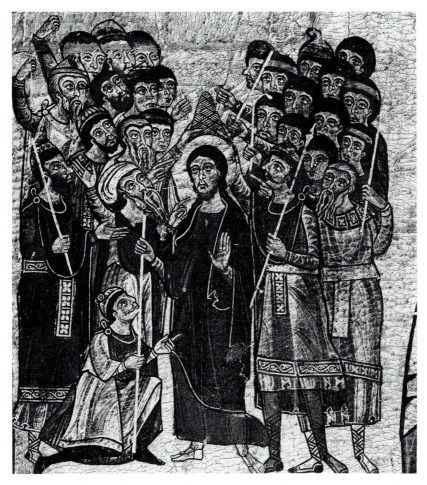

Figure 9 Mocking of Christ. Detail of painted cross from S. Sepolcro, Pisa, late twelfth century. Museo Nazionale di San Matteo, Pisa, no. 15. Photo: Alinari/Art Resource.

sions as well in the sequence of the narratives, which here read from left to right across the body of Christ – reinforcing the viewer's experience of the Crucifixion.[23] The two Florentine crosses and the San Martino cross are both typical of crosses featuring the *Patiens* in that the cycle does not begin before the Betrayal and Arrest of Christ; the Last Supper and Washing of the Feet, though theologically important, are generally omitted in favor of the expressive force of the later episodes.

The heightened emphasis on the Passion in duecento painting is seen in other respects as well. By the third quarter of the century, the Passion cycle was enlarged with the introduction of new episodes like the Stripping of Christ and the Ascent of the Cross, both of which appear in the San Diego panel (Fig. 4). Both of these new episodes intensify the affective power of

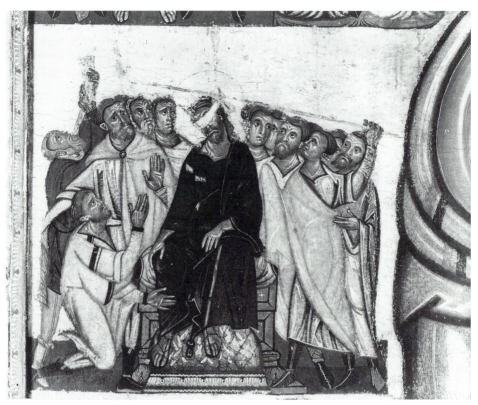

Figure 10 Mocking of Christ. Detail of painted cross, c. 1240–5. Florence, Uffizi, no. 434. Photo: Courtesy of Luigi Artini/Miklós Boskovits.

the cycle and serve as well to protract it, prolonging the moments just before the Crucifixion.[24] Further, sacred figures, especially the Virgin, are now shown responding with appropriate anguish to the emotionally charged events. Thus Mary, long depicted as standing stoically erect throughout the Passion, now swoons – often during the Crucifixion, and at times on the road to Calvary and during the Lamentation – a development that recalls the shift from the *Christus Triumphans* to the *Christus Patiens*.[25] Similarly, Mary Magdalen becomes increasingly conspicuous and increasingly impassioned; in the Crucifixion and Lamentation she hurls her arms up in a gesture evocative of the grieving Dido.[26]

Perhaps the most dramatic change of all, however, is the revolution in rendering the traditional episodes of the Passion cycle. By the middle of the century, in every episode of the Passion cycle from the Arrest of Christ up to the Crucifixion, a long-established image that stressed Christ's stoicism during the Passion was discarded and replaced with a new image that depicted the reality of the moment in more immediate and expressive terms. These breaks with inherited tradition seem directly comparable to the replacing of the *Christus Triumphans* with the *Christus Patiens*; in fact, the new narra-

tives supplant the old versions more quickly and more consistently than the *Patiens* supplants the *Triumphans*.[27] To cite a single example, depictions of the Mocking of Christ from the late twelfth century and first years of the thirteenth (Fig. 9)[28] depict a heroic Christ who stands unflinching, gazes out impassively, and raises his right hand as if affirming his divinity. By the 1240s, representations of the same event depict a far more vulnerable Christ. Now blindfolded, he is shown faltering; he no longer gestures, and his head bows under the blows of his captors (Fig. 10).[29] Surely this image, like the *Christus Patiens* and like the comparable narrative scenes that emerge at the same time, was intended not merely to instruct but also to elicit "sympathetic and affective participation." This reinventing of the Passion has largely escaped critical notice, and one purpose of this study is to document it.

The second purpose is to examine this phenomenon more closely. These are extraordinary changes; how and why did they occur? To understand how they occurred requires a careful look at images produced elsewhere – primarily in Byzantium, but also in northern Europe – and the ways in which these were used by Italian painters. To understand why requires a study of local issues and ideologies, especially those promoted by the most important sponsor of Passion images at this time, the Franciscan order. We must also ask whether the use of imported images is unrelated to Franciscan patronage, or whether the two intersect in significant ways. An overview of these questions, and of the methodology I use, is presented in Chapter 1.

PASSION NARRATIVES, ICONS, AND IDEOLOGIES

✠

BYZANTINE QUESTIONS

In fashioning the new narratives that transformed Passion imagery in the duecento, central Italian painters and their patrons appropriated much from Byzantium. This use of imported images is not surprising. Thirteenth-century Italian painting has traditionally been labeled the "*maniera greca*" (a disparaging term from the beginning) and its style described as "Italo-Byzantine"; these terms are still used today. Further, scholars often refer to the *Christus Patiens* (see, for example, Figs. 6–8) as an example of the impact of Byzantium on Italy; they have long recognized the Byzantine origins of the suffering Christ.

But labels like *maniera greca* and "Italo-Byzantine" mask as much as they reveal. Citing "Byzantine influence" does not explain the reasons for the Italian appropriation of eastern images like the *Christus Patiens* and the narrative scenes that will be considered here. To understand the limitations of these terms requires a brief review of what used to be called "the Byzantine question."

From the fourteenth century, Italian commentators recognized that much about thirteenth-century painting seemed "Greek" – and they were invariably scornful of it for that reason. Cennino Cennini, for instance, lavished praise on Giotto for transforming painting "from Greek to Latin"; for Villani, art before Cimabue was "dissolute and wayward," and Vasari was still more vituperative, condemning Byzantine art as "clumsy, awkward, and villainous."[1]

This critical stance towards Byzantium – often described today as Orientalism – has lingered into the twentieth century.[2] Indeed it still affects art

history; the relative neglect of duecento painting even today is in some ways the heritage of Vasari.[3] Even when monographs on the art of this period do appear, they generally give short shrift to its Byzantine component. For instance, several recent studies of thirteenth-century Italian painting (Castelnuovo, *La pittura in Italia: Il duecento e il trecento*, 1985; Marques, *La peinture du duecento en Italie centrale*, 1987; Tartuferi, *La pittura a Firenze nel duecento*, 1990; Boskovits, *The Origins of Florentine Painting, 1100–1270*, 1993) are valuable compendia of photographs, bibliographies, and fresh attributions. Of the four, however, only Boskovits considers the use of Byzantine art by these painters at any length. And elsewhere one still sometimes encounters pronounced hostility to Byzantine art in discussions of duecento painting.[4]

Within the last twenty-five years, Byzantinists like Otto Demus and Ernst Kitzinger have attempted to correct this neglect, arguing that Byzantium played an essential part in the formation of Italian painting. In *Byzantine Art and the West*, Demus painted the picture with broad strokes. Describing the art of the duecento, he wrote: "An entirely new art was in the making . . . – a revolution was set off by those overpowering waves of Byzantine influence."[5] James Stubblebine, one of the few specialists in central Italian art to study the relationship between Byzantine art and the duecento in depth, similarly concluded that duecento painters were in the thrall of Byzantium's "enormous and magnetic pull."[6] For Demus and Stubblebine, then, Byzantium was an almost inexorable force that exerted an irresistible influence on Italian painters.

More recently, some Byzantinists have questioned this interpretation. Anthony Cutler rightly challenged the "increasingly common view that attributes to Byzantium a series of decisive interventions in the history of Western European art" and argued cogently for shifting the issue "from the source of the influence to the needs and interests of the influenced."[7] Despite Cutler's reformulation of the question, however, the implicit assumptions of Demus and Stubblebine are still widely accepted.

Most recently, Hans Belting examined many of these issues in *The Image and its Public* and again in *Likeness and Presence*.[8] Earlier, in a review of Demus's *Byzantine Art and the West*, Belting commented that "the history of the Dugento has to be rewritten,"[9] and in some respects, in both *The Image and its Public* and *Likeness and Presence*, Belting takes up his own challenge. *The Image and its Public* is not a conventional history, but focuses on Passion imagery, especially the Man of Sorrows, in East and West; he devotes much attention to thirteenth-century Italy. The book is an important study of devotional images and their function, both in the liturgy and in private worship. Nevertheless, Belting's view of Italian painters working before Duccio is limited, largely because his study does not extend to narra-

tive painting. Like Demus and Stubblebine, he minimizes the possibility that Italian painters reworked the Byzantine images known to them. Instead, he argued that Italian art in the generation before Duccio was meant to resemble Byzantine art, which had the status of relics. For Belting, these painters valued the "privileged form" of their Byzantine "models" more than originality of expression: "Each newly produced panel was to be compared with [eastern models] and judged accordingly." He interprets duecento painting similarly in *Likeness and Presence*.[10] Thus for Belting, too, Italian painters were emulators of Byzantine images, striving to produce a faithful replica of the "model" before them.

Though Belting's comments may be valid for the devotional images that are his subject, they cannot be applied consistently to Passion narratives during the duecento. This study will approach the complexities of the issues through a close look at the narratives themselves – from the Betrayal of Christ through the Ascent of the Cross – and at the Byzantine images that they most closely resemble. In the process, several points will be clarified. First, we will see the extent to which central Italian painters availed themselves of Byzantine works. Though today we have a general understanding that these painters knew Byzantine art, their use of Byzantine art can be quite specifically documented. Many of these painters must have studied Byzantine images very carefully; at times, they reproduced elements from these images with remarkable precision. We will see, too, that a considerable range of Byzantine images – more than is generally assumed – must have been available to duecento painters, and that this stock must have been regularly replenished with new imports; images only recently introduced in the East appeared in Tuscan and Umbrian painting surprisingly quickly. It is important to show both the meticulousness with which these painters copied Byzantine motifs and the range of images at their disposal; the Byzantine originals from which these painters worked are long lost, and some scholars have recently questioned the presence of Byzantine ivories and manuscripts in central Italy during the thirteenth century.[11] Further, this assimilation of Byzantine ideas spans several generations of Italian painters. It can be seen as early as the 1230s and 1240s, but it continues through the century. In fact, some of the great artists of the trecento – among them Giotto, said by Cennini to have transformed Italian painting "from Greek to Latin" – continued to use images only recently imported from Byzantium.

But it overstates the case to assert that Italian painters invariably emulated the art of Constantinople as faithfully as possible. Though duecento painters and their patrons frequently relied on eastern models as they worked out new iconographies, they did not inevitably do so. For instance, the image of the Mocking of Christ that was favored in central Italy until about 1240 (see Fig. 9) is a traditional Byzantine formulation. But the new

image (Fig. 10) is demonstrably non-Byzantine; its origins are largely to be found in northern Europe. In fact, at exactly the time that central Italian painters adopted certain eastern images in their entirety, they manipulated and recast others and disregarded still others altogether.[12] This show of independence, at the peak of the *maniera greca*, challenges conventional definitions of the period. It suggests, at the least, that these painters and their employers aspired to something more than a dutiful copy of Byzantine work. Clearly, our definitions need to be reconsidered. We need to go beyond the assumption that these painters always emulated Byzantine art to ask how central Italians – both the artists and their patrons – responded to Byzantine art, and why they did, and why, at times, they did not.

These questions have no easy answers. The intertwined ideologies that underlie the phenomenon of the so-called *maniera greca* are still incompletely understood.[13] However, recent research suggests certain intriguing possibilities. For instance, Cathleen Hoeniger has shown that Tuscan panel painters emulated eastern fabric patterns in the thirteenth and early fourteenth centuries, a practice that implies a fascination with the novel and the exotic, specifically with luxury goods imported from the East.[14] If textiles held such allure, it is understandable that icons and manuscripts would as well. But the central Italian interest in Byzantine art clearly went beyond the appeal of the new. As noted, Belting has argued that Byzantine icons were viewed as relics in late medieval Italy, and that duecento painting was thus meant to resemble Byzantine art. Though these painters did not invariably try to replicate eastern icons, Belting is surely right that duecento painting was intended to look Byzantine. Byzantium's wealth and prestige were well known in Italy, in the twelfth century from travelers' reports and after 1204, from the plunder taken by the Italians who sacked Constantinople in the Fourth Crusade. "They stripped the service copy of the Gospels, and the Honorable Crosses, and priceless icons. . . ," chronicles tell us, and these gospels and crosses and icons must have been highly prized in Italy.[15] The *maniera greca*, in emulating the art of an envied empire, at one level reflects a tacit recognition of the prestige of Byzantium and a wish to appropriate that prestige. But the *maniera greca* may have also evoked the spoils of war, the booty plundered from Constantinople after the Fourth Crusade. It might thus be understood as an assertion of the continuing Italian hegemony in the Levant and of the colonial status of the East.[16] And in stealing "precious icons," did the pillaging crusaders hope to appropriate as well the holy powers ascribed to some of those icons? Might the *maniera greca* also reflect an attempt to transfer the efficacy of the originals to "multiples," as the Byzantines themselves did?[17]

All of these factors – a fascination with the exotic; an emulation of icons that had the status (and perhaps the power) of relics; an appropriation,

through its art, of the prestige and aura of an envied civilization; an implicit promotion of the ideology of conquest – help explain the generally Byzantine look of much duecento painting. But none of these factors helps with two problems. First is the surprisingly inconsistent reception of Byzantine images in central Italy: As noted above, the same painters who readily took over one image reworked others and jettisoned still others altogether. Second, although Byzantine art was presumably imported into Italy in great quantity after 1204, there is no evidence, at least in Passion images, that duecento painters or their patrons paid much attention until the 1230s or '40s. For instance, the *Christus Patiens* gains popularity only after 1235 or 1240. And only after this date do central Italian painters begin to appropriate Passion narratives from Byzantium. Thus, both a thirty-year time lag and a marked selectivity in the use of Byzantine images cloud the traditional view of the *maniera greca*. Clearly something more than a response to a "privileged form," in Belting's phrase, is at work. As Cutler astutely recommended, we must turn from the source of the influence to the needs of the influenced.

FRANCISCAN IDEOLOGIES, THE *ALTER CHRISTUS*, AND PASSION NARRATIVES

New Passion images appeared in the duecento because they served the interests of the groups that kept many painters employed. The most important of these groups, for our purposes, was the Franciscan order.

Claims for the primacy of Franciscan patronage are not new to studies of Italian art. Over a century ago, Henry Thode proposed that the Order played a decisive role in the development of Italian painting.[18] Within the last twenty-five years, a number of scholars have brought a sharper focus to our understanding of Franciscan patronage. Henk van Os's fundamental work on Francis as *Alter Christus* has been followed by a number of important works on images of Francis and their ideological uses, and on Franciscan treatments of other themes.[19]

The Franciscans, of course, were not alone in sponsoring religious art. Van Os has challenged "the obligatory, general reference to the special significance of the Franciscans as donors"; and he and others have written cogently about the patronage of the Dominicans, Carmelites, Augustinians, and Servites in the duecento and trecento.[20] But van Os's comments apply only to the late duecento and trecento: For much of the thirteenth century, the Franciscans were in fact the most prolific patrons of all the orders. Their only rivals in size and influence were the Dominicans; the two are almost invariably viewed as the dominant orders in central Italy during the thirteenth century.[21]

However, the two orders differed considerably in their patronage during the thirteenth century. Joanna Cannon has done pioneering work in eluci-

dating these differences. First, arguing that "inhibiting attitudes and modest finances" restricted the production of images, she points out that surprisingly few surviving works were produced for the Dominican order until the late duecento.[22] Moreover, even when the Dominicans did sponsor art, the kinds of images preferred by the two orders differed in important ways. As Cannon and van Os have shown, the Dominicans especially favored images of the Virgin and Child; both scholars have also noted that the Order also commissioned other devotional images such as the Man of Sorrows.[23] But in the thirteenth century, even late in the century, the Dominicans sponsored narrative painting only infrequently. For instance, a great many hagiographic panels of Francis, depicting the saint surrounded by narratives, have survived; comparable images of Dominic are almost unknown.[24] When Dominicans did commission themes like the Crucifixion, they generally chose single images rather than narrative cycles. Even here, figures are typically pared to a minimum; on one occasion, Dominican patrons apparently intervened to have the painter suppress extraneous elements.[25]

Patterns of Franciscan patronage differed considerably. The proliferation of Franciscan narrative cycles, both in fresco and in panel painting, contrasts sharply with the dearth of such cycles for Dominican foundations, as Cannon, van Os, and others have observed.[26] Franciscan manuscripts also tend to be far more densely illustrated than those made for the Dominicans.[27] Not only did the Franciscans favor narrative painting in general, they are likely to have especially favored narratives of Christ's Passion. Devotion to the passion was central to Franciscan piety, a defining attribute both of Francis and of the order he founded. In fact, the term "Franciscan spirituality" has become virtually synonymous with the veneration of Christ's suffering on the cross.[28]

Again, the Franciscans were not the only religious order or group promoting devotion to the passion during the thirteenth century. Caroline Bynum has drawn a useful distinction between Franciscan spirituality and uniquely Franciscan spirituality, stressing that the emphasis on the *imitatio crucis* was not confined to the Franciscans.[29] The origins of this sensibility predate Francis by decades, perhaps by more than a century. A growing empathy for Christ's suffering during the passion emerged as early as the late eleventh century and gained momentum in the twelfth; twelfth-century writers, especially St. Anselm and St. Bernard, wrote at length on the subject. Francis was profoundly influenced by these writers, but he was not alone; many of his contemporaries were as well.[30]

The intense debates on the nature of the Eucharist that occurred in the twelfth and thirteenth centuries also engaged Francis and his followers. These debates culminated in the doctrine of Transubstantiation, promulgated at the Fourth Lateran Council of 1215; the doctrine insists upon the phys-

ical presence of Christ on the altar at the consecration of the Host. Further, the body of Christ was to be experienced visually: The elevation of the Host for the viewing of the congregation gradually became established practice after Lateran IV.[31] This doctrinal focus on Christ's corporeal presence encouraged meditation on the body of Christ and on the physical reality of the Passion, and it privileged the role of sight in eucharistic devotion. Thus mystics of the thirteenth and early fourteenth centuries described seeing the crucified body of Christ at the elevation of the Host; in their visions, Christ displayed his wounds to them as he offered them communion.[32]

This heightened concern with the physical presence of Christ on the altar and with the visual experience of that presence necessarily had certain implications for Passion images. As van Os and Belting have suggested, these liturgical and devotional developments must have influenced the imagery of painted crosses and altarpieces in the course of the thirteenth century; these were, after all, liturgical objects, situated on or above the altar where the sacrifice of Christ was reenacted, and intimately associated with those rites. It has long been thought that the new rite of elevating the Host increased the demand for altarpieces, which now served to frame the elevation. The content of the altarpieces could be affected as well, as van Os has noted.[33] If eucharistic devotion also stimulated the depiction of Passion images, the Franciscan order would have been intimately involved; the Order actively promoted eucharistic devotion and was, in fact, responsible for introducing the elevation of the Host into the Roman missal.[34] But again, the Franciscans were not alone in their veneration of the *Corpus Christi*. The cult spread throughout Italy, supported and fostered in many quarters; in the early trecento, the Dominican order became official preachers of the cult.[35]

Devotion to the Passion was, then, not unique to the Franciscan order; christocentric piety was an integral part of the fabric of thirteenth-century spirituality. But the Franciscans could, and did, assert their singularity in one respect: Only they had a founder whose experience of the suffering Christ was so intense that he was rewarded with the stigmata – the "marks of the Passion of our Lord."[36]

The identification of the stigmata with Christ's wounds during the Passion was, of course, immediate in Franciscan circles. Elias of Cortona issued a letter in October 1226 announcing the discovery of the stigmata and linking them with Christ's wounds. Francis's first biographer, Thomas of Celano, similarly associated the two. Bonaventure, the politically astute Minister General of the Order, placed still greater emphasis on the stigmata, stressing their uniqueness. For instance, in a sermon of 1255, he stated: "Among all the gifts which God bestowed on this humble and poor little man, St. Francis, there was one special and if I dare to say, unique, privilege: That he bore on his body the stigmata of our Lord Jesus Christ. . . ." A few

lines later he reiterated more emphatically: "In praise of this special or, as I would rather say, unique privilege. . . ." In the *Legenda maior*, approved in 1263, he is still more forceful: "[Francis] was marked out by a new and unheard-of miracle; by an extraordinary privilege which had never before been granted to a human being in the course of history."[37] The Order, then, was unique as well: Its founder alone was granted this sign of God's favor. With their distinctiveness thus anchored, the friars jealously guarded their claim, fending off any rival order's attempt to encroach on it.[38]

Thus the Franciscans had singular reasons to promote christocentric piety, and to decorate their churches with images of what Bonaventure called the "distress and agony" of the Passion.[39] These narratives were potent reminders of Francis's devotion to the Passion and of the reward that was exclusively his. Further, they might arouse in the viewer the *compassio* felt by Francis himself; Francis's response to an image of the crucified Christ marked a turning point in his life.[40] The intimate link between pictures, piety, and the Passion was forged very early in Franciscan history.[41]

Franciscan promotion of the Passion can be seen repeatedly in thirteenth-century Italian painting. Only a few fresco cycles depicting the Passion survive from the duecento, which is not surprising considering the paltry remains of duecento frescoes in general.[42] But of the Passion cycles in fresco that still exist in central Italy, most were commissioned by Franciscans. For instance, about 1260 an itinerant artist, perhaps Tuscan, painted Passion scenes in San Sebastiano, a Clarisse house in Latium; about the same time, a second Latian house of the Clares, San Pietro in Vineis at Anagni, was frescoed with a similar program. Towards the end of the century, another anonymous painter decorated Santa Maria degli Angeli near Spoleto with Passion scenes, also for the Clares, and a few fragments from a second Passion cycle at that site exist as well.[43] Just at the turn of the century, the north chapel of Sant'Antonio in Polesine, Ferrara, was frescoed with an extensive Passion cycle; the church housed a group of women whose spiritual advisers were Franciscan friars.[44]

All of these cycles attest to the centrality of the Passion for the Franciscans. But the Order's special attachment to the subject is most conspicuous in the fresco cycles in the mother church, San Francesco at Assisi. At least three distinct painters or workshops produced Passion images there in the second half of the century. In the earliest of these cycles to survive, in the nave of the Lower Church of San Francesco, the specifically Franciscan claim to the Passion is asserted by juxtaposing Passion scenes with scenes from the life of Francis. This parallelism was a theme of special concern to Bonaventure; the frescoes were probably executed in the early 1260s, not long after he took office as Minister General in 1257. The clear intention of this program is to herald Francis as *Alter Christus* or second Christ; in fact, certain

episodes from the lives of Christ and Francis were included to underline the point.[45] On the upper north wall of the nave of the Upper Church, a Passion cycle forms part of a larger program devoted to the Old and New Testaments.[46] Perhaps the clearest evidence of the privileged position of Passion imagery at San Francesco appears in the transept of the Upper Church. On the west wall of both the north and south transepts are enormous frescoes of the Crucifixion; in both, Francis kneels at the base of the cross. In their scale, location, and repetition of theme, they forcibly declare the Order's claim to the suffering Christ.[47] The emphasis on the Passion at San Francesco continued into the fourteenth century, with an extensive cycle in the south transept of the Lower Church by Pietro Lorenzetti and his shop.[48] No other Franciscan house is more pointed than the mother church at Assisi in asserting that the Passion is the special province of the Order.

In manuscript illumination, too, we find evidence of the Franciscans' privileging of the Passion. In a late duecento *Supplicationes Variae* manuscript in Florence, for instance, the Passion episodes are the most elaborate of all the cycles.[49]

But Franciscan sponsorship of Passion narratives is especially clear in panel painting. To judge from surviving work, panels commissioned by Franciscans (or by a lay person or organization closely associated with the Order) very frequently included Passion scenes.[50] At times, as in the diptych from Santa Chiara, Lucca (Fig. 1) or the dossal from the Convento dei Frati Minori del Farneto (Fig. 3), the provenance of a panel is known. At other times, the inclusion of Francis and other Franciscan saints (Clare, Anthony) or the Stigmatization indicates that the patron especially venerated Francis. In the Crucifixion panel of the dossal in San Diego, for instance (Fig. 4), Francis kneels at the foot of the cross.[51] In fact, if the patronage of a duecento altarpiece or devotional panel with a Passion cycle can be identified, it is, far more often than not, Franciscan.[52] The Franciscan preference for Passion narratives continued into the trecento. For instance, Ugolino di Nerio's polyptych for the high altar of Santa Croce, the Franciscan church in Florence, features a Passion cycle in the predella. The choice is telling when this polyptych is contrasted with the Dominican work that it closely emulates; there the predella consists primarily of standing saints.[53]

Historiated crosses were also painted for the Order, although proving their Franciscan sponsorship is more difficult. These crosses were, of course, also found outside Franciscan circles; they were well established in Tuscany before the advent of the Franciscans. Some Franciscan communities – particularly in Umbria – evinced little interest in historiated crosses, preferring the nonhistoriated type popularized by Giunta Pisano.[54] Further, the provenance of historiated crosses is almost never obvious, as it can be in other types of panel painting. Altarpieces and devotional panels may include

·

unambiguous hallmarks of Franciscan sponsorship: images of Francis, Clare, or the Stigmatization. Francis and at times Clare can also appear on non-historiated crosses; especially in the second half of the century, a kneeling figure – usually Francis – is often included at the foot of the cross. Historiated crosses, however, are very rarely equipped with such ready identifiers.[55] Finally, even when we have some documentary indication that a given cross once hung in a given Franciscan church, we cannot conclude that it necessarily originated there; like all panel paintings, crosses were portable.

Assessing the Franciscan origins of the crosses, then, can be a vexing enterprise. Nevertheless, at least some of the crosses must have been produced for the Order; several have been traced more specifically to the Clares. One of the earliest extant crosses with a Franciscan provenance is a Sienese example from Santa Chiara, Siena.[56] Two crosses, both painted around the middle of the century, were probably intended for San Martino, Pisa, where one (Fig. 6) still hangs; the church housed a community of the Clares in the thirteenth century.[57] A fourth, originally historiated but now deprived of most of its apron, comes from Santa Chiara, Castelfiorentino.[58] The cross by Coppo di Marcovaldo (Fig. 8), now in San Gimignano, Museo Civico, has recently been traced to the Conservatorio di Santa Chiara in the same city.[59] The fact that all of these works once hung in houses of the Clares is striking. Though we cannot be certain that any of these crosses were originally destined for the Clares, it is reasonable to assume that most of them were. As subsequent chapters will show, the specific Passion images in these crosses are often nearly identical iconographically to those found in panels and frescoes that were unquestionably done for Franciscans.[60] We will revisit the question of the crosses' patronage in the Conclusion.

The Franciscans did not confine their promotion of the Passion to commissioning narrative cycles of these events. They also constructed fresh versions of these narratives. The new images – like the new version of the Mocking of Christ (Fig. 10) – invariably stress Christ's human sufferings during the Passion, and both in tone and in details they correspond closely to descriptions of these biblical episodes in Franciscan writings. These texts need not be taken as the sources of the images to be considered here; relatively few scholars today would insist on the primacy of texts over images.[61] It is more reasonable to understand both as expressions of a larger discourse on the Passion that engaged the Order during the thirteenth century. Still, the texts are an invaluable resource: They illuminate the thinking of Franciscan writers on the relevant themes; they provide a wealth of details (details often found as well in the images); and their Franciscan provenance can be firmly anchored.

The texts vary considerably in type, function, audience, and rhetorical structure. Those that will be most often cited here include liturgical texts – in

particular, an Office of the Passion by St. Francis[62] – and devotional guides, some by Bonaventure (*Lignum vitae*, *Vitis mystica seu tractatus de Passione Domini*, *De perfectione vitae ad sorores*),[63] others by pseudonymous authors writing in a similar vein. The most famous of these, and the most richly textured, is the *Meditationes vitae Christi* once ascribed to Bonaventure; the author reveals his Franciscan identity several times throughout the text.[64] A strong case can be made for the Franciscan authorship of two somewhat similar, though much briefer, pseudonymous meditations: the *Dialogus Beatae Mariae et Anselmi de Passione Domini* once attributed to Anselm and *De meditatione Passionis Christi per septem diei horas libellus*, formerly ascribed to Bede. Of the two, the latter is more comprehensive and more often accords with the Passion narratives that appeared during the duecento.[65] Two quite different types of Franciscan texts will also be cited in this study. The first, Bonaventure's *Apologia pauperum* of about 1269–70, is a lengthy, spirited defense of the mendicants, in particular of the vow of poverty, in response to the attacks of Gerard of Abbeville.[66] Finally, the *Meditatio pauperis in solitudine*, written in 1282 or 1283, is not a meditation on the Passion like those listed above; it rather details Francis's imitation of Christ's poverty, charity, and humility.[67]

We will be considering, then, a strikingly heterogeneous group of texts, which addressed diverse audiences.[68] The approaches even of the meditation guides range from allegory to straightforward narrative,[69] and they do not present a monolithic account of the biblical events that will be surveyed here. As noted above, the two texts formerly ascribed to Anselm and Bede diverge in their treatment of some moments during the Passion. Bonaventure's work also, at times, provides fresh interpretations of biblical episodes. However, despite the considerable range in function, intended readership, length, approach, and so forth, the various accounts agree to a surprising extent in their descriptions of most events of the Passion. In fact, one often notes an interesting attempt at inclusiveness: The texts at times weave together more than one version of the same event, or obligingly offer the reader options, recounting first one version, then a second.[70]

It is not merely the affective tenor of the duecento Passion images, and their correspondence with texts written by members of the Order, that identifies them as Franciscan products, although this tenor – often called a Franciscan sensibility or consciousness – is an important common link. In several cases, however, the new narratives seem more specifically Franciscan: They assert ideas and ideologies associated closely with the Order, or with dominant factions within it, at certain moments in its history. For instance, we will see that some images of Christ's Passion were manipulated to evoke aspects of Francis's life, and thus to signal more explicitly his identity as *Alter Christus*. These manipulations began around mid-century and became

still more pronounced during the rule of Bonaventure as Minister General (1257–74); as noted above, Bonaventure was especially vigorous in championing Francis as a second Christ. Similarly purposeful alterations – but of texts rather than images – have been observed by William R. Cook and Ronald Herzman; they note the ways in which Bonaventure "reworked and reinterpreted the significant stories found in earlier Franciscan writings in order to make [Francis's relationship with Christ] clear."[71] Other images – many dating from Bonaventure's tenure – also have an ideological cast; they will be interpreted in the context of the political vicissitudes of the Order, among them the struggle between the Spiritual and Conventual factions of the Order, and the attacks launched at the mendicants by the secular clergy. Again, Bonaventure structured his biography of Francis to emphasize aspects of Franciscan ideology, especially humility, poverty, and renunciation; Haase described the *Legenda maior* as a "validation and interpretation of the Franciscan Ideal in the 1260's and beyond."[72] Much as Bonaventure interwove narrative and ideology and constructed his narrative to support ideology, so too did the Passion images of the mid-duecento and later.

The following chapters will show that these Passion images promoted the Franciscan order, its founder, and its tenets, especially humility, poverty, and renunciation – the very points stressed by Bonaventure. The images functioned on one level as a kind of visual propaganda, analogous to the hagiographic panels and fresco programs on the life of Francis that also proliferated at the time.[73] It is this common correspondence with Franciscan interests, not a common fidelity to Byzantine "models," that will be shown to define and link the new Passion narratives; Byzantine images were usually, but not inevitably, essential to their formulation. Scholars have long recognized the importance of the Order in popularizing the *Christus Patiens*,[74] but the role of the Franciscans in recasting Passion images went well beyond the image of the crucified Christ.

The argument that the Order played a major part in shaping the new images gains further credence when one considers the chronology: The years in which these images begin to appear – the 1230s and 1240s – coincide with the spread of Franciscan houses throughout Tuscany and Umbria. The Order grew with astounding speed very early in its history; by 1217, the friars had organized themselves into eleven provinces that included Italy, France, Germany, Spain, and the Holy Land.[75] But the earliest friars were in no position to sponsor the production of images. Francis vehemently opposed the construction of any permanent buildings, and at the Portiuncula at Assisi, the friars lived in wooden huts until 1230.[76]

Not long after Francis's death in 1226, however, the early insistence on poverty began to soften. In 1228 Pope Gregory IX approved the construction of San Francesco to enshrine the remains of the saint, and in 1230 the Chap-

ter of Assisi appealed to Gregory for a ruling about the construction of additional churches. The pope responded in September 1230 with the bull *Quo Elongati*, allowing the friars the use (though not ownership) of churches.[77] With papal approval in hand, in the 1230s and 1240s Franciscan communities throughout Tuscany and Umbria began first to take over existing churches and then to build their own; especially after 1239, new churches proliferated.[78] All of these buildings required decorating – and the *usus simplex* of pictures, too, was specifically sanctioned by the bull of 1230. Thus members of the Order began to commission images of their founder; Bonaventure Berlinghieri's hagiographic panel of St. Francis, an early example of the type, is dated 1235.[79] The new Passion images that correspond so closely to Franciscan devotional thought also began to appear at precisely this time.

Thus the interconnections, both conceptual and chronological, between the Franciscan order and the Passion images that concern us here seem more than fortuitous. Given the centrality of devotion to the Passion to the Franciscans, and their astute and early grasp of the value of pictures in promoting their spirituality and their Order, it would be surprising not to find a close relationship between the two. The Franciscans were, of course, not alone in commissioning Passion cycles,[80] and other patrons often did not hesitate to adopt images that originated in a Franciscan context, as will be seen shortly. But the Order must have had a considerable hand in the construction and diffusion of the new images that transformed the look of the Passion in duecento painting.

THE FRANCISCANS AND THE LEVANT

What, then, of the "Byzantine Question"? We have been considering two phenomena: Franciscan patronage and duecento painters' reliance on Byzantine images. Though scholars have generally not linked the two, they may be related: The strong Byzantine component in so much duecento Passion imagery may stem, at least in part, from the specific activities of the Order in the thirteenth century.

Of course, there were many routes through which duecento painters could have encountered eastern objects like icons and manuscripts. Italian merchants traded with the Latin Kingdom of Jerusalem throughout the duecento; enterprising Italian painters similarly plied their trade in the Crusader States; and some itinerant Byzantine painters in turn made their way to Italy.[81] But the Franciscans themselves provided a direct link to Byzantine images. Among the most visible of the western religious groups in the Middle East, they participated actively in the traffic in images throughout the region.

From their founding, the Franciscans were pioneers in sending missions to the eastern Mediterranean – a kind of spiritual colonization that paralleled the military and mercantile incursions of Italy into the Levant.[82] Francis himself planned a trip to Syria in 1212 and again in 1213. Though both trips had to be postponed, he spent several months in the Levant in 1219, visiting Acre, capital of the Latin Kingdom of Jerusalem, and Damietta.[83] The ideology of mission continued to be a central principle of the Order, as E. Randolph Daniel has shown.[84] Franciscans were firmly established in Constantinople as early as 1220 and exercised influence over the Latin emperors of the city for much of the Latin occupation; John of Brienne, emperor from 1229 to 1237, was himself a Franciscan tertiary.[85] Franciscan establishments in the Levant multiplied in the course of the century, and popes often chose Franciscans as their legates to the East.[86] The Order was ultimately rewarded for its considerable investment in the East when it was assigned custody of the Holy Sepulcher.[87]

The Franciscans also became valued agents of the pope in the reunification of the Greek and Latin churches. In fact, leaders of the Order were often intensely involved in the process. Thus Haymo of Faversham, Minister General of the Order from 1240 to 1244, was dispatched by Gregory IX to the Byzantine court of Nicaea to explore unification as early as 1234, and John of Parma, Minister General from 1247 to 1257, went on a similar mission in 1249 at the behest of Innocent IV.[88] John remained keenly interested in union, and in 1254 introduced eastern saints into the Franciscan liturgical calendar.[89] Under Bonaventure, the Order again played a pivotal role in the negotiations with Constantinople.[90] In 1272, Gregory X sent a Franciscan friar, John Parastron, to instruct Michael Palaeologus in Latin theology; Parastron, a Greek born in Constantinople, had earlier been an envoy from Michael to the pope, and his efforts laid the foundations for the Council of Lyons, convened in 1274. Other friars were also emissaries to Constantinople: In 1272 four Franciscans, among them Jerome of Ascoli, the future Pope Nicholas IV, embarked for the Byzantine capital. Geanakoplos has argued persuasively that the choice of Franciscans for this mission was particularly astute: He reasons that a kinship between Franciscan spirituality and Greek Orthodoxy made the friars especially valuable intermediaries in the sensitive process of introducing the Byzantine emperor to the doctrines of Rome.[91]

All of these ventures – the establishing of Franciscans at the Latin court of Constantinople and the Byzantine court of Nicaea; the founding of Franciscan houses throughout the Levant; the travels of friars in the region; the critical role played by leaders of the Order in the effort to reunite the Latin and Greek churches – inevitably exposed Franciscans to Byzantine images. In fact, the ideology of mission led Franciscans to acquire Greek manuscripts:

To communicate with those they wanted to convert, the friars needed to learn Greek.[92] Thus the Franciscan establishment at Constantinople amassed a sizeable collection of Greek codices, and some Franciscan groups in the West similarly acquired them.[93]

Further, Byzantine religious artifacts and luxury goods – icons, manuscripts, silks, and so on – were often presented as gifts to Franciscans. At least a few Byzantine objects given to the mother church of the Order in Assisi still survive today. For instance, the emperor John of Brienne presented numerous gifts, among them a panel covered in gold leaf and silk altar dossals, to San Francesco; two of the dossals are still housed in the treasury. Another example is an eleventh-century Greek manuscript now in the Vatican, which was carried from Constantinople to Assisi, probably between 1251 and 1253, by a "frate Jacopo."[94] Moreover, the delicate negotiations between the Franciscan papal legates and the Byzantine emperor almost certainly included the exchange of gifts, and Byzantine icons and manuscripts would have been an obvious choice. We know, for instance, that Michael Palaeologus presented an illuminated bible to Louis IX in 1270; the bible was carried by Michael's envoy, the Franciscan John Parastron. Similarly, the Byzantine delegation to the Council of Lyons took icons, among other things, as gifts to the pope in 1274; the conspicuous Franciscan role in the Council has already been noted.[95]

Franciscans also brought their own images with them as they made their way east. The friars who settled in the Levant used Franciscan liturgical manuscripts that had been illuminated in the West. And, like their counterparts in western Europe, they had their churches decorated with frescoes depicting their founder, as the scenes of the life of St. Francis at Kalenderhane Camii, Constantinople, attest.[96]

In the later thirteenth and early fourteenth centuries, specifically Franciscan imagery began to appear in a number of sites in the Mediterranean East. A portrait of St. Francis, labeled "Frantzeskos," can be found in a thirteenth-century church on Crete, the church of the Virgin of Kera at Kritsa.[97] Helen Evans has demonstrated the importance of the Order in Armenian Cilicia and has convincingly documented the presence of Franciscan motifs in Cilician manuscripts; Annemarie Weyl Carr recently argued for the role of the Order in shaping images in Cyprus.[98] I have suggested elsewhere that Franciscan activity in the Levant contributed to the diffusion of new Passion imagery in the Crusader states, especially in Crusader icon painting.[99]

Because of the movement of images from West to East, we can no longer assume that an image found in the Byzantine sphere during the thirteenth century must have originated there. We now know too many counterexamples, demonstrating the appropriation of western themes and motifs in eastern painting at this time and beyond. At times, strikingly similar images will

appear almost simultaneously in East and West. This is not unexpected, given the intimate contact among cultures in the Mediterranean. Determining the origins of these images requires careful study. It is particularly important to consider the precise circumstances under which western images were imported into the East; what applies at periods and regions of closest ties among cultures may not apply at other times or places.[100]

Thus, the constant movement of Franciscans between Italy and the Levant in the thirteenth century left a mark on the visual culture of both regions. The Order's intense involvement in the Levant is one important context for the reception of Byzantine images in Franciscan circles in central Italy during the duecento. But the implications of the Order's many eastern enterprises may lead beyond that. The appropriation of Byzantine images may have seemed, to the Franciscans, a fitting expression of their missionary interests in the East, just as Cimabue's cityscapes of Palestine, Greece, and Asia in the evangelist portraits in San Francesco, Assisi, more explicitly assert the Franciscan ideology of mission.[101] The fusion of East and West that will often characterize the Passion images to be studied here seems a kind of visual corollary to the Order's promotion of union between the Orthodox and Roman churches. Indeed, we have already noted that the Order introduced eastern saints into the Franciscan calendar to signal their support of union; many of the images we will consider similarly meld East and West. The affinities between Greek Orthodoxy and Franciscan spirituality stressed by Geanakoplos also seem relevant here; this compatibility of thought makes the Franciscan adaptation of Orthodox images all the more understandable. In fact, the Franciscan texts that are so closely related to the images in question often resemble, in tenor and at times in details, Byzantine writings on the Passion. The intense Franciscan interest in the Levant – which dates almost to the Order's inception – may thus provide more than a means through which eastern images became known in central Italy; it may also explain, in part, the Order's evident eagerness to emulate these images in decorating their churches.

BYZANTIUM, BONAVENTURE, AND CIMABUE:
THE SANTA CROCE CROSS

One example will serve to illustrate some of the issues here, and the approach we will take in this study: Cimabue's cross for Santa Croce, the Franciscan church in Florence (Fig. 11).[102] This cross, generally dated around 1280–5, is well known to students of duecento painting for its startling departures from the conventions seen in earlier painted crosses.[103] The analysis of this cross has traditionally been presented in the following terms. In contrast with earlier crosses, such as the one for San Domenico, Arezzo

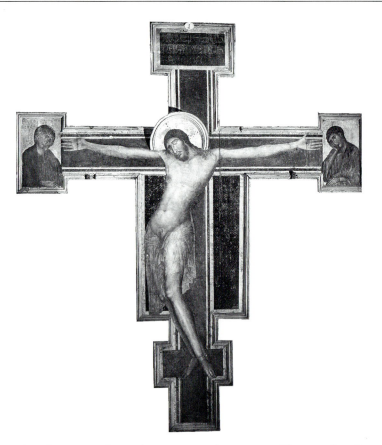

Figure 11 Cimabue. Painted cross (pre-1966 state), c. 1280–5. Florence, Sta. Croce. Photo: Alinari/Art Resource.

(Fig 12), usually attributed to Cimabue himself, Cimabue here dispenses with the conventional harsh modeling of the flesh and the schematic, linear patterns which indicate, for instance, Christ's abdominal muscles. Instead, he employs gentler modeling in light and shadow. To stress still further the naturalistic presentation, Cimabue even replaces the usual opaque loincloth with a new, translucent version – unprecedented, in the opinion of some scholars – that reveals the painterly treatment of Christ's flesh. These changes, including the loincloth, are often seen as heralding Tuscan painters' struggle to shed the "Italo-Byzantine" stylizations of the past, a struggle that culminates with the brilliant new style of Giotto.[104]

In fact, much that is new here stems not from Cimabue's success in liberating himself from Byzantium, but rather from his appreciative study of images recently introduced from Byzantium. Otto Demus and others have noted parallels between Cimabue's work and mid-thirteenth-century Byzantine painting; the frescoes of Sopoćani are often cited,[105] and in these frescoes one can find subtle modeling of the flesh similar to that in the Santa

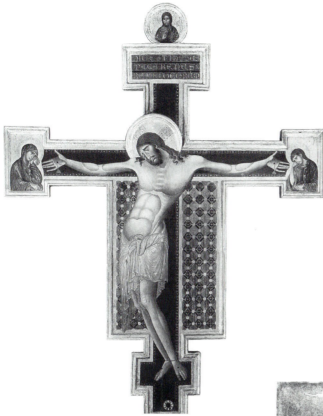

Figure 12 Cimabue(?). Painted cross, c. 1270–5. Arezzo, S. Domenico. Photo: Alinari/Art Resource.

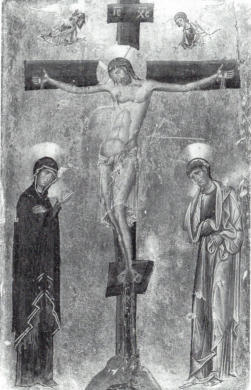

Figure 13 Crucifixion, detail: center. Mount Sinai, St. Catherine, twelfth century. Photo: Published through the courtesy of the Michigan-Princeton-Alexandria Expedition to Mount Sinai.

Croce cross. However, a more precise appropriation of Byzantium has gone thus far unnoticed: The famous translucent loincloth also finds precedents in Byzantine Passion images, such as a twelfth-century icon of the Crucifixion at the monastery of St. Catherine on Mt. Sinai (Fig. 13).[106] The diaphanous loincloth was known, in fact, as early as the eleventh century. A mosaic in the narthex of Hosios Lukas depicts Christ in a virtually transparent cloth, and he appears similarly in a late eleventh-century icon with Passion narratives also on Mt. Sinai.[107] In the icons, the loincloth approaches transparency; by comparison, even Cimabue's version seems discreet. Despite the currency of the translucent loincloth in Byzantium, to my knowledge Byzantinists have not discussed the motif and its theological implications; some connection of the motif with the humanity of Christ, a concern especially apparent in the wake of Iconoclasm, seems likely.[108]

Cimabue's reliance on a Byzantine image similar to these is not surprising. But Cimabue's assimilation of eastern art is still largely a neglected area, and this example provides us with some idea of the extent to which he studied these images: His use of Byzantine forms was not merely generic but often quite specific. Given the frequency of Franciscan contact with the Levant in the 1270s and 1280s, Cimabue may have owed his acquaintance with this particular image to his Franciscan employers.[109]

The Santa Croce cross would seem to corroborate Demus's and Stubblebine's arguments about the centrality of Byzantine models for the duecento. But to point to the Byzantine origins of its "revolutionary" features is to tell only part of the story. We have not considered why Cimabue, or the friars who advised him, found this image so worthy of emulation. Matters of style – that is, the more convincing representation of the body – may in part account for the appeal of the eastern image. But a further element in its appeal may be the fact that it presents us with a nearly nude image of Christ on the cross.

Images like this appear to have been understood in Byzantium as depicting the nude Christ. An oration on the Crucifixion by Michael Psellos, recently studied by Elizabeth Fisher, describes Christ as nude on the cross; this oration has been linked with the mosaic at Hosios Lukas, which contains an early instance of the translucent loincloth in Byzantium.[110] There is reason to believe that this image would have been similarly understood in Tuscany, especially in Franciscan circles. As Lambert has rightly observed, the naked Christ was a "key figure" for Francis;[111] references to Christ hanging nude on the cross abound in Franciscan texts in the later duecento. For instance, Franciscan writers of devotional tracts – Pseudo-Anselm, Pseudo-Bede, Pseudo-Bonaventure – consistently note Christ's nudity during the Crucifixion, describing his stripping in increasing detail.[112] But perhaps the most insistent is Bonaventure, who also makes explicit the reason for this

emphasis: Just as Francis stripped to renounce his father's wealth, Christ's nudity likewise proclaimed his poverty, and thus validated the vow upon which Francis founded the Order. The Minister General made the point again and again, repeatedly linking Christ's nudity with his renunciation of worldly goods.[113] In Chapter 3, "On Perfect Poverty," of *De perfectione vitae*, he wrote:

Not only was the Lord of angels poor at the time of His birth,. . . but He became poorer than ever in death, to inflame us with love for the same poverty. O *all ye* who profess poverty, *attend and see* how poor in death this rich King of heaven became for our sake. He was despoiled and stripped of everything. His clothing was taken when *they divided His garments* among them, and upon His vesture they cast lots. . . . [They] treated Him as a criminal; as was foretold by Job in the prophetic complaint: *He has stripped me of my glory* [Job 19:9].[114]

In the *Apologia pauperum*, written around 1269–70, Bonaventure returns to the theme with still more force: "He was suspended naked on the cross and all of His life was a road of Poverty," and, similarly, "He was suspended destitute and naked on the cross."[115] He insisted, too, that Christ's nakedness, and the poverty that it signaled, were voluntary: "Since He desired to end His life in the nakedness of absolute poverty, He chose to hang unclothed upon the cross."[116] His vehemence is understandable, given the political context: He wrote to rebut the attacks of those who challenged the mendicants' vow.

The Santa Croce cross thus evokes the words of Bonaventure, who repeatedly described Christ "suspended destitute and naked." Though Christ is not literally naked in the Santa Croce cross, the translucent loincloth approximates nudity as closely as decorum would allow in the thirteenth century.[117]

The translucent loincloth may not be the only reference to Franciscan poverty in the Santa Croce cross. Monica Chiellini recently contrasted the cross with its Dominican counterpart, the cross for San Dominico, Arezzo (Fig. 12). Noting, in the Santa Croce cross, the elimination of the gold striations in the cloaks of Mary and St. John, and the relatively subtle treatment of the decorative panels, she proposed that these features may be a Franciscan adaptation, a deliberate muting of the ornate to make the image "less regal and sumptuous."[118]

The Santa Croce cross thus seems to serve as a validation of the vow of poverty, proclaiming the poverty of Christ as exemplar for the Order. The nearly nude Christ became widely diffused; it appears often in the late duecento and into the trecento, and the earlier crosses are often demonstrably Franciscan.[119] Gradually, however, the image was appropriated by other groups, such as the Dominicans, as the cross for Santa Maria Novella by

Giotto or a follower shows.[120] This is not an unfamiliar phenomenon; during the duecento much Passion imagery originated in a Franciscan context but soon spread to rival orders.[121]

Though the Santa Croce cross asserts the ideal of poverty, it is not sufficient simply to identify the image as Franciscan. The Order was hardly monolithic in the second half of the duecento; on the contrary, bitter ideological struggles threatened its very existence. Even early in Franciscan history, tensions developed between those who espoused a strict interpretation of the vow of poverty and those who preferred greater laxity; by 1274, the two groups would coalesce into two factions, the Spirituals and the Conventuals.[122] When Bonaventure was elected Minister General in 1257, a vexing task was to restore a semblance of unity to the Order; with enviable finesse, he seems to have largely (if temporarily) succeeded in doing so. One measure of his fine diplomatic hand is the meeting of the general chapter at Narbonne, which he convened in 1260. On the one hand, he supported those who argued for a more stringent adherence to the vow of poverty; the resulting statutes of Narbonne reasserted fidelity to the vow.[123] Bonaventure's *Expositio in Regulam Fratrum Minorum* similarly insisted upon strictest poverty, and the choice of adjective is interesting: *"nudissima paupertas."*[124]

On the other hand, Bonaventure was a moderate, credited with charting a middle path between the extremes of both factions. Though the Chapter of Narbonne called for greater simplicity in church decoration, Bonaventure also defended the friars' building programs as essential to their teaching mission. Bonaventure's balanced approach to the debates of these decades may provide a context for the Santa Croce cross, which at first seems to fit less obviously with the competing ideologies of the day. The issue is this: If the translucent loincloth and the comparative restraint of the Santa Croce cross are, in fact, references to the centrality of poverty to the Order, it might seem paradoxical to encounter them at this juncture in the history of Santa Croce. The cross was probably commissioned for the new church of Santa Croce, the third church on the site, which was planned in the mid-1280s.[125] Though the second church of Santa Croce was still relatively new (it had been under construction in 1252), discussion of a third began in the 1280s – no doubt, as Goffen has noted, prompted by the grandeur of Santa Maria Novella, the Dominican church, which had been completed in 1279.[126] The decision to build a new church was vigorously opposed by the Spiritual faction at Santa Croce, but plans were drawn up in 1285, and Ubertino da Casale, the Spiritual leader, finally left the convent in defeat in 1289.[127]

It thus seems at first curious to find, in a cross commissioned by the ascendant Conventuals, these apparent references to tenets most stringently held by the Spirituals. A cynic might describe the cross as an act of monu-

mental chutzpa, a pious proclamation of continued allegiance to the vow hung shamelessly in one of the most lavish churches in Florence. But other explanations might apply. This "destitute and naked" Christ, and the relative restraint noted by Chiellini, may have been conciliatory gestures on the part of the Conventuals, intended to mollify the Spirituals and their sympathizers. It is possible that the friars did not see any inconsistency between the image and the grandeur of the church in which it hung. Bonaventure, after all, insisted upon *nudissima paupertas* but allowed the construction of new churches. And references to the poverty of Francis continued in Santa Croce, as Giotto's fresco in the Bardi Chapel of Francis Renouncing his Father's Goods shows. Even the Conventual Franciscans remained, after all, Franciscans; though they renounced the absolute poverty advocated by the Spirituals, most presumably believed in the ideals on which the Order was founded.[128] In a sense, the Santa Croce cross can be understood as brilliantly Bonaventuran, adroitly mediating the extremes of both factions: It celebrates *nudissima paupertas* even while it also declares the legitimacy of images, and, by extension, the legitimacy of the building in which it hung. The Conventual friars who commissioned the cross must have been keenly aware of the implications of this nearly nude Christ. With Cimabue's cross, they reasserted their own allegiance to *nudissima paupertas* at a time when some found reason to question their adherence to the rule.[129]

The Santa Croce cross, then, effectively demonstrates several points, to which we will return often in the following pages. First, it reiterates the importance of Byzantine images for duecento painters – even those considered "progressive" – and their patrons; these images were responsible even for some of the naturalistic treatments typically deemed Tuscan innovations. But it also suggests that more than one aspect of the eastern images would have prompted Italian interest in them. We can assume that Cimabue and his employers would have admired the naturalism of the translucent loincloth. Probably the very Byzantine-ness of Cimabue's presumed source also appealed to them, especially at a time when Franciscan preoccupation with the Levant was so keen. But at least as important was the value of the image in giving visual form to ideas central to the Franciscan order in general, and more specifically to the friars of Santa Croce at a critical point in the church's history.

To return, then, to the arguments long advanced to explain the *maniera greca*: Italian painters' assimilation of Byzantine images did not stem from the "magnetic pull" of these models, as Stubblebine claimed, nor from the "authority of a privileged form," in Belting's phrase. These painters took much from Byzantium, particularly when Byzantine images corresponded to ideas that their employers wanted to promote – as the Santa Croce cross illustrates. The compatibility of Franciscan spirituality and Orthodox tenets

is important here; it insured that this correspondence would be frequent. But Byzantine images did not inevitably fit the needs of the Franciscans; when they did not, duecento painters employed by the Order adapted distinctly non-Byzantine forms instead.

The following chapters examine in detail the relationship – often intimate, at times distant – between Italian and Byzantine Passion narratives. Each of the narratives, from the Betrayal of Christ to the Stripping of Christ and Ascent of the Cross,[130] is approached as a sort of case study, in a manner similar to that just taken with the Santa Croce cross. A chapter is devoted to each image. First we will survey late twelfth- and thirteenth-century versions of the image to establish the profound changes that occurred in the duecento. The thirteenth century is the focus of this study and will receive the most attention. Occasionally the issues here continue to be important into the fourteenth; excursuses into the trecento will lead to brief considerations of Duccio, Giotto, and Pietro Lorenzetti. After examining the new images, we will then consider them in the context of Byzantine art, to determine the extent to which Italian painters did or did not rely on eastern sources in formulating them. This much of the study is largely an iconographic analysis; such an analysis is essential to establish the specific ways in which duecento painters broke with the past and used imported images to do so. Finally, we will examine the relevance of the new narratives to Franciscan spirituality and to more specifically Franciscan ideologies. The process will illuminate the role of the Franciscans in formulating and spreading the new ways in which the duecento pictured the Passion.[131]

THE BETRAYAL OF CHRIST

The Betrayal in Italian Painting

O f all the Passion themes to be considered here, the Betrayal best documents the Italian appropriation of Byzantine images in the thirteenth century. It offers the clearest evidence both of the range of Byzantine works that must have been available in central Italy, and of the precision and care with which Italian painters studied them. This subject, then, offers us an unusual opportunity to analyze the reception of Byzantine art by the duecento in some detail.

In part, it is the sheer number of surviving Italian examples of the subject that makes this sort of close analysis possible. The Betrayal is the first theme to be depicted with any frequency in Tuscan and Umbrian Passion cycles, and after about 1235–40 it was among the most commonly represented Passion themes, appearing in panel painting, frescoes, and manuscripts.[1] Earlier narrative programs do not necessarily include it, but from the fifth decade of the century, the scene almost always introduces the Passion cycle.[2] Its prominent place may reflect liturgical use: The Betrayal also introduces the cycle of the liturgical year in the Office of the Passion written by St. Francis, for "on that night Our Lord Jesus Christ was captured and taken prisoner."[3]

These years, about 1235–40, mark another juncture. Examples of the Betrayal produced in central Italy in the twelfth and early thirteenth centuries are fairly consistent; after about 1235–40, a new, sharply different iconography was introduced, and it quickly displaced the other. This new image is clearly Byzantine in inspiration and details; equally clearly, it fit the needs of the Franciscan order. Still later in the duecento, by the 1270s,

another variant appeared; this image, too, found precedents in Byzantium, and it, too, coincided neatly with Franciscan interests at that point in the Order's history. Even in the early trecento, at the mother house in Assisi, the image was further modified to assert contemporary Franciscan ideology.

At one level, at least, the shifting interpretations of the Betrayal that appear in duecento painting find their origins in the varying interpretations of the event in the Bible. The event is described by all four evangelists. Matthew (26:47–56), Mark (14:43–53), and Luke (22:47–53) all concur on the essentials of the drama. As Christ addressed the apostles in the garden of Gethsemane, the traitor Judas, followed by a crowd of armed men, approached Christ and kissed him, thereby revealing his identity. The crowd seized Christ, whereupon one of the apostles leaped to his defense by attacking the high priest's servant and severing his ear. According to Matthew (26:52), Christ reproached his defender – "all who take the sword will perish with the sword" – and according to Luke (22:51), he not only quashed the attack but healed the ear. Finally, Christ spoke briefly with his captors; the apostles then fled in fear and the mob led their prisoner away.

In John's account, on the other hand (18:1–12), it was Christ rather than Judas who took the initiative and thus precipitated the ensuing events. As Judas merely stood to one side, Christ approached the mob – now described as soldiers, and police provided by the priests and Pharisees (18:3; 18:12) – and identified himself; the crowd, presumably stunned by his forthright behavior, fell to the ground. The sequence described by the synoptics then followed: The apostle, here identified as Peter, again attacked the servant, now named as Malchus; Christ again admonished the apostle ("The chalice which my Father hath given me, shall I not drink it?" [18:11]) and was led off by the crowd. These shifts in emphasis and, in the case of John, in Christ's actions underlie the conception and representation of the Betrayal in thirteenth- and fourteenth-century Italian painting.

Early versions of the theme do not vary greatly. A representative example is found on the first dated historiated cross to survive: the cross in Sarzana, dated 1138, by the Lucchese painter Gullielmus (Fig. 14).[4] In the center of the composition stands Christ, embraced by Judas. Judas, who approaches from the right, is seen in profile – a posture traditionally associated with evil. The only other apostle present is Peter, who kneels to the left upon Malchus and severs his ear. Malchus reaches toward Christ, who turns to Peter to reprimand the apostle and presumably to restore the ear. Peter turns to acknowledge Christ's command. All but deserted by the apostles, Christ is now surrounded by twelve helmeted soldiers. Also participating in the arrest are two stately men with elegantly coiffed beards. Their long robes suggest that they represent the Jewish elders and high priests. One gestures to the left, as if urging the soldiers on.

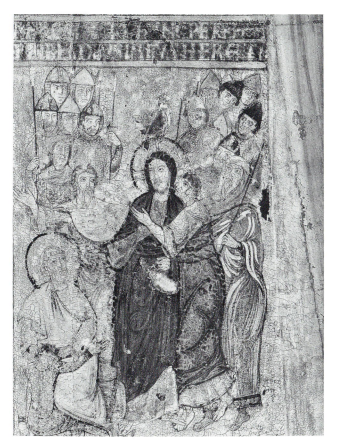

Figure 14 Gullielmus. Betrayal of Christ. Detail of painted cross from Sta. Maria, Luni. Sarzana, Cathedral, 1138. Photo: Alinari/Art Resource.

The Betrayal occurs similarly some fifty or sixty years later, on the cross now in the Uffizi, no. 432 (Fig. 15), and in related examples in Rosano and Siena.[5] In these, Christ again seems oblivious to his captors and his betrayer, and directs his attention instead to Peter and Malchus. The panel on the Uffizi cross is a particularly dramatic rendition: Judas wraps his arms around Christ in a serpentine embrace; Malchus's eyes bulge, blood streams down his cheek, and his hair bristles like the fur of a cornered animal. Most striking is the forceful gesture of Christ, an unambiguous assertion of authority.

By the second third of the duecento, a considerably different interpretation of the Betrayal had appeared. An early example is seen on a Lucchese cross in Santa Maria, Tereglio, from around 1235–45 (Fig. 16).[6] Here Christ still stands at the center of the composition, surrounded by a crowd brandishing weapons, and Judas still embraces him. But little else remains the same. The Peter-Malchus episode, heretofore given major prominence, has all but disappeared. The two

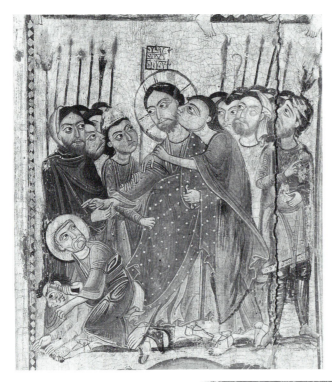

Figure 15 Betrayal of Christ. Detail of painted cross, late twelfth century. Florence, Uffizi, no. 432. Photo: Alinari/Art Resource.

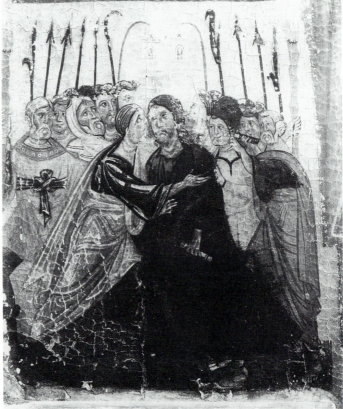

Figure 16 Betrayal of Christ. Detail of painted cross, c. 1235–45. Tereglio, Sta. Maria. Photo: Kunsthistorisches Institut, Florence.

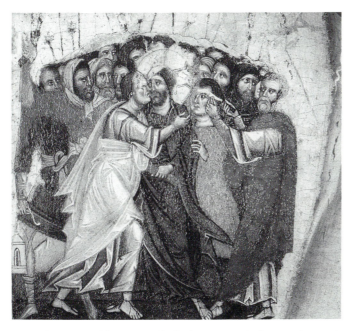

Figure 17 Coppo di Marcovaldo. Betrayal of Christ. Detail of painted cross from Sta. Chiara, San Gimignano, c. 1261. San Gimignano, Museo Civico. Photo: Renate J. Deckers-Matzko/Valentino Pace.

are still present, but now stand to Christ's left and thus merge visually with the crowd; Peter has even been stripped of his halo, which further minimizes their presence. Even Malchus is now oblivious to Peter's assault; he is engrossed in the capture and lays his left hand on Christ's back. Christ, too, ignores the episode entirely; he no longer reprimands Peter but merely submits to Judas's embrace. Finally, the crowd is no longer subdivided into two clear groups; it is arranged in a tight semicircle interrupted only by the gold of Christ's halo.

No less striking than the iconographic differences visible here are the stylistic differences. The figures in the Uffizi cross have massive heads and enormous black eyes, which overpower their other, more schematic features. Now, however, the canon of proportions is more naturalistic, eyes are smaller and all the features are more clearly delineated. Though such changes do not originate with the Tereglio painter – he derives them from Berlinghiero and his son Bonaventura – they indicate the stylistic fluidity of Tuscan painting during the early duecento.[7]

The new interpretation of the Betrayal, with Christ newly passive and the episode of Peter and Malchus all but deleted, was accepted fairly quickly; the earlier version, emphasizing Christ's forthright command to Peter, is seen only rarely from about 1240 to about 1275–80.[8] One example of the new type occurs in a cross executed around 1261 by one of the great masters of the duecento, Coppo di Marcovaldo (San Gimignano, Fig. 17).[9] Gertrude

Coor has observed Coppo's early connections with the Lucchese school,[10] which the striking similarities between the Tereglio and San Gimignano Betrayals confirm. Iconographically the two scenes are virtually identical: in the central group of Judas advancing from the left and embracing an impassive Christ; in Peter's assault on Malchus, placed on the far right and almost unnoticeable; and in Malchus's gesture of seizing Christ. Even Coppo's minor figures, such as the cowled, white-bearded man behind Judas and the bounding figure on the far left, seem directly comparable to their Tereglio counterparts. Only in a few details does Coppo's Betrayal differ from the Lucchese scene. For instance, the figure standing next to Peter now turns and glares at him reproachfully; the exiting figure on the left now carries a lantern.

In subtle ways, however, Coppo has sharpened the dramatic intensity of the scene. Judas now holds Christ so close that his profile obscures the right side of Christ's face. The crowd, now somewhat larger, here completely surrounds Christ; earlier his halo formed a sort of protective barrier between him and his captors, screening out those directly behind him, but now they seem to close in from all sides. Coppo's characteristically expressive line further adds to the power of the scene. The spiky, staccato patterns of Judas's drapery – especially the jagged contour line of his cloak, which suggests broken glass – reinforce the tension here.

Similar versions appear on a painted cross in the Cathedral of Pistoia, dated 1274–5, by Coppo and his son Salerno;[11] in several Pisan works, such as Enrico di Tedice's San Martino cross (Fig. 18);[12] in a Lucchese triptych in Pittsburgh;[13] and elsewhere. These examples are not identical. The San Martino version is an idiosyncratic rendition in which Malchus oddly accosts Judas rather than Christ (this peculiarity is repeated in certain other Pisan examples) and the crowd seems curiously static, frozen in a kind of tableau. But all are consistent in showing Christ oblivious to Peter and Malchus, and in minimizing their presence further by depicting them standing and thus blending imperceptibly into the crowd. The new image of a vulnerable Christ, almost engulfed by his captors, seems as far removed from the earlier version as the *Christus Patiens* from the *Triumphans*.

But this poignant new image was soon modified. By 1275–80, as in a panel by Guido da Siena (Fig. 19),[14] Christ again gestures, presumably to admonish Peter and restore Malchus's ear, though this part of the panel is lost. Christ gestures similarly in a number of examples from the later 1270s, '80s and '90s.[15] In most of these examples, Peter and Malchus still stand, deemphasizing their presence, and in most the crowd still forms a dense mass, encircling Christ and Judas. However, in a fresco in the Upper Church of Assisi (Fig. 20),[16] Peter and Malchus resume their kneeling stance, thus restoring the prominence of the pair; here, too, the mob – most of whom

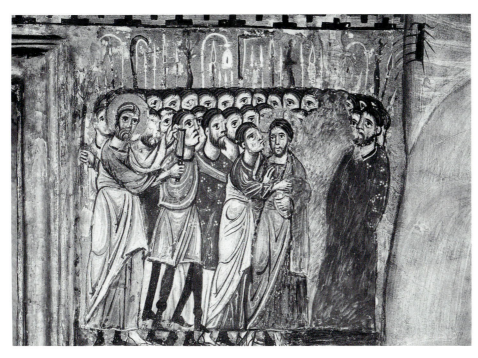

Figure 18 Enrico di Tedice. Betrayal of
Christ. Detail of painted cross, 1245–55.
Pisa, S. Martino. Photo: Alinari/Art
Resource.

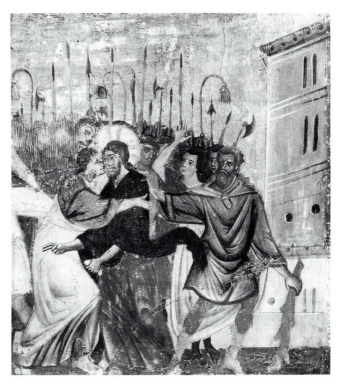

Figure 19 Guido da Siena. Betray-
al of Christ, c. 1275–80. Siena,
Pinacoteca. Photo: Alinari/Art
Resource.

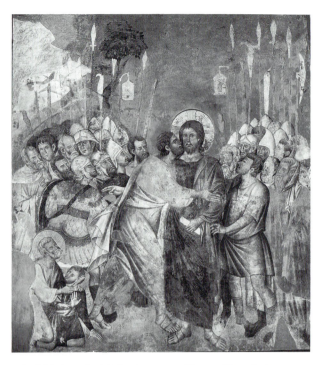

Figure 20 Betrayal of Christ. Assisi, S. Francesco, Upper Church, late 1280s–early 1290s. Photo: Kunsthistorisches Institut, Florence.

are helmeted soldiers – parts into two distinct groups, so that they no longer surround Christ. In a sense, then, the Assisi fresco and similar examples, among them a panel in Perugia from Sant'Antonio di Padova, Paciano,[17] seem to return to the earliest versions of the theme, in which a forthright savior quells Peter's act of resistance and thus asserts his willingness to proceed with the Passion.

In fact, occasional late thirteenth- and early fourteenth-century works signal still more forcefully Christ's voluntary acquiescence by depicting him halting Peter's attack more assertively than before. In a panel now in Portland, Oregon (Fig. 21), probably from the 1280s or '90s,[18] Christ neither faces Judas nor stares out, but turns away from Judas to face Peter, who turns back in response. In a fresco in the Lower Church of Assisi, painted about 1316–19 by Pietro Lorenzetti or his workshop (Fig. 22),[19] Christ again turns to the right, and now he gestures towards Peter. These images continue the emphasis seen in the earlier Assisi fresco, asserting that Christ chose to halt Peter's attack and, implicitly, to sacrifice himself to redeem humanity. In several of these examples, like the Perugia panel and Pietro Lorenzetti's fresco, Christ's willingness is contrasted with the stealthy exit of his apostles, who depart to the right, sometimes casting a furtive look back as they leave.[20]

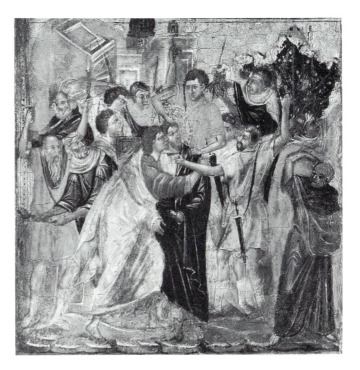

Figure 21 Betrayal of Christ, 1290s. Portland, Ore., Portland Art Museum. Photo: museum.

Figure 22 Pietro Lorenzetti and workshop. Betrayal of Christ, c. 1316–19. Assisi, S. Francesco, Lower Church. Photo: Alinari/Art Resource.

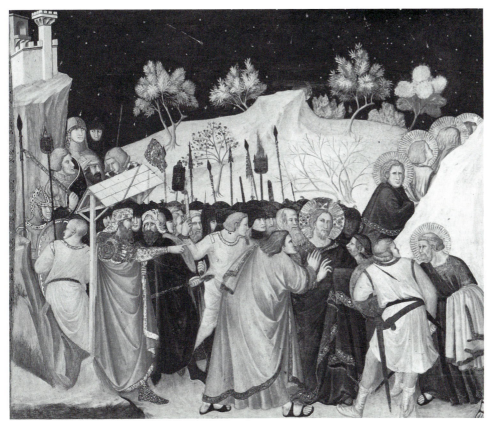

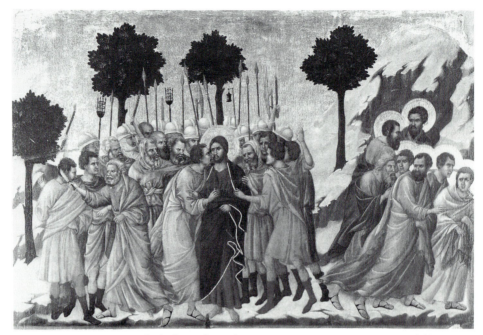

Figure 23 Duccio. Betrayal of Christ, from the *Maestà*, 1308–11. Siena, Museo dell'Opera del Duomo. Photo: Alinari/Art Resource.

The fresco in the Lower Church and the panel in Perugia are not, however, typical of the early trecento in emphasizing Christ's resolute rebuke. Duccio and Giotto, whose compositions were repeated by numerous followers, both minimize the episode of Peter and Malchus. In Duccio's panel from the *Maestà* (Fig. 23), Christ gestures toward Peter and Malchus, but much less obviously than in the earlier Sienese example by Guido (Fig. 19), and a haloless Peter stands as he accosts Malchus. And in Giotto's fresco in the Arena Chapel (Fig. 24), Christ ignores Peter and Malchus entirely, turning his back on them to confront his betrayer. Here the apostle and the servant stand again, and are made even less conspicuous because a man seen from the back stands in front of them, thus blocking the view of their struggle. By the early trecento, then, Duccio and Giotto developed a version of the Betrayal most akin to the mid-duecento type, with little or no emphasis on Christ's directive to Peter.

In formulating these shifting interpretations of the Betrayal, duecento painters and their advisers relied heavily upon Byzantine images. Moreover, most of the numerous small variations we have observed – the presence of a figure, a gesture, even a glance – can be traced to specific types of Byzantine examples. The Betrayal provides us with an unusually clear instance of Ital-

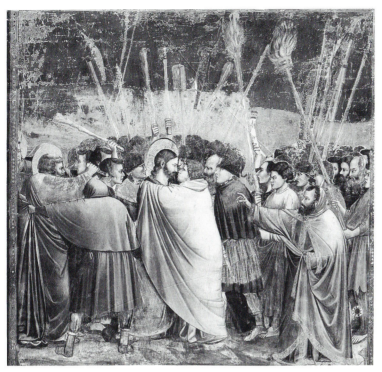

Figure 24 Giotto. Betrayal of Christ, 1303–5. Padua, Arena Chapel. Photo: Alinari/Art Resource.

ian painters' uses of eastern art; to understand the depth and precision of this phenomenon requires a look at the depiction of the Betrayal in the East. We will consider the changes in the image over time, especially in the twelfth and thirteenth centuries, as well as liturgical texts and dramas that help provide the context for these images.

THE BETRAYAL IN BYZANTINE PAINTING

Present knowledge of the image of the Betrayal still owes much to the inroads made early in this century by Gabriel Millet.[21] Millet demonstrated that the Betrayal as it exists in Middle Byzantine art is a composite scene that fuses three episodes: the kiss of Judas, the arrest of Christ, and Peter's attack on Malchus. These episodes appear as separate scenes in Early Christian and Early Byzantine art,[22] but gradually were combined into a single composition. The new composite image seems to have emerged rather rapidly in the ninth and early tenth centuries, presumably as a result of post-iconoclastic formulations and the development of the Middle Byzantine mosaic program.[23]

Though the general chronological development of the Betrayal is clear, more problematic is the question of defining and clarifying the various guises under which the scene appears. Millet, and later Hans Belting, argued that two types exist, on the basis of which each scholar constructed a system of classification.[24] Neither system, however, can be consistently applied to Middle Byzantine art.[25] But if one cannot insist on "types," it is nevertheless possible to trace different interpretations of this event in Byzantium, and to discern the pictorial cues that signal these differences.

Rooted in the biblical descriptions of the Betrayal is a subtle tension between Christ's human wish to avoid the Passion ("let this chalice pass from me" – Matthew 26:39) and his willingness to redeem humanity in compliance with the divine plan ("The chalice which my Father hath given me, shall I not drink it?" – John 18:11). The synoptic gospels tell us that Judas set the arrest in motion: "And when he was come, immediately going up to him, he saith: Hail, Rabbi; and he kissed him" (Mark 14:45). John, however, more forcefully asserts the voluntary nature of the Passion; only in John's account does Christ refer to his willingness to "drink the chalice," and only here does Christ take the initiative in approaching the crowd. The earliest representations of the Betrayal draw from both versions, taking the kiss from the synoptics but their emphasis on Christ's voluntary participation from John. In a relief on an Early Christian sarcophagus in Verona (Fig. 25),[26] Christ, on the left, strides boldly toward Judas and embraces him.[27] The placement of Christ on the left is significant: Because a narrative sequence normally unfolds from left to right, iconographic convention generally places a figure in motion on the left, especially one who initiates an action.[28] Thus Christ's position on the left implies that it was he who approached Judas and thus set into motion the events that would follow – a conception of the Betrayal that strongly recalls St. John's account in tone if not in particulars. This suggestion of Christ's willing participation in the arrest is further reinforced by his energetic stride and by the outstretched right arm with which he embraces his betrayer. The Early Christian composition, then, seems designed to stress the voluntary nature of Christ's sacrifice: By seizing the initiative and freely embracing Judas he seems, by implication, to embrace his role as redeemer as well.

This emphasis on the positive aspects of Christ's sacrificial death is consistent with Early Christian attitudes toward the Passion; the early church generally viewed Christ in death as triumphant savior rather than suffering victim.[29] For this reason it is not surprising that Early Christian Betrayals typically place Christ on the left, freely approaching Judas.[30] Though Christ generally embraces his betrayer, in one variant, seen in the Rabbula Gospels,[31] he raises his right hand in a gesture of speech; according to both Matthew (26:50) and Luke (22:48), he spoke to Judas at the moment of the kiss.

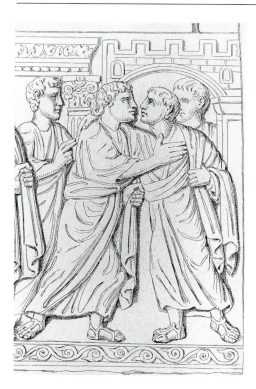

Figure 25 Betrayal of Christ. Detail of sarcophagus, c. 400. Verona, S. Giovanni in Valle. After Garrucci, 1879.

By the sixth century, a greater willingness to depict the Passion is seen; at Sant'Apollinare Nuovo, Ravenna, for instance, we find a fairly extensive Passion cycle.[32] Here, too, we find a shift in the depiction of the Betrayal that suggests the beginnings of a change in the interpretation of the event (Fig. 26). Now it is Judas who appears on the left, marches purposefully forward, and extends his arm in an embrace. Consistent with the shift in the position of Christ is his new stance: The assertive striding pose seen earlier has been discarded, and the newly passive figure merely stands motionless, gazes distantly, and submits to Judas's kiss. The mosaicist compensates in certain respects for the change in Christ's demeanor: Christ is now half a head taller than his adversary and the soldiers to the left, who stand at some distance. In a sixth-century hymn by the Byzantine melodist Romanos, the *kontakion* for Holy Thursday, we find a comparable account of the event. Judas initiates the arrest, but Romanos still reminds his audience of the voluntary nature of the Passion:

> Then the lawless fellow came running and treacherously
> > kissed the Lover of man
> And deliberately destroyed
> The One who voluntarily had chosen suffering, the Giver of
> > life to all.[33]

Gradually, however, presumably prompted by theological debates about Christ's Passion and death on the cross,[34] the early implications of willing

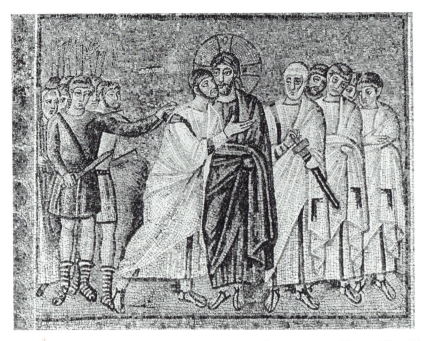

Figure 26 Betrayal of Christ, c. 500. Ravenna, S. Apollinare Nuovo. Photo: Alinari/Art Resource.

and heroic self-sacrifice begin to yield to suggestions of a newly human Christ who accepts his fate but no longer embraces it. Like the Ravenna mosaic, Middle Byzantine representations often depict Judas approaching Christ rather than the reverse.[35] Among the numerous examples are miniatures in a lectionary in the Morgan Library (fol. 268v.; Fig. 27),[36] another lectionary at Dionysiou (fol. 104v.; Fig. 28)[37] and another in the Vatican (fol. 194v.; Fig. 29).[38]

At the same time, Byzantine painters introduced new details that further heightened the suggestion of Christ as human victim. Especially telling are the modifications in the treatment of Christ's captors. When they begin to appear they seem to pose little immediate threat to Christ. At Ravenna, for instance (Fig. 26), only a handful of soldiers – all considerably shorter than Christ – are present, and they are confined to the far left corner of the composition. Further, the apostles remain on hand to provide at least the illusion of possible defense; Peter already reaches for his sword. But in Middle Byzantine art, as in the Dionysiou lectionary (Fig. 28), generally the apostles have fled, and now a large throng of men appears. They no longer stand discreetly to one side but swarm about. In the eleventh-century lectionary in the Vatican (Fig. 29), the ranks of the crowd have swollen even further: A massive horde presses in from all sides and completely surrounds Christ.

An analogous change, which developed at about the same time, similarly intensifies this sense of Christ's plight. This change concerns not the crowd

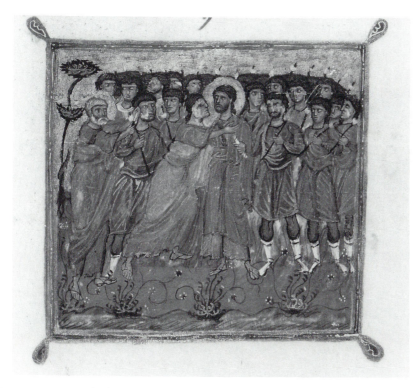

Figure 27 Betrayal of Christ, from a lectionary, late eleventh century. New York, The Pierpont Morgan Library, ms. 639, fol. 268v. Photo: museum.

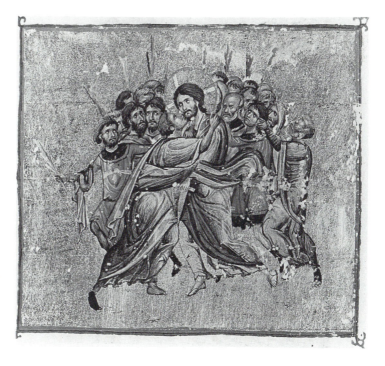

Figure 28 Betrayal of Christ, from a lectionary, second half of the eleventh century. Mt. Athos, Dionysiou, ms. 587, fol. 104v. Photo: after Pelekanides et al., 1974.

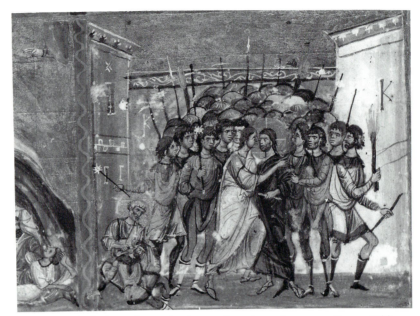

Figure 29 Betrayal of Christ, from a lectionary, late eleventh century. Rome, Biblioteca Apostolica Vaticana, ms. 1156, fol. 194r. Photo: museum.

as a whole but Peter and Malchus. In some Middle Byzantine examples, Peter and Malchus stand somewhat apart from the mob in reminder of the pair's earlier autonomous existence.[39] Even when they are placed closer to the crowd, they at times remain distinct from it because of their poses: Both assailant and victim sit or kneel (as in the lectionary in the Vatican, Fig. 29). Malchus generally struggles in these examples, thus further drawing attention to the incident.

But beginning in the eleventh century, Peter's act of defense is often deemphasized. For instance, in the Dionysiou lectionary (Fig. 28), both apostle and servant stand, so they begin to merge with the crowd behind them. Further, Malchus here seems completely unaware of Peter's attack and no longer struggles to extricate himself. At times, Peter stands slightly apart from the group;[40] in the lectionary, however, the apostle blends seamlessly into the semicircle of the crowd.[41]

Thus the episode, once of major importance, has almost faded from view; in most Byzantine Betrayals of the later eleventh and twelfth centuries it is similarly insignificant, absorbed into the rhythm of the crowd.[42] By deemphasizing – nearly eradicating – the sole act of defense in Christ's behalf, the new image clearly reinforces the suggestions of Christ's vulnerability at the hands of his captors. But it also removes any reference to Christ's words to Peter, and thus to his free acceptance of his fate. This formulation – in which Judas approaches from the left, the crowd completely

envelops Christ, and the episode of Peter and Malchus has all but vanished – is most characteristic of Middle Byzantine art.[43] The decisive savior seen in the sarcophagi has here metamorphosed into an overpowered victim who submits to an inevitable fate but does nothing that would accelerate its fulfillment.

The preference for this image in the post-iconoclastic era is not surprising. The period typically stressed Christ's human sufferings during the Passion rather than his heroic and willing self-sacrifice.[44] Textual accounts of the Betrayal similarly represent the event. For instance, in the drama *Christos Paschon*, probably of the twelfth century, the emphasis throughout is clearly on the grief of Mary and the anguish of Christ; in the description of the arrest, Peter's attack on Malchus and Christ's words to the apostle and to his captors are not mentioned.[45] A lengthier account appears in Nikolaos Mesarites's description of the Church of the Holy Apostles in Constantinople, written between 1198 and 1203.[46] His description of the mosaics there – which should not be understood as a literal report, but rather as an example of *ekphrasis* – first draws a vivid, detailed portrait of the mob, who "come forth murderously and wildly." He is explicit in stating that Judas initiated the arrest; Christ is depicted throughout as a passive victim, "patient in the face of slaughter." Mesarites does discuss the episode of Peter and Malchus, and the healing of the ear, but he alludes to the miracle only obliquely, without actually mentioning that Christ took action to heal it and without mentioning his words of rebuke to Peter: "The cry of Malchus strikes the ears of the Lord.... The ear is as sound as it was before." Thus this description, in emphasizing the brutality of the mob and the plight of Christ and in minimizing the miracle, clearly corresponds to the most commonly depicted twelfth-century images, which similarly show Christ as the victim of a teeming mob and downplay the story of Peter and Malchus.

This stress on Christ's plight was not universal, however. In some Middle Byzantine monuments, Christ stands on the left, perhaps implying that he initiated the arrest, and gestures in speech; at times the gesture seems directed at Peter.[47] The suggestion of rebuke, usually rather tentative,[48] in some cases is clearer: In a fresco at Asinou, Cyprus, and a clearly related image in a manuscript in Berlin, quarto 66 (Fig. 30),[49] Christ again gestures, but now Peter and Malchus kneel, and the apostle turns in response, so that the meaning of the gesture is fairly explicit. The miniature painter, however, has carelessly placed Peter and Malchus in the left corner, so that Christ gestures incongruously at an empty space; at Asinou, the pair kneels to the right, and the gesture thus makes sense.[50] The gesture is most explicit in a Cypriot fresco at St. Neophytos, Paphos, of around 1200 (Fig. 31).[51] Here Christ is again placed on the left, but now he flings his arm toward Peter in an unequivocal command to halt; as in the Asinou fresco and Berlin 66, Peter turns in

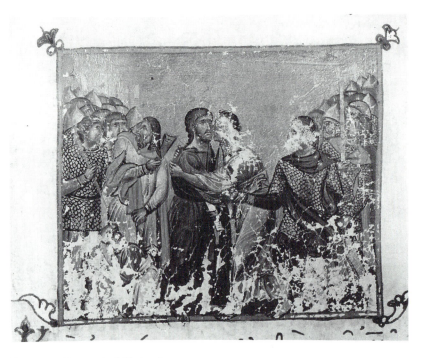

Figure 30 Betrayal of Christ, from a Gospel book, c. 1205–10. Berlin, Staatliche Museum, ms. gr, qu. 66, fol. 89r. Photo: Foto Marburg.

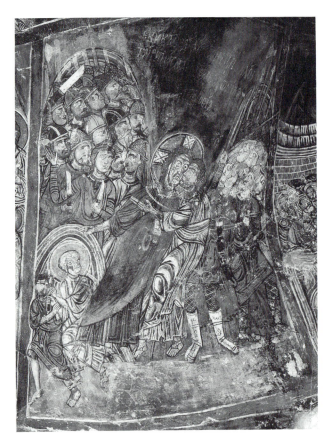

Figure 31 Betrayal of Christ, c. 1200. Paphos, St. Neophytos. Photo: Byzantine Visual Resources, copyright 1995, Dumbarton Oaks, Washington, D.C.

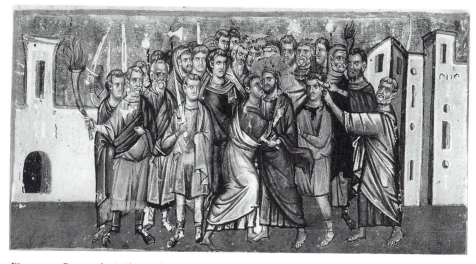

Figure 32 Betrayal of Christ, from a Gospel book, 1270s or 1280s. Paris, Bibliothèque Nationale, ms. gr. 54, fol. 99. Photo: museum.

response. In this image, then, Christ is perhaps most obviously depicted as the resolute savior, who blocks any interference with the completion of his divine mission.

Though this forcefully gesturing Christ is rare in Byzantium in general,[52] it is less uncommon in the provinces of the empire, particularly in Cyprus; the frescoes at Asinou and St. Neophytos attest to the Cypriot preference for this image, and the Berlin Gospel book has been attributed to Cyprus as well.[53] This stress on Christ's reprimand may be an indication of local preferences: A Cypriot Passion play of the mid-thirteenth century portrays a similarly resolute Christ.[54] The account of the Betrayal in the Passion play follows the gospel of John: It is Christ who initiates the arrest by approaching the crowd and identifying himself. Here, after the mob falls backward, he approaches them and identifies himself a second time: "I have told you that I am he [Jesus of Nazareth]." Next, Judas kisses Christ and Peter attacks Malchus. Now, however, in contrast to Mesarites's account, Christ reprimands Peter at some length, explaining that the scriptures must be fulfilled, and he heals the ear; the mob then leads Christ away. The play contains no references to the "murderous mob"; in fact, Christ has to approach them twice to prod them into action. Thus these Cypriot texts and images clearly present their audience with an assertive Christ, quite unlike the meek and passive figure described by Mesarites and depicted in most Middle Byzantine images. Annabel Wharton has emphasized the autonomy of Cyprus, and she notes occasional instances of provincial images that reflect the tastes of a local audience and resist the hegemony of Constantinople.[55]

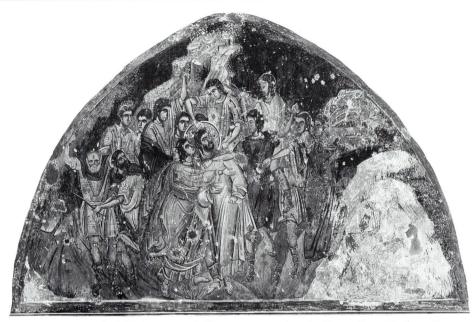

Figure 33 Betrayal of Christ, 1296. Arilje, monastery church. Photo: Foto Marburg/Art Resource.

The interregnum of the thirteenth century (1204–61) saw the continuation of some traditional formulae.[56] For instance, a Gospel book in Paris (Fig. 32), probably dating not long after this period, continues the usual Middle Byzantine Betrayal, with Judas and Malchus standing and a vulnerable Christ ignoring them.[57] By the end of the thirteenth and beginning of the fourteenth centuries, the new experiments of Late Byzantine narratives with space and heightened drama begin to be seen in images of the Betrayal (examples at Arilje, in Serbia, 1296, Fig. 33, or Staro Nagoričino, in Macedonia, from the early fourteenth century, Fig. 34).[58] The crowd often grows still larger with the addition now of the apostles, who are generally found in the background fleeing behind a ledge of rock. The physicality and intensity of these images reaches new heights: Individual members of the mob are still more menacing, attacking Christ more brutally than before, and Peter matches their intensity by attacking Malchus with new force (Fig. 34). In the center of this swirling activity, Christ is often relatively passive, usually merely gesturing in speech (Fig. 34).[59] At times, however, he turns away from Judas – perhaps in response to the assault of the man on the right, who has seized him at the neck and raises his hand to strike him (Fig. 33).[60] Thus in these Late Byzantine examples, we encounter considerable diversity in representations of the Betrayal; the principle point of consistency is the expansive space and heightened drama of these images.

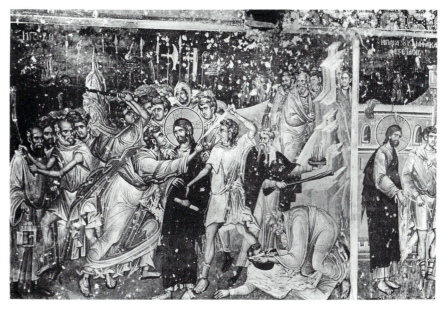

Figure 34 Betrayal of Christ, c. 1316–18. Staro Nagoričino, St. George. Photo: Foto Marburg/Art Resource.

ITALY AND BYZANTIUM

1. The Twelfth Century

With some understanding of images of the Betrayal in Byzantine painting, it now becomes possible to return to the theme in Tuscan and Umbrian art. Virtually all the variations seen in Italy were, at some point, appropriated from the Byzantine sphere. The earliest representations, as in the examples in Sarzana and Florence (Figs. 14–15; pp. 37–8), consistently emphasize Christ's forthright injunction to Peter. This formulation appeared in the East as early as about 900, and in an example like St. Neophytos (Fig. 31, p. 52), the resemblance to the Tuscan versions, especially Gullielmus's (Fig. 14), is especially clear. In fact, this iconography had been imported into the West by about 900–10, as in a Betrayal in a south Italian fresco cycle in the Basilica dei Santi Martiri, Cimitile.[61] The fresco may, as Belting proposes, stem from a Roman prototype; Belting assumes a similar source for the clearly related miniature in the Egbert Codex.[62] Especially in south Italy, but also in Tuscany, eleventh- and twelfth-century renditions of the scene often resemble the Cimitile fresco in emphasizing Christ's gesture of admonition.[63]

Not only does the image become characteristic of Italian painting, it becomes characteristic only of Italy: Despite its early appearance in the Egbert Codex, most northern European painters omit the rebuke to Peter.[64] Thus Gullielmus and the painters of the Uffizi and Rosano crosses followed

in their Betrayals a type that was not only long established in Italy but favored only in Italy. The connections between the Lucchese image of the Betrayal and those in south Italy are not surprising; Montecassino held property in Lucca from the late eleventh century, and south Italian painters worked in Lucca at the beginning of the thirteenth century.[65]

2. The Thirteenth Century: The Mid-Century Image

Thus, early Tuscan images of the Betrayal consistently follow a traditional formulation, long established in Italy. During the second quarter of the duecento, however, the picture shifted radically. Now Italian painters and their employers became acutely interested in Byzantine images; from this point into the early fourteenth century, they experimented with a range of possibilities to represent the Betrayal, all appropriated in essentials and at times in details from Byzantium. The poignant representations popular at mid-century, seen in the Tereglio cross and the San Gimignano cross (Figs. 16–17), clearly were taken from the eastern version that minimizes Peter and Malchus and depicts Christ surrounded by his enemies (Figs. 27–9). But the resemblance is not merely generic. Painters like this Lucchese artist and Coppo must have studied eastern images quite closely; they could be meticulous in inserting specific details taken from the Byzantine repertoire into their narratives. For instance, many details are common to the Tereglio Betrayal and the one in the Dionysiou lectionary (Figs. 35–6). In both, Christ's halo extends above the circling throng and shields him from being completely surrounded. And in both, the specific composition of the mob is quite similar. Both begin with a bounding figure who wears an uncommon type of tunic, with a wide border at the neck and knotted sash at the chest. Next, in both, is a partially concealed head, then two bearded figures to the left of Judas. On the other side of Judas and Christ one encounters, from the right, Peter, an intervening head, and Malchus. Stylistically, too, this is a strongly Byzantinizing image. Despite differences, it is not difficult to envision the Lucchese painter working from an image similar to the one in the Dionysiou lectionary.[66]

The Betrayal on Coppo's San Gimignano cross (Fig. 17), though very close to the Lucchese Betrayal (Fig. 16), differs in a few respects, which suggest the painter's use of another source. First, the crowd now completely encircles Christ; he is no longer shielded by his halo (Fig. 37). This treatment appeared fairly often in Byzantium, as in the Gospel book in Paris (Fig. 38). Another detail in Coppo's Betrayal that is not present in the Tereglio version is the figure on the right who turns to glower at Peter. This sort of individual characterization of the minor figures can be seen in Middle Byzantine art and continues into the thirteenth century (Fig. 38). Even Peter's exact stance, as he severs Malchus's ear, especially resembles his position in the

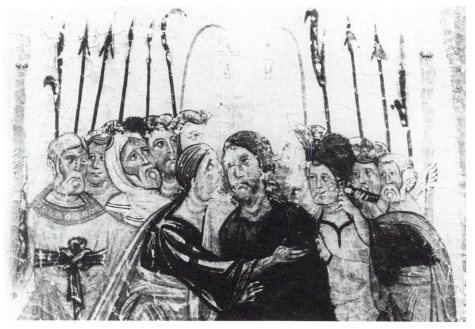

Figure 35 Detail of Betrayal of Christ, from the Tereglio cross, c. 1235–45. Photo: Kunsthistorisches Institut, Florence.

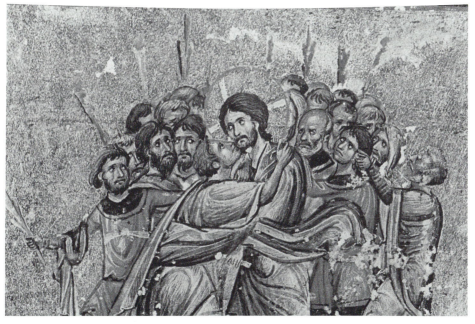

Figure 36 Detail of Betrayal of Christ, from the Dionysiou lectionary, ms. 587, fol. 104v. Second half of the eleventh century. Photo: after Pelikanides, 1974.

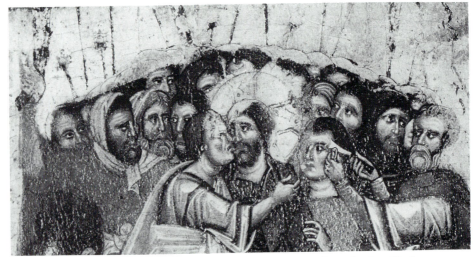

Figure 37 Coppo di Marcovaldo. Detail of Betrayal of Christ, from the San Gimignano cross, c. 1261. Photo: Renate J. Deckers-Matzko/Valentino Pace.

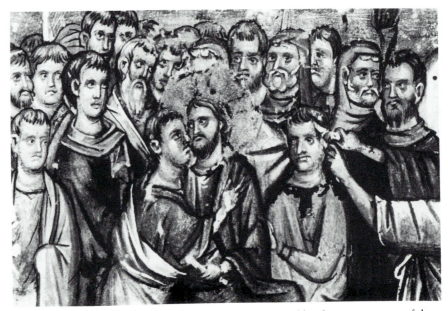

Figure 38 Detail of Betrayal of Christ, from the Paris Gospel book, ms. gr. no. 54, fol. 99. 1270s or 1280s. Photo: museum.

Paris Gospel book (Fig. 38). A final unusual feature of Coppo's composition is the bounding lantern-carrier on the extreme left (see Fig. 17). This detail appears in a Serbian fresco at Djurdjevi Stupovi, around 1168,[67] and in a strongly Byzantinizing miniature in the Hortus Deliciarum, executed between 1167 and 1195.[68] Thus, despite the close resemblance between the Tereglio and San Gimignano Betrayals, Coppo could not have derived his image wholly from the Lucchese version; these new details must have come, directly or indirectly, from Byzantium, and probably from a work especially close to the Paris Gospel book.

Still another variant was favored by Pisan painters active at mid-century. Pisan versions, such as the example in Enrico di Tedice's San Martino cross (Fig. 18, p. 41) and several closely related works, differ in several respects from the mid-duecento Lucchese and Florentine types: the incongruous stance of Malchus, reaching for Judas rather than Christ; the placement of Judas, who approaches Christ but does not yet kiss him; the arrangement of the mob in two parallel rows; and the odd stasis that has overcome the crowd, in contrast with the animation of most earlier examples. All of these idiosyncratic treatments find antecedents in eastern painting. In a Constantinopolitan lectionary, Morgan 639 (Fig. 27, p. 49), Malchus similarly accosts not Christ but Judas, because Christ stands on the right. Here, too, the mob stands motionless in two straight lines, and Judas does not yet kiss Christ but only begins the embrace.[69] Similar compositions recur in the provinces of the empire. Several scholars have called attention to "provincial" qualities in the San Martino cross; Carli specifically related the cross to Cappadocian painting.[70] Whatever the precise source, these Pisan painters must have had access, direct or indirect, to a Byzantine image quite different from those available in Lucca and Florence.

3. The Later Duecento: The Gesturing Christ

The shift that occurred in the 1270s, with a renewed emphasis on Christ's gesture of rebuke and on Peter and Malchus, shows an equally specific reliance on imported images. The painter of the Assisi fresco (Fig. 20), for instance, presumably had seen something like the manuscript in Berlin (Fig. 30); there, too, Christ gestures and Peter and Malchus are sharply distinguished from the mob. In details, too, the two images are particularly close (Figs. 39–40). The treatment of the mob – which no longer encircles Christ but is instead separated into two densely clustered groups of men – is quite similar, even to the energetically bounding soldier (on the left in the fresco, on the right in the manuscript) and the conical helmets worn by some figures.[71] In fact, the very inclusion of soldiers in both images may be significant. A recent study by Andreas and Judith Stylianou has argued that "militarized" Betrayals, populated by soldiers, are characteristic especially of Cyprus; as Annemarie Weyl

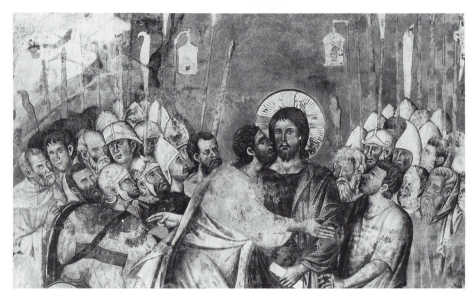

Figure 39 Detail of Betrayal of Christ, from Assisi, S. Francesco, Upper Church late 1280s or early 1290s. Photo: Kunsthistorisches Institut, Florence.

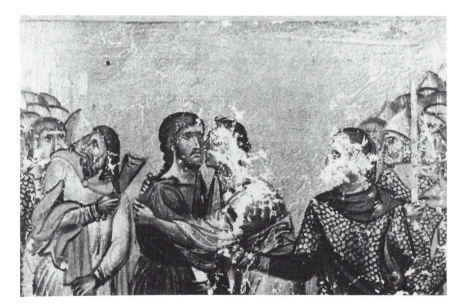

Figure 40 Detail of Betrayal of Christ, from the Berlin Gospel book, ms. gr. qu. 66, fol. 89r. 1205–10. Photo: Foto Marburg.

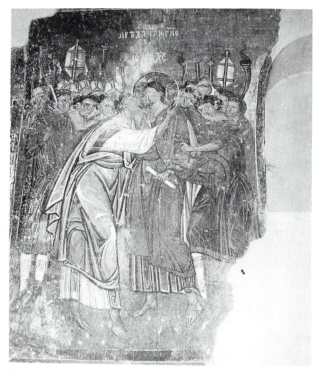

Figure 41 Betrayal of Christ, 1230–37. Mileševa, monastery church. Photo: S. Gabelić.

Carr suggested earlier, the Berlin manuscript may be a Cypriot product.[72] It is true that in Constantinople (e.g., Figs. 27–9) and in the duecento works that draw so heavily from those examples (e.g., Figs. 16–18), soldiers are not much in evidence. Thus the swarming soldiers in the Assisi fresco are as atypical of contemporary central Italian painting as the soldiers in the Berlin manuscript are of Constantinopolitan versions; possibly the Assisi painter had access to a Cypriot or Palestinian example of the scene. Finally, a fresco at Mileševa (Fig. 41), from the 1230s, also provides us with some idea of the Assisi painter's source; there a boy with a bare forearm reaches for Christ, much like the corresponding figure in the Assisi fresco.[73] The greater mass of the Assisi figures, compared with the relatively slender types in earlier Italian painting, also resembles the robust form of the figures in both the Berlin manuscript and the Mileševa fresco.

Even at the end of the thirteenth and into the fourteenth centuries, Italian painters and their patrons found much of interest in eastern art. For instance, the newly emphatic position of Christ, turning away from Judas (Figs. 21–2, p. 43), was taken from the Byzantine sphere; it was fairly com-

mon in Palaeologan Macedonia, and known as well in Romania and Serbia (as at Arilje, Fig. 33, p. 54).[74] Pietro Lorenzetti's composition (Fig. 22) resembles some Late Byzantine examples also in the placement of Judas, who at times (Fig. 33) stands at a distance from Christ. The exiting apostles seen in the Assisi fresco and Paciano panel, and in Duccio's panel (Figs. 22–3), appear fairly frequently in Late Byzantine painting, as at Staro Nagoričino (Fig. 34, p. 55).[75] The expansion of space, introduction of landscape, and dispersal of the figures through most of the available space can be seen in most of these works; the diagonal rock that forms the apostles' escape route in the Lorenzetti fresco (Fig. 22) plays a similar role in the fresco at Staro Nagoričino (Fig. 34). Finally, the new violence of these Byzantine works was also adopted in central Italy. Thus in both the Paciano panel and at Staro Nagoričino (Fig. 34), Peter lunges at Malchus, who sprawls in the lower right and props himself up by extending his arm; in another example, a fresco at the Peribleptos (St. Clement), Ohrid, Peter pins the hapless servant with his left knee just as he does in the Paciano panel.[76]

Similarly, the figures assaulting Christ are at times lifted in their entirety from the Byzantine repertoire. The Portland panel (Fig. 21) offers a particularly good example. The white-bearded man at the far left, holding torches aloft with both hands, is found in the same position in the Arilje fresco (Figs. 42–3). Next to the torch-carrier, in both the panel and the fresco, is a man who leans back and swings a weapon (this figure appears also at Staro Nagoričino, Fig. 34). In both the panel and the fresco, a boy with bent elbow grabs Christ by the hair; and in both, a man in a short tunic seizes Christ and raises his arm high to strike him (this figure also recurs at Staro Nagoričino). The painter of the Portland panel obviously scrutinized Byzantine images, much like the Tereglio painter and Coppo before him.

Thus, well past the heyday of the *maniera greca*, we find clear evidence of Italian painters looking hard at Byzantine images and freely taking inspiration from them. These painters must have viewed Byzantine icons and manuscripts as a rich source of ideas, offering new ways of conveying three-dimensional space and fresh and expressive characters with which to populate their narratives. The precise Byzantine images that these painters studied so intently are largely now lost to us; very few Byzantine works survive in Tuscany and Umbria today. But while the works that these painters must have known have not survived, the evidence of their use has.[77] They must have had a considerable supply of imported works to study, and a rich variety at that. And the usefulness of Byzantine art for Tuscan and Umbrian painters extended into the fourteenth century.

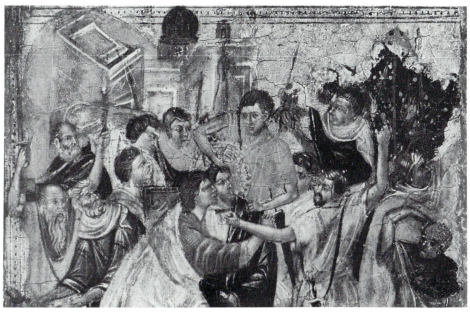

Figure 42 Detail of Betrayal of Christ, 1290s. Portland, Ore., Portland Art Museum. Photo: museum.

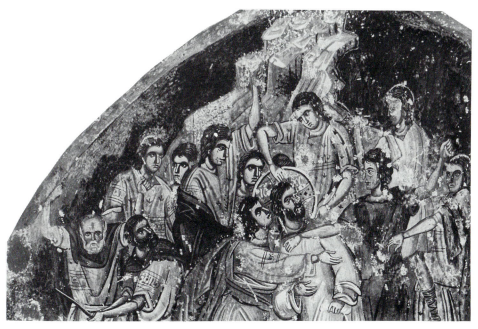

Figure 43 Detail of Betrayal of Christ, from Arilje, monastery church, 1296. Photo: Foto Marburg/Art Resource.

THE BETRAYAL AND THE FRANCISCANS: PIETY AND IDEOLOGY

The mere availability of Byzantine art is not, however, enough to explain this eager assimilation of it, nor is it enough to explain the shifts in the interpretation of the Betrayal that we have observed. Not only the representation of the scene but also the underlying interpretation of the moment changed substantially from the twelfth century to the mid-thirteenth, and the interpretation shifted again later in the thirteenth century. The changing conception of the moment must reflect the larger changes in the understanding of Christ's Passion that are widely ascribed to the ascendancy of the Franciscan order. The earlier version of the Betrayal (e.g., Figs. 14–15) clearly corresponds to the *Christus Triumphans*: Both images depict Christ as transcending the torment that ordinary humans would suffer at such moments. Both stress his divinity rather than his humanity: As the son of God, he performed a miracle, simultaneously signaled his willingness to die, and triumphed over death. In fact, western theologians had long interpreted the episode of Peter and Malchus in this light; Alcuin and Hrabanus Maurus, for instance, viewed Malchus's restored ear as symbolic of the spiritual healing of all humanity through Christ's death and resurrection.[78]

This insistence on Christ's divine nature was deeply entrenched in Italy. It is seen in the persistence of the *Christus Triumphans* throughout the twelfth century and well into the thirteenth, long after most of western Europe had accepted the *Christus Patiens*. It is seen as well in popular accounts of the Passion narrative, and specifically in descriptions of the Betrayal. For instance, a twelfth-century south Italian Passion play from Montecassino devoted an entire scene to Peter's attack and Christ's reprimand.[79] The emphasis on the Peter-Malchus episode and on Christ's rebuke of Peter in most south Italian paintings of the twelfth century, and in the Tuscan examples that resemble them (Figs. 14–15), shows the consistency between text and image in the interpretation of the Betrayal.[80]

It is not until the 1230s and 1240s that we find visual evidence in Italy of a new interpretation of the Passion; the gradual acceptance of the *Christus Patiens*, which made an early appearance at Assisi,[81] attests to the change, and so does the new image of the Betrayal. The Franciscan order, which was establishing itself throughout central Italy in just those years, played a similar role in the shifting understanding of the Betrayal. We cannot establish the patronage of the Tereglio cross, though it has close stylistic ties to a body of work produced for the Order.[82] The San Gimignano cross, however, has been traced to the local convent of Santa Chiara.[83] Other works in which the new image appears are likely or certain Franciscan commissions. The two crosses from San Martino, Pisa, were probably intended for the community of the Clares housed at San Martino, and the Lucchese panel in the

Frick Museum, Pittsburgh, has a firm Franciscan provenance.[84] In all of these, Christ is depicted as passive victim rather than heroic savior.

Early Franciscan texts describing the Betrayal correspond to the new image fairly closely, strengthening the likelihood that it was initially produced for the Order. Perhaps most revealing are readings from the Office of the Passion written by St. Francis himself.[85] The Office is composed largely of verses from various psalms; the readings for Compline of Holy Thursday, the night on which "our Lord Jesus Christ was betrayed and taken prisoner,"[86] presents a picture of the Arrest sharply different from that in the twelfth-century play. This account suggests the overpowered victim of the mid-century Betrayal far more than the assertive miracle-worker of earlier representations:

> All my foes whisper together against me (40:13).
> They repaid me evil for good and hatred for my love (108:5). . . .
> My holy father . . . be near, for I have no one to help me (21:12).
> My friends and my companions stand back because of my afflic-
> tion (37:12).
> You have taken my friends away from me; you have made me an
> abomination to them; I am imprisoned, and I cannot escape
> (87:9).[87]

This poignant image of a man deserted by his friends, a prisoner with no hope of escape, could not depart more markedly from the earlier descriptions. Now there is no reference to Christ's willing participation in the arrest, and none to the episode of Peter and Malchus and Christ's courageous words to his apostle. It is difficult to reconcile Francis's office with the traditional image of the Betrayal; that type, in which Peter conspicuously leaps to Christ's defense, seems hardly relevant to Francis's vision of the prisoner who has "no one to help" him. But the new image popular at mid-century, in which the episode of Peter and Malchus is almost imperceptible and Christ seems at the mercy of the mob (Figs. 16–18), is another matter: Text and image both present the audience with a new understanding of Christ as powerless victim rather than triumphant savior. Like the *Christus Patiens* that was replacing the *Triumphans* now, the new image of the Betrayal gives newly vivid and immediate expression to Christ's human suffering during the Passion.

Franciscan writers active a generation or so later developed Francis's imagery still further. Thus Pseudo-Bede's *De meditatione Passionis Christi per septem diei horas libellus*, a Franciscan text probably from the middle years of the century,[88] includes an extensive treatment of the Betrayal in the meditation for Compline. Despite the length, this author, like Francis, omits any mention of Peter's valiant act of resistance and Christ's reprimand.

Instead, he emphasizes the apostles' flight, which he discusses in detail. He then concludes: "O how often they look back, seeing how their Lord is tied and dragged away without honor. . . . O Lord Jesus. . . you went among wolves and most evil dogs took hold of you, and you did not cry out but like an innocent lamb went to death."[89]

Again, then, Christ is presented as a helpless captive, abandoned by friends, surrounded by enemies – just as he appears in contemporary representations of the scene (Figs. 16–18). In both these texts and images, the heroic savior who once forcefully admonished Peter and restored Malchus's ear has been replaced by this powerless victim. Though the mid-century image was unquestionably taken from Byzantium, it was not the "magnetic pull of Byzantium" (in Stubblebine's phrase) that explains its sudden appearance, nor is its resemblance to "old icons from the East" (in Belting's) a sufficient explanation. At least as important was its correspondence to the new interpretation of the Betrayal promoted at this time by the Franciscans.

But if the mid-duecento type seems to reflect the prevailing Franciscan conception of the Betrayal, it was probably a shift in this conception that prompted the resurrection, later in the century, of the older type in which Christ rebukes Peter for his attack (Figs. 19–22). The return to this type seems to temper the mid-century stress on Christ's helplessness by reminding the viewer that he freely cooperated with his captors and quashed Peter's attempt to resist. It is precisely this aspect of the Betrayal – Christ's willingness to submit to the mob – that was emphasized by the leading Franciscan theologian of the second half of the century, St. Bonaventure.

Bonaventure wrote in the *Lignum vitae*, about 1259–60, an account that departs sharply from the earlier Franciscan texts. Even the subheadings of this text suggest a shift in emphasis. Book II is titled "On the Passion of Christ," and the first section, describing the Agony in the Garden, Betrayal, and Arrest, is sub-titled "Fifth Fruit: His Heroism in Trials." The passage describing the Betrayal and Arrest reads:

Yet, when the men of blood, led by the betrayer, came in the night with torches, lanterns, and weapons to capture Him, He clearly showed His readiness. He hurried forward to meet them, proclaimed His identity, and gave Himself up. Even so, in order that human presumption might realize that it is powerless against Him except as He permits, He caused these servants of evil to fall to the ground by a word expressing His almighty power. But not even then did He in anger withhold His compassion, nor did this honeycomb cease to drip loving-kindness: for He healed with a touch of His hand the ear of the arrogant servant, severed by one of His disciples, and He restrained the zeal of His defender, bent on wounding the aggressors.[90]

Bonaventure subsequently describes Christ bound and led away – probably a specifically Franciscan interpolation, as we will discuss in Chapters 3

and 5 – and here his language more clearly recalls that in Francis's Office and Pseudo-Bede.[91] But in his account of the Betrayal itself, Bonaventure's emphasis is clearly on Christ's "Heroism in Trials." To this end, Bonaventure returns to the gospel of St. John, who had earlier insisted on Christ's freely chosen Passion; Bonaventure follows John not only in tone but even in the detail of the mob falling to the ground.[92]

The Minister General reaffirmed the voluntary nature of Christ's sacrifice about ten years later in his *Apologia pauperum* of 1269–70, in which he underscored Christ's courage in facing death. The text was written to refute the attacks of the "calumniator," Gerard of Abbeville, who denounced the vow of poverty, but who also "lavishly praise[d] flight from persecution and death as the characteristic action of the holy and perfect."[93] Bonaventure countered this claim – which for him approached heresy – by upholding the desire for martyrdom as essential to the Franciscan mission. He devoted a full chapter to this argument; his chapter 4, which is entitled "The Desire for Martyrdom is Shown to be Perfect as Such," insists that "the desire to suffer and die in the name of Jesus Christ holds the foremost place."[94]

These texts by Bonaventure, and the larger political discourse to which they contributed, would seem to clarify the fresco painted at Assisi in the late 1280s or early 1290s (Fig. 20, p. 42). Here Christ assuredly does not attempt to flee death. On the contrary, he blocks the sole act of resistance, "restrain[ing] the zeal of His defender" and thus signaling his "desire to suffer and die." In neither Bonaventure's description of the Betrayal nor the Assisi fresco is there any suggestion that Christ is physically overpowered by the mob; instead, in both, he seems fully in control of the proceedings. Painters like Guido (Fig. 19, p. 41) and the artist responsible for the Paciano panel – another Franciscan commission – similarly reinstate the gesturing Christ, though in these the mob still threatens to engulf Christ. The Assisi painter, logically, seems closest to the spirit of Bonaventure.

Thus Bonaventure's insistence on Christ's voluntary participation in the Arrest, and on the desire for martyrdom mandated for all friars, probably encouraged the reemergence of Christ as heroic man of action who forthrightly puts a halt to Peter's attack. The shift is still more emphatic in the Portland panel – still another Franciscan commission (Fig. 21, p. 43)[95] – and most forceful in the Assisi fresco by Pietro Lorenzetti (Fig. 22, p. 43). In both Christ no longer faces Judas, as he typically did in mid-duecento versions, but turns toward Peter, as if to "restrain the zeal of His defender" more explicitly. The new composition is, again, ultimately Byzantine, derived from the variant that appeared in the Byzantine sphere by the end of the thirteenth century (as at Arilje, Fig. 33). While the Portland panel seems to be a very close copy of such a model (Figs. 42–3), Pietro Lorenzetti altered the image, and the changes give it a more specifically Bonaventuran reading. At Arilje,

though Christ turns away from Judas, he does not direct his attention to Peter and Malchus. There (and in other Late Byzantine versions), he looks up to face the man about to strike him. But Pietro Lorenzetti suggests that Christ turns instead to address his impetuous apostle: Christ looks in the direction of Peter and Malchus and gestures to Peter to halt the attack (Fig. 22).

Thus, through this subtle but strategic change, Pietro Lorenzetti asserts Christ's free cooperation with his captors more insistently than other similar versions. This heroic Christ exemplifies and validates Bonaventure's call for Franciscan self-sacrifice, reminding the audience that Christ himself willingly embraced death. Lorenzetti departed still further from the Byzantine norm in the mob's relatively gentle treatment of Christ. In contrast to the violence of almost all Palaeologan versions, which depict Christ being assaulted from all sides (Figs. 33–4, pp. 54–5), in Pietro Lorenzetti's fresco no one but Judas even touches Christ. This restraint recalls the earlier fresco at Assisi, in the Upper Church (Fig. 20, p. 42), where the crowd does not yet surround Christ, but stands back. Perhaps Bonaventure's insistence on Christ's "almighty power" even during the Arrest discouraged any display of violence in these Assisi works.

In fact, Lorenzetti's fresco is unusual among its contemporaries in its fidelity to Bonaventure's conception of the Arrest. Trecento painters like Duccio and Giotto, by contrast, share little with this account; they do not stress the episode of Peter and Malchus, but instead downplay it and either mute or eliminate Christ's gesture of reproach. Thus in Duccio's panel from the *Maestà* (Fig. 23, p. 44), Christ points vaguely towards Peter and Malchus, but Judas stands between them and Christ; further, the pair is difficult to detect amid the swarming mob. Giotto minimizes the episode still more (Fig. 24, p. 45). Not only does Christ not gesture to Peter, but he turns his back on the pair; and by planting a bulky figure directly in front of them, Giotto obscures them further.

Evidently, then, neither Duccio nor Giotto – neither of whom was then working for a Franciscan patron – evinced any interest in Bonaventure's account of the Betrayal, which stresses Christ's willing cooperation with his captors. Interestingly, however, the interpretation of the Betrayal by Giotto and Duccio is consistent with another Franciscan text: the well-known *Meditationes vitae Christi*, written by an anonymous Tuscan Franciscan. This author finds a middle ground in his description of the Arrest. Like Francis and Pseudo-Bede and unlike Bonaventure, he depicts a passive Christ who submits meekly to his captors' rough treatment, and, again like them and unlike Bonaventure, he makes no mention of Peter's act of defense. On the other hand, unlike Francis and Pseudo-Bede, this author is explicit in telling us that Christ allowed the arrest:

Pay careful attention and follow the Lord as He patiently and benignly receives the treacherous embraces and kisses of that wretch.... How patiently He allows Himself to be captured, tied, beaten, and furiously driven, as though He were an evildoer and indeed powerless to defend Himself! How even He pities His fleeing and errant disciples! And see also their grief as, unnerved, sorrowfully weeping and lamenting like orphans, and frightened by fear, they leave.[96]

Duccio's and Giotto's images of the Betrayal – minimizing the episode of Peter and Malchus and depicting a Christ who "patiently and benignly receives [Judas's] embraces" – thus seem close in spirit to this account, which restores the pathos minimized by Bonaventure. In light of the works by Duccio and Giotto – both artists from whom Pietro Lorenzetti absorbed much – Pietro's version of the Betrayal seems more specifically a Bonaventuran construction.

Pietro's composition differs from Duccio's and Giotto's, and from Byzantine versions of the theme, in another respect as well. In the Assisi fresco (Fig. 22, p. 43), the man directing the arrest – standing to the left and pointing to Christ – is bedecked in gold, from his lavish head cloth to his ornate sleeve to the gilded thread stitching his boots. Some earlier versions of the Betrayal in Franciscan monuments also represent one or two of the arresters as somewhat more elegantly clad than the rest. For instance, Enrico di Tedice's version (Fig. 18, p. 41) depicts the presiding priest and one of the crowd in a patterned garment, and the fresco in the Upper Church at Assisi (Fig. 20, p. 42) includes soldiers in unusually ornate helmets. But no earlier work approaches the Lower Church fresco in signaling the wealth and privilege of Christ's arresters. The contrast is especially sharp if we consider again the Betrayals by Pietro's great predecessors, Duccio and Giotto (Figs. 23–4, pp. 44–5). In their compositions, such sartorial splendor is held to a minimum. Giotto's priest has a gold border on his cloak, but otherwise is simply dressed, without the gilded headgear, sleeves or boots of Pietro's figure. In Duccio's Betrayal, the only character wearing finery in any form is Christ, whose robe is lightly edged in gold.

The opulent garb of Christ's enemies in the Franciscan works, and especially in Pietro's Betrayal (Fig. 22), seems again a self-consciously Franciscan device: It effectively links worldly display with those who killed Christ. Though the arresters are especially richly clad, Pietro makes clear Judas's link with them; both Judas and the gesturing man wear elegant robes of bright red that set them apart from the rest of the crowd.[97] Numerous Franciscan texts of various types stress that Judas not only betrayed Christ, but did so out of avarice. As Lambert has shown, both Francis and Bonaventure equated Judas's betrayal of Christ for thirty pieces of silver with the betrayal of the vow of poverty; the friar who violated the vow became a kind of second Judas.[98] Bonaventure's *Apologia pauperum* is especially

forceful on the subject of Judas and covetousness:

As soon as *covetousness,...the primary root of all evils* [1 Tim. 6:10], has invaded the fortress of the human mind, it imposes upon it such cruel tyranny that it leads it back to the servitude of idols and makes it as cruel as a beast. A clear proof of this is the malice of Judas the betrayer. While he held the purse with which he might have appeased the voracity of his covetousness, he was driven by such craving for a promised sum of money that, small as it was, it made him thirst for the blood of the Savior of All, and sell unto death the Author of Life.[99]

Bonaventure similarly used Judas to warn against avarice by reminding the friars that only the apostle who carried money was damned: "This was also a warning to misers who crave for a purse, since none of Christ's disciples were lost, except the one who carried it."[100]

In devotional guides as well, Judas's covetousness is often made explicit. Bonaventure opens his discussion of the Passion in the *Lignum vitae* with this passage: "The first thing that occurs to the mind of anyone who would contemplate devoutly the Passion of Christ is the perfidy of the traitor. This man...burned so intensely with the fire of greed that he would sell for money the All-good God, and accept for Christ's priceless Blood the price of a cheap reward...."[101] Even the author of the *Meditationes vitae Christi* links Judas with commerce: Referring to the Betrayal, he says, "Even as He spoke, that wicked man, Judas, most evil merchant, came before the others and kissed Him."[102]

There was, then, a long tradition identifying Judas with avarice, but only at Assisi are he and his co-conspirators so luxuriously clad. As we have seen, the vow of poverty was hotly contested both within and without the Order in the thirteenth and early fourteenth centuries.[103] Within the Order, the second decade of the fourteenth century, when Pietro Lorenzetti was at work in the Lower Church, was especially critical. In 1312 Clement V issued a bull, *Exivi de paradiso*, urging on the friars a stricter interpretation of the vow.[104] His successor John XXII, elected in 1316, initially supported the bull and so, more fervently, did Minister General Michael of Cesena, elected in the same year. Not long after his election, Michael met with a group of friars at Assisi to tighten standards of poverty by revising the Order's statutes. Michael and his committee based the revision closely on the statutes of Narbonne (1260), the handiwork of Bonaventure. In a letter accompanying the statutes, Michael stressed several key points; among them, he ordered *vilitas* (cheapness) for the habits of all friars, specified acceptable length, size, and cut of the habits, greatly restricted the wearing of shoes, and placed stringent limits on the friars' access to money.[105]

The Assisi frescoes, painted in the mid- to late teens, date exactly to the

time of Michael's reform.[106] It may be that a Franciscan audience would have understood any image of the Betrayal as a reminder of the evils of covetousness. But at Assisi, the linkage of Christ's enemies with conspicuous wealth, seen in their glittering garb, is most explicit. Further reinforcing the point, the Betrayal at Assisi is followed by a very unusual scene, the Suicide of Judas, here a particularly grisly depiction of the disemboweled traitor. Just as the corpses of executed men were left on view as admonitions to the public, so this corpse is a potent warning to those who would, like Judas, betray Christ for money. The fresco forcibly recalls Bonaventure's words of caution: Only the apostle who held the purse was damned. Michael of Cesena no doubt took special pleasure in this image, a graphic reminder of the fate of all who betrayed their vow.[107]

To summarize, then, both Byzantine images and Franciscan ideologies shaped the ways in which the Betrayal of Christ was pictured in late medieval Italy. In working out the new compositions, Italian painters and the friars who employed them found much of use in Byzantine art; they found among the images circulating in Tuscany and Umbria a group rich and varied enough to give visual expression to shifting interpretations of this event. Even trecento artists like Pietro Lorenzetti took inspiration, directly or indirectly, from Byzantine art. But these painters did not emulate Byzantine images simply because of their "privileged form." Instead, they chose, or were directed to choose, the images that most closely corresponded to the understanding of the event promoted by their Franciscan employers, and at times they modified even those to make the correspondence still closer. We will see in subsequent chapters that duecento painters continued to appropriate eastern compositions freely when they accorded with local interpretations of those themes. When they did not, however, these painters and their patrons did not hesitate to alter them or to reject them entirely, in favor of a distinctly non-Byzantine image.

THE TRIAL OF CHRIST

✠

THE TRIAL IN ITALIAN PAINTING

Unlike the Betrayal of Christ, which seems almost ubiquitous in duecento Passion cycles, the Trial appears less often. Examples of the Betrayal, in media from panel painting to frescoes to manuscripts to mosaic, can be found throughout central Italy. In contrast, the surviving images of the Trial of Christ are largely by Florentine painters, and most appear on panels, especially painted crosses. By the trecento the theme is seen elsewhere, and in other media; but the early clustering of the image in Florentine panels is striking. In other respects, however, the Trial presents us with a familiar pattern. Again by 1240–5, a new image appeared that broke sharply with tradition. Again the formulators of the new image relied heavily on Byzantine works in constructing the new scene. Again, the new image aptly promoted local ideologies, especially those of the Franciscan order.

Now, however, we encounter not a new version of a specific Passion theme but rather a distinct episode, which substituted for the one featured until about 1240. There were actually several trials of Christ, as the Bible makes clear: He appeared before the Jewish high priests, before Pilate, and before Herod. According to the synoptic gospels, the crowd took Christ to the reigning high priest, named by Matthew as Caiaphas (Matthew 26:57; Mark 14:53; Luke 22:66); according to John, however, they led him first to Annas, Caiaphas's father-in-law, for a preliminary hearing.

Of all the trials, the most important legally was that before Pilate, the Roman procurator. Only Pilate had the authority to condemn Christ to

death; the sentence passed by the Jewish tribunal, the Sanhedrin, had to be ratified by the procurator (John 18:31). The trial before Pilate is thus of intrinsically greater importance than the earlier but legally inconclusive appearances before the high priests; the importance of the event is reflected in the lengthy accounts of it in both canonical and apocryphal sources.[1]

One might therefore expect a narrative cycle in which only one of the trials is depicted to represent the Roman rather than the Jewish trial, and in Italian painting, most extant cycles before about 1240 confirm this expectation. Passion cycles appear in a number of Italian churches from the eighth through the twelfth centuries: among them, Santa Maria Antiqua, San Bastianello, and Sant'Urbano alla Caffarella, all in Rome; Sant'Angelo in Formis; the Cathedral of Monreale; and San Marco in Venice. But none of these includes the Trial before Annas or Caiaphas; each instead represents Pilate, who is typically shown washing his hands.[2] Neither trial appears often in early panel painting, but one twelfth-century Pisan cross does represent Pilate washing his hands.[3] Thus, if we can judge accurately from the work that still exists, the Trial before the Priests was depicted only rarely in Italian painting before the thirteenth century.[4]

In the course of the thirteenth century, however, the situation changed considerably. The Trial before Pilate, despite its historical significance and despite its long history in Italian painting, occurred only infrequently; it apparently did not become common again until the trecento. For most of the century, when one of the trials was represented, it was the priests rather than the procurator who presided.[5] These two episodes are clearly described by John as distinct events (John 18:13: "They led him away to Annas first"; John 18:24: "Annas sent him bound to Caiaphas the high priest"). However, in Italian painting, the two events are usually telescoped into a single hearing.

The very occurrence of the Trial before Annas and Caiaphas, and the fact that this scene supplanted the Trial before Pilate, thus represents a reversal of Italian tradition. Perhaps the earliest instance to survive is on the Florentine cross in the Uffizi, no. 434, of about 1240–5 (Fig. 7). The Trial before Annas and Caiaphas appears as well on Coppo's San Gimignano cross of about 1261 (Fig. 8), on the cross in Pistoia of 1274 by Coppo and his son Salerno, and on a Pisan cross in Santa Marta, Pisa, of about 1280–90, which has been closely associated with the Pistoia cross.[6] The priests are also included on a Florentine dossal of about 1285–90, a panel in Oxford attributed to the San Gaggio Master.[7] Early in the trecento, Giotto followed his Florentine predecessors in depicting Christ before the priests in the Arena Chapel; like most of them, he omitted the Trial before Pilate. Duccio, by contrast, includes an unusually detailed sequence of these legal procedures in the *Maestà*; Christ appears once before Annas, twice before Caiaphas, once before Herod, and four times with or before Pilate.[8]

Figure 44 Trial of Christ. Detail of painted cross, c. 1240–5. Florence, Uffizi, no. 434.
Photo: Courtesy of Luigi Artini/Miklós Boskovits.

The essential elements of the scene remain constant in the four earlier
works. In the cross in the Uffizi (Fig. 7), the Passion narrative opens with
the Trial (Fig. 44). In the upper left apron panel, Christ stands to the left,
surrounded by his accusers. A soldier equipped with sword and scabbard
grips Christ's arm. In front of the high priest's palace, seated on a cushioned
bench, are Caiaphas, one of the leaders in the plot (John 18:14), and his
father-in-law Annas. The trial has almost ended; the witnesses have recited
their testimony, and Caiaphas has just challenged the defendant: "I adjure
thee by the living God, that thou tell us if thou be the Christ the Son of
God?" (Matthew 26:63). Now Christ acknowledges his divinity, as his ges-
ture suggests. Enraged by Christ's answer, Caiaphas rips open his garment –
a traditional Jewish response to blasphemy;[9] Annas gestures in shock, and
one of the crowd, Annas's servant, raises his hand to strike Christ for his
reply (John 18:22).

Coppo's representation of the scene (Fig. 45), which is now the second
episode on the cross, shares much with that of his fellow Florentine. The
compositions are almost identical in the placement of the principal figures
and groups. Many gestures, too, are common to both works: the threatening
raised hand of Annas's servant, Caiaphas's cloak-tearing, and Annas's ges-
ture of shock. As in his Betrayal, however, Coppo has subtly heightened the

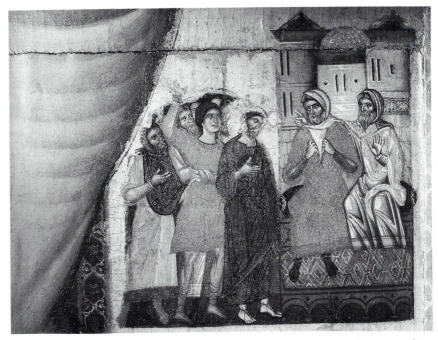

Figure 45 Coppo di Marcovaldo. Trial of Christ. Detail of painted cross from Sta. Chiara, San Gimignano, c. 1261. San Gimignano, Museo Civico. Photo: Renate J. Deckers-Matzko/Valentino Pace.

drama of the scene, intensifying the confrontation between Christ and his accusers. In the Uffizi cross (Fig. 44), Christ stood at a distance from Caiaphas, but now the soldier-escort has been omitted, and Christ stands only inches away from the raging high priest. In the earlier work a strong isocephalism ruled; here, a larger throne elevates the priests and seems to confer, through their greater physical stature, a greater sense of their authority. Annas no longer merely expresses shock; he now also leans toward Christ and points ominously.

The Trial in the Pistoia cross (Fig. 46) was probably designed and executed by Salerno rather than Coppo; though it closely resembles the version in the San Gimignano cross, it dilutes the intensity of the earlier work. Like the painter of the cross in the Uffizi, Salerno places Christ at some distance from Caiaphas, so that the eyeball-to-eyeball confrontation between accuser and defendant is lost. The crowd is smaller and stands slightly back instead of jostling Christ. The violent gesture of the man striking Christ has been omitted; instead, a sedate figure simply places his hand on Christ's back.[10]

The tabernacle in Oxford, executed toward the end of the century, differs in several respects from the earlier works.[11] First, this panel features an unusually comprehensive christological cycle, with thirteen scenes of the Passion – more than twice the number on the fullest crosses. The painter devot-

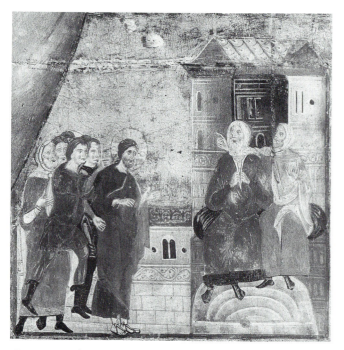

Figure 46 Salerno di Coppo. Trial of Christ. Detail of painted
cross, 1274. Pistoia, Cathedral. Photo: Art Resource.

ed two episodes to aspects of the judicial procedure, anticipating the much
fuller treatment in Duccio's *Maestà*. Here the first of the two episodes (Fig.
47) depicts Christ before two men at a desk. One wears the usual head
shawl of a high priest, but the other, who is crowned, must represent Pilate;
an attendant presents him with the jug with which he will wash his hands.
Christ's hands are now bound before him, and thus he no longer gestures
as he did before; this change is consistent with the accounts of Matthew
(27:2) and Mark (15:1), who note that the chief priests brought Christ
bound to the procurator. The next panel (Fig. 48) again shows Christ before
a second crowned ruler and a high priest. Now the ruler is Herod, the king
to whom Christ was led after Pilate dismissed him (Luke 23:7–11); the archi-
tectural forms behind the figures have changed, indicating a change of scene,
and the ruler's clothing has changed as well (Pilate wears an olive green
tunic; Herod's is pink). Though some of the figures are familiar from earlier
versions – the man in front of Christ recalls the soldier in the Uffizi cross
(Fig. 44); the servant about to strike Christ appeared there and in Coppo's
cross (Fig. 45); Herod's gesture is similar to Annas's in Coppo's and Saler-
no's panels (Figs. 45–6) – in general the Oxford panel departs significantly
from earlier Tuscan images of the trial.

Giotto, in his fresco in the Arena Chapel (Fig. 49), still works within the
Florentine tradition, though he adds newly expressive details. Like the

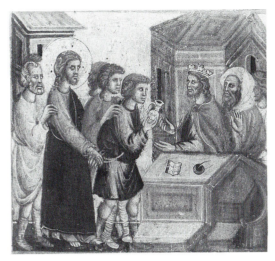

Figure 47 San Gaggio Master. Trial of Christ.
Detail of tabernacle, c. 1285–90. Oxford, Christ
Church Museum. Photo: The Governing Body,
Christ Church, Oxford.

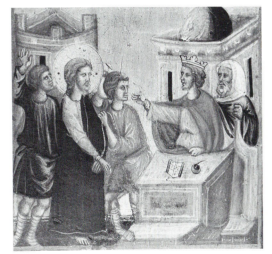

Figure 48 San Gaggio Master. Trial of Christ.
Detail of tabernacle, c. 1285–90. Oxford, Christ
Church Museum. Photo: The Governing Body,
Christ Church, Oxford.

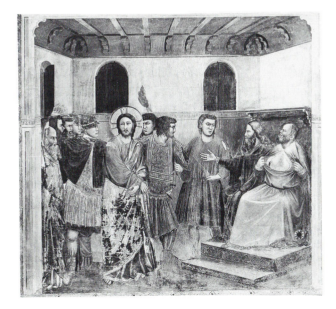

Figure 49 Giotto. Trial of Christ,
1303–5. Padua, Arena Chapel. Photo:
Alinari/Art Resource.

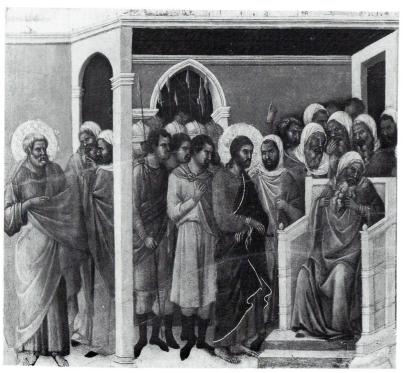

Figure 50 Duccio. Trial of Christ, from the *Maestà*, 1308–11. Siena, Museo dell'Opera del Duomo. Photo: Alinari/Art Resource.

painters of the early crosses, Giotto replaces the Trial before Pilate with the Trial before the Priests; the procurator appears only once, in the Mocking of Christ, where he plays a minor role. Caiaphas's rending of his cloak also recalls the early works, but here, the rather corpulent priest bares an expanse of fleshy chest. Christ's hands are again bound as in the two scenes in the Oxford panel (Figs. 47–8); according to John (18:24), Annas sent Christ bound to Caiaphas. One detail does not appear earlier in extant Italian painting: Christ here turns away from the priests to face Annas's servant, who is about to strike him. Finally, Duccio's sequence in the *Maestà* depicts an unprecedented number of judicial procedures; his Caiaphas (Fig. 50) again rends his cloak, but also turns away from Christ as if to recoil from Christ's claim of divinity.

Thus, beginning around 1240–5, extant Tuscan Passion sequences drop the Trial before Pilate and replace it with the Trial before Annas and Caiaphas. Only toward the end of the century, when narrative cycles often expand considerably, is the trial before the Roman procurator included as well; in the Oxford panel, Pilate and the priests share the judicial role. As in the Betrayal, those formulating the new compositions took them from Byzantine images, both in broad outlines and in details. A survey of the Trial

of Christ in Byzantine painting will provide us with some sense of these works, and the reasons why they appeared when they did in Byzantium.

THE TRIAL IN BYZANTINE PAINTING

When limitations of space did not restrict the length of a cycle, Byzantine painters represented both the Trial (or Trials) before the High Priests and the Trial before Pilate. The Passion cycles at Sant'Apollinare Nuovo in Ravenna, at Qeledjlar Kilise in Cappadocia, and a number of later monuments all show both phases of the judicial procedure.[12] In less detailed cycles, however, only one of the scenes appears: Sometimes Pilate, sometimes one or both priests, presides over the trial. The choice of episode generally seems tied to the date of the specific monument. Early cycles almost invariably represent the Roman trial, but beginning in the mid-ninth century, cycles frequently substitute the trial before the Jewish priests.[13]

The substitution of the priests for the procurator in these later monuments probably stems from Byzantine attitudes towards both Pilate and the Jews. The Roman governor was often viewed leniently, even sympathetically, from the early years of the church, but this magnanimous attitude did not extend to the Jews; the Crucifixion was defined as a Jewish crime.[14] Though both notions had a venerable history in the Byzantine empire, anti-semitism grew particularly virulent in the mid-ninth century, when the Jewish trial begins to replace the Roman trial. Kathleen Corrigan has convincingly described the antisemitic content of the same ninth-century manuscripts in which the images of the Jewish trial appear.[15] In a lucid analysis, she associates this intense hostility to Jews with the return to orthodoxy following the Iconoclastic Controversy. As she shows, the Jewish role in the death of Christ was debated often in the eighth and ninth centuries; after the iconodule victory, Jews were compared with iconoclasts and similarly demonized.

Basil I (867–86) launched an especially intense campaign against the Jews, which in range and cruelty far eclipsed earlier episodes.[16] Basil's vilification of the Jews found visual expression in the Church of the Holy Apostles in Constantinople, probably decorated during his reign.[17] From Mesarites's description, it appears that several mosaics depicted the villainy of the priests. Mesarites referred first to Christ in the court of the high priest, then to an unusual episode, which evidently depicted Annas and Caiaphas bribing the guards who watched Christ's tomb after the crucifixion. The priests may have appeared a third time too: Mesarites claimed that the priests also tried to bribe Pilate to have Longinus beheaded.[18]

The Trial before the Priests appears often in psalter illumination dating from just this period: Both the Pantocrator Psalter (fol. 39v.) and the Khlu-

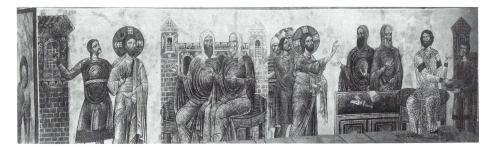

Figure 51 Trial of Christ, c. 1156. Pskov, Spaso-Mirozhsky Monastery. Photo: Byzantine Visual Resources, copyright 1995, Dumbarton Oaks, Washington, D.C.

dov Psalter (fol. 31v.) illustrate Psalm 35:11 with the Trial before the High Priest.[19] The text of the psalm ("malicious witnesses step forward") applies equally to both the Roman and the Jewish trials, for false witnesses testified on both occasions; the selection of the priest seems pointedly antisemitic. Thus the Trial before the Priests gained prominence especially in the later ninth century, and from this point on, appeared frequently in Byzantine Passion cycles; it was displaced only occasionally by the Trial before Pilate.

At times, even when the Trial before Pilate does appear in Byzantine cycles, the high priests appear with the procurator. For instance, at Spaso-Mirozhsky Monastery, Pskov (Fig. 51),[20] two episodes of the trial appear. On the left, Christ stands before Annas and Caiaphas. On the right, he has been taken to Pilate; the desk, signaling Pilate's legal authority, indicates the change of scene, and the procurator washes his hands to the right. But the priests are present as well, and indeed they dominate the composition, gesturing assertively as Pilate withdraws to wash his hands and thus to proclaim his innocence.

From the Middle Byzantine period, then, the priests are especially prominent, often displacing Pilate, and at times overshadowing him even when he does appear. When the Trial appears in duecento Passion cycles, Pilate's role is similarly minimal; for most of the century, only the priests appear. The designers of these cycles must have carefully studied Byzantine images of the Trial: The new versions of the Trial in duecento painting clearly depend on Byzantine formulations.

ITALY AND BYZANTIUM

1. The Mid-Duecento Image

The first noteworthy aspect of the Trial in duecento painting is that, as noted above, it unites two separate events, the Trial before Annas and the Trial before Caiaphas. To judge from surviving examples, this pairing of the two

priests occurs only rarely in pre-thirteenth-century western art.[21] In Byzantine art, however, this condensation of the two episodes is fairly common. Only occasional cycles, such as the richly detailed Gospel book in Paris, gr. 74, represent the trials before the two priests individually.[22] It may have been the limited space of a fresco or mosaic cycle that forced the conflation of the two moments into a single scene, just as the various episodes of the Betrayal were similarly fused into a single composition. This sort of conflation emerged in the late ninth or early tenth century[23] – the same time that the composite Betrayal first appeared – and seems to have been especially popular in the twelfth and early thirteenth centuries.[24] The infrequent occurrence of the paired priests in the West and their more common presence in the East suggests that Tuscan painters and their advisers took the idea from Byzantine images.

The representation of the protagonists in duecento painting – Christ, the crowd, and the high priests – confirms these painters' close study of Byzantine versions of the theme. In each of the four crosses, Christ stands and extends his right hand. In most western representations of the scene, a different tradition prevails. Sometimes Christ is shown with his hands bound, sometimes he is dragged unceremoniously by both arms; in neither case can he raise his hand to acknowledge his divinity.[25]

In Byzantine art, Christ at times appears gesturing, and at other times with hands tied. Early Christian and Early Byzantine images depict him standing unfettered, gesturing, as at Sant'Apollinare Nuovo and in the Rabbula Gospels.[26] This type continues into the Middle Byzantine period and can be seen at least until the second half of the twelfth century (for example, in the Pskov fresco, Fig. 51; in St. Petersburg 105, fol. 103r., Fig. 52).[27] During the Middle Byzantine period a second type, in which Christ's wrists are tied before him, also appears. Christ is seen bound before Pilate, as Matthew and Mark specify (as in Paris gr. 74, fol. 56v.; Fig. 53), but also before Caiaphas, as John recounts.[28] This more expressive image became common in Byzantine images of the Trial by the late thirteenth century.[29]

It is curious that Italian painters at first either avoided this type or were not familiar with it. For instance, the Trials in the earlier crosses follow the earlier Byzantine type, which stressed Christ's gesture of self-affirmation rather than depicting him bound (e.g., Figs. 44–6). Only towards the end of the duecento and in the early trecento, as in the examples in the Oxford tabernacle (Figs. 47–8), about 1285–90, or those by Giotto and Duccio (Figs. 49–50), is Christ represented with bound hands.

In each of the Tuscan examples, Christ is accompanied by two or more men. A number of these "bit players" in the drama emerge as individual personalities, identifiable by specific actions: the soldier who escorts Christ (Fig. 44); Annas's servant, who raises his hand to strike him (Figs. 44–5, 48–9);

Figure 52 Trial of Christ, from a Gospel book, 1180s. St. Petersburg, National Library of Russia, ms. 105, fol. 103r. Photo: museum.

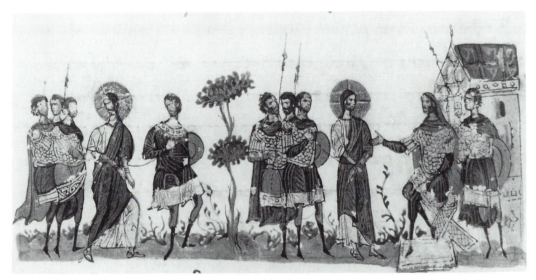

Figure 53 Trial of Christ, from a Gospel book, mid-eleventh century. Paris, Bibliothèque Nationale, ms. gr. 74, fol. 56v. Photo: museum.

and the man grasping Christ's shoulder (Figs. 46–7). Though all of these derive ultimately from Byzantine compositions, one – the soldier-escort – appeared in the West as early as the eleventh century.[30] But the others do not significantly resemble earlier western figures; far closer parallels can be found in Byzantine art.

For instance, the striking figure, Annas's servant, makes an early appearance in the West in the Uffizi cross (Fig. 44). The figure is clearly drawn from the Byzantine repertory of types: The identical figure had occurred in Constantinople by the eleventh century.[31] But the motif remains uncommon in earlier Comnenian art; most eleventh- and early twelfth-century monuments omit it.[32] Later in the twelfth century, however, it appears with increasing frequency. It occurs, for instance, in the first episode of the Trial at Pskov (Fig. 51) and in St. Petersburg 105 (Fig. 52).[33] The new popularity of the motif probably reflects the growing interest in dramatic gesture and emotion so often seen in later Comnenian monuments. The presence of this character in the Uffizi cross (Fig. 44) and in the San Gimignano cross (Fig. 45) again suggests that the Byzantine images available to these painters were produced no earlier than this period. In both the Pskov fresco and the St. Petersburg manuscript (Figs. 51–2), the servant wears a short tunic, as he does in the Tuscan works. In the stance of the servant, the duecento examples especially resemble the manuscript in St. Petersburg.

The figure with his hand on Christ's shoulder (as in Salerno's cross, Fig. 46) also seems to have been drawn from a Byzantine source. This character, too, had been developed by the eleventh century: In Paris 74 (fol. 57v.) one of the crowd pushes Christ by the shoulder as they walk to Pilate's palace.[34] Still closer, however, are later versions, such as the second episode of the trial, where Christ appears before Pilate and the high priests, in the twelfth-century fresco at Pskov (Fig. 51). This image resembles Salerno's in other respects as well. For instance, the man striking Christ is not included either in the second episode at Pskov or in Salerno's panel. Its omission in the fresco makes sense; it did appear in the first episode, which depicts Christ before the priests, and it was Annas's servant who struck Christ. But Salerno's exclusion of the detail is more surprising, since he depicts Christ before the priests, not Pilate, and since the striking servant was included in earlier Tuscan painting, including the cross by his father. In other details as well – the smaller crowd behind Christ, the greater distance separating him from the priests (especially in the first episode at Pskov) – and even in the rather delicate, elongated proportions of the figures, Salerno's panel resembles the Pskov fresco more closely than it resembles his father's version of the theme. These points of correspondence between the panel and the fresco may clarify our understanding of Salerno's methods. It has long been acknowledged that this painter often modified or eliminated the expressive motifs favored

Figure 54 Trial of Christ, c. 1314. Čučer, St. Nikita. Photo: after Millet and Frolow, vol. 3, 1962.

by Coppo.[35] It now appears that in doing so he may have based his composition on a Byzantine image different from the one used by his father.

One final gesture common in Tuscan images indicates these painters' use of Byzantine versions of the theme: Caiaphas's enraged gesture of ripping his cloak. Particularly in Constantinople, this overt gesture of rage was apparently avoided for some time; certain Middle Byzantine examples depict the high priest merely sitting placidly.[36] In other instances, Caiaphas does react visibly to Christ's words, but only by standing rather than by tearing his garment. This milder expression of anger – which may derive from the text of St. Mark, who tells us that the priest stood (14:60) – occurs in the tenth and eleventh centuries and may have existed much earlier.[37]

However, Caiaphas is shown tearing his garment occasionally, especially in the provinces of the empire, in the late twelfth century and after.[38] The motif probably appeared earlier,[39] but became more popular in the late Comnenian period, when expressive gestures and devices became increasingly common in Passion narratives, and it continued into Late Byzantine art. The gestures of both Annas and Caiaphas in Tuscan images such as Coppo's (Fig. 45) can be compared to the early fourteenth century fresco at St. Nikita, Čučer (Fig. 54);[40] presumably an icon or manuscript resembling this fresco was in Tuscany by the mid-thirteenth century.

Finally, a few details indicate just how carefully mid-duecento painters scrutinized Byzantine images. The large, well-upholstered footstool on which

the priests rest their feet (Figs. 44–6) directly recalls similar objects in Byzantine painting; compare the footstool in the crosses with the one in, for instance, St. Petersburg 105 (Fig. 52). Even the diaper pattern on Coppo's footstool (Fig. 45) recurs exactly in the Trial before Pilate in St. Neophytos in Paphos, executed around 1200.[41]

2. The Image in the Late Duecento and Trecento

The Tuscan assimilation of Byzantine images of the Trial continued into the last decade of the duecento and into the trecento. The San Gaggio Master may have had access to eastern depictions of the scene; the Trial scenes in his altarpiece in Oxford (Figs. 47–8) include several features that are not found in earlier extant Tuscan art.[42] For instance, as noted above, Christ's bound hands – absent in earlier duecento painting – occur often in Byzantine images as early as the eleventh century (e.g., Paris 74, fol. 56v.; Fig. 53) and especially in the late thirteenth century and after. Particularly in the second Oxford scene (Fig. 48), a number of details confirm the Byzantine origins of the composition. In fact, it seems almost a fusion of two surviving Byzantine versions, the Gospel book in Paris (Fig. 53) and the later example in St. Petersburg (Fig. 52). For instance, both Christ's bound hands and the extended arm of Herod recur similarly in the Paris manuscript (Fig. 53). Still more elements especially recall the Trial in St. Petersburg 105 (Fig. 52). Perhaps most strikingly, both the panel and the manuscript pair one of the high priests (presumably Annas, since his servant appears) with a ruler: Herod in the panel, Pilate in the manuscript. This combination in Byzantine art is very unusual; Colwell and Willoughby, identifying the St. Petersburg image as Pilate with Annas, concluded "as such, it is unique."[43] In both the ruler wears a cloak fastened at the neck, which falls in much the same way across the shoulders, and in both, he grasps the bottom of the cloak with his left hand. In both, the ruler sits behind a similarly proportioned, domed tower. The two images resemble each other even the reduction of the crowd to one or two figures, and in the stance and location of Annas's servant, who in both stands directly behind Christ and gestures energetically. In view of all these similarities, it is not hard to imagine the San Gaggio Master working from an image that combined features of the Paris and St. Petersburg manuscripts.

The presence of two episodes of the Trial in the Oxford panel – and the much more pronounced expansion of the narrative in Duccio's *Maestà*, where eight episodes occur – also may derive from Byzantium. We have already noted a pair of episodes at Pskov, and narratives of the Trial proliferated in Late Byzantine painting. For instance, the fresco cycle at Staro Nagoričino, dated about 1316–18, includes five different episodes. Further, the *Maestà* and the Staro Nagoričino cycle share one unusual scene: Pilate releasing Christ to the Jews.[44] The fresco cycle also reveals the sort of spatial experimentation

Figure 55 Trial of Christ, c. 1315. Veroia, Church of Christos. Photo: after Pelekanides, 1973.

noted earlier in Paleologan images of the Betrayal; now, however, we see the exploration of interior space, particularly a two-story interior for a single composition. Duccio's scenes of the interior of the high priest's palace reveal similar architectural inventiveness.[45] Finally, in the Trial before Caiaphas (Fig. 50), Duccio must have derived the stance of Caiaphas, recoiling from Christ as he rends his garment, from Late Byzantine images as well; the fresco painter at Čučer (Fig. 54) must have worked from something very similar, for the stance and facial type of the priest are almost identical to Duccio's.

Even Giotto, celebrated as the artist who liberated Tuscan painting from the *maniera greca*, evidently also found much of interest in Byzantine formulations of the Trial; his version in the Arena Chapel (Fig. 49) includes several features which are unknown in earlier extant Italian painting, but which do find precedents in Byzantium. Apparently new to Italian art is the stance of Giotto's Christ; he does not face the priests but turns to the left, his attention diverted by the man (now a soldier) who raises his hand to strike him. Though this stance is very unusual, a few comparable examples survive in Byzantine art. A miniature in the eleventh-century Gospel book in Paris, gr. 74 (Fig. 53), provides us with a glimpse of the sort of image that Giotto presumably encountered. There, as Christ is led to Pilate, he turns back to face the soldiers behind him. Still closer, both chronologically and visually, is a damaged fresco in the church of Christos, Veroia, of about 1315 (Fig. 55).[46] Here Christ again turns away from the priests, but now, as in

Giotto's composition, he turns in response to the man who is about to strike him. The miniature and the two frescoes share as well the gesture of the high priest – seen earlier in the Oxford panel – who reaches out, palm up, towards Christ. Further, both frescoes also include, near the center of the composition, a boy who turns toward the priests. And in both frescoes, the setting is no longer defined by facades of buildings, as before (e.g., Figs. 44–8, 51–3); instead, both place the event in an interior space, indicated, in both, by a corner to the left, one or more deeply shadowed, arched openings (a door at Veroia, windows in the Arena Chapel), and a corniced dado about as high as the boy's head in each composition.

Finally, Giotto's treatment of Caiaphas also indicates that he carefully studied Byzantine images only recently imported to Tuscany. The Arena Caiaphas, whose physical bulk is amply revealed when he tears his garment, differs from Tuscan precedents (Figs. 44–8), where Caiaphas was not noticeably hefty and where the tear, if present at all, was fairly small and v-shaped. In Late Byzantine painting, the cloak-rending gesture is especially common, and now it is almost always much more theatrical than before: A portly Caiaphas, with a large, rounded gap in his robe, now bares a substantial, fleshy torso (Fig. 54).[47] Demus has already observed that the bulk of Palaeologan figures may have inspired Giotto's similarly massive types;[48] it now appears that Giotto at times studied Byzantine images with the attention to detail that we have observed in his Tuscan predecessors. Though Giotto's composition obviously differs in many respects from the Paleologan versions, his assimilation of Byzantine art goes well beyond what is generally assumed.[49]

THE TRIAL BEFORE THE PRIESTS, ANTISEMITISM, AND THE FRANCISCANS

Clearly, then, the painters who produced these images of Christ's trial were familiar with Byzantine versions of the scene and had studied them assiduously; as in the Betrayal, even trecento painters continued to adapt eastern images. Giotto and Duccio evidently valued Palaeologan images for their fresh details and characterizations, and for their treatments of interior space. But the initial Tuscan appropriation of Byzantine images, seen as early as about 1240–5, may stem from a more specific set of circumstances. As we observed earlier, the Byzantine preference for the Jewish trial rather than the Roman trial emerges at a time of heightened antisemitism. I will argue that the replacing of the Trial before Pilate with the Trial before the Priests in mid-duecento Tuscan painting also coincided with a new preoccupation with the Jews, which became, at times, sharply antisemitic.

The gradual deterioration of Christian-Jewish relations in the first half of the thirteenth century is well documented. The rise of antisemitism can be

traced in papal letters, which refer to Jews with new harshness, and in council decrees such as those of the Fourth Lateran Council of 1215, which mandated badges or other special clothing for Jews.[50] This intolerance of Jews was part of a larger pattern directed against all non-believers: Heretics and Muslims loomed large as threats to orthodox Christianity, but Jews were targeted as well. In fact, as in post-iconoclastic Byzantium, heterodox groups, whose commonality was their "otherness," were often linked in the minds of their Christian antagonists.[51]

One of the clearest examples of the new insistence on orthodoxy is the Inquisition. Most historians place its emergence as an organized force in the 1230s. In 1231, Pope Gregory IX appointed the first papal inquisitors; though he favored Dominicans for these posts, he named Franciscans as well. In the 1240s and 1250s, Innocent IV widened both the Inquisition in Italy and the role of the Franciscans in the effort. He allowed the Dominicans to retain control of the Inquisition in parts of the peninsula, but assigned jurisdiction over all of central and northeastern Italy to the Franciscans.[52] Though the Inquisition was initially charged with prosecuting heretics, Jews did not escape its notice.[53] Perhaps because Jews and heretics were so often linked in the early thirteenth century, inquisitors in some communities accused Jews of harboring heretics. The Inquisition also arrested Jews who had been forced to convert to Christianity and charged then with secretly practicing their own faith.[54]

Closely related to the Inquisition, and dating from the same years, was a move more specifically directed against Jews: a concerted attack on the Talmud. In June 1239, Gregory IX ordered the seizure of all books of the Jews, to take place on 3 March 1240; the books would then be turned over to the Dominicans and the Franciscans, and any texts with errors were to be burned.[55] The investigation of the Jewish books took place in Paris in the spring of 1240. Robert Chazan describes this proceeding as "a trial of the Talmud," with testimony by witnesses, judges, and a sentence: burning. As he notes, "the procedure in Paris . . . was essentially an inquisitorial investigation of the Talmud."[56]

Thus the first image of the Trial before the High Priests, which appears in a cross of about 1240–5, coincides with this spate of aggression towards medieval Jews; the year 1240 is, in fact, sometimes seen as a turning point in the history of medieval antisemitism.[57] It is possible that the Inquisition, with its tribunals and hearings, spurred further interest in images of judicial procedures, and in particular in the trial before the Jewish priests. In the dominant Christian view in the 1240s, Jews had brought Christ to trial and plotted his death; thus, according to anti-Jewish polemics, it was only fitting for Christians to bring the Jews to trial in return. For instance, in 1244 Pope Innocent IV wrote to the King of France of "the wicked perfidy of the Jews,

from whose hearts our Redeemer has not removed the veil of blindness because of the enormity of their crime. . . ." Innocent continued: "Because the blasphemous abuse of these Jews has not ceased, . . . we beseech you to strike down with merited severity all the detestable and heinous excesses of this sort which they have committed in insult of the Creator . . ., and which you with laudable piety have begun to prosecute."[58] Attacks like these presumably motivated the response of Rabbi Meir ben Simon of Narbonne, whose *Milhemet Mizvah*, written around mid-century, discussed the trial of Christ by Caiaphas at some length. The text pointedly defended Caiaphas's decision, referring to him as "the greatest of the priests and high priests."[59]

This tide of overtly antisemitic activity is best documented outside Italy. Of the Tuscan communes, evidently only Lucca had a sizable Jewish population in the thirteenth century.[60] The burning of the Talmud and other books, though ordered throughout Europe, seems to have actually taken place in few sites other than France.[61] Nevertheless, Jews in Italy noted these activities with understandable apprehension. Although we have no evidence that the Talmud was confiscated and burned in Rome in the 1240s, the Jewish community's fear of such actions is recorded in a fast day of 1239, and in poems by Jewish writers.[62] Further, the activities of the Inquisition in Florence are well known. The fact that the Trial occurs most often in works by Florentine painters may be significant; the *Tribunale della Fede* was especially visible in Florence in the 1240s.[63] As noted, it was in the 1240s that Innocent IV increased the Franciscan order's responsibility for the Inquisition in central and northeastern Italy; by 1254 authority for all Tuscany was centralized in Florence, at Santa Croce.[64]

Moreover, though most outbreaks of violence against Jews seem to have occurred elsewhere, antisemitic attitudes can be well documented in central Italy during the duecento. At least partial responsibility must be assigned to the Franciscans. The extent to which the Franciscans fomented antisemitism in thirteenth-century Italy is a question that has generated much controversy. Jeremy Cohen has indicted the Order, along with the Dominicans, for their hostility to Jews and participation in the Inquisition. Cohen argues, in fact, that the demonizing of the Jews in the thirteenth century "derived at least in part from a new Christian theological stance toward the Jews first developed and propagated by the Dominicans and the Franciscans."[65] Cohen focuses on a tendency, new in the thirteenth century, to assert that the Jews intentionally killed Christ; earlier, he argues, Jews were perceived as merely ignorant. He notes further that Bonaventure subscribed to this view, citing his commentary on Luke: "they conspired not from ignorance, but from certain malice toward Christ."[66] Simonsohn has generally supported Cohen, ascribing to the friars considerable culpability for the new viciousness of thirteenth-century antisemitism.[67] However, Randolph Daniel, among others, has challenged this

view; Daniel argues that the Franciscans "were less hostile and more receptive to Jews...than was the average Christian of the crusading era."[68]

Still, even Daniel acknowledges that the Order and some of its closest advisers vigorously supported the conversion of the Jews.[69] One of Francis's early concerns was the "infidel," the non-Christian; the Franciscan ideology of mission required all non-believers to embrace Christianity. In fact, the Rule of 1221 includes a relatively long chapter (chapter 16) on the mission to "Saracens and other unbelievers."[70] Though Francis and other early friars directed their efforts especially to Muslims, both in the Levant and in Spain, he was (as chapter 16 of the Rule of 1221 indicates) concerned with all unbelievers, and conspicuous non-Christians were closer at hand.[71] As early as 1231, the influential lector to the Order, Robert Grosseteste, urged the conversion of the Jews, and prepared tracts to help the Franciscans persuade Jews of their "errors."[72] Indeed, the images of the Trial in which Christ gestures in response to Caiaphas (Figs. 44–6) suggest the kind of disputation between Christian and Jew that Grosseteste recommended to the Order. Similar disputations between believer and non-believer took place in the tribunals of Florence, which, by the 1240s, were increasingly in Franciscan hands.[73]

Pseudo-Bonaventure provides an interesting glimpse into Franciscan attitudes toward Jews and strategies used in sermons directed to them. Though he describes Christ's preaching, his remarks seem filtered through the lens of thirteenth-century Franciscan missionizing. Chapter LIX, "How the Lord Said to the Jews That the Church was to Devolve Upon the Gentiles, Under the Likeness of the Vine-Dressers Who Killed the Son of Their Master," opens as follows:

Our Lord and Redeemer, desiring the salvation of the souls for which He had come to give His, tried to draw them to Him in all ways and to extricate them from the prisons of the enemies. Thus He sometimes used persuasive and humble sermons, sometimes reproving and harsh ones, sometimes examples and parables, sometimes signs and virtues, sometimes threats and frights. But in this place He used against the chief priests and Pharisees hard words and a terrible example, so complete and true that they themselves passed sentence upon themselves.[74]

His references to Christ's sermons – at times "persuasive and humble, sometimes reproving and harsh" – probably could equally well describe the proselytizing sermons of the Order. And the mention of Christ's use of "threats and frights" seems intended to legitimize the harsher tactics of the ideology of mission. The phrase "they themselves passed sentence upon themselves" is particularly suggestive in the context of the trial of Christ; in Franciscan discourse, in condemning Christ, the Jews condemned themselves.

Pseudo-Bonaventure concludes the same chapter by referring to the "malice" of the Jews, which kept them from accepting Christ:

...He also related...that He was to destroy and crush the Jews. At that they understood that these words referred to them. They were not chastised but more angered, for their malice had blinded them.[75]

Franciscan writers' descriptions of the Passion also offer instructive parallels to the duecento images of the Trial of Christ. The authors of devotional texts accord the trial before the priests far more prominence than the trial before Pilate, just as duecento painters substituted the Trial before the Priests for the Trial before Pilate. As one example, Pseudo-Bede, probably writing in the mid-duecento, discusses the Jewish trial at great length, devoting both the meditations for Matins and for Prime to events associated with it; he describes the actual appearance before Pilate relatively briefly, in the meditation for Terce.[76] Similarly, Bonaventure details the "affronts" borne by Christ: "O Lord Jesus, they bind You in the garden, they strike Your face in the house of Annas, they spit upon You in the courtyard of Caiaphas, they mock You in the palace of Herod, they make You carry the cross along the road, and crucify You on Golgotha."[77] Noticeably absent in this capsule description of the Passion – which records Christ's sufferings in the tribunals of both Annas and Caiaphas – is any mention of the Roman procurator.

More overt antisemitism marks Bonaventure's *Vitis mystica*: "See, a wild beast, a rabid dog – the Judean mob – devours Him; a wild beast condemns your Son, your Brother, your Spouse!"[78] Pseudo-Bonaventure, in his usually exhaustive *Meditationes*, becomes uncharacteristically taciturn in discussing Christ's appearance before Pilate; his curiously prosaic account omits even such well-known aspects of that trial as the episode of Barabbas and the washing of the hands.[79] His description of the trial before the priests, by contrast, is vivid, enlivened by pointed depictions of their glee at Christ's capture ("they rejoice like lions who have taken their prey") and a recitation of the physical abuse heaped on Christ by the crowd.[80]

Thus the duecento preference for the Jewish trial, and the anti-Jewish sentiment implicit in that choice, again seems consistent with Franciscan accounts. The very inclusion of the theme in Passion cycles beginning around 1240–5 accords with the Franciscan preoccupation with converting all non-Christian "others" – and anxiety about Jews in particular was especially acute in these years. It coincides as well with the Inquisition in Florence, where the Franciscan role expanded in the 1240s. The prominent position of the Trial in a Florentine cross of about 1240–5 (Fig. 44) is striking; it here occupies the upper left panel of the apron, displacing the Betrayal, which usually opens the Passion cycle (see Figs. 6–8).[81] Antisemitic sentiment is not unique to this Passion theme; we will see antisemitic insertions in the Mocking of Christ and the Way to Calvary as well, again beginning in the 1240s.[82]

By the last quarter of the duecento (as in the Oxford tabernacle, Figs.

47–8), the representation of the image changes: Christ no longer gestures, but is shown with his hands conspicuously tied. As noted, this version of the scene is ultimately Byzantine; it is odd that it was not accepted in Tuscany until this relatively late date. Again, Franciscan ideology may have prompted the change: The new image of the bound Christ coincides with an emphasis in Franciscan circles on the ropes with which Christ was tied during the Passion, especially at the trials. Bonaventure in particular wrote at length about the binding of Christ. He devoted chapter 4 of the *Vitis mystica*, "On the Tying of the Vine," to this subject, and described Christ bound before the high priest and Pilate:

O God of gods, what an offense against Your freedom and Your power! You to be bound with so many ropes who alone are free! You to be bound who alone have the power to bind and to release! But it was because of Your mercy that You submitted; it was in order that we might be freed from our miseries. Oh, the cruelty of the ropes with which those most cruel men tied the Lamb most mild! O Lord Jesus, I see You with the eyes of my mind – the only way now possible to me – tied with the rough rope, dragged like a bandit to the high priest's tribunal and then to Pilate.. . .O sweet Jesus, praised by Your bonds which so powerfully break our own.[83]

Bonaventure's stress on "rough rope" was probably intended to evoke the prominence of rope for the Order; Francis, rejecting even a belt, substituted a rope or cord around his waist, and the cord – specified in the Rules of 1221 and 1223 – remains an integral part of the Franciscan habit today.[84] In his *Expositio in Regulam Fratrum Minorum*, Bonaventure explicitly associates the cord with the ropes that tied Christ during the Passion:

And the belt [is] assuredly a rope, because it is said in Isaiah [3, 24]: 'And instead of a girdle, [there shall be] a cord.' This belt is a rope because haircloths [sacci] are used with rope as belts. However, I believe that St. Francis chose that belt, because it is said in Matthew: 'They brought him bound, and delivered him to Pontius Pilate.'[85]

Thus the new emphasis on the rope tying Christ from the later duecento and trecento parallels Bonaventure's stress on it in devotional guides, and his association of the same rope with the distinctive cord of the Franciscan order. We have no firm information about the provenance of the Oxford panel, though Garrison has noted several iconographic features that find parallels in Franciscan works.[86] However, Christ's bound hands appear prominently in works that were unquestionably commissioned by the Order, such as the *Officium Passionis* manuscript in Boston.[87] Christ also appears conspicuously tied in other Passion scenes – the Mocking of Christ, the Way to Calvary, the Ascent of the Cross – produced for the Order in the second half

of the century. As we will see in subsequent chapters, all of these images are profoundly informed by Franciscan thought.

Despite the close correlation between the image of the Trial and writings by Bonaventure and other Franciscans, however, this theme was not unique to Franciscan monuments. It does appear early in works produced for the Order; Coppo's San Gimignano cross was a Franciscan commission, and as I will argue in the Conclusion, the Uffizi cross probably was as well. The Oxford tabernacle may have Franciscan affiliations, though the patronage remains uncertain. The cross by Coppo and Salerno, however, was commissioned for the cathedral of Pistoia, and the Santa Marta cross may have been Dominican. On the other hand, hostility to the Jews was hardly a uniquely Franciscan phenomenon. If the inclusion of the Trial before the Priests in a Passion cycle does suggest antisemitism, then its occurrence in non-Franciscan sites is to be expected.

In any case, the painters who produced the new image must have viewed Byzantine images of the theme with keen interest. Both the Byzantine versions of Christ's trial and the Italian images which emulated them constructed Christ's death as a Jewish crime, and thus justified the anti-Jewish polemic that was widespread in duecento Italy. Byzantine images also provided the expressive details – Annas's servant striking Christ, Caiaphas rending his cloak, Christ's bound hands – that conveyed Christ's physical and emotional suffering at the hands of his captors. These details further fed, and rationalized, the antisemitic discourse of the day. Thus in this case, as in the Betrayal, Tuscan painters and patrons saw in Byzantine images a potent visualization of local concerns. In formulating other Passion scenes, however, they found less of value in Byzantine types. The next scene, the Mocking of Christ, demonstrates that the Tuscan reception of Byzantium was a complex phenomenon: The new image of the Mocking that appeared in Tuscany around 1240 is only peripherally Byzantine.

THE MOCKING OF CHRIST

✠

THE MOCKING IN ITALIAN PAINTING

As we have seen, by 1240 or so strikingly new images of the Betrayal and the Trial of Christ appeared in central Italy. We have seen, too, that those who constructed both of these new images relied very heavily on Byzantine versions of the theme. A new version of the Mocking of Christ, which also broke sharply with the past, also appeared around 1240, in exactly the same circles, and even on some of the same panels, that we have been considering. But in this case, those responsible for the new image clearly found little of interest in Byzantine works. Images of the Mocking produced in northern Europe suited them far more.

Though the Mocking was not as common in duecento Passion cycles as the Betrayal of Christ, a number of examples survive. It was fairly frequently included on painted crosses, especially in Pisa and Florence. An early example is found on the San Sepolcro cross in Pisa, and it recurs on two later Pisan works, the San Martino and the Santa Marta crosses. The scene occurs as well on the early Sienese cross from Santa Chiara. Most surviving examples, however, are Florentine: Two mid-century crosses, that in the Uffizi and Coppo's San Gimignano cross, depict it, and it is also found in four Florentine altarpieces from the end of the century.[1] The theme appears as well in manuscripts, such as the *Supplicationes Variae* manuscript in Florence, and in frescoes, as in those from Santa Maria degli Angeli, Spoleto, and Sant'Antonio in Polesine, Ferrara, both from the end of the duecento.[2]

Most of these images fuse elements from two distinct events described in the Bible. The first, which is sometimes called the Buffeting of Christ, occurred

just after the high priest pronounced Christ guilty of blasphemy. According to biblical accounts, the crowd reacted by mocking his admission that he was the son of God. They spat at him, then blindfolded him, struck him in the face, and challenged him to identify his assailant: "Prophesy!" (Matthew 26:67–8; Mark 14:65; Luke 22:63–4).[3] This episode was followed by a closely related incident after Christ appeared before Pilate, when the procurator's soldiers similarly taunted him. The evangelists thus describe a Jewish trial and mocking, followed by a Roman trial and mocking, and the reason for the derision differed in the two cases. The Jews, the religious authorities, mocked Christ's claim of divinity; the Romans, the secular authorities, mocked his claim of kingship. Thus the Romans bedecked him with trappings of royalty – a purple robe, a crown of thorns, a reed as scepter – and bowed before him, crying, "Hail, King of the Jews!" (Matthew 27:27–31; Mark 15:17–19; John 19:2–3).[4] In this second mocking – also known as the Crowning with Thorns – as in the first, Christ's tormentors spat at him and struck him, but now with reeds rather than their bare hands. Such common details, as well as the general similarities between the two episodes, gradually led to a blurring of the distinctions between the two in images of the Mocking.[5]

Because of the frequent shifting of motifs from one episode to another, the two can be most conveniently treated as a single theme. However, the moment represented by duecento painters changes subtly during the course of the century: Earlier versions of the Mocking tend to include details properly belonging to the Crowning with Thorns, while later versions drop some of these details and introduce elements associated with the Buffeting. This shift in focus, from the Roman to the Jewish Mocking, is significant; as we will discuss below, it further reinforces the visual antisemitism seen in images of the Trial of Christ from the same time and place.

The first examples of the scene – as in the Pisan San Sepolcro cross (Fig. 9, p. 10) and the Sienese Santa Chiara cross[6] – are fairly consistent. They primarily reflect the second episode, in which Pilate's soldiers paid pseudo-homage to Christ's kingship. In the Pisan cross, for instance, the crowd surrounding Christ includes several helmeted figures, one of whom is about to crown him with a curiously textured, cone-shaped version of the crown of thorns. A second hands Christ the reed which serves as his scepter and genuflects before him. Others brandish spears or staves – the reeds with which they assaulted Christ. Yet none of the mob actually strikes the prisoner. Despite the taunts and jeers, Christ retains his dignity: He stands erect and raises his left hand in quiet affirmation of his true kingship. The essentials of the scene are similar in the Sienese cross, in which a central, standing Christ seems equally serene in the face of the crowd's antics.

By the mid-duecento in Florence, a considerably different image emerged. The example on the Uffizi cross (Fig. 10, p. 11) – which appears just below

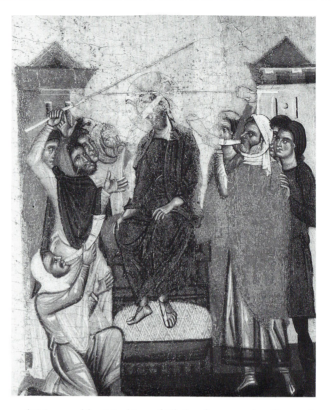

Figure 56 Coppo di Marcovaldo. Mocking of Christ, from a painted cross from Sta. Chiara, San Gimignano, c. 1261. San Gimignano, Museo Civico. Photo: Renate J. Deckers-Matzko/Valentino Pace.

the Trial before the Priests (see Fig. 7) – shifts the moment depicted from the second episode of mocking to the first: Christ is now blindfolded, as in the Jewish mocking, and he lacks both the crown of thorns and the reed-scepter added by Pilate's soldiers. However, one man kneels before Christ in a parody of worship, and a second strikes him on the head with a reed; both of these details properly belong to the second episode, the Crowning with Thorns. Further, two aspects of the new image cannot be explained by the evangelists' accounts of either episode. First, Christ is now seated; he stood in earlier versions of the scene. Second, to the cacophony of the crowd's taunts has been added the blare of a ram's horn or shofar sounded by the standing man on the far left. But the two images differ most forcibly in tenor. Here, Christ no longer seems impervious to the barrage of verbal and physical abuse: His hands rest limply on his knees instead of gesturing in calm self-assertion, and his head, once held erect, now droops.

This new image soon becomes fairly common in central Italy.[7] For instance, Coppo, in his San Gimignano cross (Fig. 56), followed it closely. Christ's central, enthroned placement, his blindfolded eyes, bowed head, and

limply resting arms all directly echo the earlier Florentine work (Fig. 10). The man who strikes Christ's head with the reed recurs, as does the one who kneels to the left. However, Coppo subtly modified the image, both intensifying the assaults Christ endures and more explicitly identifying the crowd as Jewish. For instance, two men now raise threatening hands, as if to strike the prisoner; such figures belong properly to the first episode of the Mocking, the buffeting of Christ. Further, a second man now assaults Christ with a reed and a second one blasts away on a ram's horn, which he holds perilously close to Christ's ear; all of these men wear Jewish prayer shawls.

Most later Tuscan versions of the Mocking do not differ significantly from these two Florentine examples: Christ is typically shown seated, blindfolded, and suffering visibly under a barrage of abuse.[8] The new image, an unsparing depiction of a visibly suffering Christ, departs radically from the earlier type, just as the new versions of the Betrayal and the Trial broke sharply with local tradition. Now, however, the new formulation cannot be ascribed to Byzantine "influence." On the contrary, it is the earlier scheme that is closer to Byzantine examples, though the type had been introduced to Italy much earlier. The new image is only peripherally Byzantine.

THE EARLY IMAGE: BYZANTIUM AND WESTERN EUROPE

The Byzantine roots of the early version of the Mocking (as seen in the San Sepolcro cross, Fig. 9) can be easily shown. Byzantine images of this Passion scene are strikingly consistent. By the mid-eleventh century a standard composition had emerged that persisted, with only minor changes, into the Paleologan era. For instance, in the Gospel book in Paris, gr. 74 (fol. 55v.; Fig. 57), the composition has a static, hieratic appearance. Christ stands, in a frontal pose, in the center of the composition, flanked by symmetrically placed tormentors; the scene has the timeless, formal character of a ritual, or an icon.[9] This composition was introduced almost immediately into Italy, as the fresco in Sant'Angelo in Formis (Fig. 58) demonstrates: The standing, frontal, impassive figure of Christ, the symmetrical placement of the men, and the "worshipers" kneeling before him are much the same, and continue in the early Tuscan examples. Even in its present condition, the Sienese example can be seen to resemble these works especially closely.[10]

But the Pisan version (Fig. 9), while generically related, differs from these examples in a number of features. Most interesting is the transient nature of the proceedings: Phases of the Mocking are represented in progress rather than completed. Thus the soldiers are here depicted in the act of crowning Christ, and a man is depicted in the act of handing him the reed that serves as his scepter. Both details, unparalleled in earlier extant Italian depictions of the Mocking, occur with some frequency in transalpine, and specifically Ger-

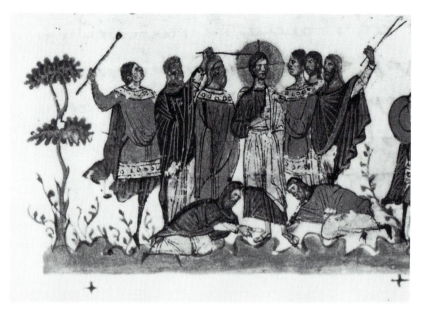

Figure 57 Mocking of Christ, from a Gospel book, late eleventh century. Paris, Biblio-thèque Nationale, ms. gr. 74, fol. 55v. Photo: museum.

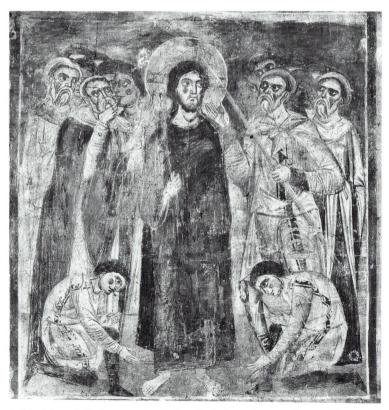

Figure 58 Mocking of Christ, c. 1085. S. Angelo in Formis, near Capua. Photo: Alinari/Art Resource.

man, works of the eleventh and twelfth centuries. For instance, in the ceiling panel of St. Martin in Zillis,[11] two soldiers are similarly seen crowning Christ, and Christ raises his left hand in an identical gesture. The man handing Christ his "scepter" can likewise be traced to Ottonian art; it occurs, for example, in the gold antependium of Aachen Cathedral,[12] of about 1000 (Fig. 59), and there, too, is a single kneeling man, similarly pointing at Christ. Any number of other details – the staffs held by the crowd, their oddly shaped caps, and even the curiously woven texture of the crown of thorns – also find their closest parallels in German monuments.[13] Thus the Pisan painter, though he did not deviate in iconographic essentials from a type pervasive in Italy, had probably come into contact with German images. A number of Germans had settled in Pisa by the late twelfth century, as Herlihy has observed; this cross seems further documentation of their presence.[14]

THE MID-DUECENTO IMAGE AND NORTHERN EUROPE

The new formulation that had appeared in Florence by mid-century (Fig. 10) would have a long history in later Italian painting. Soon adopted by Coppo, this new image continued into the trecento and the quattrocento.[15] In fashioning the new type, however, Tuscan painters and their advisers largely disregarded eastern versions of the theme. As noted above, Byzantine images of the Mocking varied relatively little from the mid-eleventh century on. The type seen in Paris 74 (Fig. 57) continued into the twelfth century (as in the Gelat Gospel book, Fig. 60) and the thirteenth; it recurs in late thirteenth- and early fourteenth-century Macedonian and Serbian frescoes (Prilep, St. Nicolas, Fig. 61; Staro Nagoričino, St. George, Fig. 62).[16] In each surviving example Christ stands, with head held erect, and directs his unflinching gaze at, or beyond, the viewer. In no case that I know is he shown seated, as in the Uffizi cross; in no case is he blindfolded, and in no case is his head bowed.[17]

All of these elements do, however, occur in northern European versions of the Mocking. Though the standing Christ occasionally appears in Gothic art into the late thirteenth century, a seated type had been introduced almost three hundred years earlier; one of the first surviving examples is found on the Aachen antependium of about 1000 (Fig. 59). The reasons for the change in the iconographic type have not been established.[18] One explanation is suggested by the fact that the Aachen Christ is seated not on a throne but, incongruously, on what appears to be a mound of rubble. This unexpected detail leads one to consider possible connections between the new image and the image of Job, mocked by his friends or his wife and seated on a dunghill; in medieval manuscripts Job at times appears seated frontally, on a loosely packed mass of dung, confronted by figures who gesture in much the same

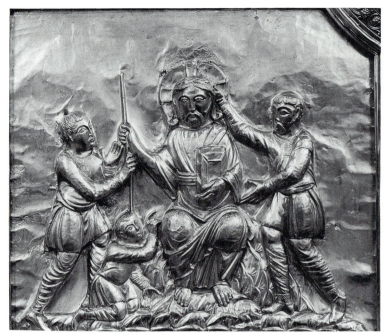

Figure 59 Mocking of Christ. Detail of antependium of high altar, c. 1000. Aachen, Cathedral Treasury. Photo: Foto Marburg/Art Resource.

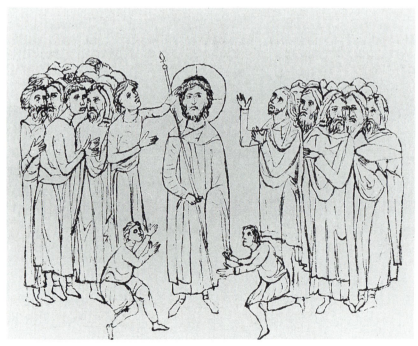

Figure 60 Mocking of Christ, from the Gelat Gospels, late twelfth century. Tbilisi, Institute of Manuscripts, fol. 163 v. Photo: after Pokrovskii, 1887.

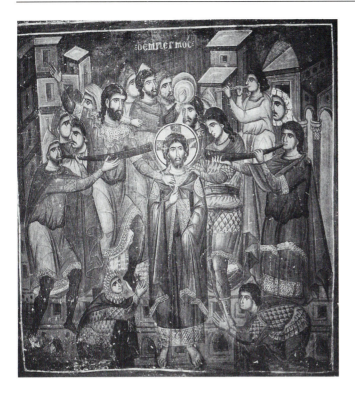

Figure 61 Mocking of Christ, 1299. Prilep, St. Nicolas. Photo: Skopje, Institute for the Protection of Monuments

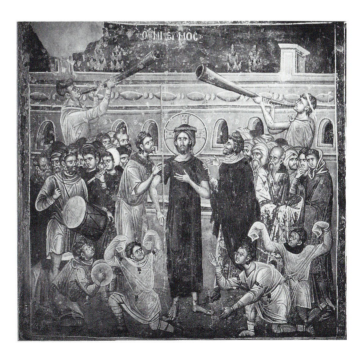

Figure 62 Mocking of Christ, c. 1316–18. Staro Nagoričino, St. George. Photo: Skopje, Institute for the Protection of Monuments

Figure 64 Mocking of Job, from a *Moralia in Job*, c. 1090–1100. Bamberg, Staatsbibliothek, Ms. bibl. 41, fol. 29r. Photo: museum.

Figure 63 Mocking of Job, from a *Catena in Job*, ninth century, Rome, Biblioteca Apostolica Vaticana, gr. 749, fol. 179v. Photo: museum.

way as the soldiers in the Aachen antependium (Figs. 63–4).[19] The torments of Job, who like Christ was mocked and spat upon (Job 30:1–10), had been interpreted as a prefiguration of the Passion of Christ since the early days of the Church; the typological parallel was specifically discussed in Gregory the Great's widely circulated *Moralia in Job*.[20] Whatever the reasons for the change, the image of the seated Christ spread from Germany to England and France; it occurs with particular frequency in moralized bibles.[21] By the second half of the thirteenth century, it had almost supplanted the older version.

The blindfold, too, can be traced to northern Europe; in this case the motif seems to have originated in England. The blindfold makes an early appearance in the St. Albans Psalter of about 1120, and for the next hundred years, most instances of this detail occur in English works.[22] By the middle of the thirteenth century, however, the blindfold had been adapted elsewhere, as in, for instance, a miniature from Beauvais (Fig. 65).[23]

Similarly, the bowed head of Christ appears in French Gothic art by the mid-thirteenth century, as in the Beauvais psalter, or a stained glass window in the Sainte-Chapelle, Paris, from the 1240s (Fig. 66).[24] English and German painters of the Mocking avoid this detail; throughout the thirteenth century both continue to represent Christ with head erect, stoically enduring the assaults of his antagonists.[25] Duecento painters, however, showed no such reluctance to convey the physical reality of Christ's sufferings. In the hands of mid-century Florentines (Figs. 10, 56), Christ's enfeebled state frequently comes through even more vividly than in the French examples.[26]

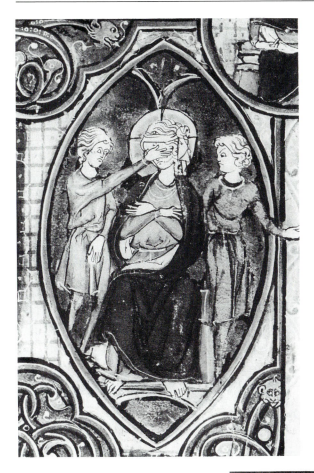

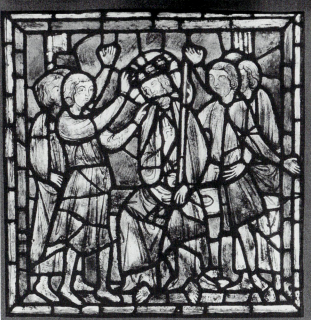

Figure 65 Mocking of Christ, from a psalter, c. 1255–60. New York, The Pierpont Morgan Library, ms. 101, fol. 20 v. (detail). Photo: museum.

Figure 66 Mocking of Christ, 1240s. Paris, Ste. Chapelle. Photo: from Aubert et al., 1959.

Thus the new image of the Mocking that appeared in mid-duecento Tuscany finds its closest antecedents in northern Europe. Though each of the three features just discussed probably originated in a different region, both Christ's seated posture and his blindfold were known in France by mid-century, as the Beauvais miniature (Fig. 65) indicates. It thus seems that an image of the Mocking similar to this one, probably also French, was available in Florence by about 1240–5.

The extensive commercial contacts between Tuscany and France at this time might explain the presence of these works.[27] Another likely conduit was the Franciscan order. As I will argue shortly, the new image closely conforms to Franciscan interpretations of the Mocking and promotes tenets essential to the Order, and the Franciscans had numerous ties to France. First, as early as the 1230s, the Order had established foundations throughout France. The Franciscan school at Paris, founded during Francis's lifetime, drew a great many promising Italians; among them was Bonaventure, who entered as a student in 1235 and eventually rose to the position of master of theology (1254).[28] Further, the French king Louis IX, a generous benefactor of the Order, presented the mother house with numerous gifts, including a lavish missal. The missal, perhaps the work of the atelier that produced the Beauvais psalter (Fig. 65), is still preserved in Assisi. [29]

Any of these routes – the considerable Franciscan presence in Paris, travels of friars between Italy and France, the gifts of Louis and others – could explain how the Gothic version of the theme became known to Italian members of the Order. Interestingly, the two Gothic examples that especially resemble the Tuscan versions can be linked, either tangentially or directly, with Louis IX. The Beauvais psalter (Fig. 65) is very close to the missal that the king presented to Assisi, and the Sainte-Chapelle window (Fig. 66) is a direct product of the king's patronage.

In any case, those responsible for reshaping the Mocking at mid-century clearly took inspiration from northern European, not Byzantine, models. Thus Stubblebine's theory of the "exclusive domination of Constantinople" in duecento painting[30] – a commonly held assumption – is not entirely accurate. Even in mid-duecento Tuscany, when painters were avidly studying Byzantine Passion images, at least at times the same painters and their patrons rejected eastern compositions in preference for a distinctly non-Byzantine type.

THE MID-DUECENTO IMAGE AND BYZANTIUM

Yet the situation is still more complicated: The new image that appears in mid-century Tuscany (Figs. 10, 56) cannot be fully explained by assuming that Tuscan painters knew only Gothic works like the Beauvais psalter (Fig. 65). The Italian painter included a number of details absent in the French

work: The sizeable crowd that surrounds Christ, the kneeling "worshiper," the figure assaulting Christ with the reed, and the shofar-blower. It is unlikely that these features stem from a French version of the theme; most French examples resemble the Beauvais miniature in paring the crowd down to a few figures. Thus, in spite of the resemblance between the figures of Christ in the Italian and French Mockings, the Italian painter probably relied on another source for the secondary features of his composition.

This source is most likely to have been Byzantine: All of the figures that appear here were well established in Byzantine iconography. The man striking Christ with the reed, for instance, had appeared in Byzantine art by the eleventh century (Paris 74, Fig. 57) and thereafter, though it remained relatively uncommon, it occurred in twelfth-, thirteenth-, and fourteenth-century representations.[31] The considerable size of the mob points more specifically to a date in the late twelfth or thirteenth century. Earlier versions generally restrict the crowd to only a few figures, but one late twelfth-century example, the Gelat Gospel book (Fig. 60), depicts Christ flanked by an enormous throng, and in the late thirteenth and early fourteenth centuries, versions of the Mocking similarly represent a swarming mob. Particularly close to the treatment of the mob in the Uffizi cross (Fig. 10) is that in the Staro Nagoričino Mocking (Fig. 62): In both works the crowd stands back slightly from Christ, then forms a compact mass of which the top descends in a gently sloping diagonal.

The most interesting detail, however, is the figure blowing the shofar. As noted above, this curious feature was apparently unknown in the West before it appeared in mid-duecento Tuscany.[32] To my knowledge, no early or mid-thirteenth-century Byzantine version of the Mocking has survived, but at the end of the century, at Prilep (Fig. 61), one encounters not merely one horn-blower but a pair, accompanied by a flutist and a cymbalist. Nor is Prilep an isolated example: The ensemble at Curtea de Arges consists of two horn-blowers, at Čučer there are two horn-blowers and a drummer, and at Staro Nagoričino (Fig. 62) two horn-blowers, a flutist, a cymbalist and a drummer perform.[33]

We can only speculate about the reasons for this musical intrusion. Music was, however, very commonly associated with the worship of the Lord in the Old Testament, and the specific instruments seen here – the horn, flute, cymbals, and timbrel or drum – are frequently mentioned in this context.[34] The musical instruments may simply represent another expression of mock reverence; the use of a traditionally Jewish means of paying tribute to God may be another example of medieval antisemitism, intended to signal Jewish culpability in Christ's death.

But music and song have other connotations in the Old Testament: They are sometimes associated with mocking and derision. Lamentations 3:14, for instance, states: "I am made a derision to all my people, their song all

the day long." Similar imagery appears in Job 30:1–9: "But now the younger in time scorn me. . . . Now I am turned into their song, and am become their byword." In fact, two specific details seen at Čučer and Staro Nagoričino (Fig. 62) may be directly derived from the Book of Job: In both, the musicians are joined by dancers who cavort about at Christ's feet, and in both, the dancers are depicted as children.[35] Responding to the cries and taunts of his friends, Job curses the wicked and laments: "Their little ones go out like a flock, and their children dance and play. They take the timbrel, and the harp, and rejoice at the sound of the organ" (Job 21:11–12). The combination of musical instruments and dancing children seen in these Byzantine works may thus allude to the torments of Job, who in the East as well as the West was viewed as a prefiguration of Christ.[36]

Whatever the explanation for the musicians, it seems reasonable to assume that some connection exists between them and the horn-player in the Uffizi cross. A single horn-player had probably appeared in Byzantine Mockings earlier in the thirteenth century; such an image would explain the presence of the figure in mid-duecento Tuscan painting.[37] The exact placement of the trumpeter in the Uffizi cross (Fig. 10), who holds his instrument high, most closely resembles the corresponding figure at Staro Nagoričino (Fig. 62). It appears most likely, then, that the painter of the Uffizi cross derived certain details of his Mocking from near-contemporary Byzantine works, probably something resembling the fresco at Staro Nagoričino (Fig. 62).

Coppo's composition (Fig. 56), by contrast, in certain details especially resembles the Prilep fresco (Fig. 61). Thus both include towers to indicate the palace where the Mocking occurred; in both the trumpeter standing to the right of Christ blows his horn directly into Christ's ear; in both a man on the left raises his hand to strike Christ.[38] Facial types are similar too; compare the beardless man on the far right in Coppo's panel with the horn-blower again to the far right, at Prilep. Again, then, duecento painters seem to have had access to a range of Byzantine images, probably only recently imported into Tuscany.

The Mocking of Christ, like the Betrayal and the Trial, thus confirms the bent for experimentation that characterizes mid-duecento Passion images: Again an inherited image has been discarded and replaced with a substantially different new version. As with the Betrayal and the Trial, the mid-century Florentine version of the Mocking reflects an awareness of nearly contemporaneous Byzantine sources; again it is probable that not a single eastern model but several were circulating during the second half of the century.

But in the case of the Mocking, the new image that had emerged by the middle of the century was appropriated largely from northern Europe, probably from France. Byzantine sources, though used, played a relatively minor role, providing Tuscan painters only with certain details. Perhaps most inter-

esting is the process by which central Italians evidently crafted the new image. The fact that this new image stems not from a single model but from at least two distinct sources shows that Tuscan painters were more than passive receivers of outside influence who mechanically transcribed the productions of another culture. Rather, they and their employers seem to have consciously selected new motifs and manipulated them to construct a compelling new image – original not in its individual components, but in the union of these components. The careful crafting of the new image reveals an inventiveness and ingenuity rarely ascribed to the duecento. Further, the strategic assembling of diverse sources that characterizes the Mocking is not an aberration; much the same process shaped the iconography of the Way to Cavalry, as I will show in the following chapter.[39]

THE MOCKING OF CHRIST: JOB, FRANCIS, AND THE *IMITATIO CHRISTI*

But if the complex construction of the new image comes as a surprise, the end result does not: Again mid-century Italians rejected an image that minimized Christ's human sufferings during the Passion and replaced it with one that accentuated his plight. This phenomenon clearly occurred in the image of the Betrayal, where the divine miracle-worker of pre-duecento crosses gave way to the passive, overpowered figure seen later, and to an extent in the Trial, where the ambivalence of Pilate was replaced by the overt hostility of Annas and Caiaphas. In the Mocking, the difference is still more sharply drawn: The unflinching stoic of the San Sepolcro cross (Fig. 9) seems only distantly related to the battered, blindfolded, physically exhausted victim of the Florentine crosses (Figs. 10, 56).

As in the first two Passion scenes, this dramatic change aptly expresses the christocentric piety popularized by St. Francis and his followers. In fact the extreme pathos of the new type specifically recalls St. Francis's interpretation of Christ's Mocking. For instance, the readings for Terce in his Office of the Passion state:

> All who see me scoff at me; they mock me with parted
> lips, they wag their heads (21:8).
> But I am a worm, not a man; the scorn of men, despised by
> the people (21:7).
> For all my foes I am the object of reproach, a laughingstock
> to my neighbors, and a dread to my friends (30:12).[40]

And the meditation for Sext continues:

> For your sake I bear insult, and shame covers my face . . .
> (68:8–10).[41]

In the context of these passages, the discarding of the earlier image and its replacement by the later type seems understandable. Francis's conception of Christ as "the scorn of men," bearing "insult, and shame," is far better expressed by the visibly suffering figure in the Uffizi cross (Fig. 10) or the San Gimignano cross (Fig. 56) than by the imperturbable Savior of the San Sepolcro cross (Fig. 9). In fact, Francis's language, though taken from the Psalms, also recalls the plight of Job, mocked by neighbors and friends, just as the image of the seated Christ recalls that of the seated Job. Later Franciscan writers develop the theme of Christ's abasement during the Mocking still further. Pseudo-Bede's account of the event especially suggests the new iconography, for he tells us specifically that Christ was seated just before the ordeal: "Then you will meditate, and see, in spirit, how your Lord sat among His enemies, abandoned by His disciples and friends. Thus I think that you will say, 'O Lord Jesus, how do you sit thus, so greatly despised and so greatly dishonored?'"[42] One need not claim this tract as the literary source of the new image; it is at least as likely that Pseudo-Bede's meditation was, in part, shaped by mid-duecento images that he had seen. But the correspondences between the written account and the duecento images suggest a new discourse on the Passion and on the Mocking of Christ, in which both text and image participated.

Other Franciscan descriptions of the Passion, though they do not record Christ's pose during the episode, similarly stress the theme and leave no doubt as to his abject state. Bonaventure dwells on the Mocking. In the *Vitis mystica* he devotes two chapters to the two episodes of the Mocking – one to the buffeting of Christ, the other to the crowning with thorns – in his text the Third and Fourth Shedding of Christ's blood; he also refers to both episodes repeatedly elsewhere in the text.[43] In the *Lignum vitae* and *De perfectione vitae ad sorores*, Bonaventure also alludes to both episodes on several occasions.[44] He follows exegetical tradition in evoking Job as a figure of Christ: Twice in his commentary on the gospel of Luke, he compares the Mocking of Christ to the Mocking of Job.[45] As for Pseudo-Bonaventure, his *Meditationes* records no fewer than six separate episodes in which Christ's captors derided him.[46]

This keen interest in the humiliations borne by Christ probably characterizes Franciscan authors not only because of their devotion to the suffering Christ, but for a second reason as well. St. Francis repeatedly emphasized the virtue of humility, and he, like Christ, was mocked on a number of occasions: by the townspeople of Assisi, by his father, by the soldiers of the sultan, and even, at his request, by the friars, to counter the praise of his admirers.[47] For Franciscan theologians, the mocking of Francis offered another opportunity to evoke biblical precedents. Elisha (disciple of the prophet Elijiah), who was derided by children, was one prototype of Francis,

as Amy Neff has demonstrated.[48] On several occasions, Bonaventure compared Job and Francis: In a sermon of 1267, he developed the parallel at some length, and elsewhere he referred to Francis as "a second Job" and to Job as "a figure of St. Francis."[49]

But the most important exemplar for the Franciscans was Christ, and Franciscan theologians did not hesitate to cite Francis's humility as another form of their founder's *imitatio Christi*. For instance, Odo of Chateauroux, in a sermon of 1262, told his audience that "Francis was made in the likeness of Christ's humanity in three ways: his form of life, his Passion and his resurrection.... The Lord Jesus lived in poverty and humility. ... St. Francis also lived in poverty and humility."[50] Bonaventure, for whom humility represented "the greatest virtue" and the "summit" of the ideal Franciscan life, also explicitly linked the humility of Christ with that of the Order's founder.[51] In a sermon of 1267, he noted the self-abasement of both men and cited the mocking of Francis by the people of Assisi: "Desiring to show us his wisdom, [Christ] humbled himself. Anyone who desires to possess the wisdom of Christ must begin at the root of holiness, just as St. Francis did. When he first changed his way of life the townsfolk pelted him with mud from the streets and threw stones at him; he went naked in front of the bishop and all the people...."[52] These are hardly the only occasions on which the Minister General discussed the centrality of humility; he stressed the theme repeatedly in other sermons of the 1260s.[53] Though these sermons postdate the first appearance of the new Mocking, they provide a context for its reception by a Franciscan audience.

An unusual image of the public penance of Francis (Fig. 67) – to which we will return in the next chapter – also seems relevant here. The image, from a dossal of the 1240s in the Bardi Chapel, Santa Croce, Florence, is particularly interesting because of the dossal's close associations with the Uffizi cross, where the first extant example of the new Mocking of Christ appears.[54] The source of the scene is usually taken to be Thomas of Celano's *Vita prima* of 1228–9; Bonaventure (who wrote after the dossal was painted) describes the occasion as well. According to both, Francis repented after eating meat and bade a friar to lead him, with a rope around his neck, through Assisi.[55] In the dossal, the saint appears seated in the center of the composition and flanked by a gesturing crowd. The resemblance to the image of the Mocking of Christ that appears in Florence at just the same time is probably more than fortuitous, as is its resemblance to Florentine images of the Mocking of Job (Fig. 68); Job, like Francis, is shown nearly nude and in three-quarter view, facing left.[56] In fact, Francis's seated stance here contradicts Celano's account, and the later description of Bonaventure as well. Celano tells us only that he was dragged through the city, and Bonaventure adds that he went to "the stone where criminals were punished...[and] mounted

Figure 67 Penance of St. Francis. Detail of Bardi dossal, 1240s. Florence, Sta. Croce. Photo: Alinari/Art Resource.

Figure 68 Mocking of Job, from Book of Job, second half of the twelfth century. Florence, Biblioteca Medicea Laurenziana, Plut. VII, dext. 11, fol. 8v. Photo: museum.

the stone and preached vigorously." Neither mentions that Francis ever sat during his penance.[57] His seated position here thus appears to be a deliberate invention, probably designed to evoke both Job and Christ. Francis's partial nudity may also be an attempt to associate him with Job, who is similarly shown stripped; again, this detail appears nowhere in Celano (though Bonaventure's later account does mention it). The painter of the Bardi dossal has carefully indicated Francis's profound abasement. In contrast both to the crowd around Job and even more to the crowd around Christ, here the onlookers tower over the lowly Francis. Nonetheless, the similarities among the images seem intended to assert Francis's status as a second Job and, especially, a second Christ. Indeed, the image of Francis's penance may proclaim his *imitatio Christi* in other ways, as we will discuss in the next chapter.

Thus the new image of the Mocking of Christ, the work of the same artistic ambient that produced the Bardi dossal, succinctly captures the Job/Christ/Francis typology that Bonaventure would develop further in the 1250s and '60s. In graphically conveying the abasement of Christ during the Passion, it also would have reminded its audience of Francis's similar abasement and thus reasserted his identity as *Alter Christus*. Further, it underscored the primacy of humility – "the summit of evangelical perfection" to Bonaventure – for all Franciscans. Predictably, the theme occurs in a number of works commissioned by the Order. The crosses in Siena, San Martino,

and San Gimignano were all apparently done for the Clares; the *Supplicationes Variae* manuscript has strong Franciscan connections; Santa Maria degli Angeli in Spoleto housed a community of Clarisses, and Sant'Antonio in Polesine, Ferrara, was home to a group of women whose spiritual advisers and protectors were Franciscan friars. The Mocking also appears in works for the Order in the trecento, among them the *Officium Passionis* manuscript and an altarpiece in Bologna that also includes the Stigmatization of Francis.[58]

Finally, as noted earlier, the new image may also be read as further evidence of mid-duecento antisemitism – which was clearly fomented by the Order, among others. In deemphasizing the crown of thorns (prominently featured earlier – see Fig. 9), and in introducing the blindfold, these images shift the focus from the actions of Pilate's soldiers, who crowned Christ, to those of the Jewish mob, who blindfolded him. Bonaventure's *Lignum vitae* explicitly identifies the mob who blindfolded and mocked Christ as Jewish; just after his description of this episode comes the following inflammatory passage: "Oh, horrible impiety of the Jewish mob that, not content with inflicting upon Him insults innumerable, went on, convulsed with animal rage, to abandon the life of the Just One to a pagan judge.... "[59] By contrast, Bonaventure describes the soldiers who crowned Christ with thorns relatively mildly: They are merely "sacrilegious" and "godless."[60] Mid-duecento images of the Mocking similarly make the Jewish identity of the mob explicit: In Coppo's version, for instance (Fig. 56), several of the men wear the robe and head shawl of a Jewish priest. Here and elsewhere, the conspicuous addition of the shofar, which (like the head shawl) is used ritually in synagogues even today, is more obviously a visual cue that defines the mockers as Jewish – and, by extension, defines the Crucifixion as a Jewish offense. It is probably not coincidental that the two crosses that include the Trial before the Jewish high priests – the Uffizi cross and the San Gimignano cross – are two of the first to use the new image of the Mocking of Christ; in both, the Jewish Mocking is placed directly below the Jewish Trial (Figs. 7–8). The version of the scene in Enrico di Tedice's cross in San Martino, which depicts the buffeting of Christ by the Jewish mob and omits any intrusions from the Crowning of Thorns, similarly dates from the mid-duecento, and similarly seems a conscious attempt to castigate Jews for the Passion.[61]

In conclusion, then, the new image – fashioned primarily from the Gothic North and secondarily from the Byzantine East – can be read as a Franciscan construction on more than one level. In presenting Christ as the hapless victim of the mob, it vividly captures the intensely christocentric piety fostered especially by the Order. But it also forcibly asserts Christ's humility, and by implication the humility of Francis himself, who was similarly mocked and dishonored throughout his life. Thus central tenets of the

Order – Francis as *Alter Christus* and the primacy of humility – are important subtexts of this image. Finally, the antisemitism of the image validates the ideology of mission that was central to the Order from the beginning. In this instance, then, any concern on the part of Tuscan painters or their employers with emulating the authority of Byzantine models was fairly peripheral; far more important was the usefulness of the new image in asserting Franciscan interests. A similar manipulation of Passion images, one that more emphatically promotes the ascendancy of the Franciscans, also characterizes the next image we will discuss, the Way to Calvary.

THE WAY TO CALVARY

THE WAY TO CALVARY IN ITALIAN PAINTING

As we have seen, beginning around 1240 a systematic reformulation of Passion images took place in central Italy, in which inherited types were discarded and substantially new versions introduced. The image of the Way to Calvary seen in mid-century painting also departs markedly from earlier types. The designers of the new image again drew on two distinct traditions, one from the Gothic North, the other from the Byzantine East. As with the new Mocking, only details of the new image can be called Byzantine. And as with the Mocking, these narrative manipulations very probably originated with the Franciscan order.

The Way to Calvary is one of the more important themes in late medieval Italian Passion cycles: Of the scenes preceding the Crucifixion, only the Betrayal and Flagellation occur more often. It is common on panel painting. Several Tuscan painted crosses include it; it appears first on the Sarzana cross, and on other pre-duecento crosses in both Pisa and Florence. During the duecento, it was apparently favored especially around the middle of the century: With the exception of Coppo's San Gimignano cross, most of the crosses executed during the 1240s, '50s and '60s represent it. It appears as well on several other panel paintings surviving from this period, even those with curtailed programs, such as the Lucchese diptych from Santa Chiara (Fig. 1).[1] Though it is less routinely included later in the century – in part because it is at times replaced by the Ascent of the Cross – it is found in the cycle in the Upper Church of San Francesco, Assisi, and in several altarpieces by Cimabuesque painters.[2]

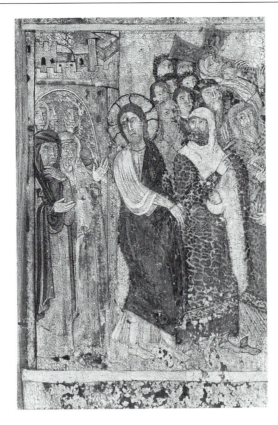

Figure 69 Gullielmus. Way to Calvary. Detail of painted cross, 1138. Sarzana, Cathedral. Photo: Alinari/Art Resource.

The prominence of the theme in duecento painting contrasts with the relatively terse accounts in the Bible. Though the procession to Golgotha, or Calvary, is described by all four evangelists, most allot only a sentence to this moment of the Passion. One notable point, significant for duecento representations of the theme, distinguishes the different texts. According to the synoptics (Matthew 27:32; Mark 15:21; Luke 23:26), the mob commandeered a passerby, Simon of Cyrene, and forced him to carry the cross on which Christ was to die. According to John's account, however, Christ carried the cross himself (John 19:16–17). A second detail of note is found in Luke – the only one of the four to provide any additional information about the procession. Luke describes Christ's encounter with the mourning women of Jerusalem (Luke 23:27–31); he pauses to speak to them before continuing on the road. This episode is of interest here, as it is represented often in Tuscan painting beginning with the duecento.

The image as it appears on Gullielmus's Sarzana cross (Fig. 69) is typical of the pre-duecento type: As specified by the synoptic gospels, Simon of Cyrene carries the cross. Gullielmus also included Christ's encounter with the holy women mentioned by Luke, the "daughters of Jerusalem" whom Christ turns to address. The Lucchese painter added as well a few extra-

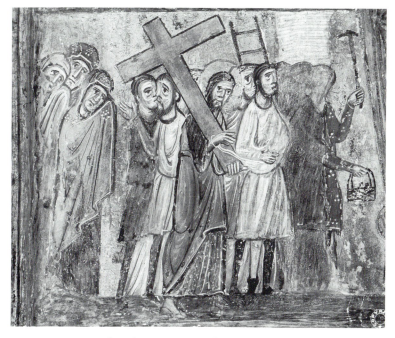

Figure 70 Enrico di Tedice. Way to Calvary. Detail of painted cross, 1245–55. Pisa, S. Martino. Photo: Alinari/Art Resource.

canonical details, most notably the hammer and nails carried by the bearded man on the far right. The Way to Calvary appears similarly on other twelfth-century works, such as the Florentine cross in the Uffizi, no. 432, and on a Pisan work of about 1200 still in Pisa, in San Frediano.[3] In all, Simon carries the cross as Christ turns to counsel the holy women.

Mid-duecento versions of the theme differ considerably. The rendition of the scene by Enrico di Tedice (Fig. 70) provides an early example of the changes. The major change is the absence of Simon: Now, as described by the text of John (19:16–17), Christ himself carries the cross. Virtually every example of the scene from the mid-duecento to the end of the century similarly omits Simon and depicts Christ as the cross-bearer.

Duecento painters depart from their predecessors in other respects as well. In Enrico's version, for instance, Christ no longer pauses to speak to the holy women, but marches resolutely ahead. The only response to the women is the threatening gesture of one member of the crowd, who seems to order them to desist. This feature will be significant for later Tuscan painting; artists will incorporate it well into the trecento. A final modification of the earlier scheme appears in the equipment conspicuously displayed by the executioners. The man leading the procession carries a basket of nails and

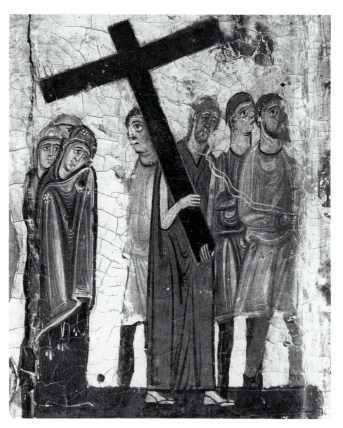

Figure 71 Castellare Master. Way to Calvary. Detail of dossal, 1260–70. Florence, Bargello. Photo: Kunsthistorisches Institut, Florence.

swings a hammer high above his head. Behind him another man carries the ladder which Christ will climb to his death. The *Arma Christi* had been included earlier in Tuscan images of this scene; for instance, the hammer and nails had appeared in the Sarzana cross and the basket in Uffizi no. 432. The ladder, however, is new; its presence here anticipates a new Passion theme, the Ascent of the Cross, which becomes popular later in the century.

Closely related to Enrico's Way to Calvary, but revealing significant changes, are the Castellare Master's renditions of the scene – one in a damaged painted cross, the other, shown here, from a panel of about 1260–70 in the Bargello Museum, Florence (Fig. 71). Though this painter abridged his version, paring the crowd and omitting the *Arma Christi*, in several respects – the stances of the holy women, the gesture of the man threatening them, even the way Christ grips the base of the cross – the Castellare Master's treatment of the theme closely resembles Enrico's. But two striking changes distinguish this scene from its predecessors; each depicts a new humiliation to which Christ was subjected. As in Enrico's example, Christ's executioners lead their prisoner by a rope – tied now, however, not around his wrists but

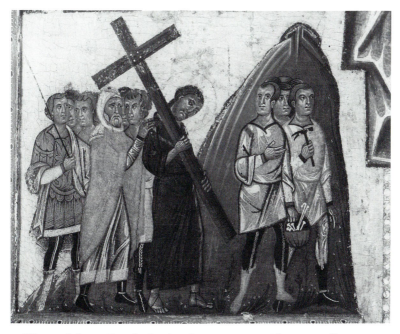

Figure 72 Way to Calvary. Detail of painted cross, 1240–5. Florence, Uffizi, no. 434. Photo: Luigi Artini/Miklós Boskovits.

around his neck. The rope around Christ's neck is another element that will become frequent in later depictions of this scene. Further, Christ has been stripped of his distinguished long tunic and mantle and now wears a sleeveless colobium. Nevertheless, here Christ retains his dignity; though he bends slightly under the weight of the cross, he still carries his head erect.

However, in a Florentine version of the theme, that on the cross of about 1240–5 in the Uffizi (Fig. 72), we encounter still another variation that heightens the affective power of the scene. Now Christ's strength seems almost completely dissipated. In contrast to the Pisan examples, his head droops, and his step seems halting and painful. His frailty is understandable when we consider the expansion of the cross, which extends below the level of his knees. As if to reinforce the suggestions of Christ's ebbing strength, a bearded priest shoves him forward. Another change occurs in the setting, in the Pisan examples indicated only by a perfunctory ground line. Now a hilly landscape forms the backdrop: A great rock outcropping, perhaps signifying the hill of Calvary, soars behind the leaders of the procession. A final difference is the absence of the Virgin and holy women. This change is unexpected – they had been a standard feature in almost all earlier Tuscan versions.

Later duecento versions add relatively little to the image as it appears in these examples. Among the most important images from the later duecento is a fresco in the Upper Church at Assisi (Fig. 73). Here Christ again bends

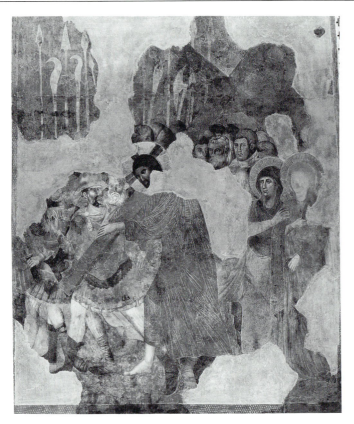

Figure 73 Way to Calvary, late 1280s–early 1290s. Assisi, S. Francesco, Upper Church.
Photo: Kunsthistorisches Institut, Florence.

under the weight of a huge cross, as in the cross in the Uffizi, no. 434. In the
San Diego dossal (Fig. 4), the Virgin is far more prominent than before; she
reaches for Christ as if to prevent him from continuing. Early trecento cycles
like Giotto's frescoes in Padua and Duccio's *Maestà* also include the scene;
Duccio's is unusual in reverting to the earlier type with Simon of Cyrene as
cross-bearer. Finally, among the frescoes by Pietro Lorenzetti and his work-
shop in the Lower Church at Assisi is a version of this theme (Fig. 74). Here
Christ is again led by the neck (as in the Castellare Master's panel), and
among the great throng of marchers and onlookers are the thieves, at the
head of the procession.

Again, then, around 1240 the traditional scheme was substantially recast
to produce one far more expressive than before; most later painters did not
significantly modify the new image. Before turning to this image and its
meanings, we will consider the earlier type that it displaced; this analysis
will provide the background for the discussion to follow.

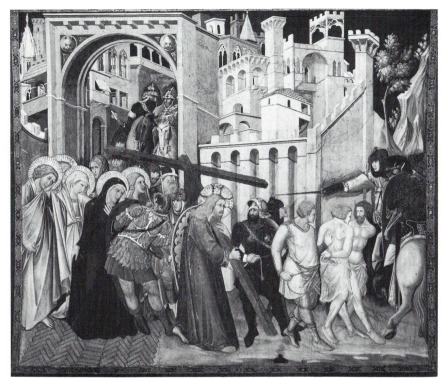

Figure 74 Pietro Lorenzetti and workshop. Way to Calvary, c. 1316–19. Assisi, S. Francesco, Lower Church. Photo: Alinari/Art Resource.

THE PRE-DUECENTO IMAGE

The major feature common to the three twelfth-century versions of the Way to Calvary is the presence of Simon of Cyrene, who carries the cross. This type is frequently described as Byzantine, and this description is, in a sense, correct: The vast majority of eastern representations of the scene depict Simon, not Christ, carrying the cross.[4] But the type is not exclusively Byzantine: It was transmitted early in the Middle Ages to the West and, with few exceptions, northern European painters continued to use this formulation until the end of the eleventh century.[5] The dominance of the type in the West until then – a point often overlooked in the literature[6] – also applies to Italy: Representative works include the frescoes at Santi Martiri, Cimitile, and Sant'Angelo in Formis.[7] Thus the early versions of the scene in Italian painting perpetuate a type with a long history in the West in general and in Italy specifically.

The secondary elements found in pre-duecento versions of the scene similarly depend on inherited formulations. Many of these features, like the use of Simon as cross-bearer, derive ultimately from Byzantium, but had entered the western iconographic repertoire before their appearance in Tuscan paint-

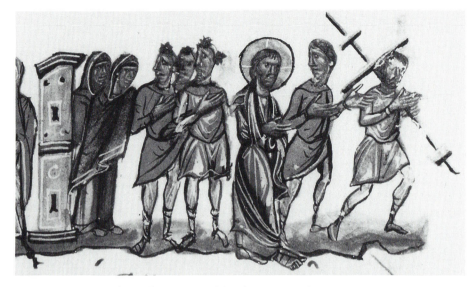

Figure 75 Way to Calvary, from a Gospel book, early twelfth century. Florence, Biblioteca Medicea Laurenziana, Plut. VI. 23, fol. 161r. Photo: museum.

ing. Other details are more firmly rooted in western tradition. For instance, Gullielmus's version of the Way to Calvary (Fig. 69) includes much that can be traced to Byzantium, but closer antecedents can be found in the West. The Lucchese panel includes one important motif for later Tuscan painting, the holy women. The women had been introduced to Byzantine illumination by the eleventh century; they appear especially in Gospel books among the illustrations to the text of St. Luke, who is the only evangelist to specify their presence on the road to Calvary (as in the Paris Gospel book, or the Gospel book in Florence, Plut. VI. 23, fol. 161r., Fig. 75). In the Paris manuscript, Christ walks forward but turns back to the women as he does in the apron panel, and in the Florence Gospel book the women stand before a schematic building that presumably represents the city gate, somewhat like the gate in the Sarzana version. Finally, Christ's wrists are usually shown bound in Middle Byzantine painting, as they are in the Lucchese panel; Paris 74 is but one example.[8]

Each of these details, however, was known in the West by the eleventh century. The holy women, though uncommon at this early date, occur in a late Ottonian Gospel book from the church of St. Peter, Salzburg; there, too, Christ glances back in response to their cries.[9] Further, in this illumination Christ's wrists are bound – a detail seen in Ottonian art at least from the early eleventh century[10] – and the women stand next to a towerlike building which may signify the city gate. Thus, one cannot assume that Gullielmus's Byzantinisms stem from direct exposure to eastern sources; he may well have had access to an Ottonian intermediary like the Salzburg Gospels.[11]

Further, certain aspects of Gullielmus's representation are emphatically non-Byzantine. The hammer and nails carried by one of Christ's executioners cannot be explained by adducing a Byzantine model: The *Arma Christi* are virtually unknown in Byzantine art at this date.[12] They do appear, however, in the West as early as 1100: In a relief from the bronze door of the Cathedral of San Zeno, Verona, two members of the crowd hold nails, and in a contemporary door panel from the Cathedral of Le Puy, one of the executioners brandishes a hammer.[13] In Italy the *Arma* occur only sporadically until the middle of the duecento, and in northern Europe the motif enjoyed widespread popularity only in France; the great majority of twelfth- and thirteenth-century examples are French.[14]

This evident fascination with the instruments of the Passion no doubt reflects the cult of relics of the Passion;[15] the crusades fanned the cult, and in fact the *Arma* first appear just at the time of the First Crusade (1095–9). The relic mania of the crusading Franks was fed by the discovery, in 1098, of a piece of iron identified as the Holy Lance; this relic, and similar treasures, were triumphantly brought to France by the returning warriors, where they were used to generate enthusiasm for the Crusade of 1101.[16] Because of this general rekindling of interest in Passion relics, and possibly because of specific associations with the Holy Lance,[17] a new awareness of the nails in particular emerges at the turn of the twelfth century. At just this time fervent descriptions of the nails appear in devotional texts,[18] and at just this time the motif receives new attention in the pictorial arts.[19] But the nail was more specific to Lucca, which also claimed possession of a relic of the nail; it was one of several Passion relics stored in the *Volto Santo*, which had been dubiously acquired from neighboring Luni, where Gullielmus's cross once hung.[20] This visual echo of the prized relic once in their ownership was presumably small comfort to the citizens and canons of Luni. In any case, Gullielmus's inclusion of the hammer and nails in his Way to Calvary may have been intended to promote the local cult object; if so, his image would be a self-consciously Lucchese interpretation of the theme.

Mid-Duecento Images, Northern Europe, and the Crusades

As noted above, the images of the theme that date from the middle of the thirteenth century depict the Way to Calvary in a radically new way: Now Christ, not Simon, carries the cross to Golgotha (Figs. 70–2). But this change cannot be ascribed to the reception of Byzantine images; as in the new version of the Mocking, Tuscan painters relied on eastern sources only for relatively minor aspects of the new image. The major visual impetus for the new type was almost certainly western.

The purely western character of the general type, in which Christ car-

ries the cross himself, is easily documented. Though for centuries the West followed Byzantium in representing Simon as cross-bearer, at the end of the eleventh century the scene underwent a change: Simon was summarily jettisoned and Christ himself carried the instrument of his execution.[21] The new image spread rapidly in northern Europe, and by the thirteenth century Simon had almost disappeared.[22] A number of factors have been proposed to explain this dramatic transformation of the scene; the most convincing explanation, put forward by Ulbert-Schede, links the change to the launching of the crusades. Urban II, preaching the First Crusade at Clermont in 1095, exhorted the faithful to heed Christ's words: "If any man will come after me, let him...take up his cross, and follow me" (Matthew 16:24).[23] This passage thus became the spiritual justification for Urban's venture: The countless numbers who responded to the call fastened a cross to their right shoulder and became known as the takers of the cross, or crusaders.

The connection between this biblical passage and the Way to Calvary as described by John, in which Christ himself bore the cross, is immediately apparent; the two had been linked, in fact, since the early days of the Church.[24] It thus seems logical to conclude, with Ulbert-Schede, that the crusading fervor that swept much of western Europe in the late eleventh and early twelfth centuries must lie behind the proliferation of images depicting Christ as cross-bearer.[25]

Though the new image spread rapidly in northern Europe, all but eclipsing the earlier type by the end of the century, in Italy it was slower to take hold. Despite its early appearance in Sant'Urbano, San Zeno, and the Gospel book of Matilda, the rest of Italy, particularly Tuscany, remained noticeably cool to the new formulation; Gullielmus (Fig. 69), the painter of the cross in the Uffizi, no. 432, and the painter of the San Frediano cross all depicted Simon as cross-bearer. It was not, apparently, until the middle of the duecento that Tuscan painters like Enrico, the Castellare Master, and the painter of cross no. 434 finally discarded Simon and adopted the new image.

Mid-duecento Tuscan painters not only changed the general type of the Way to Calvary, however; they also introduced a number of new motifs, all taken from imported images. Some of these were contemporary French versions of the theme, but others were clearly Byzantine. Thus, as in the case of the Mocking, duecento painters and their employers did not base the new versions of the Way to Calvary exclusively on either western or eastern types; rather, they ingeniously fused disparate elements, and in the process constructed a new image that singularly suited local concerns.

One concern must have been to heighten the affective tenor of the image, as Enrico's Way to Calvary suggests (Fig. 70, p. 115). Here we encounter several details, absent from earlier extant Italian compositions, that contribute to the emotional impact of the scene. Two very probably stem from northern,

specifically French, images; the third was almost certainly drawn from a Byzantine model. The ladder displayed by one of the executioners is one of these additions. Though the *Arma Christi* began to appear in Italian painting as early as the Sarzana cross, the ladder apparently did not occur in Italy until the mid-duecento. Like the other instruments of the Passion, the ladder is unknown in Byzantine art at this time; it may reflect the western fascination with the relics of the Passion that reached a fever pitch during the crusades. The ladder itself was taken to the West in the twelfth century, and it is during the twelfth century that it makes its initial appearance in the Passion cycle.[26] In the Way to Calvary specifically, however, it occurs primarily in thirteenth-century French monuments, hence the likelihood of Enrico's use of a French source.[27] A second detail may also suggest Enrico's awareness of French images: the fact that Christ's wrist is bound by a rope although he carries the cross himself. Normally when Christ is depicted with bound wrists, Simon of Cyrene carries the cross; when Christ does so, his wrists are free. However, in an early thirteenth-century French manuscript in Paris, Christ similarly manages to carry the cross even though his wrists are bound.[28]

MID-DUECENTO IMAGES AND BYZANTIUM

But Enrico's Way to Calvary includes one motif, important to later Italian representations, that he may have drawn directly from a Byzantine source: the man who turns to the holy women and motions them away. This figure, which does not appear in earlier western examples that I know of, was often adopted by central Italian painters after Enrico, and persisted throughout the trecento; Simone Martini, in his panel in the Louvre, transformed the mildly menacing figure into a vicious thug.[29] For all its expressive potential, however, this detail apparently does not occur in twelfth- or thirteenth-century northern European painting; in fact, northern painters rarely include it before the fifteenth century.[30]

The episode was, however, known in the East: It appears, albeit rarely, in Middle Byzantine painting. One example occurs in the Florence Gospel book (Plut. VI. 23, fol. 161r.; Fig. 75): Here two or three of the crowd turn to the lamenting women as if to dismiss them. The presence of this motif is surprising in this Gospel book; its illustrations generally follow each evangelist's text scrupulously, but this incident is not mentioned in Luke's account.[31] The source is not canonical but apocryphal; it is derived from Recension B of the *Acta Pilati*: "The Jews, seeing [the Virgin] lamenting and crying, came and drove her from the road; yet she would not flee, . . . saying, 'Kill me first, ye lawless Jews.'"[32] The miniature seems to follow this text in another respect as well: It depicts Christ simply marching ahead instead of turning to speak to the holy women, and Recension B similarly omits any mention of Christ's

response. Thus, by the twelfth century, this apocryphal tale had been interpolated into the canonical text illustrations of at least one major Gospel book; this sort of prototype must ultimately lie behind Enrico's Way to Calvary.

In fact Enrico must have known an image fairly close to the Calvary scene in the Florence Gospel book, because other details, generally absent from earlier Italian iconography, appear in both works. Most telling is Christ's new obliviousness to the entreaties of his mother and her companions. In each earlier Italian version in which the holy women appear, he turns to counsel them as the text of Luke relates; here, as in the Byzantine manuscript and as implied by Recension B, he simply walks ahead. Smaller points also link the two representations: the gestures of the holy women, who in each raise their veiled hands to their faces; the short tunic worn by the man exhorting Christ; the strongly isocephalic arrangement of the figures. It is interesting that Enrico's version of the Mocking also bears a resemblance to the example in the same manuscript, as noted before.[33]

The Castellare Master also seems to have taken certain elements of his composition (Fig. 71, p. 116) from Byzantine images. Though his version clearly resembles Enrico's formulation (Fig. 70), two new motifs appear: the rope around Christ's neck and the sleeveless colobium that he wears instead of his usual garb of tunic and mantle. Neither detail could have been taken from northern Europe, where both were apparently unknown; both strongly suggest contact with Byzantine art, perhaps more specifically with images from the provinces of the empire.

The rope around Christ's neck has long been considered a distinguishing characteristic of Cappadocian iconography, and it does occur often in Cappadocian representations of the Way to Calvary from the early tenth through the early thirteenth century.[34] It is not exclusively Cappadocian, however; in a late twelfth-century manuscript from Constantinople, Athens 93, Christ appears before Pilate with a rope around his neck.[35] In images of the Way to Calvary, the rope appears elsewhere in the Byzantine sphere by the Palaeologan era (as in a fresco in the church of Christos, Veroia, Fig. 76).[36] This particularly debasing treatment may have first appeared in Palestine: The Good Friday liturgy used in Palestine during the fourth century requires that the Patriarch, representing Christ, be led by the neck,[37] and among the relics displayed in Jerusalem was the chain used to lead Christ to Pilate which was said to have been placed around Christ's neck.[38]

Despite the occasional instances of the rope in eastern images, it does not appear in a western version of the Way to Calvary, to my knowledge, until the middle of the duecento. The Castellare Master may have had access to an East Christian, possibly Palestinian, source. If so, the early occurrence of this detail in Pisan painting would be understandable; many Pisans settled in the Levant during the twelfth and thirteenth centuries, and the regular contact between

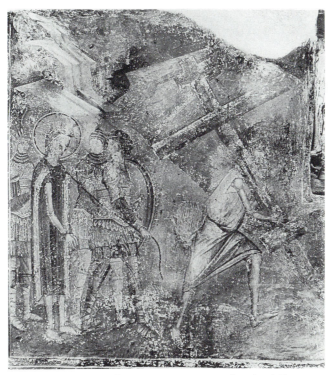

Figure 76 Way to Calvary, c. 1315. Veroia, Church of Christos. Photo: after Pelekanides, 1973.

these Pisan colonies and their homeland could account for the Castellare Master's knowledge of a motif from the eastern Mediterranean. But another likely conduit was the Franciscan order, with its multiple activities in the Levant. As we shall discuss, the rope was a potent bearer of meaning for the Order, and many of the works that include it are Franciscan.

The rope around Christ's neck may not be the only East Christian detail in the Castellare Master's versions of the Way to Calvary; another is the sleeveless colobium which Christ wears instead of the usual mantle and tunic. This garment appears in a number of Byzantine Crucifixions that are believed to stem from a Palestinian source.[39] It is conceivable, then, that a Palestinian version of the Way to Calvary also depicted Christ in a sleeveless colobium, and that such a source explains the Castellare Master's composition.[40] However, the combination of the rope around Christ's neck and sleeveless colobium appears elsewhere, as in the fresco at Veroia (Fig. 76); the fresco provides us with some idea of the image presumably available to this Pisan painter. Even the slightly hunched stance of Christ in both images reinforces the similarity between the two.

Finally, the painter of the Uffizi cross must have also studied Byzantine images before composing his version of the Way to Calvary (Fig. 72, p. 117).

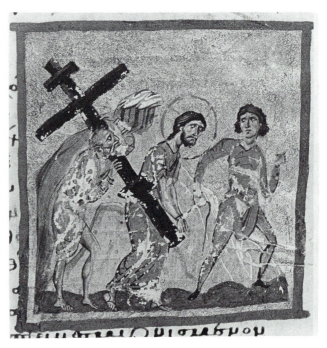

Figure 77 Way to Calvary, from a Gospel book, late twelfth century. Athens, National Library, ms. 93, fol. 84r. Photo: after Marava-Chatzēnikolaou and C. Touphexē-Paschou, 1978.

This Florentine painter, like his Pisan counterparts, portrays Christ as the cross-bearer, but his composition differs from theirs in several respects: Christ's newly pronounced fatigue, the sleeved tunic that he now wears, the considerably elongated cross, the absence of the Virgin, and the hilly terrain in which the scene is set all distinguish this image from other central Italian examples. Each feature stems ultimately from Byzantium, and the changes, when considered together, strongly suggest that this Florentine painter worked from a near-contemporary Byzantine version of the theme.

The first point to be examined is the faltering stance of Christ. Byzantine painters similarly depicted Christ by the late twelfth century: In a late twelfth-century miniature in Athens (ms. 93, fol. 84r.; Fig. 77), Christ's frailty is also pronounced, and a number of roughly contemporary works, like a miniature in St. Petersburg (ms. 105, fol. 167r.; Fig. 78) and a fresco in St. Neophytos, Paphos, also stress his fatigue.[41] In the manuscript in Athens and the fresco at St. Neophytos, the vertical beam of the cross is elongated as in the Florentine composition, so that the lower end extends to the knees of the figures. And in each of the Byzantine works of this period, as in the Florentine cross, Christ wears only a sleeved tunic.[42] The profound pathos of this new type is clearly another instance of the late Comnenian exploration of Christ's suffering during the Passion.[43]

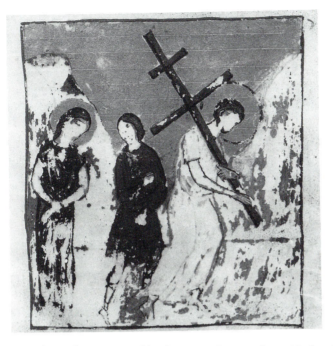

Figure 78 Way to Calvary, from a Gospel book, 1180s. St. Petersburg, National Library of Russia, ms. 105, fol. 167r. Photo: museum.

The Florentine painter's omission of the Virgin and holy women further suggests his adaptation of a Byzantine image. Though the women appear occasionally in Middle Byzantine painting, their presence is the exception rather than the rule, presumably because only one of the four Gospels mentions them; thus in none of the twelfth- and thirteenth-century Byzantine manuscripts illustrated here (Figs. 77–9) do the women appear. In northern Europe, however, and especially in France, they occur far more commonly.[44] The popularity of the motif – also reflected in twelfth- and thirteenth-century meditations on the Passion – probably grew out of the cult of the Virgin in the medieval West; the holy women and especially the Virgin figure prominently in the devotional texts circulating at this time. The absence of the holy women in the Uffizi cross thus seems to be a departure from western textual and visual tradition and suggests again that this painter worked closely from a Byzantine image.

Other details tend to confirm such a conclusion. The prominence given the landscape, for instance, is unlikely to derive from a French source: No northern Way to Calvary that I know of includes more than a perfunctory indication of setting. In Byzantine painting, however, especially in the late twelfth and thirteenth centuries, a hilly background regularly appears. The manuscripts in Athens (Fig. 77) and St. Petersburg (Fig. 78), and the fresco at St. Neophytos, all testify to the frequency of the motif.[45]

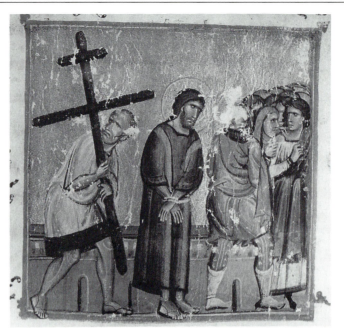

Figure 79 Way to Calvary, from a Gospel book, c. 1205–10. Berlin, Staatliche Museum, ms. gr. qu. 66, fol. 253v. Photo: Foto Marburg.

Even minor points in the depiction of the crowd find their closest antecedents in late twelfth- and early thirteenth-century Byzantine manuscripts. The executioner gesturing forward is very close in stance to the corresponding figure in St. Petersburg 105 (Fig. 78). The men at the left, who exchange knowing glances, appear in much the same fashion in Berlin 66 (fol. 253v.; Fig. 79). Even the white stripes of the dark stockings worn by the man just ahead of Christ are duplicated in Berlin 66.[46] It seems, then, that this painter had made a careful study of Byzantine images, most closely approximated by the miniatures in manuscripts like St. Petersburg 105, Berlin 66, and Athens 93, or the fresco at St. Neophytos. He may have worked directly from such images; alternatively, he may have had access to a good copy. But despite his absorption of Byzantine features, in depicting Christ as cross-bearer his image is demonstrably non-Byzantine.

CHRIST BEARING THE CROSS, THE *ALTER CHRISTUS*, AND THE FRANCISCAN IDEOLOGY OF MISSION

These images of the Way to Calvary confirm the revisionist mood of the mid-duecento in picturing the Passion: As with each previously examined Passion scene, a long-entrenched type is rejected in favor of a newly affective depiction of the event. As in the case of the Mocking, the mid-century image results not from a single source but from a purposeful eclecticism in which

painters and their advisers carefully culled features from East and West. And again, as with the Mocking, both the new image – Christ Bearing the Cross – and a number of details, notably the man threatening the Virgin and the rope around Christ's neck, would have a long history in later Italian art.

However, understanding the new iconography requires not only documenting Tuscan painters' use of Byzantine and northern European images but considering the reasons for their choices. In each of the Passion narratives studied thus far, the rising tide of Franciscan piety was associated with the increased emotionality of the new mid-century image; in this case, as in each previous scene, the new type emphasizes Christ's physical and emotional ordeal far more than did the earlier version. Thus this transformation of the Way to Calvary accords with the general tendency, in mid-duecento Passion images, to accentuate the pathos of Christ's great sacrifice – a tendency consistently found in Franciscan devotional texts. And almost all of these accounts stress that Christ carried his own cross. Pseudo-Anselm, recently identified as a Franciscan writing after 1240, includes both versions: First, he tells us, Christ carried the cross, but Simon took over when Christ became too weak to continue. Pseudo-Bede, another Franciscan, provides his audience with a detailed account of the burden of the cross and the Virgin's response: She wished to carry it herself to spare her son.[47] Bonaventure's *Lignum vitae* similarly emphasizes that Christ bore the cross. Bonaventure quotes John 19:17 in describing the event: "And bearing the cross for himself, He went forth to the place called the skull." Later in the text he elaborates: "He is forced to stoop under the load of the cross, bearing the instrument of His own disgrace"; he refers to Christ as cross-bearer in other texts as well.[48] Pseudo-Bonaventure likewise tells his readers several times that Christ bore the burden himself.[49]

But in this case, it was not merely the pathos of the new image that led to its adoption; the image had a more particular valence to the Franciscans. As it was to Urban II, to Francis Christ's instruction to "take up the cross and follow me" was freighted with meaning. After the vision in which he renounced his dissolute youth, according to his biographers Francis thought instantly of this biblical passage. As Bonaventure relates, he "immediately recognized that the words of the Gospel were addressed to him: 'If you have a mind to come my way, renounce yourself, and take up your cross and follow me'" (see Matt. 16:24).[50] Thus it was upon this exhortation that Francis based the Rule of the Order. The Rule of 1221 states: "The Rule and life of the friars is to live in obedience, in chastity, and without property, following the teaching and the footsteps of Our Lord Jesus Christ, who says, . . . 'If anyone wishes to come after me, let him take up his cross, and follow me.'"[51] The passage also appears in the Gospel of the Mass of the Stigmatization and is inscribed on works of Franciscan origin.[52] Pseudo-Bede's Fran-

ciscan origins are strongly suggested in his highlighting of this passage, which he uses to frame his meditation on the Passion. His opening paragraphs describe the apostles asking the Lord where they were going; he replies, echoing the Rule of 1221: "We will go to my Passion. . . . Whoever wishes to come after me, . . . let him take up his cross and follow me."[53]

This biblical passage presumably loomed large for Francis in part because of its currency, from the early twelfth century, in the rhetoric of the crusades. Before his conversion, Francis aspired to the life of a young knight and took part in military campaigns – one heralded as a "crusade" by Pope Innocent III.[54] Presumably because of Francis's early crusading ambitions, his mission to the Levant, and the continuing centrality of mission to the Order, the language of crusading resonates in early Franciscan writing. Thus Francis was described early as "*novus miles Christi*"; Thomas of Celano compared him with the soldier saint, Martin of Tours.[55] By the early 1260s, Bonaventure, in the *Legenda maior*, describes the Stigmatization of Francis in language that is even more emphatically militaristic: "O valiant knight of Christ! You are armed with the weapons of your invulnerable Leader." He continues in this vein: "[I]t was revealed to you that you were to be a captain in Christ's army and that you should bear arms which were emblazoned with the sign of the cross."[56] The Franciscan ideology of mission was thus intertwined with the rhetoric of crusading; Francis, like crusaders, was marked with the sign of the cross, and Franciscans, like crusaders, took up their crosses to follow Christ. In fact, Pope Gregory IX made the linkage explicit; in 1238 he granted crusading privileges to Franciscan and Dominican missionaries to the Levant.[57] Though the history of the Order is marked by some ambivalence concerning actual crusading,[58] in the middle years of the duecento friars became increasingly active as preachers of the crusades; not infrequently they accompanied crusading armies to the Holy Land.[59]

The Order's usurping of crusading rhetoric, and the friars' often direct involvement with the crusading movement, logically found expression in their adoption of the image of Christ Bearing the Cross as a badge of their mission. Just as the image was encoded with meaning for crusaders, the linkage of Matthew 16:24 and the image of Christ Bearing the Cross in the visual arts was similarly predictable for the Franciscan order: Depictions of Christ carrying the cross himself begin to occur prominently on monuments commissioned by the Franciscans. In 1238 – the year the friars were granted crusading privileges – the image appeared on the Order's seal, and it persisted on Franciscan seals well into the fourteenth century.[60] It appears as well in numerous panels and frescoes for the Order. An early instance is found on the right panel of the Lucchese diptych in the Uffizi, painted in the 1250s for the convent of Santa Chiara in Lucca (Fig. 1; Fig. 80); here one quarter of the panel is given over to the scene. The two crosses for San Mar-

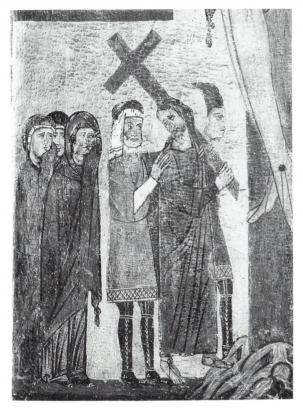

Figure 80 Way to Calvary, from a diptych from Lucca, Sta. Chiara, c. 1255–65. Florence, Uffizi. Photo: Alinari/Art Resource.

tino, which housed a community of the Clares, also include it. In both of these crosses, as well as several others, the scene is found on the lower left panel of the apron, closest to the viewer's eye level.[61] The theme also occurs several times in San Francesco, both in the Upper Church cycle of the 1280s and in the Lower Church cycle by Pietro Lorenzetti and his shop (Figs. 73–4); it is found as well in a stained-glass window in the apse.[62] The depiction of the theme three times in the mother church of the Franciscan order seems significant, particularly given the omission of the theme elsewhere, such as the mosaic cycle in the Baptistery in Florence.

The subject also appears repeatedly in Franciscan monuments of the trecento. To cite a single site, in the Florentine church of Santa Croce, at least three images of the theme were once present. It occurs in an enormous fresco in the sacristy (where it appears with only two other narratives of that scale) and in another in the refectory; it appeared as well in the central panel of the predella of Ugolino di Nerio for the high altar.[63] Its centrality for the Order is explicit also in a diptych in Munich (Fig. 81), where it is found directly above the Stigmatization of Francis.[64]

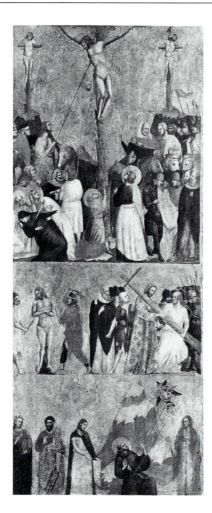

Figure 81 Crucifixion, Flagellation, Way to Calvary, Stigmatization of St. Francis. Right wing of a diptych, early fourteenth century. Munich, Bayerische Staatsgemäldesammlungen. Photo: museum.

In view of the significance of the biblical theme to the Franciscans, and of the Order's increasing hegemony during the mid-duecento, it seems reasonable to ascribe the sudden proliferation of the new iconography largely to Franciscan ideology. The type had been known in Italy, after all, for over a hundred years; that it finally took hold at just the time of Franciscan ascendancy seems more than fortuitous. Though the Dominicans again followed the Franciscan lead in adopting the image, first on seals and eventually in panels and frescoes, Dominican instances are far fewer in number, and most date from the trecento.[65]

One detail at times found in the new image probably also had a specifically Franciscan interpretation: the cord or rope around Christ's neck. This feature is arguably another Franciscan assertion of their founder's identity as *Alter Christus*: Francis was once dragged by a cord around his neck just as Christ is represented in the Castellare Master's Way to Calvary (Fig. 71). This humiliation was part of Francis's public penitence discussed earlier in

Chapter 4, in the context of the Mocking of Christ. According to Thomas of Celano, to atone for breaking a fast, Francis "commanded a certain brother who was with him to tie a rope about his neck and to drag him in this way like a robber through the entire city."[66] The tale occurs similarly in Bonaventure; a variation, preserved in the "Legend of Perugia," explains that the rope was the one the saint wore around his waist: "St. Francis taking off his tunic, and putting round his neck the rope which he wore, ordered brother Peter to lead him naked before the people."[67] In a scene in the Bardi dossal of the 1240s (Fig. 67, p. 110), discussed before in connection with the Mocking of Christ, Francis sits, clad in a loincloth and tied by the neck to a column. The image literally shows Francis "like a robber"; in late medieval Italy, criminals were stripped, led by the neck, shackled to a post, and exposed to public ridicule.[68]

The episode of Francis's penance was not depicted often in later Franciscan art; as the Order grew in wealth and status, its officials were presumably not inclined to encourage such a graphic portrayal of their founder's extreme self-abasement.[69] But there is evidence that the episode continued to engage the Order, and in particular that it came to be associated with the biblical theme of Christ on the road to Calvary. Mid-century Franciscans knew the legend of Christ led by the neck on the way to Calvary: According to the Franciscan Pseudo-Bede, the chain or shackle (*catenam*) by which Christ was led was exhibited to pilgrims in Jerusalem.[70] Though the image of Francis in the Bardi dossal would have evoked the punishment of a robber, the fact that he is tied by the neck would also have suggested Christ on the way to Calvary. In fact, just as Celano has Francis dragged "like a robber" during his penance, Franciscan texts similarly describe Christ on the *Via Crucis*. For Pseudo-Bonaventure, Christ was led "bound, like a thief, to the place of Calvary"; the Latin texts are still closer ("*quasi latronem*" in Celano, "*ut latronem*" in Pseudo-Bonaventure).[71] Further, the chain (*catenam*) that was exhibited to pilgrims in Jerusalem becomes a cord or rope (*funis*) in Franciscan accounts of the Passion. For instance, some *laude* – the Franciscan roots of which have been discussed often – mention a rope around Christ's neck: One Pisan example notes "*una fune miselil'en collo.*"[72] This alteration underscores the link between Christ and Francis; Francis's biographers consistently describe the saint led by a rope, and the "Legend of Perugia" adds that the rope was Francis's own belt. As discussed in conjunction with the Trial of Christ, Bonaventure unequivocally associates the ropes that bound Christ in the Passion with the cords worn by all friars.

Perhaps most telling, ritual use of the rope around the neck seems to have become part of Franciscan devotional practice early in the Order's history. Again, the Bardi dossal offers visual evidence of the practice. In one scene, worshipers are shown at the tomb of St. Francis, clutching cords

around their necks; both their cords and their near-nudity clearly evoke the episode of Francis's penance.[73] Even today, the rope around the neck – at once signifying both Christ led to Calvary and Francis as *Alter Christus* – figures prominently in Franciscan ritual: Friars in Assisi still celebrate the ceremony of the *Corda pia* on Good Friday and walk in procession with cords around their necks to the chapel of the Crucifix in San Francesco. As they walk, they sing a hymn with this refrain: "Corda pia enflammantur dum Francisci venerantur stigmata insigna."[74] *Corda*, "hearts" in Latin, is also a play on the distinctive Franciscan rope-belt; in Italian, *corda* is also a cord or rope, and a *cordigliero* is a Franciscan friar – as it was at least as early as the trecento.[75]

Given all of the above – Francis's act of penance, Bonaventure's lengthy meditations on the ropes tying Christ, his association of those ropes with the belt of the Franciscan habit, and the early and continuing importance of the rope around the neck in Franciscan ritual – it is not surprising to discover Christ being dragged in just this fashion in several monuments produced for the Order. We do not know the provenance of the Castellare Master's panel (Fig. 71), though ropes are unusually conspicuous in its Flagellation as well as in its Way to Calvary,[76] and in the Upper Church at Assisi (Fig. 73) damage to the fresco obscures the view of Christ's neck. But Christ is shown with a rope around his neck fairly often in Franciscan Passion scenes during the second half of the century. Thus Coppo di Marcovaldo's cross from Santa Chiara, San Gimignano, of about 1261, depicts Christ before the cross in this fashion (Fig. 88, p. 145) – an image we will discuss in more detail in the next chapter. The rope also appears twice in the *Supplicationes Variae* in Florence – significantly, both in the Mocking of Christ and in the Way to Calvary.[77]

In the trecento, the motif is more common. One prominent example in which it occurs is the Way to Calvary in the Lower Church of San Francesco by Pietro Lorenzetti and his shop (Fig. 74, p. 119); there the rope is even knotted at the end, much like the knotted cords still worn by Franciscan friars today.[78] In this fresco a second aspect of the composition, the unusual prominence of the thieves, also evokes Franciscan interpretations of the event; Bonaventure and especially Pseudo-Bonaventure stressed the thieves, considering Christ's association with criminals still another humiliation.[79] The thieves may also subtly allude to Francis, who was, as Celano recounts, led "like a robber" through Assisi. The rope around Christ's neck appears as well in a number of other Franciscan works from the trecento, among them three works by Pacino di Bonaguida or his shop: a *Vita Christi* manuscript in the Morgan Library, a Tree of Life panel in the Accademia, and a tabernacle in Tucson; the Munich diptych (Fig. 81); a Franciscan *Officium Passionis* in Boston; a fresco in Santa Maria Donnaregina, Naples; the predella

of Ugolino di Nerio's altarpiece for Santa Croce, Florence; the fresco in the sacristy of Santa Croce; and the panel in Perugia from Sant'Antonio da Padova, Paciano.[80] Though the rope clearly had a particular relevance to the Order, and though it was often included in works for Franciscan patrons, during the trecento it gradually became more widespread; it is common especially in Sienese painting of the trecento, appearing in works of unknown provenance and at times in clearly non-Franciscan monuments.[81] We will return to the larger phenomenon – aspects of Passion imagery in use first by Franciscans, then more widely adopted – in the Conclusion.

Thus both the new image of Christ Bearing the Cross and the motif of the cord around his neck were favored by the Franciscans for good reason. They presented the audience with a newly potent image of the suffering Christ; but more than that, they asserted the Order's ideology of mission and enhanced the status of its founder as *Alter Christus*. Indeed, Christ Bearing the Cross became a kind of emblem of the Order. Other elements of the new image also convey Christ's sufferings during the Passion and correspond as well to descriptions of the episode in Franciscan devotional texts. For instance, Christ's obvious exhaustion in mid-duecento Florentine images (Fig. 72) is consistent with the Office of the Passion by Francis himself: "I am numbered with those who go down into the pit; I am a man without strength" [Psalm 87:5–6]).[82] Bonaventure also describes Christ's physical burden: "He is forced to stoop under the load of the cross"; and Pseudo-Bonaventure elaborates: "He goes along bowed down by the cross and gasping aloud."[83] The emphasis on the length of the cross in these images finds an analogue in Pseudo-Anselm, who describes it as fifteen feet long;[84] Pseudo-Bonaventure again embroiders: "the long, wide, very heavy cross. . . .fifteen feet high."[85] These descriptions especially call to mind images of the later duecento and early trecento, such as the two frescoes in San Francesco (Figs. 73–4), where Christ is burdened with an enormous cross.

The new prominence of the Virgin in some works – such as the San Diego dossal, in which she reaches for her son as if to prevent his journey (Fig. 93, p. 165) – is likewise consistent with Franciscan texts. As Meiss has observed, Pseudo-Bonaventure assures his readers that Mary tried to dissuade Christ from going to Jerusalem.[86] Conflict between Mary, anxious to intercede for her son, and his executioners, who refused to let him pause, erupts often in duecento texts and images. Thus, in Enrico's panel (Fig. 70), the Castellare Master's version (Fig. 71), and the two frescoes in Assisi (Figs. 73–4), one of the crowd motions the Virgin and the holy women away as another urges Christ forward; in none of these does he turn to respond to them. All of these details – the man ordering the holy women to desist, the man driving Christ ahead, Christ ignoring the women and walking forward – can be read as other antisemitic insertions. The episode of the man with

the holy women comes from an apocryphal text that is explicitly antisemitic: When Christ is hurried by his executioners, Mary responds, "Kill me first, ye lawless Jews." Further, the person shown urging Christ on, sometimes shoving him – both here and in other Passion themes – may be an allusion to an antisemitic legend that became known in the West in the thirteenth century: the tale of the Wandering Jew. A Bolognese account of 1223 describes pilgrims encountering a Jew in Armenia, "who had been present at the Passion of the Lord, and, as He was going to His martyrdom, drove Him along wickedly with these words: 'Go, thou tempter and seducer, to receive what you have earned.' The Lord is said to have answered him, 'I go and you will await me until I return again'" – thus consigning him to wander the earth until the day of judgment.[87] The legend also appears in writings by Franciscans, as in *De astronomia tractatus X* by Guido Bonatti, a friar from Forli. Bonatti claims to have seen the man "who had driven the Lord along when he was being led to the Crucifixion" in Forli in 1267.[88]

The *Meditationes* likewise refers to men prodding and hurrying Christ; it recounts that when Mary saw Christ on the road, she "could not say a word to him; nor could he speak to her, He was so hurried along by those who led Him to be crucified."[89] The crowd is specifically identified as Jewish by writers like Bonaventure, who refers to the "horrible impiety of the Jewish mob. . . convulsed with animal rage."[90] Not surprisingly, the man shoving Christ in some images, such as that in the Uffizi cross (Fig. 72) or the Santa Chiara diptych (Fig. 80), wears the head shawl of a Jewish priest. All of these images, then (Figs. 70–4, 80) – in which Christ is conspicuously hurried or in which a member of the crowd waves the women away – seem to participate in the antisemitic discourse of mid-duecento Italy, and may allude more specifically to the legend of the Wandering Jew. Some confirmation of this thesis appears in Diane Wolfthal's study of the image of the Wandering Jew. She publishes the frontispiece to Sext in the Hours of William de Brailes, of about 1240 (London, British Library, Add. ms. 49999, fol. 43v.). The first medallion depicts Christ speaking with the Wandering Jew, who, as Wolfthal notes, is identified as such by the inscription; the second medallion depicts the Way to Calvary, in which a man uses both hands to shove Christ ahead.[91]

In conclusion, then, the metamorphosis of the Way to Calvary in mid-duecento Tuscany cannot credibly be attributed to Byzantine models; as with the image of the Mocking, the new image cannot be construed as a Tuscan response to a "privileged form." The image of Christ bearing his own cross was promoted by the Franciscans for good reason: Not only did it depict the human reality of the Passion, but it also evoked the biblical phrase on which the rule of the Order had been based. At the same time, in appropriating an image associated with the crusades, it aptly expressed the Francis-

can ideology of mission. The specific source for the new image may have been one of the uncommon Italian depictions of the type, or one of the plethora of Gothic versions; the precise origin seems less important than the narrative strategies that prompted its formulation. Despite the largely western origins of the new image, however, certain elements, like the rope and Christ's frailty, were derived from Byzantium; again, these details were particularly apt expressions of local, specifically Franciscan, concerns. The next chapter will present further evidence both of the ingeniously crafted narratives of the mid-duecento and of the prominent involvement of Franciscans in the construction and diffusion of these new images.

THE STRIPPING OF CHRIST AND THE ASCENT OF THE CROSS

✠

The Passion themes that we have discussed thus far are all canonical; the evangelists' accounts prompted their inclusion in medieval Passion cycles, and their presence in duecento painting is not unexpected. The next episodes, however, depict the moments just before the Crucifixion, about which the evangelists are silent. But Christ's final moments became the subject of late medieval writers in both Byzantium and western Europe, and by the mid-duecento two new images had begun to appear in central Italian painting: the Stripping of Christ and the Ascent of the Cross.

The two seem to have appeared almost simultaneously; the first monuments to include them are dated between 1255 and 1265. They are closely linked in other respects as well. The earliest Italian examples of both images originated in the same Byzantine compositions; the same devotional texts describe them, and images depicting one of the two often include allusions to the other. The links are still deeper: Both were shaped by Franciscan ideology and promote themes of critical importance to the Order.

THE STRIPPING OF CHRIST IN ITALIAN PAINTING

This theme, all but unknown in Byzantine art, was evidently depicted in medieval painting only rarely until the thirteenth century.[1] But beginning about 1260, it appears with some frequency in Italian painting. Among the first monumental examples are two virtually contemporary frescoes: one in the Lower Church of San Francesco, Assisi, from the early 1260s (Fig. 82), the other in San Sebastiano, a Latian monastery that housed a community of

Figure 82 Stripping of Christ, c. 1260–5. Assisi, S. Francesco, Lower Church. Photo: Kunsthistorisches Institut, Florence.

Figure 83 Stripping of Christ, c. 1260–5. S. Sebastiano, near Alatri. Photo: Kunsthistorisches Institut, Florence.

the Poor Clares (Fig. 83). Eric Prehn, who published the San Sebastiano frescoes, dated them 1260–5 and ascribed them to a Tuscan painter closely associated with Coppo.[2] The Assisi fresco is badly damaged; of the left part of the composition, only Christ's arms survive. He evidently was shown freely removing his garments; he extends his arms to hand his robe to the men opposite the cross, whose long robes and covered heads identify them as Jewish priests. At San Sebastiano, more of the composition is preserved. There Christ stands in front of the ladder and removes his garments with minimal assistance; in the position of his arms, the fresco closely resembles the Assisi version. At San Sebastiano, he stands nearly nude, for his loincloth is translucent. The Virgin is also included at San Sebastiano; she stands behind her son and gestures in protest as another member of the mob motions her away.[3]

The Stripping of Christ also appears in two manuscripts dated to the same years. One instance occurs in a Bible formerly in the collection of J. R. Abbey; it is dated about 1260 and ascribed to a Bolognese painter (fol. 3v.). The manuscript may have been destined for Ascoli Piceno: The calendar contains a reference to St. Emygdius, the first bishop and patron saint of that

Figure 84 Stripping of Christ and Ascent of the Cross, from a psalter, c. 1255–65. Melk, Stiftsbibliothek, ms. 1903, fol. 47v. Photo: P. Jeremia, Stift Melk.

city.[4] Here a fairly abbreviated version of the Stripping is represented; neither the Virgin nor the ladder appears. As at San Francesco, Christ removes his robe without assistance. The other example is not Italian but German. It appears in a psalter from Bamberg now in Melk (fol. 47v.; Fig. 84); the manuscript has also been dated to the decade 1255–65.[5] Here the Stripping does not greatly resemble the Italian examples, for Christ is now depicted ascending the cross. He stands on the third rung of the ladder and turns to an executioner who peels away his garment, thus revealing the still-bleeding wounds of the Flagellation and, as in the San Sebastiano fresco, a translucent loincloth that does little to conceal his nakedness.[6]

These works are thus closely related chronologically, thematically, and, in the case of the three Italian works, visually. The Italian examples are significant also in their link to a group of later duecento Passion scenes. The image in the Bolognese manuscript closely resembles several later compositions, all from the region of Umbria, the Marches, Emilia and Romagna. For instance, the theme appears in the altar dossal in Perugia, from the Franciscan convent in Farneto (Fig. 3, p. 4).[7] Here the absence of the ladder and the pres-

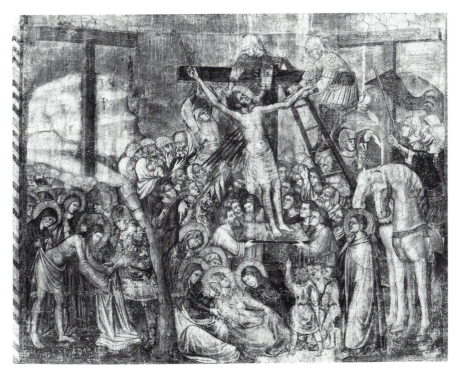

Figure 85 School of Pietro Cavallini. Ascent of the Cross, early fourteenth century. Naples, S. Maria Donnaregina. Photo: Alinari/Art Resource.

ence of the soldiers to the left recall the Bolognese manuscript, while the group of Jews standing to the right resembles the fresco at Assisi. A late variation, in which the Virgin stands to the right, appears in Emilia and Romagna: in a Bolognese panel still in Bologna attributed to the Faenza Master; in a panel formerly in the collection of M. Griggs by the Master of Forli, probably from a Franciscan tabernacle; and in a Bolognese panel in the Vatican.[8] The theme also appears in the early fourteenth-century Franciscan *Officium Passionis* in the Boston Public Library (fol. 38v.), which was probably destined for Ascoli Piceno;[9] here the composition most closely resembles that in the Bolognese manuscript of about 1260, which is also thought to have been made for use in Ascoli.

Relatively few examples of the theme seem to survive from an area much beyond the region of Emilia, Umbria, and the Marches. One appears in the Franciscan dossal in San Diego, a Florentine work from the end of the duecento (Fig. 94, p. 166). This version resembles the fresco at San Sebastiano in that the Virgin stands just behind her son, to the left. Another appears in a larger composition found in a fresco at the Clarisse church, Santa Maria Donnaregina in Naples (Fig. 85). In this fresco the Stripping takes place in the lower left corner; the Virgin is present again, now covering Christ to

shield his nudity as he drops his robe on the ground. Interestingly, this is just one of three images in the cycle that depict the Stripping of Christ: Christ similarly sheds his clothing before the Flagellation and again in a composition that also includes the Mocking and the Way to Calvary.[10] Still another image of Christ disrobing, from the late trecento, is Tuscan; it appeared in the predella of another Franciscan work, Bartolo di Fredi's Ciardelli altarpiece for San Francesco, Montalcino.[11]

The early occurrence of the scene in Franciscan contexts – San Francesco, the mother house of the Order, and San Sebastiano, which housed the Clares – strongly suggests that the new image was promoted by the friars. The Bolognese manuscript, though it was probably a Dominican commission, also has apparent ties to the Franciscans; Francis appears on the first page of the Bible, in a medallion opposite St. Dominic, and is also mentioned in the calendar.[12] Of the later examples, the panels in Perugia and San Diego, the Montalcino altar, the manuscript in Boston, and the frescoes in Naples are demonstrably of Franciscan provenance, and the panel from the Griggs collection is probably from a Franciscan altarpiece. The location of the theme in so many Franciscan sites is not accidental; the image was a potent bearer of meaning for the Order. But if it can best be understood as an Italian subject formulated for a Franciscan audience, it is also true that those formulating it derived the basic composition from a Byzantine source.

THE PREPARATION FOR THE CRUCIFIXION

In several respects, the new composition is clearly derived from a Byzantine theme, the Preparation for the Crucifixion. This subject evidently emerged in the Middle Byzantine period: An early instance is found on an icon of Mount Sinai dated to the late eleventh century.[13] Though this example is still iconographically spare, the essential components of the scene are already present. With hands bound, still wearing a tunic, Christ stands before the cross; the priest on the opposite side gestures toward it in explicit reference to his imminent fate. The scene presumably evolved from a detailed narrative sequence representing the Way to Calvary in several stages. In a Byzantine reliquary in Esztergom, dated about 1200 (Fig. 86), the narrative flavor is still strong. Here both Christ and the priest stand on the left of the cross. The priest turns back to Christ and gestures in a stance clearly related to the pose of the analogous figure who urges Christ on in representations of the Way to Calvary; here, however, he points ominously to the cross. Another transplant from Calvary images is the soldier who shoves Christ's shoulder. A related composition, in which the derivation from the Way to Calvary is even clearer, inspired the Italian illuminator of a manuscript in the Vatican, lat. 39, fol. 64v.[14] Here, in fact, Christ is still being led; a soldier holds one

Figure 86 Preparation for the Crucifixion, Descent from the Cross. Detail of a reliquary, c. 1200. Esztergom, Keresztény Múzeum. Photo: Giraudon/Art Resource.

end of a rope, the other end of which is knotted around Christ's neck. As in the reliquary, this figure turns toward Christ. This sort of composition, presumably extracted from a very dense narrative cycle, must lie behind the new image seen in the Sinai icon. In the icon the narrative elements, the sense of progression from left to right, have been suppressed; the new image is static, symmetrical, and hieratic. Thus this scene, like the Betrayal and the Mocking, further illustrates the emergence of hieratic and iconic elements in Middle Byzantine painting, a phenomenon first elucidated by Kurt Weitzmann.[15]

But if the Preparation can be traced in skeletal form to the eleventh century, it was the late twelfth century, with its propensity for expressive imagery, which fleshed out the composition with new detail. The mosaic at Monreale (Fig. 87) is an apt example. Now a small battery of soldiers, wielding spears and halberds, surrounds Christ, and a similar group accompanies the gesturing priest on the right. Another new motif appears in the bearded figure kneeling at the base of the cross, who raises a mallet to drive in the stakes securing the cross. Neither the mob nor the stake-driver is, however, an invention of the twelfth century; both were derived from earlier Passion scenes. Clusters of soldiers carrying assorted weapons appeared as early as the sixth century, as in the Betrayal at Sant'Apollinare Nuovo. The stake-driver also seems to have been taken from an earlier motif, the executioner who nails Christ's feet to the cross in psalter illustrations.[16] Versions of the Preparation from the late twelfth and thirteenth centuries sometimes

Figure 87 Preparation for the Crucifixion, c. 1183. Monreale, Cathedral. Photo: after Gravina, 1859.

include another significant detail: the ladder that Christ will climb to his death. In a Gospel book on Mount Athos (Iviron, cod. 5, fol. 214),[17] the ladder has been placed directly before Christ and propped against the cross. This sort of composition must have been available to the painters who worked out the new image of the Stripping of Christ. The placement of Christ to the left and the gesturing priests to the right (as at, for instance, Assisi, Fig. 82) could have been derived from examples like the Sinai icon or the Monreale mosaic (Fig. 87). The gesture, placement and garb of the Assisi priest (Fig. 82) clearly recall the corresponding figure at Monreale. The ladder leaning against the cross at San Sebastiano and San Francesco was presumably derived from an image like the miniature in the Iviron

Figure 88 Coppo di Marcovaldo. Ascent of the Cross. Detail of painted cross from Sta. Chiara, S. Gimignano, c. 1261. San Gimignano, Museo Civico. Photo: Renate J. Deckers-Matzko/Valentino Pace.

Gospel book. Clearly, then, Byzantine images provided these painters with a useful framework for the new composition. Equally clearly, however, these Byzantine sources served not as "models" but as points of departure, from which duecento painters, with the guidance of their patrons, created something new. A similar process can be observed in the formulation of the Ascent of the Cross, of which the first extant example was similarly based upon the Byzantine Preparation for the Crucifixion.

THE ASCENT OF THE CROSS IN ITALIAN PAINTING

The Stripping of Christ and Ascent of the Cross are closely related, as the Melk manuscript (Fig. 84) suggests.[18] The first Italian monuments to include the Ascent appear at about the same time as the first instances of the Stripping: The first extant example appears in Coppo di Marcovaldo's San Gimignano cross, c. 1261.[19] The theme becomes fairly common in later duecento painting, though later surviving examples do not greatly resemble Coppo's version. In Coppo's composition (Fig. 88), Christ's executioners

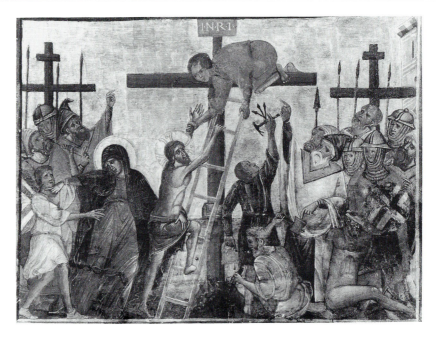

Figure 89 Guido da Siena. Ascent of the Cross, c. 1275–80. Utrecht, Rijksmuseum Het Catharijneconvent. Photo: museum.

have already stripped him of his robe, baring his blood-spattered torso, as in the Melk manuscript (Fig. 84).[20] His stooped shoulders reveal his physical exhaustion, and his crossed hands, though apparently derived from his bound hands in the Way to Calvary, here imply a futile attempt to hide his near-nakedness. Most compelling, though, is the suggestion of Christ's psychic suffering at the moment just before his death: His halting and tentative stance, his bowed head, and his downcast eyes all betray a deeply human reluctance to proceed. But a cowled, bearded priest signals that the climactic moment has arrived; pointing to a ladder held by a helmeted soldier, he orders Christ to begin the ascent. Slowly, he complies, placing one foot on the lowest rung. As if impatient at the pace of the execution, soldiers prod him along. One shoves his shoulder while another, stationed on the patibulum, brandishes nails and yanks a rope tied around his neck.

Guido da Siena's panel in Utrecht (Fig. 89), probably from the later 1270s, at first glance appears to be a more elaborate representation of much the same theme. As in Coppo's panel, this scene represents Christ's actual ascent: Again he begins to climb the ladder with one foot still on the ground, the other poised on a low rung. A number of common details – the placement of the ladder, the gesticulating bearded figure to the right, the spear-wielding soldiers, the executioner stationed at the cross-bar, the conspicuous display of hammer and nails – further underline the kinship of the two scenes. However, Guido's scene differs considerably. Anticipating Duccio's

great crowd scenes, he expands Coppo's cast of characters to include a wide range of soldiers and spectators, among them the nude, blindfolded thief seated on the ground to the right. Befitting the Sienese devotion to the Virgin, he accords a prominent role to Mary, who here encircles Christ's waist in a futile attempt to prevent her son's death. One of the soldiers, presumably the centurion Longinus, even carries a shield emblazoned with the Sienese coat of arms. In these respects, then, Guido has evidently adapted the image to a Sienese audience.[21]

The greatest difference, however, is the stance of Christ. Unlike Coppo's anguished prisoner who laboriously begins the ascent, Guido's Christ resolutely seizes the ladder and bounds forward, actually bypassing the lowest rung in his apparent eagerness to proceed. The profoundly human image of Coppo's suffering victim has been displaced by this image of Christ as triumphant savior, whose will to redeem humanity far outweighs any reluctance to suffer and die. This general composition makes a number of appearances in the later duecento and early trecento. But though the scene undergoes many modifications, most later versions – such as the one in the San Diego dossal (Fig. 95, p. 167) – follow Guido in depicting Christ freely climbing the ladder and in thus emphasizing his heroic acceptance of death.[22]

THE ASCENT OF THE CROSS: ITALY AND BYZANTIUM

Both versions of the theme demonstrate again Italian painters' assimilation of Byzantine images, but Coppo and Guido probably worked from different sorts of eastern compositions. Coppo evidently derived his version of the Ascent (Fig. 88) in large part from the Byzantine images of the Preparation for the Crucifixion that also served the first painters of the Stripping of Christ. In several respects, the version at Monreale (Fig. 87) especially anticipates Coppo's. In each Christ stands before the crucifix, confronted by the gesturing priest; in each Christ's stance, with wrists crossed, is much the same. Further, in each the two protagonists are joined by a group of figures, some of whom carry weapons. In each the placement, garb, and stance of the priest are virtually identical. Another comparable detail is the kneeling executioner. Coppo has transferred this figure from the foot of the cross to the patibulum and restored, in a sense, his original function: As in the earlier psalters, it will be his task to nail Christ to the cross.[23] Despite these differences, the relationship between the two executioners, and the ultimate derivation of both from the corresponding figure in the psalters, is fairly clear.

Other details of Coppo's panel more specifically recall other late twelfth- and early thirteenth-century versions of the theme. The soldier shoving Christ's shoulder appears in the Esztergom reliquary (Fig. 86). The ladder

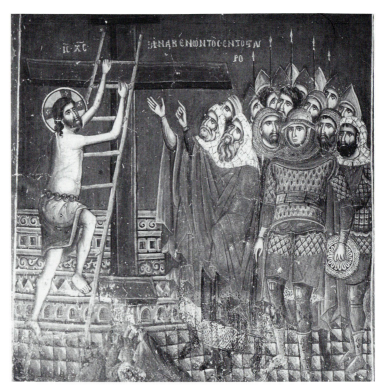

Figure 90 Ascent of the Cross, 1299. Prilep, St. Nicholas. Photo: Smiljka Gabelić.

and the wall in Coppo's panel similarly appear in Iviron 5; there Christ's bowed head especially resembles Coppo's Christ. The rope around Christ's neck was seen in the Vatican miniature and possibly in its Byzantine proto- type. A final detail also seems related to a western work based on a Byzantine source: the position of the soldier holding the ladder may have been derived from a model similar to that used by the illuminator of the *Hortus Delicia- rum*.[24] Thus, as with each previously examined Passion scene, Coppo's Ascent of the Cross reveals his careful study of Byzantine compositions, particularly compositions dating from the late twelfth and thirteenth centuries.

But the close correspondences between Coppo's panel and these Byzan- tine and Byzantinizing works do not obscure the significant differences: Coppo has again altered his model to present an image far more potent than those that preceded his. Thus he depicts Christ stripped, conveying to the audience both the physical suffering inflicted by the Flagellation and the psy- chic humiliation of near nudity. Christ's blood-spattered torso may be an adaptation of the Byzantine composition to a central Italian audience: Bared and bloody backs would have been a familiar sight in Tuscany and Umbria around the year 1260, when the *disciplinati*'s penitential zeal swept through

central Italy.[25] Most significantly, Coppo has changed the actual moment represented: Christ no longer merely contemplates his imminent death but haltingly begins his ascent up the ladder.[26]

Some fifteen or so years after Coppo, Guido similarly appropriated and adapted a Byzantine composition (Fig. 89). In this case, images clearly related to Guido's can be found in the art of the eastern Mediterranean and the Byzantine spheres of Macedonia and Serbia. An early instance appears in an Armenian manuscript published by Thomas Mathews;[27] the basic composition recurs in Macedonian and Serbian fresco cycles towards the end of the thirteenth century.

One of the closest examples appears in the fresco cycle at St. Nicholas, Prilep, executed about twenty years later than the Utrecht panel (Fig. 90). The Prilep fresco provides us with a clear example of the sort of composition that must have been available to Guido. Compare, for instance, Christ's bounding stance, the angle of his head, the gesturing, bearded priests to the right, and the helmeted, spear-bearing soldiers behind them. Guido must have studied an image much like this one, though he recast it considerably; such important elements as the interceding Virgin and the seated, nude thief appear nowhere in the Byzantine sphere.[28]

Thus Coppo and Guido, like the painters who first depicted the Stripping of Christ, again clarify the complexity of Tuscan painters' appropriations of Byzantium. These painters must have had access to Byzantine images; Coppo, like the painters of the Stripping, presumably worked from some version of the Preparation for the Crucifixion, while Guido almost certainly knew a Byzantine Ascent of the Cross. But all of these painters reworked their sources substantially; if they intended their compositions to resemble imported icons, they nonetheless felt no compunction about reinterpreting them. In so doing they created new images formulated expressly for a local audience.

THE STRIPPING OF CHRIST AND THE FRANCISCANS: THE POLITICS OF POVERTY

That local audience was very probably Franciscan. Both new images – the Stripping of Christ and the Ascent of the Cross – assert central tenets of the Order. The relevance of the Stripping of Christ to the Franciscans can be readily demonstrated; the narrative scene is in some ways comparable to Cimabue's Santa Croce cross, where, as discussed in Chapter 1, the translucent loincloth suggests Christ's nakedness. Like the translucent loincloth, the Stripping appears first in Franciscan contexts: the frescoes at San Francesco and San Sebastiano; thereafter it is seen repeatedly in works demonstrably produced for Franciscan patrons.

Similarly, references to Christ's stripping occur repeatedly in Franciscan texts. Pseudo-Anselm's *Dialogus Beatae Mariae*, written after 1240, is relatively terse. There the Virgin describes the moment to Anselm: "They stripped Jesus, my only son, completely of his vestments. . . Taking the veil from my head, I wrapped it around his limbs."[29] Pseudo-Bede, however, is considerably more expansive:

Then consider that the clamoring crowd leads Christ to the place of Calvary, and then, with them all watching there, He is stripped of His garments, and with greatest pain, because the inner part of the garment stuck tight [to Him] because of the blood of the flagellation, and then His body appeared, [once] so finely formed, totally bloodied. O what great sorrow it was to you, most holy Mother, when you beheld that sight.[30]

Bonaventure similarly refers repeatedly to the disrobing of Christ. The *Vitis mystica* discusses the theme at some length:

But let us come now to the final events. Our most loving Lord Jesus Christ is stripped of His clothes. Why? So that you may be able to see the ravages done to His most pure body. Therefore is this supremely good and sovereign Jesus despoiled. Alas, the Lord is stripped, He who was King before time began, *in splendor robed. . .and girt about with strength*; He to whom we sing: *You are clothed with majesty and glory, robed in light as with a cloak.* He is *made a spectacle* and a shame *to the world. . . and to men, as a portent . . . to many, and a laughingstock among the peoples*: He, our Head, our Joy, our Honor, Jesus All-good![31]

The fullest description, however, is found in Pseudo-Bonaventure. This writer tells his readers that Christ was stripped on three occasions: before the Flagellation, after which his captors "led Him naked and beaten through the house, seeking His clothes. . ."; just after he was condemned by Pilate, when he was "led back inside, stripped of the purple and [stood] before them nude"; and finally, just before the Crucifixion, when he was "nude before all the multitude for the third time."[32] His description recalls Pseudo-Anselm and Pseudo-Bede in several points, but he provides a still more complete picture:

Again He is stripped, . . . His wounds reopened by the adhesion of His garments to His flesh. Now for the first time the Mother beholds her Son thus taken and prepared for the anguish of death. She is saddened and shamed beyond measure when she sees Him entirely nude: they did not leave Him even His loincloth. Therefore she hurries and approaches the Son, embraces Him, and girds Him with the veil from her head. . . .[33]

These Franciscan writers thus dwell on the stripping in part to convey

Christ's humiliation during the Passion; it was one additional indignity, inflicting psychic and physical pain. But these authors elaborate on this moment for other reasons as well. As I argued in the discussion of Cimabue's Santa Croce cross (Chapter 1), Christ's nudity proclaimed his poverty, and thus the vow on which Francis founded the Order.

Franciscan writers seized upon the image of Christ's nakedness to promote and defend their vow of poverty, and thus they repeatedly wove references to his disrobing into their devotional texts. As noted before, Bonaventure explicitly associated the stripping of Christ with the ideal of poverty; the fullest exposition of Bonaventure's use of Christ's nudity as a metaphor for poverty is found in his *Apologia pauperum*, which is laced with references to "the naked Christ" and "the nakedness of absolute poverty." The *Meditatio pauperis* similarly relies heavily on the metaphor.[34]

The emphasis on Christ's stripping in Franciscan Passion cycles can therefore be read as a visual justification of the vow of poverty: The vow is sanctioned by the example of Christ himself. The theme also asserts Francis's identity as *Alter Christus*, for it recalls Francis's similar acts of disrobing, to the same end. Francis's contempt for worldly goods was seen repeatedly throughout his life; on several occasions, he cast off his garments and stood "completely naked before all."[35] The best known occurrence was the rejection of his father's patrimony that marked his entrance into religious life. Francis publicly renounced his father's wealth when he dramatically stripped off his clothing, at which point the Bishop of Assisi hastened to cover the nude young man with his cope. This was not, however, the first such instance. The *Legenda maior* mentions one episode, before the renunciation, when Francis "took off his own clothes" and gave them to an impoverished knight, and other occasions when he was approached by beggars and "took off his clothes and gave them away."[36] After the renunciation, Francis shed his clothing repeatedly. For instance, he once exchanged his cloak for a lamb that was maltreated and on another occasion disrobed in public penance. The *Scripta Leonis* provides still another example; not long before his death, he "undressed himself, and continued to sit, quite naked, on the bare earth." Later he instructed his companions to "undress [him] completely" after his death, and place his body "on the bare earth."[37] Each of these instances reaffirms the ideal of poverty on which Francis founded the Order.

The importance of these events to the Order is underlined by their depiction in art. The Bardi dossal depicts no fewer than three of the events in which Francis rid himself of his garments.[38] Francis's nudity as *imitatio Christi* is explicit at the Lower Church at Assisi, where the Stripping of Christ appears just opposite the scene of Francis's renunciation of his father. In fact, the link between the two events is made still closer by Franciscan writers like Pseudo-Anselm, Pseudo-Bede, and Pseudo-Bonaventure, who

insert a new detail into their narratives: Mary shielding Christ's nudity with her veil. Her gesture clearly parallels the actions of the Bishop of Assisi and suggests a manipulation of the Passion narrative to promote Francis's identity as *Alter Christus*. The motif eventually appears in images of the Stripping of Christ and Ascent of the Cross, such as the fresco in the Clarissan convent, Santa Maria Donnaregina (Fig. 85).[39]

Thus the Stripping of Christ would have forcefully conveyed to a Franciscan audience the voluntary vow of poverty, on which Francis founded the Order. And this image would have been particularly charged with meaning for that audience about 1260–5, when the subject first appeared in Italy. As already discussed in Chapter 1, the correct interpretation of this vow was then the subject of intense debate. The Chapter of Narbonne, convened by Bonaventure in 1260, supported a rigorous fidelity to the vow, just as Bonaventure's *Expositio in regulam fratrum minorum* mandated *"nudissima paupertas."* The appearance of the Stripping of Christ in four images of about 1260–5 coincides closely with the Chapter of Narbonne and the renewed emphasis on *"nudissima paupertas."*[40] Further, all the images show Christ voluntarily shedding his garments, with minimal assistance or none at all – thus visually proclaiming his free embrace of poverty. Like the Santa Croce cross discussed earlier, and like the agile Bonaventure, the frescoes stake out an interesting middle ground: They manage to signal the centrality of poverty while simultaneously affirming the validity of images, and the validity of the (often lavish) churches that they decorated.

The emergence of these images just at the time of Narbonne thus is eminently understandable. Both the issues and the images lived on well beyond the early 1260s, however. In subsequent general chapters, the Order continued to grapple with the interpretation of poverty, repeatedly issuing modifications.[41] Bonaventure's *Apologia pauperum*, written about 1269–70, is a detailed, closely argued, and unequivocal treatment of poverty, intended primarily to rebut the attacks on the vow by the secular clergy.[42] Bonaventure's stance was affirmed by the bull of Nicholas III, *Exiit qui seminat*, issued in 1279.[43] The continuing struggles between the Conventuals and Spirituals at the end of the century and into the next kept the debates alive; these struggles provide a context for the continuing interest in the theme in the late duecento and into the trecento. One of the three branches of the Spirituals was based in the Marches; as noted above, most of the later images of the Stripping to survive come from this area and neighboring Romagna and Umbria.[44] Conceivably the interest in the theme in this region was generated, in part, by the presence of the Spiritual community; though the strictest interpretation of *usus pauper* would presumably exclude most art altogether, staunch proponents of poverty who tolerated images would have found, in this one, an apt expression of their position. The Stripping appears as well,

not once but three times, in Santa Maria Donnaregina, Naples. This triple appearance conforms with Pseudo-Bonaventure's *Meditationes*, but may similarly indicate Spiritual ideology: A Spiritual community was housed at the second Clarissan church in Naples, Santa Chiara, which was closely linked with Santa Maria.[45] Conversely, the absence of the Stripping from the densely illustrated Passion cycle by Pietro Lorenzetti and his shop in the Lower Church of Assisi may suggest that, by this date, the theme had taken on a Spiritualist cast no longer acceptable in the Conventual bastion of San Francesco.[46]

THE ASCENT OF THE CROSS, RENUNCIATION, AND THE *IMITATIO CHRISTI*

The Ascent of the Cross, closely related to the Stripping of Christ visually, is equally close ideologically; it, too, was forged by the Franciscans, and the issues that seem to inform it are much the same. Like the Stripping, it also appears in several identifiably Franciscan monuments, among them a Sienese panel in the Wellesley Museum, where it is placed above the Funeral of St. Clare; the San Diego dossal (Fig. 95); a fresco at Sant'Antonio in Polesine (where Christ is depicted in a particularly gauzy loincloth); the *Vita Christi* manuscript by the workshop of Pacino di Buonaguida; and in the *Supplicationes Variae* manuscript in Florence, which has strong Franciscan affiliations.[47] Coppo's cross (Fig. 88), which contains the first extant example of the theme, is also a Franciscan commission; the rope around Christ's neck in his version of the scene seems still further evidence of its Franciscan origins.[48]

The provenance of another important monument depicting the theme, Guido's panel in Utrecht (Fig. 89), is unknown, but worth exploring. The panel has often been considered part of an altarpiece for San Domenico in Siena, though that assumption has been questioned by Henk van Os, among others.[49] Van Os's arguments gain further credence when we consider the specific imagery of the Utrecht panel, which is arguably Franciscan. Particularly suggestive here is the inclusion of the nude thief seated on the ground in the Utrecht panel. This unusual motif, which to my knowledge does not appear in other extant versions of the Ascent of the Cross, seems to work on more than one level. First, it serves to remind the audience of Christ's abasement during the Passion. Several Franciscan writers stress the presence of the thieves at the Way to Calvary and the Crucifixion, in particular Bonaventure, who emphasized that his Passion was "UTTERLY DEGRADING" [his capitals] because Christ was "hung on a tree like a robber and a thief" at the execution site for "the vilest of men."[50] Pseudo-Bonaventure elaborates:

He was led outside with His companions, the two thieves. Behold, this is His company! O good Jesus! How much shame these friends of yours cause you! They associate you with thieves, yet make you their inferior, for they impose on you the carrying of the cross, which we do not read was done to the thieves. Thus you are not only "numbered with sinners," according to Isaiah (Isa. 53, 12), but as more sinful than sinners. Your patience, Lord, is indescribable.[51]

In describing the Crucifixion, Pseudo-Bonaventure picks up this thread again: "He bears the bitterest pain and is affected beyond anything that can possibly be said or thought. He hangs between two thieves."[52] The author of the *Meditatio pauperis* also tells us that Christ hung among thieves.[53] The insertion of the thieves in later Passion narratives produced for the Order – such as the Ascent of the Cross at Santa Maria Donnaregina (Fig. 85) or the Way to Calvary by Pietro Lorenzetti at San Francesco (Fig. 74) – also attests to the importance of the motif in Franciscan Passion narratives. In fact, the good thief, as a penitent, was at times featured alone in Franciscan monuments, as at the Magdalen Chapel at Assisi.[54] The inclusion of the thief in the Utrecht panel parallels the thieves' prominence for Bonaventure and Pseudo-Bonaventure and thus reinforces the likelihood of the panel's Franciscan origins. However, the presence of the thief – naked, seated on the ground – is still more suggestive. His nakedness can be read as another Franciscan concern: It underlines the nearly nude status of Christ himself and recalls the insistence on Christ's nudity in Franciscan accounts of the Passion. Finally, the fact that the thief sits naked, on the ground, just before his execution calls to mind the incident described by the *Scripta Leonis*, in which Francis sat "naked, on the bare earth" just before his death. Just as Francis was compared by Bonaventure with a thief, here the thief may evoke Francis.[55]

It is not merely the thief, of course, but the Ascent itself that suggests that Guido's panel was a Franciscan product. Like the Stripping of Christ, the Ascent of the Cross is described repeatedly in Franciscan devotional texts – the same texts that describe the Stripping of Christ. A terse account appears in Pseudo-Anselm's *Dialogus*: "He ascends the wood of the cross."[56] Bonaventure elaborates only slightly in his *Officium de compassione beatae Mariae virginis*: "With the cross erected, Christ ascends and extends his arms; his hands and feet are nailed; seeing this, his most pious Mother grows faint with sorrow."[57] A far more explicit description is provided by Pseudo-Bede's *De meditatione Passionis Christi*. He first describes the Stripping, then continues:

Then, when the cross had been prepared, they cry: "Ascend, Jesus, ascend." O how freely He ascends, with what great love for us He bore everything, with what patience, what gentleness! . . . Thus, entirely nude, He is raised and extended on

the cross. But His most loving mother, full of anguish, placed her veil, which had been on her head, around Him, and covered His shame. . . . Then cruelly He is raised, extended, and with His entire sacred body He is spread and stretched apart.[58]

The key to the meaning of this episode for the Franciscan order is in the phrase "ascend, Jesus, ascend." The Ascent of Christ on the cross was typologically linked with the ascent of Elisha to Bethel, when the prophet was mocked by boys who taunted his baldness: "Ascende, calve, ascende, calve" (2 Kings 2:23). The connection is sharply drawn by St. Bernard, who wrote: "Sed ubi crucifixerunt eum? In Calvariae loco. Ad hanc calvitem Elisaeus ascendebat. . . *Ascende, calve, ascende, calve.*" Elsewhere, he similarly linked the two: "Ascendit itaque crucem calvus noster."[59] The imagery of Christ's ascent and Elisha's ascent also appears in mid-thirteenth-century sermons on the crusades. As Penny Cole has shown, Roger of Salisbury and Eudes of Chateauroux used the Ascent of the Cross to exhort potential crusaders; Roger again uses the typological tie to Elisha, citing the same passage ("adscende, calve, adscende"). For these preachers, the Ascent thus became a metaphor for taking the cross, and for renouncing the world, traveling "from the world to the Father."[60]

As noted in Chapter 5, the Franciscans rarely hesitated to adapt the rhetoric of the crusades, and the appropriation of the metaphor of ascending the cross seems another example, comparable to the Order's adoption of Matthew 16:24 as a credo and the image of Christ carrying the cross as an emblem. For the Franciscans as for preachers of the crusades, the image of voluntary self-sacrifice implicit in Christ's willing ascent of the cross similarly referred to the renunciation of the world. Now, however, renouncing the world took on a more specifically Franciscan meaning. Franciscan promotion of Francis as a new Elisha made the imagery of the Ascent of the Cross especially useful to the Order. As Amy Neff has demonstrated, Francis, like Elisha, left his family and renounced worldly goods to preach; the moment of his calling, in which Francis was covered by the Bishop of Assisi, finds a parallel in the calling of Elisha, chosen as the successor to Elijah when the prophet cast his mantle over him.[61] The link between Francis and Elisha is explicit in the *Meditatio pauperis*, written in 1282–3, which Neff cites in connection with the wicked children mocking Christ.[62] In this text, Francis, as a second Elisha, rejects "all the riches of the world" and ascends to Bethel, "that is, into the Order of the Friars Minor, which truly is the home of God."[63] To a Franciscan audience, then, the image of Christ ascending the ladder – especially the image of the willing ascent seen in the Utrecht panel and the related examples (Fig. 89) – would have evoked Francis's ascent "into the Order of the Friars Minor" and their own renunciation of the riches of the world to follow Francis and Christ.[64]

The author of the *Meditatio pauperis* may have drawn his metaphor also

from Bonaventure, who had used the imagery of ascent and *imitatio Christi* in a related context. In the *Legenda maior* (IX, 1), he wrote of Francis: "He followed [Christ] everywhere by His likeness imprinted on creation; of all creation he made a ladder by which he might mount up and embrace Him who is all-desirable." Similarly, in a sermon of 1267, preached on the eve of the Ascension, Bonaventure described Francis ascending a ladder and thus imitating Christ: "The Lord says to [Francis]: Go up with my help, for I am the ladder on which you can ascend. This is signified by the ladder which Jacob saw. . . . What is this ladder other than our Lord Jesus himself? . . . Then the Lord says to me: Go up after me by following my example perfectly in your life."[65]

Bonaventure also used a similar metaphor in his *Apologia pauperum*, written about 1269–70. As discussed before, the text forcefully reasserts voluntary poverty and self-sacrifice in response to the criticisms of Gerard of Abbeville. Insisting on voluntary poverty, he wrote: "In your nakedness follow the naked cross. You will then climb Jacob's ladder more easily and lightly."[66]

A related theme in the text also seems relevant to the image of the Ascent: Bonaventure insists, at some length, upon the desire for martyrdom as essential to evangelical perfection. Chapter 4 of the *Apologia* – "The Desire for Martyrdom is Shown to be Perfect As Such, and the Flight from Martyrdom to be Imperfect As Such" – opens by quoting a gloss to Heb. 12:1: "Let us dauntlessly run to the fight of the martyr."[67] This insistence on martyrdom, discussed already in reference to the Betrayal of Christ, again refuted Gerard, who "lavishly praises flight from persecution and death."[68] Again, the image of Christ vigorously bounding up the ladder to be crucified seems to embody Bonaventure's exhortation to "dauntlessly run to the fight of the martyr." Given this context, then, the frequent occurrence of Christ's ascent in Franciscan texts and monuments and the emphasis on Christ's energetic ascent to his death becomes understandable.[69]

Coppo's version of the theme stands in sharp contrast, for he clearly conveys the anguish of Christ at this critical juncture rather than his willing self-sacrifice. The Melk illumination, of about 1260, similarly depicts a weary, battered Christ rather than the dynamic figure seen later. The cross, like the Melk manuscript, is an early work, probably around 1261. Though it was a Franciscan commission, as Coor suggested long ago,[70] Coppo's Ascent was presumably an early formulation that did not gain wide acceptance. The stance of Christ in the Utrecht panel and the related works – none earlier than about 1275, and most later – far more forcefully conveys the willingness of his sacrifice, and thus seems more consistent with the tone of Bonaventure's *Apologia* (circa 1269–70) and the *Meditatio pauperis* (circa 1282). The correspondence between this type and these Franciscan texts pre-

sumably helped establish the image; it was repeated well into the trecento.[71]

These images, the Stripping of Christ and the Ascent of the Cross, thus offer the clearest case of the direct involvement of the Franciscans in constructing the new images of the Passion that appear in mid-duecento Italy and beyond. In this case we see again newly graphic representations of Christ's sufferings during the Passion, again appropriated and adapted from Byzantine monuments. But if the new images encouraged the christocentric piety fostered by the Order and others, they served the Franciscans still more specifically. They can be read as a kind of visual equivalent to texts like the Statutes of Narbonne and Bonaventure's *Apologia pauperum*: an assertion of the Franciscan vow of poverty and longing for martyrdom, and a reminder of the origins of Franciscan poverty and self-sacrifice in that of Christ.

CONCLUSION

✠

This survey of Passion narratives in duecento painting suggests that the prevailing definitions of the period need to be reconsidered. We have seen, first, that the visual culture of this period was far more fluid than it is often thought to be. Traditional religious images were in a state of flux during the thirteenth century, and beginning about 1235–40, a full-scale transformation of traditional Passion narratives took place. This transformation – a kind of iconographic sea-change – is not entirely surprising, in that it parallels the similar shift from the *Christus Triumphans* to the *Patiens*. The shift in the treatment of the Crucifixion is standard fare in surveys of the period; however, the concomitant changes described here are almost unknown. Taken together, they challenge the conventional view of the duecento as a time of stasis, a kind of dormant period in Italian painting before the great reawakening heralded by Giotto. The significance of the new images can perhaps be understood in light of Clifford Geertz's definition of culture as "an historically transmitted pattern of meanings embodied in symbols, a system of inherited conceptions expressed in symbolic forms."[1] What we have seen consistently is the conscious manipulation of images to reshape and redefine those patterns of meaning – in other words, a series of interventions into inherited conceptions and the symbolic forms that express them.

Like the *Christus Patiens*, the new images attest to a willingness to depict Christ's humanity with an unsparing directness. In so doing, the painters appear to follow the instructions that would be issued later in the century by the author of the *Meditationes*: "Turn your eyes away from His divinity for a little while and consider Him purely as a man."[2] At times the new

images that depict Christ "purely as a man" depart so sharply from the versions sanctioned earlier that they must have shocked the first viewers with their immediacy.

The second purpose of this study has been to analyze the new images in the context of Byzantine art. The profound reconsideration of Christ's Passion and the images depicting it took place at a time when Byzantine works – icons on panel, mosaic icons, ivories, manuscripts – are usually believed to have been widely available in central Italy. This assumption has recently been contested: Few of these Byzantine works can be documented in Tuscany until the fifteenth century. But duecento painting itself offers compelling testimony, which is, in my view, almost as definitive as written records: As we have seen repeatedly, these Passion narratives often resemble Byzantine versions extremely closely. It is hard to imagine how so many painters could have so nearly duplicated such a wide range of Byzantine images if they had not had Byzantine objects, or very good copies, close at hand.

However these works might have reached Italy – as the booty of the Fourth Crusade, through Tuscan commercial transactions in the Levant, through itinerant Byzantine painters, through the Franciscans' various ventures east – and whatever their ultimate fate, they became an invaluable resource for the painters who "turned [their] eyes away from [Christ's] divinity." The extent to which central Italian painters must have scrutinized these Byzantine images has not always been acknowledged, and I have tried to give some indication of the depth and precision of their scrutiny. Even in the early trecento, painters like Duccio and Giotto at times evidently viewed Byzantine images with interest, on occasion adapting the latest eastern imports almost as readily as did their duecento predecessors. This use of Byzantine images even by the great artists of the *dolce stil nuovo* again challenges the traditional Vasarian claims for Giotto and his contemporaries, which might allow for Byzantine "influence" during the *maniera greca*, but rarely countenanced its continued importance after 1300.

Third, I have argued that even in the duecento, the reception of Byzantine images was a considerably more complex matter than it is generally thought to have been. This appropriation of Byzantine forms was carefully calculated, tempered by a fine sense of the utility of the eastern image to an Italian audience. Whatever the status of Byzantine icons, whatever their prestige as luxury goods, or *apotropaia*, or trophies, duecento painters and their employers did not view them merely as models to be reproduced as "multiples" of privileged originals. Byzantine images unquestionably offered alternatives to traditional formulae, and these alternatives often coincided closely with Italian interests. But when they did not – especially in the Mocking of Christ, and also in the Way to Calvary – duecento painters and patrons found more useful images elsewhere. Even in these two cases, painters

retained some Byzantine features; perhaps this eastern gloss conferred a certain status or authenticity to the images. But we cannot assume, as Belting seems to, that Byzantine icons represented the authority of "privileged forms" that allowed no deviation.

Real authority in the formation of duecento Passion images seems to have been wielded by Italian religious groups, most prominently by the Franciscans. Franciscan hegemony especially in Passion images has been implicitly accepted by modern scholars: The replacing of the *Christus Triumphans* by the *Patiens* has been almost universally ascribed to the influence of the Order. I have tried to show that the Order's impact on the visual culture of duecento Italy went still further, and that the new narratives of the Passion, most of them directly comparable in tenor to the *Christus Patiens* which they often accompany, similarly bear a Franciscan imprint.

Even circumstantially, one can build an argument implicating the friars in the crafting and diffusion of the new narratives. To begin, one might argue that the swift success of the newly minted narratives, which circulated throughout central Italy in fairly short order, implies a powerful patron. In theory, any small and enterprising band trying to foster devotion to the Passion might have refashioned the narratives, decorating a church or two with the new images. But the rapid spread of the new images throughout central Italy suggests larger forces at work. Only a group that was itself widely dispersed, and that sponsored painting on a large scale, would seem to have had the resources to effect such a thorough transformation.

The Dominicans, the Franciscans' only serious rival in position and influence, do not seem a likely candidate: They evinced comparatively little interest in narrative cycles of any kind throughout most of the duecento. But almost from the beginning, the Franciscans were unequivocally concerned not only with the Passion but also with the use of images to stimulate affective piety; Francis himself responded powerfully to the painted cross in San Damiano. The followers of Francis commissioned narrative cycles of the Passion with evident zeal. Despite the paucity of surviving duecento fresco cycles, enough of them remain to show that the Order repeatedly decorated their churches with frescoes recording the Passion: The Passion cycles at San Francesco, Assisi, as well as those at San Sebastiano in Alatri, San Pietro in Vineis in Anagni, Santa Maria degli Angeli in Spoleto, and Sant'Antonio in Polesine in Ferrara, all attest to the preeminence of the theme. If we move beyond the thirteenth century into the trecento, the number of extant fresco cycles devoted to the Passion in Franciscan churches multiplies. Passion images in duecento panel paintings for the Franciscans and Clares only further affirm the Order's considerable investment of its energies (and its funds) in the subject. The circumstantial case for the Order thus seems reasonably strong.

The case becomes stronger when we consider the Passion narratives more specifically. The changes in the images – all observable in these Franciscan frescoes and panels – unquestionably accord with the view of Christ's Passion promulgated by the Order. Like most of the contemporary accounts of the Passion written by Franciscans, the new images fairly consistently depart from the traditional versions that minimized the reality of Christ's death, instead portraying him as a vulnerable, suffering human. Moreover, we have seen that there are often strikingly close correspondences between texts authored by Franciscans and these new narratives. The texts and images agree not only in tenor but also, often, in details. Recall the seated Christ faltering under a barrage of assault by taunting men, the rope around his neck used to lead him to Calvary, his stripping before his mother, who hastens to cover his nudity, the ascent up the ladder – all of these extra-canonical details are described, often at length, in Franciscan devotional tracts, and all are seen in contemporary frescoes and panel paintings commissioned by Franciscans.

In fact, the aptness of the new images for the Order goes still further: Often the new narratives seem to have been consciously and ingeniously constructed to advance Franciscan interests. Most of the new images can be read, in Blume's term, as a kind of Franciscan "*Ordenspropaganda*," as visual assertions of Franciscan ideology. For instance, the new version of the Mocking of Christ forcibly proclaims Christ's humility: a central tenet for the friars, the "summit of evangelical perfection" for Bonaventure. Christ Bearing the Cross becomes a kind of emblem of the Order, evoking the reference to Matthew 16:24 – "take up your cross" – in the original Rule. The Stripping depicts Christ as exemplar of Franciscan poverty, "naked and destitute." The Ascent of the Cross suggests his renunciation of the world and embrace of death. The centrality of precisely these points for Francis's order has been noted by Daniel, who summarizes Bonaventure's vision of the friars' task as follows: "The imitation of Christ and the apostles includes self-vilification, because Christ emptied himself for the sake of mankind; renunciation of worldly goods, because Christ was stripped of all clothing; obedience unto death, because the crucifixion exemplified perfect virtue."[3]

Though all of these images are of course christological, a Franciscan would have immediately read them as references as well to the Order's founder. All implicitly assert Francis's identity as *Alter Christus* – an essential construct for the status and authority of the Order. Thus the Mocking recalls Francis's own repeated acts of self-abasement and self-mortification. The Stripping calls to mind the numerous occasions on which he publicly shed his clothes and the rejection of worldly goods that those acts symbolized. The rope around Christ's neck in the Way to Calvary and other Passion themes implies the penitent Francis similarly led; the ropes suggest as well

the cord that was integral to the Franciscan habit. Both the Way to Calvary and Ascent of the Cross evoke his words and his mission: to follow the footsteps of Christ even unto death.

Even the timing seems to support some of these narratives as self-conscious, and especially Bonaventuran, "*Ordenspropaganda.*" For instance, the Stripping appeared around 1260–5, just at the time of the Chapter of Narbonne, where Bonaventure, and the full chapter, reiterated support for "*nudissima paupertas.*" The Ascent of the Cross in which Christ bounds up the ladder emerged first in the 1270s, not long after Bonaventure wrote the *Apologia pauperum*, in which he returned with new vigor to the theme of the friars' desire for martyrdom. The version of the Betrayal that appeared around 1240 does not promote the *Alter Christus*, though it does conform nicely to Francis's own description of the event. However, the later version of the Betrayal in which Christ halts Peter's attack – seen in the Upper Church at Assisi and elsewhere, again beginning in the 1270s – seems distinctly Bonaventuran. It invokes the Minister General's similar emphasis in descriptions of the Betrayal and his insistence on Christ's – and Franciscans' – willingness to embrace death. And both versions of the Betrayal may have reaffirmed the vow of poverty to a Franciscan audience, reminding them that Judas's covetousness led him to betray Christ.

Finally, the Trial of Christ has few apparent connections with Francis himself, nor with Bonaventure beyond the fact that both this scene and some of Bonaventure's writings participate in the discourse of antisemitism. The image can, however, be read as a corollary to and justification of contemporary antisemitic polemics, and a reminder of the non-Christian "other" whose conversion was central to the Order's mission. All of the new images, then, go beyond a mere correspondence with Franciscan piety, and even beyond a fairly precise correlation with Franciscan written accounts. Like the texts, they seem to have been carefully crafted to promote the Order's founder and its mission; at times they seem particularly fitting expressions of a more specifically Bonaventuran ideology. All suggest the confluence of text and image, and the skillful assertion of the same issues in both visual and verbal spheres.

The ways in which the images work in tandem can be seen by examining one full cycle, the Florentine dossal in San Diego, in which the narratives date from about 1290–1300 (Fig. 4; repeated here as Fig. 91). The work has been said to come from Santa Maria dei Candeli in Florence, which was, at least from the mid-trecento, an Augustinian church. But the imagery in the panel is explicitly Franciscan: In the Crucifixion scene, Francis embraces the foot of the cross (Fig. 92).[4] Even without Francis, one could argue that the dossal was a Franciscan commission; its Passion cycle is an unusually rich compendium of Franciscan imagery. The Virgin and Child are here flanked

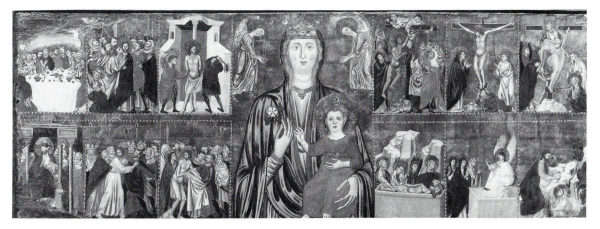

Figure 91 Magdalen Master and San Gaggio Master. Madonna and Child with Passion Scenes, from Sta. Maria dei Candeli, Florence(?). Madonna and Child by Magdalen Master, 1280s; narratives by San Gaggio Master, 1290s. San Diego, Calif., Timken Museum of Art, The Putnam Foundation. Photo: museum.

by twelve narratives, ten of which depict episodes from the Passion cycle. Only two images, the Marys at the Tomb and Noli Me Tangere, come from the Resurrection cycle.

The episodes are grouped in four clusters of three scenes. Such a scheme is less common than one might expect; in fact, the San Diego dossal is the only panel in Garrison's *Index* that is so composed.[5] The very organization resembles the structure of the St. Francis cycle at the Upper Church of Assisi, also probably painted in the 1290s. Smart and Mitchell have demonstrated its organization in groups of three scenes, which Mitchell compared to Bonaventure's three stages of illumination.[6] The images in the San Diego dossal's first triad are not unique to the Order, but all are consistent with Franciscan spirituality. The cycle opens with an image that we have not considered, the Last Supper. This theme is often omitted in Tuscan Passion cycles. For instance, no surviving painted cross from the thirteenth century includes it, though it does appear in the twelfth-century San Sepolcro cross in Pisa (Fig. 5). Conceivably it was omitted in deference to images that more graphically depicted Christ's human sufferings during the Passion. The Deposition and Entombment – both extremely common in duecento painting, both emotionally charged – are, in a sense, liturgical equivalents of the Last Supper: All three are profoundly eucharistic.[7] Further, Francis's Office of the Passion opened with the Betrayal; perhaps many Passion cycles did as well for liturgical reasons. The inclusion of the Last Supper here is, then, somewhat unusual. However, the theme is represented more often toward the end of the century, especially with the narrative expansion of the later duecento. Its relevance to the Order is self-evident; we have already discussed the close Franciscan involvement with the cult of the Eucharist throughout

Figure 92 San Gaggio Master. Crucifixion. Detail of Madonna and Child with Passion Scenes, 1290s. San Diego, Calif., Timken Museum of Art, The Putnam Foundation. Photo: museum.

the thirteenth century.

Next to the Last Supper is the Betrayal of Christ – as we have seen, one of the most frequently represented images in the Passion cycle. Offner rightly compared this image with the Assisi fresco.[8] In neither does the mob engulf Christ, and in both Peter and Malchus regain prominence; in these respects the image recalls Bonaventure's description of the theme. Adjoining the Betrayal is the Flagellation. Although it is almost ubiquitous in duecento Passion programs, this study has not considered the theme; it is almost unknown in Byzantium at this date, and thus could shed no light on Italian painters' uses of eastern sources. But it figures prominently in Franciscan meditations on the Passion. Bonaventure, for instance, devoted chapter XXII of the *Vitis mystica*, the Fifth Shedding of Blood, to the Flagellation.[9] Its presence in a Franciscan Passion cycle is to be expected. One notable omission is the Trial of Christ, absent despite its earlier occurrence in some Florentine Passion cycles.

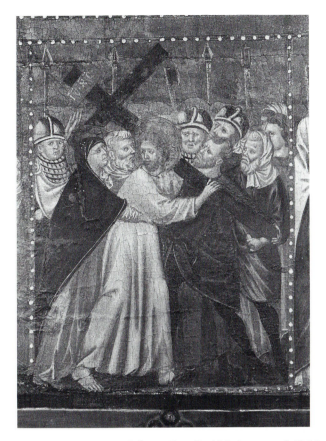

Figure 93 San Gaggio Master. Way to Calvary. Detail of Madonna and Child with Passion Scenes, 1290s. San Diego, Calif., Timken Museum of Art, The Putnam Foundation. Photo: museum.

The three scenes below the first triad are all more closely identified with Franciscan ideology. All directly evoke *Francis Alter Christus*, and all were popularized in Franciscan circles. On the left is the Mocking, with Christ seated and blindfolded in the manner introduced around 1240. The theme is emblematic of humility, both Christ's and Francis's, and an essential virtue for all members of the Order. In the center is the Way to Calvary (Fig. 93), with Christ bearing his cross. Its central placement in the group of three reveals its prominence for the Order; it would later be similarly centered in the predella of Ugolino's polyptych for the high altar of Santa Croce in Florence. To the right is the Stripping of Christ (Fig. 94), again a Franciscan theme *par excellence*, directly recalling a defining moment in the life of Francis and giving visual form to the vow of poverty. This Florentine work was produced in the 1290s; we cannot discount its possible association with Santa Croce and the struggle between the Spirituals and Conventuals over the construction of the third church, which was underway in the 1290s.

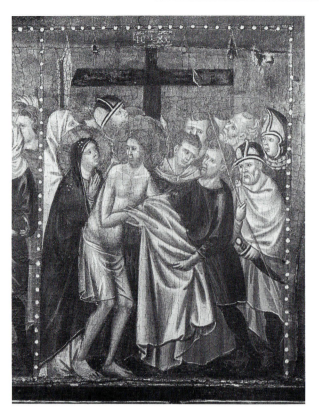

Figure 94 San Gaggio Master. Stripping of Christ. Detail of Madonna and Child with Passion Scenes, 1290s. San Diego, Calif., Timken Museum of Art, The Putnam Foundation. Photo: museum.

The third group of three, to the upper right, continues the assertively Franciscan focus of the dossal. The group opens with the Ascent of the Cross (Fig. 95). Christ's willing climb again evokes Francis, typologically identified with Elisha's ascent in the *Meditatio pauperis*, of about 1282; it asserts as well Bonaventure's insistence on the friars' willingness to face martyrdom. Francis himself appears in the adjacent scene, the Crucifixion; its importance is underlined by its central position here (Fig. 92). His stance, embracing the foot of the cross, recalls the two great frescoes in the Upper Church of Assisi. Christ's nearly translucent loincloth, seen as well in the Stripping and the Ascent, is also specifically Franciscan; it echoes Cimabue's cross for Santa Croce, finished not long before this dossal (Fig. 11). On the right is the Descent from the Cross; as a theme following the Crucifixion, it was not considered here. However, it completes the triad, thematically balancing the Ascent; this sort of rhetorical juxtaposition of Ascent/Descent is not uncommon in Byzantine Passion cycles.[10] The placement of the Descent in the far right corner also reiterates the eucharistic theme of the Last Supper, to the

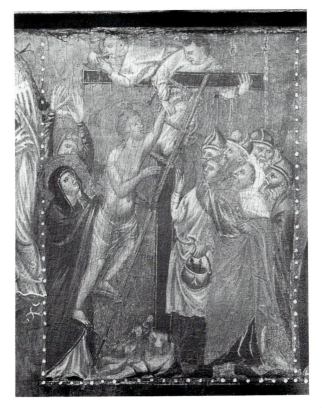

Figure 95 San Gaggio Master. Ascent of the Cross. Detail of Madonna and Child with Passion Scenes, 1290s. San Diego, Calif., Timken Museum of Art, The Putnam Foundation. Photo: museum.

far left; the display of the body of Christ parallels the veneration of the consecrated Host.[11] Again, the theme asserts the Order's advocacy of the cult of the *Corpus Christi*, and recalls its role in introducing the elevation of the Host into the Roman missal.

The images in the final group of three, the Entombment, Three Marys, and Noli Me Tangere, fall beyond the scope of this volume. At the least, their Mariological emphasis reiterates the centrality of the Virgin here – she is unusually prominent from the Way to Calvary forward – and reminds us of Francis's and Clare's devotion to Mary.

Thus the dossal now in San Diego is almost a *summa* of the specifically Franciscan treatment of the Passion. *Francis Alter Christus* is implicit especially in the second triad and in the Ascent of the Cross; Francis's identity with Christ is explicit in the next panel, where he embraces the cross. Some of the narratives evoke images in major houses of the Order – San Francesco, Assisi and Santa Croce, Florence – and all conform with iconographies commonly seen in other Franciscan works. The particular emphasis

on the Virgin here is also appropriate for a panel commissioned for a community of the Clares. We have seen that Passion themes occur with great frequency in the houses of the Clares; in several examples (such as the diptych for Santa Chiara, Lucca, Fig. 1, or the Stripping of Christ in the Clarissan church of San Sebastiano, Fig. 83, where the Virgin appears much as she does here), the Virgin plays a particularly prominent role.

However, the ambiguities surrounding the dossal's provenance lead us to a primary obstacle in a study like this one: the impossibility of pinning down the patronage of all the works under discussion. The fresco cycles studied here are securely Franciscan, as are most of the few manuscripts we have considered. As for the panels, many of those with Passion cycles have fairly solid Franciscan provenances. Images of Francis on these panels, as on the San Diego dossal, seem reliable evidence at least that the patron especially venerated the *poverello*. Even with these works, determining the precise church for which they were painted remains a considerable challenge; without a definite provenance, the sophisticated contextual work current in art history today is severely hampered. Still more problematic are the many panels that lack even general Franciscan identifiers. For these, fixing the patronage with confidence is often difficult, and in many cases hopeless; some works were parted too long ago from their original setting, and documentation of that setting no longer exists.

It may be that certain images or constellations of images provide us with some intimation of patronage. However, a survey of the monuments examined here reveals nothing resembling a standard Franciscan Passion cycle. As noted in the Introduction, the number of images in a narrative cycle varies enormously; the choice of scenes fluctuates as well. Even when the format is fairly standardized, as it is in historiated crosses, the choice of scenes ranges widely; very few of the extant crosses have identical programs.[12] Despite these fluctuations, particular scenes do appear in Franciscan monuments far more often than in works for other client groups. To begin with the subjects that seem most clearly Franciscan, both the Stripping of Christ and the Ascent of the Cross appear in a series of unequivocally Franciscan works – in fresco, panel, and manuscript illumination. In fact, the two are almost unknown in non-Franciscan contexts during the duecento and first years of the trecento. Neither is included among two prominent, and unusually detailed, Passion cycles for non-Franciscan patrons: Giotto's Arena Chapel and Duccio's *Maestà*. Their recurring presence in Franciscan monuments, as well as the prominence of both themes in Franciscan texts, seems to indicate fairly conclusively their importance to the Order.

The very close association of both themes with Franciscan patronage may clarify the origins of some important monuments of the duecento. To begin, I would argue that the Badia Ardenga narratives by Guido da Siena

were probably intended for a Franciscan or Clarissan church. First, the very presence of the Ascent of the Cross (Fig. 89), particularly in what was apparently originally a fairly curtailed program, suggests the Order's patronage.[13] Further, this panel is the earliest extant version in which Christ bounds up the cross, thus emphasizing the voluntary renunciation of the world and the embrace of death so forcefully advocated by Bonaventure. Moreover, the panel also includes the unusual motif of a thief, a feature that figures often in Franciscan texts and is seen as well in the Way to Calvary at Assisi by Pietro Lorenzetti (Fig. 74). In still another indication, Guido's Betrayal of Christ (Fig. 19) from the same narrative cycle is an early example of Christ assertively commanding Peter to desist – again, an alteration of the usual iconography to make the image consonant with the writings of Bonaventure. It seems unlikely that these early references to Franciscan tenets, and especially to Bonaventure, would occur at this date – the 1270s – in a work for a non-Franciscan patron. Moreover, the well-established links between the Badia Ardenga panels and a Franciscan tabernacle in Perugia may also suggest that both were produced for the Order.[14]

Other duecento panels with either the Stripping or the Ascent of the Cross were also arguably Franciscan commissions. Coppo's San Gimignano cross (Fig. 8), recently traced to the Clares in that Tuscan town, is particularly plausible as a work for the Order. The cross has often been dated to about 1260, a date that accords well with the 1261 date of the founding of the Clarisse house in San Gimignano. Further, the program, with its exceptional emphasis on the Passion (as noted in the first chapter, it is the first extant cross to drop the post-Passion themes) and the very early appearance of the Ascent of the Cross, is fully consistent with the provenance. Even the individual narratives often accentuate the pathos of the episodes; these little scenes are, in fact, some of the most expressive Passion images of the century. All of these points accord with the new provenance of the cross and confirm the insight of Gertrude Coor, who suggested some fifty years ago that the cross was originally intended for the Order.

What, then, of the other Passion narratives? Though these narratives cannot be considered unique to the Order – a point to which we will return below – most of them appear with some frequency in works commissioned by Franciscans. The Betrayal of Christ is exceedingly common in Franciscan monuments: It is included, for instance, in two fresco cycles at Assisi – both in the Upper Church and in the Lower Church cycle by Pietro Lorenzetti (Figs. 20, 22); in the altarpieces in Pittsburgh, in Santa Chiara, Assisi, in Perugia, and in San Diego (Fig. 91); in the San Gimignano cross (Fig. 17); in the panel in Portland (Fig. 21), and in Guido's Badia Ardenga narratives, here ascribed to Franciscan patronage. The Mocking of Christ also appears in several thirteenth-century Franciscan monuments, among them the fres-

coes of Santa Maria degli Angeli, Spoleto, and Sant'Antonio in Polesine, Ferrara; the San Gimignano cross (Fig. 8); and the San Diego dossal (Fig. 91). The Way to Calvary is seen often as well – for instance, on the Santa Chiara diptych in the Uffizi (Fig. 1), several times at Assisi (Figs. 73–4), and, in the fourteenth century, several times at Santa Croce. It may also be worthwhile to contrast a Franciscan monument with something comparable for a different sort of patron. Compare, for instance, the cross in San Gimignano by Coppo (Fig. 8) with the very similar cross by Coppo and his son Salerno for the Cathedral of Pistoia.[15] Though the programs share four of the six narratives, and though the iconography of the narratives is similar, the Pistoia cross omits both the Mocking of Christ and the Ascent of the Cross. Both scenes seem to have had particular resonance for the Order, and both appear in other Franciscan monuments, such as the San Diego dossal and the frescoes of Sant'Antonio in Polesine – but presumably these two images had no special significance for the canons of Pistoia.

We should return briefly to the provenance of the other historiated crosses. As Boskovits has noted, historiated crosses were most often commissioned for female communities, and five of the crosses have been traced to Clarissan houses.[16] All include episodes that seem to have been favored by the Order. For example, the Betrayal appears in all five; Christ Bearing the Cross in the Santa Bona cross, the Volterra cross, and the San Martino cross; the Mocking of Christ in the Siena and San Martino crosses. Further, with the exception of the cross in Siena, which is a very early work, and the Volterra cross, where the narratives are too fragmentary to judge, the crosses depict the Passion narratives just as they appear in monuments with firmer Franciscan provenances. Thus we have several reasons to accept the assumption that these crosses were, in fact, intended for the Clares, as other scholars have already asserted, and no compelling reason to doubt it; they may have originated in the churches where they once hung, or still hang today.

No record of any sort exists for an important work: the cross in the Uffizi, no. 434 (Fig. 7). First, as noted before, the cross is one of the first extant Florentine crosses to depict Christ as *Patiens*.[17] This cross is also distinguished by an unusual proliferation of Passion scenes: Its apron contain eight narratives instead of the usual six. Here, too, are very early appearances both of Christ carrying his own cross and of the new version of the Mocking, both images that seem deeply informed by Franciscan ideology. Further, several scholars have rightly observed close connections between this cross and Coppo's San Gimignano cross, of which the Clarissan provenance is now established. Goffen has already proposed for the painter of the Uffizi cross a "close association with the Franciscan order," noting that the same painter (or one very close to him) produced two works for the Order – a Stigmatization also in the Uffizi and the panel of St. Francis in the Bardi

Chapel of Santa Croce.[18] I agree that this cross, too, is most plausibly a Franciscan work. Because historiated crosses were so frequently painted for the Clares, this one may also have been commissioned for the Second Order.[19] A final work – the Bargello panel by the Castellare Master (Fig. 2) – also seems to me a likely Franciscan commission, not only because of its exclusive focus on the Passion cycle but also because there we find an early example of Christ led to Calvary by the rope around his neck.

The exercise just engaged in is, however, necessarily tentative, particularly for works executed later in the duecento. Ironically, it is the popularity of the narratives that casts some doubt on the attempt to localize patronage by choice of image. Though I have argued that these new Passion narratives originated with the Order, the Franciscans could not claim exclusive rights to them. The Order used most of these images to promote and validate their identity, but other groups found the images compelling too, and over time appropriated them.

This phenomenon is well known in the case of the *Christus Patiens*. This new image is widely assumed to have been used by Giunta Pisano in his cross for Brother Elias, and it can be seen recurrently in Franciscan churches throughout the century. But it spread fairly quickly to other quarters: Giunta painted a cross of the same type for San Domenico, Bologna, which is usually dated fifteen or twenty years after his cross for Brother Elias, and other examples may well have preceded this one. The same pattern occurs with the translucent loincloth described in Chapter 1. Cimabue's Santa Croce cross (circa 1280–5; Fig. 11) is almost always held to be the first monumental cross to include the device, and I have tried to place the motif in the context of Franciscan ideology. But it, too, was adopted some ten or fifteen years later by the Dominicans, who must have felt some legitimate claim to it; they, after all, had also taken a vow of poverty. The image of Francis embracing the base of the cross was, again, favored by the Order, which had it depicted repeatedly (Fig. 92), but Dominic was on occasion depicted in much the same way. Amy Neff has demonstrated exactly the same phenomenon with the motif of the children mocking Christ: Conceived by the Franciscans, it gradually became widely diffused in Tuscan painting.

This unsurprising pattern holds as well for the Passion images under discussion. The new version of the Betrayal, introduced around 1235–40 and soon a standard feature in Franciscan Passion cycles, can be found in non-Franciscan cycles by the 1270s, perhaps earlier. For instance, it occurs on the cross for the Cathedral of Pistoia by Coppo and Salerno; not unexpectedly, the Betrayal there looks very much like the version on Coppo's cross for the Clares of San Gimignano. The Way to Calvary with Christ bearing his own cross is more clearly identifiable as Franciscan, but again, it cannot be considered exclusively Franciscan. The Dominicans were quick to usurp

it, emblazoning it on their seals very shortly after the Franciscans had done so. The new Mocking of Christ likewise seems to become fairly widespread; by the end of duecento it appears in non-Franciscan works (e.g., the Thebiad panel, which may have been intended for the Carmelites, and in both Giotto's Arena frescoes and Duccio's *Maestà*). And by the trecento, certain ways of representing standard images seem to become codified in a given painter's shop. Thus Pacino di Bonaguida painted three versions of the Way to Calvary for Franciscan patrons, and in all of them, Christ is led by the rope around his neck. But in a fourth, for a different client, Christ is depicted in much the same way. By this time, it would appear that these details were identified less closely with the Franciscan order.

Thus assuming Franciscan patronage for panels with particular Passion scenes, or particular modes of depicting those scenes, becomes a risky enterprise, especially toward the end of the duecento and into the trecento. The new narratives considered here, like the *Christus Patiens* and translucent loincloth, were popularized by the Franciscans, but most of them were not confined to the Order for long. It is precisely because devotion to the suffering Christ was so prevalent during the duecento that a larger audience, not merely the friars, evidently responded warmly to the new images; in fact, it is a measure of the images' success that they were so broadly accepted. Though the new narratives often brilliantly promote Franciscan themes and concerns – the humility, poverty, and self-sacrifice of Christ and, implicitly, of the *Alter Christus* – they work on more than one level; they were, evidently, equally brilliantly attuned to emerging strains of popular piety. In fact, we sense in these images a kind of visual perfect pitch at work; they seem to have been finely calibrated to appeal to a wide circle of the devout. Their success was such that they gradually became part of the public domain; towards the end of the century, most of them developed into images that were no longer specifically Franciscan but Italian. Some persisted even into the quattrocento and cinquecento, carrying the legacy of the duecento into the Renaissance.

NOTES

✠

INTRODUCTION

1. "The New Role of Narrative in Public Painting of the Trecento: *Historia* and Allegory," *Pictorial Narrative in Antiquity and the Middle Ages* (National Gallery of Art, Studies in the History of Art, 16), ed. H. Kessler and M. S. Simpson (Hanover, N.H., and London, 1985), 151–68. There is a growing bibliography on narrative in early Italian painting; in addition to this National Gallery volume, see M. A. Lavin, *The Place of Narrative: Mural Decoration in Italian Churches, 431–1600* (Chicago and London, 1990), and a review by C. Baskins, *Art Bulletin* 74 (1992): 161–5, with additional bibliography.

2. "New Role of Narrative," 151.

3. Ibid., 152.

4. Belting's study of Passion imagery, *Das Bild und sein Publikum im Mittelalter: Form und Funktion früher Bildtafeln der Passion* (Berlin, 1981), translated by M. Bartusis and R. Meyer as *The Image and Its Public in the Middle Ages: Form and Function of Early Paintings of the Passion* (New Rochelle, N.Y., 1990), includes a lengthy discussion of the new piety that found expression in the art and texts of the thirteenth century (see especially chap. VI.). However, because he confines this study to devotional images, he does not consider the profound changes in duecento narrative paintings of the Passion. Belting's most recent study, *Bild und Kult: Eine*

Geschichte des Bildes vor dem Zeitalter der Kunst (Munich, 1990), translated by E. Jephcott as *Likeness and Presence: A History of the Image before the Era of Art* (Chicago and London, 1994), similarly excludes a treatment of narrative, as he notes briefly in his Foreword (xxi). Michael Camille, in a largely laudatory review in *Art Bulletin* 74 (1992): 514–17, notes Belting's "narrow definition of what constitutes an image" and observes that he "has written a narrative story against narrative images" (515).

5. These are most commonly found on hagiographic panels, in which the saint is surrounded by narrative scenes from his or her life. E. B. Garrison, *Italian Romanesque Panel Painting: An Illustrated Index* (Florence, 1949; reprint New York, 1976), 151–6, publishes over twenty examples featuring St. Francis. Of similar panels devoted to other saints, no saint appears more than three or four times. On this format, see also R. Goffen, *Spirituality in Conflict: Saint Francis and Giotto's Bardi Chapel* (University Park, Pa., and London, 1988), 25–6; J. Wood, "Perceptions of Holiness in Thirteenth-Century Italian Painting: Clare of Assisi," *Art History* 14 (1991): 301–28; P. Scarpellini, "Iconografia francescana nei secoli XIII e XIV," in *Francesco d'Assisi: Storia e Arte* (Milan, 1982), 91–126; K. Krüger, *Der Frühe Bildkunst des Franziskus in Italien: Gestalt- und*

Funktionswandel des Tafelbildes im 13. und 14. Jahrhunderts (Berlin, 1992); and a series of articles by W. R. Cook, cited in Chapter 1, Note 19. Goffen observes that "it was Francis himself, and his biographers, who provided the theoretical justification for narrative art as pictorial biography" (25). On hagiographic panels, see also Note 15 below.

6. The Infancy appears especially on panels with Marian cycles; see Garrison's *Index*, nos. 360, 368, 378, and L. Marques, *La peinture du duecento en Italie centrale* (Paris, 1987), fig. 90. Infancy scenes are also featured on occasional fragments (*Index*, nos. 665, 667). In some Infancy cycles, one or more Passion scenes appear as well (*Index*, no. 322A; A. Tartuferi, *La pittura a Firenze nel Duecento* [Florence, 1990], fig. 145). The Ministry appears on a painting on linen by Guido da Siena; see J. Stubblebine, *Guido da Siena* (Princeton, 1964), fig. 10.

7. The Passion cycle opens with the Entry into Jerusalem and concludes with the Entombment; however, one or more images from the Resurrection cycle, especially the Marys at the Tomb, may appear as well. For thirteenth-century panels that include two or more Passion narratives but omit scenes from the Infancy or Ministry, see Garrison's *Index*, nos. 243 [Fig. 1 of this study], 282, 283, 326, 327, 331, 347, 351, 367 [Fig. 4], 390 [Fig. 2], 412, 422 [Fig. 3], 441–2, 673, and 679. The last three listed are fragments of altarpieces, of which the original narrative programs are unknown. Garrison published a reconstruction of the dossal to which his nos. 441 and 442 belonged; according to the reconstruction, only the Passion cycle appeared (*Index*, 171). For a reconstruction of Garrison's no. 679 (three panels in New Haven), see Tartuferi, *Pittura*, fig. 48. For this altarpiece, see also M. Boskovits, *The Origins of Florentine Painting, 1100–1270*, section 1, vol. 1 of R. Offner's *Critical and Historical Corpus of Florentine Painting* (Florence, 1993), 74–6 and note 147. Tartuferi also published a gabled tabernacle not included by Garrison; its narrative cycle opens with the Flagellation and concludes with the Deposition (*Pittura*, fig. 222).

Other duecento panels include an Infancy scene with two or more Passion scenes: *Index*, nos. 303, 664. The Passion cycle also dominates the extant panels of a diptych of

c. 1290, on which see M. Boskovits, *The Thyssen-Bornemisza Collection: Early Italian Painting, 1290–1470* (New York, 1990), cat. no. 21.

For altarpieces with comprehensive cycles that include the Infancy and Passion, or all three christological cycles, see *Index*, nos. 325, 348, 354–5, and 382 (the last three are probably from the late duecento rather than the trecento, as Garrison believed; on nos. 354 and 355, see Marques, *Peinture*, figs. 258 and 259, and the discussion in Note 11; and on no. 382, see Marques, fig. 103). Guido da Siena's narratives from Badia Ardenga (Stubblebine, *Guido*, fig. 18 and figs. 20–30) also comprised an extensive cycle; Stubblebine has argued that it once included the Ministry (54–60 and fig. 16), but his reconstruction required him to assume an original twenty-four panels, twelve of which have been lost. This reconstruction has rightly been challenged; see C. Ressort, *Retables italiens du XIIIe au XVe siècle*, exh. cat., Musée de Louvre (Paris, 1978), 7–9; H. Van Os, *Sienese Altarpieces, 1215–1460: Form, Content, Function*, vol. 1: *1215–1344* (Groningen, 1984), 28. All three christological cycles also appear in the nave frescoes in the Upper Church of S. Francesco, Assisi (see Note 8). The mosaics in the Baptistery of Florence also include a comprehensive christological cycle; see A. Antony de Witt, *I mosaici del battistero di Firenze*, 5 vols., Florence, 1954–9.

8. Examples include two cycles in S. Francesco, Assisi, one in the Lower Church by an Umbrian painter working in the 1260s and another in the nave of the Upper Church, part of a larger cycle of Old and New Testament scenes, probably from the late 1280s or early 1290s; frescoes at S. Pietro in Vineis, Anagni, after 1255; frescoes on the wall behind the altar at S. Sebastiano, a convent of the Clares near Alatri in Latium, painted by a Tuscan or Umbrian painter around 1260; frescoes in the crypt of Siena Cathedral, c. 1275–80; fragments of two cycles from Sta. Maria degli Angeli, Spoleto, from the end of the century; and a fairly extensive cycle in the left chapel of S. Antonio in Polesine, Ferrara, also from the end of the century. For the frescoes in the Lower Church at Assisi, see J. Schultze, "Zur Kunst des 'Franziskusmeisters,'" *Wallraf-Richartz-*

Jahrbuch 25 (1963): 109–50; S. Romano, "Le storie parallele di Assisi: il Maestro di S. Francesco," *Storia dell'arte* 44 (1982): 63–81. J. Cannon, "Dating the Frescoes by the Maestro di S. Francesco at Assisi," *Burlington Magazine* 124 (1982): 65–9, dates the frescoes c. 1260, claiming that they must predate Bonaventure's *Legenda maior* (approved by the Order in 1263). Marques, *Peinture*, 58–9, dates the frescoes c. 1257–61, but does not exclude Bonaventure's influence on the cycle; he argues that Bonaventure was in residence at Assisi in 1259 and could have spoken directly with the painter of the cycle about the content of the scenes. William Cook also sees much that is Bonaventuran in the cycle and argues that it postdates this text; I am grateful to him for discussing this point with me.

On the Upper Church, see H. Belting, *Die Oberkirche von San Francesco in Assisi: Ihre Dekoration als Aufgabe und die Genese einer neuen Wandmalereien* (Berlin, 1977). For excellent photographs of the both cycles at Assisi, and additional bibliography, see J. Poeschke, *Die Kirche San Francesco in Assisi und ihre Wandmalereien* (Munich, 1985). For the frescoes in S. Pietro in Vineis, see V. Pace, "Pittura del Duecento e del Trecento a Roma e nel Lazio," in *La pittura in Italia: Il Duecento e il Trecento*, ed. E. Castelnuovo (Milan, 1985), vol. 2, 423–42, especially 436, and A. Bianchi, "Affreschi duecenteschi nel S. Pietro in Vineis in Anagni," in *Roma Anno 1300. Atti della IV settimana di studi di storia dell'arte medievale dell'Università di Roma "La Sapienza,"* ed. A. M. Romanini (Rome, 1983), 379–92; for S. Sebastiano, see E. Prehn, "Una decorazione murale del duecento toscano in un monastero laziale," in his *Aspetti della pittura medievale toscana* (Florence, 1976), 69–90, and T. Iazeolla, "Gli affreschi di S. Sebastiano ad Alatri," in *Roma Anno 1300*, 467–76; for the frescoes in Siena, see E. Carli, "Affreschi senesi del Duecento," in *Scritti di storia dell'arte in onore di Ugo Procacci*, vol. 1 (Milan, 1977), 82–93; for Sta. Maria degli Angeli, see B. Toscano, "Il Maestro delle Palazze e il suo ambiente," *Paragone* 25, no. 291 (1974): 3–23; for S. Antonio in Polesine, see L. Caselli, *Il monastero di S. Antonio in Polesine* (Ferrara, 1992).

9. For the diptych in the Uffizi, see Garrison,

Index, no. 243; A. Derbes, "Siena and the Levant in the Later Dugento," *Gesta* 28 (1989), 193, 197; E. Ayer, "Thirteenth-Century Imagery in Transition: The Berlinghiero Family of Lucca" (Ph.D. diss., Rutgers Univ., 1991), 224–42. Boskovits, *Origins*, 73, note 146, ascribes the diptych to Bonaventura Berlinghieri. For a color photograph of the right wing, see E. Carli, *Italian Primitives: Panel Painting of the Twelfth and Thirteenth Centuries* (New York, 1965), plate 2.

For the dossal in the Bargello (Garrison, *Index*, no. 390), see Garrison, "Post-War Discoveries. Early Italian Paintings. I," *Burlington Magazine* 89 (1947), 147–52. The panel is the work of a Pisan painter, dubbed the "Castellare Crucifix Master" by Garrison. For the Castellare crucifix, see Garrison, *Index*, no. 514.

For the dossal in Perugia (Garrison, *Index*, no. 422), see F. Todini, *La pittura umbra: dal Duecento al primo Cinquecento* (Milan, 1989), vol. 1, 140; vol. 2, fig. 114 (a detail of the Betrayal); and the catalogue entry by A. Labriola in C. Bon Valsassina and V. Garibaldi, *Dipinti, sculture e ceramiche della Galleria Nazionale dell'Umbria* (Florence, 1994), cat. 10, 86–8, color plate on p. 87. The dossal is the eponymous work of the Umbrian painter known as the Master of Farneto. On the painter, see also M. Boskovits, "Gli affreschi della Sala dei Notari a Perugia e la pittura in Umbria alla fine del XIII secolo," *Bollettino d'Arte* 66 (1981): 1–41. Boskovits dates the Perugia dossal to 1285–90 (4).

10. For a fairly detailed Passion cycle in a small devotional triptych, see a mid-duecento Florentine example in the Metropolitan Museum (Garrison, *Index*, no. 282). Generally the small size of these works limits the Passion scenes to one or two, as in a Sienese triptych in Cracow (ibid., no. 347), where the Virgin and Child are flanked by the Crucifixion and the Entombment.

11. This panel, formerly in the Hirsch collection, is the work of two Florentine painters. The central Madonna and Child is ascribed to the Magdalen Master and usually dated to the 1280s; the narratives, by the San Gaggio Master, date from the 1290s. See Garrison, *Index*, no. 367; R. Offner, *An Early Florentine Dossal* (Florence, n.d.); A. and M. Mongan, *European Paintings in The Timken Art*

Gallery (San Diego, 1969), 18; Marques, *Peinture*, 205–6; Tartuferi, *Pittura*, 93–4, 109. The provenance will be discussed in greater detail in the Conclusion.

For an even more extensive Passion cycle, also by the San Gaggio Master, see Garrison's reconstruction of a tabernacle with thirteen Passion scenes, from the Entry into Jerusalem through the Lamentation. The central panel is in Oxford, Christ Church; the shutters were once in Milan; see Garrison, "The Oxford Christ Church Library Panel and the Milan Sessa Collection Shutters: A Tentative Reconstruction of a Tabernacle and a Group of Romanizing Florentine Panels," *Gazette des Beaux-Arts* 88 (1946): 321–46; *Index*, nos. 354 and 355; Marques, fig. 258; Tartuferi, 109.

12. A similar enlarging of the narrative cycle is at times seen well before the end of the century; the mid-duecento Bardi *St. Francis* recounts the story of Francis's life and death in twenty episodes (see Goffen, *Spirituality*, 29–50), and a Florentine panel of the Virgin and Child, c. 1270–80, in the Pushkin Museum, Moscow, includes seventeen scenes depicting the life of the Virgin; see Boskovits, *Origins*, 108–10; Add. pls. III–III[17].

13. For the crosses, see E. Sandberg-Vavalà, *La croce dipinta italiana e l'iconografia della Passione* (Verona, 1929; reprint Rome, 1980); Garrison, *Index*, 174–7, 181–2, 193, 197–8, 204; H. Hager, *Die Anfange des italienischen Altarbildes* (Munich, 1962), 75–81; M. Burresi and A. Caleca, *Le croci dipinte* (Pisa, 1993). The *Index* lists 149 crosses and fragments from another 11. The painted crosses presumably originated in monumental crosses in metal (such as the cross of Archbishop Ariberto, c. 1037–40, in copper relief, in the Cathedral of Milan; Hager, fig. 89), stone, or wood (such as the celebrated *Volto Santo* in S. Martino, Lucca, probably a late twelfth- or early thirteenth-century copy of a late eleventh-century version [Burresi and Caleca, plate XXIII], or an example in Naples, S. Giovanni Maggiore [Hager, fig. 93]; for other examples, see Sandberg-Vavalà, 59–70). A connection between the painted crosses and the metal versions in particular is suggested by the very similar treatment of the terminals in, for instance, the Ariberto cross and the early Lucchese crosses, the earliest of which – the cross of 1138 by Gullielmus now in

Sarzana (*Index*, no. 498) – is the first securely dated example in panel. Compare especially the semicircles completing the terminals of the cross-bar in both the metal cross and the twelfth-century Lucchese versions (*Index*, nos. 498, 501, 504); this type of terminal is found only in the early Lucchese crosses.

14. Garrison, *Index*, 194–203. Precedents of sorts for the historiated crosses can be found in a variety of objects. For the general juxtaposition of a central figure and smaller narratives, see N. Ševčenko, "Vita Icons and 'Decorated' Icons of the Komnenian Period," in *Four Icons in the Menil Collection*, ed. B. Davezac (Austin, Tex., 1992), 57–69. Garrison suggests that historiated crosses developed by analogy to historiated altarpieces (*Index*, 176, 197, where he notes earlier examples in metal, as at Città di Castello); he also points to early twelfth-century enamel processional crosses from northern Europe with narratives in the terminals (ibid., 197). These in turn may be linked with Middle Byzantine processional crosses in silver, also equipped with narratives; see K. Weitzmann, "Three Painted Crosses at Sinai," *Studies in the Arts at Sinai* (Princeton, 1982), 409–17, especially 410. Still earlier are the small pectoral crosses with narratives from seventh- to ninth-century Palestine: phylacteries with relics of the True Cross. Some of these were eventually brought to Tuscany; one is now in Pisa, Pieve di Sta. Maria e S. Giovanni, and was earlier in Vicopisano (A. Kartsonis, *Anastasis: The Making of an Image* [Princeton, 1986], figs. 25a and 25b; Weitzmann, 410). The pectoral crosses depicted scenes from Christ's Infancy and Ministry rather than Passion, though they typically depict the Ascension at the top of the cross and the Descent into Limbo at the base. This arrangement is found also in at least one early cross (the strongly Byzantinizing example in Museo Nazionale di San Matteo, Pisa, no. 20; *Index*, no. 521). For a lengthy discussion of the pectoral crosses, see Kartsonis, 94–125. Weitzmann discusses these and the processional crosses in conjunction with the Italian versions, concluding that "the question must for the time being be left unanswered whether the Byzantines ever made painted processional crosses or whether they confined themselves to those of precious metal" (417). However, in the introduction

to his *Studies*, he states that his article "provides evidence that the form of the painted cross, so familiar in Italian Ducento [sic] art, has its root in Byzantine art as proved by the fragments of a painted cross at Sinai" (ix); he refers here to one of the three crosses (not a processional cross, but probably one for an iconostasis) which he terms "purely Byzantine in style and iconography" (417). See also H. Hallensleben, "Zur Frage des byzantinischen Ursprungs des monumentalen Kruzifixe, 'wie die Lateiner sie verehren,'" in *Festschrift für Eduard Trier zum 60. Geburtstag* (Berlin, 1981), 7–84.

The reasons why the historiated crosses appear only in Tuscany are uncertain. One factor that requires further study is the role of Lucca in the early production of the historiated cross. The first firmly dated historiated cross, from 1138, is by the Lucchese painter Gullielmus (*Index*, no. 498); the cross was originally in Sta. Maria, Luni and is now in the Cathedral of Sarzana. Scholars have long associated the Lucchese cross form, which differs from others in its chalice-shaped base, with the relic of the Holy Blood, preserved at nearby Luni (see especially C. Black, "The Origin of the Lucchese Cross Form," *Marsyas* 1 [1941]: 27–40). Lucca also possessed a number of relics of the Passion; a Holy Nail and portions of the winding cloth, among others, were housed in the *Volto Santo*, the large wooden image of the crucified Christ (cited in Note 13), and other Passion relics belonged to various churches in Lucca. Conceivably the Passion narratives that appeared so early on Lucchese painted crosses were intended to tout the city's trove of relics, just as the distinctive chalice-base evoked one of the most prized of relics, the Holy Blood. For instance, the Way to Calvary in Gullielmus's cross depicts one of the soldiers displaying nails – an unusual motif, discussed further in Chapter 5, that may allude to the Holy Nail in the *Volto Santo*; the Entombment in the same cross shows a prominent winding cloth. The Entombment, with its display of the cloth, continues on Lucchese crosses, though their narratives become more curtailed (see those in the *Index*, nos. 501, 503–4). Perhaps Gullielmus's cross for Luni was intended to substitute for the *Volto Santo* and the relics it contained. The sculpture was at Luni until

the Bishop of Lucca took possession of it – an act of theft that must have occurred before 1100 (the King of England, who died that year, allegedly swore on "the holy countenance of Lucca"; Black, 36). On the relics in Lucca, see H. Schwarzmaier, *Movimenti religiosi e sociali a Lucca nel periodo tardo-longobardo e carolingio. Contributo alla leggenda del Volto Santo* (Lucca, 1973); Ayer, "Thirteenth Century Imagery," 3–6. For the history of the *Volto Santo*, see Schwarzmaier.

Regardless of the early date of Gullielmus's cross, we cannot assume that Lucca popularized the historiated cross. Other twelfth-century historiated crosses may predate the Lucchese example; Boskovits has recently ascribed a Pisan example in S. Frediano, Pisa, to c. 1110–20 (see *Origins*, 19, note 14), and a Florentine one, in Rosano, to c. 1129–1134 (28–30). Despite the apparent origins of the historiated crosses in Tuscany, however, it is curious that no non-Tuscan examples of the type have survived. Historiated crosses may well have appeared in other regions, such as Umbria, but no such examples are known today.

15. For hagiographic panels as icon and narrative, see Wood, "Perceptions," 308. Similar fusions of icon and narrative occur often in Byzantine art; consider the very similar configuration in Byzantine panels of saints surrounded by narratives of the saint's life (Sevčenko, "Vita Icons," 56–69). The similarities between these and Tuscan hagiographic panels were observed by J. Stubblebine, "Byzantine Influence in Thirteenth-Century Italian Panel Painting," *Dumbarton Oaks Papers* 20 (1966): 85–101, especially 91–3; see also Belting, *Likeness and Presence*, 377–84.

The narratives in earlier crosses often read from left to right (see Note 21 for a discussion), whereas most thirteenth-century examples read from top to bottom on the left, then on the right. One exception is Coppo di Marcovaldo's cross in S. Gimignano (Fig. 8; see the discussion in Note 23). On narrative sequence in general, see F. Deuchler, "Le sens de la lecture: À propos du boustrophedon," in *Études d'art médiéval offertes à Louis Grodecki*, ed. S. Crosby et al. (Paris, 1981), 251–8; Lavin, *Place of Narrative*. On narrative sequence in thirteenth-century horizontal Tuscan panels, see L. Taylor-Kelley, "The

Horizontal Tuscan Panel, 1200–1365: Frame Format and Pictorial Composition," Ph.D. diss., Univ. of Michigan, 1988. Her Appendix B includes diagrams of narrative sequence in these horizontal altarpieces. I am grateful to Prof. Taylor-Kelley for sending me portions of her dissertation.

16. The S. Sepolcro cross, now in the Museo Nazionale di San Matteo, is usually referred to by its old inventory number, no. 15; for the cross, see Garrison, *Index*, no. 520; E. Carli, *Pittura medievale pisana* (Milan, n.d.), 26–8; Boskovits, *Origins*, 35–9. For the S. Martino cross, see Garrison, *Index*, no. 524; Carli, 38–9 and 48–51. For a color photograph of the cross, see A. Caleca, "Pittura del Duecento e del Trecento a Pisa e a Lucca," in Castelnuovo, *Pittura*, vol. 1, 239, fig. 362. Both crosses include eight narratives, instead of the more common six.

17. Garrison, *Index*, 176, 197, argued that crosses destined for rood beams or screens (*tramezzi*), like those hung in the choir, were probably not historiated; even the crosses placed on rood beams would probably have been too high for the scenes to be easily legible. Some screens were, in fact, quite tall. The screen at Sta. Croce, for instance, was over five meters high; see M. Hall, "The *Tramezzo* in Santa Croce, Florence, Reconstructed," *Art Bulletin* 56 (1974): 325–41, and idem, "The Italian Rood Screen: Some Implications for Liturgy and Function," in *Essays Presented to Myron P. Gilmore*, vol. 2, (Florence, 1978), 213–18. However, the height of the screen varied; the one in the Lower Church of S. Francesco, Assisi, was only a bit over two meters (B. Kempers, *Painting, Power and Patronage: The Rise of the Professional Artist in Renaissance Italy* [London, 1993], 39). For depictions of painted crosses on *tramezzi*, see the well-known frescoes of the Upper Church, San Francisco, Assisi (J. Stubblebine, *Assisi and the Rise of Vernacular Art* [New York, 1985], figs. 13, 22). If a historiated cross was placed on the high altar, the screen would have at least partially obstructed the laity's view of the cross. Hall cites cases in which the high altar would have been blocked from view, including Sta. Croce; she states that the cross would have been placed on the screen, to serve as the focal point for the congregation ("*Tramezzo*," 337–8). As she argues, the *tramezzo*

served to exclude only women; men would have been allowed beyond it, between the screen and the choir (ibid., 339–40; "Italian Rood Screen," 215). However, a second screen at the choir would have further blocked the laity's view of the high altar; see W. Hood, *Fra Angelico at San Marco* (New Haven and London, 1993), 2–5. Hood notes that the doors were opened occasionally so that the congregation would have been able to see the high altar. Side altars, however, were accessible to the laity. See also Kempers, *Painting, Power and Patronage*, 36–59. One of the few extant historiated crosses for which some documentation survives is a cross in Pistoia, probably destined for a side altar of the cathedral, the altar of St. Michael. See Garrison, *Index*, 197; A. Derbes, "The Pistoia Lamentation," *Gesta* 23 (1984), 131. For lay access to church decoration, see also Blume, *Wandmalerei*, 100–6; and W. Cahn, "Romanesque Sculpture and the Spectator," in *The Romanesque Frieze and its Spectator*, The Lincoln Symposium Papers, ed. D. Kahn (London, 1992), 45–60. He discusses the limited accessibility of much Romanesque sculpture, far from the view of any audience, on pp. 49–51.

18. On Giunta, see D. Campini, *Giunta Pisano Capitini e le croci dipinti romaniche* (Milan, 1966); A. Tartuferi, *Giunta Pisano* (Soncino, 1991); Marques, *Peinture*, 46–69. The rapidity with which Giunta's new formulation spread in Umbria accounts in part for the absence of historiated crosses there.

19. For recent comments, see Goffen, *Spirituality*, 21–2; Belting, *Image and its Public*, 143–8.

20. In both crosses, the Ascension is placed in the upper terminal or *cimasa* – typical of almost all historiated crosses in which that panel survives (for an exception, see the cross in S. Frediano, Pisa [Garrison, *Index*, no. 522], where the Pentecost replaces the Ascension).

21. In the sequence of its narratives, which read from left to right, the S. Sepolcro cross is typical of many earlier crosses. This sequence tends to locate any Passion scenes at the upper level of the apron. Here, for instance, the Mocking of Christ and the Crucifixion – an unusual early image of the suffering Christ – are both relatively far from the viewer's eye level. One is reminded of the Early Christian doors of Sta. Sabina, Rome, where

the Crucifixion was placed at the uppermost corner, as far as possible from the viewer. Crosses with similarly configured narratives include the Pisan S. Frediano cross (*Index*, no. 522), a Florentine cross in Rosano (no. 525), and an archaizing late thirteenth-century cross from Sta. Marta, Pisa (Garrison, *Index*, no. 523). For the S. Frediano cross and the Rosano cross, see also Boskovits, *Origins*, 19–30.

22. In the cross in the Uffizi, no. 434, two post-Passion scenes appear: the Marys at the Tomb and the Supper at Emmaus. On this cross, see E. Prehn, *A XIII-Cent. Crucifix in the Uffizi and the 'Maestro del S. Francesco Bardi'* (Edinburgh, 1958); idem, "Il crocifisso N. 434 degli Uffizi e il 'Maestro del S. Francesco Bardi,'" in *Aspetti della pittura medievale*, 39–56; Boskovits, *Origins*, 95–105 and 374–91. Boskovits dates the cross c. 1240–5 (99). Extant Florentine crosses produced before this time almost invariably depict Christ as *Triumphans*. Another early Florentine *Patiens* of uncertain date is a cross by the Bigallo Master in Chicago; for the range of critical opinion as to its date, see Boskovits, *Origins*, 328–31. On Coppo see Coor, "Coppo di Marcovaldo: His Art in Relation to the Art of his Time," *Marsyas* 5 (1947–9): 1–21; idem, "A Visual Basis for the Documents Relating to Coppo di Marcovaldo and his Son Salerno," *Art Bulletin* 28 (1946): 233–47; Boskovits, *Origins*, 117–25 and, on the cross, 524–36. The cross once belonged to Sta. Chiara, San Gimignano; see Boskovits, 524, and E. Carli and J. Vichi Imberciadori, *San Gimignano* (Milan, 1987), 65. See also Chapter 1, Note 59.

Similar examples include another Florentine cross, a collaborative work by Coppo and his son Salerno in the Cathedral of Pistoia (for which see Boskovits, 125–6 and 596–610, and Derbes, "Pistoia Lamentation"). One exception is the cross traditionally known as Pisa no. 20, one of the first painted crosses to represent the *Christus Patiens*; its apron scenes depict the post-Passion cycle in some detail (on this cross, see Boskovits, 50–4).

If the central Crucifixus is the *Christus Triumphans*, the choice of images is less predictable. In some crosses with the *Christus Triumphans*, most of which are early examples of this type, the central Crucifixus is

consistent with the emphasis of the narratives in the apron. Thus the S. Frediano cross, the Rosano cross, and the archaizing Pisa no. 9 of the early trecento all resemble the S. Sepolcro cross in depicting Christ as *Triumphans*, and in placing equal weight on the Passion and post-Passion cycles in their apron panels. But several early crosses – most painted before the introduction of the *Christus Patiens* in painted crosses – anticipate the affective piety of that image and perhaps paved the way for its acceptance in their narrative programs, which give greater weight to the Passion cycle than to the Resurrection and Apparitions. For instance, a twelfth-century cross in the Uffizi, no. 432 (*Index*, no. 515; Boskovits, *Origins*, 40–5, 246–59), depicts six Passion scenes and only one, the Marys at the Tomb, from the post-Passion cycle. Similar works include the Sarzana cross, the earliest dated example, where Lucchese Passion relics may be in part responsible for the choice of scenes; a Sienese cross from Sta. Chiara (*Index*, no. 527; see also Chapter 1, Note 56) and several Pisan examples of the mid-century and later (e.g., *Index*, no. 514, 517, 523), all of which persist in depicting Christ as *Triumphans* despite their emphasis on his Passion in the apron.

23. This deviation from the top-to-bottom sequence more typical of duecento crosses may stem from the pronounced sway of Christ's hip, which encroaches on the left apron, especially in the central panel. The Flagellation, which occupies that panel, requires less space than most of the other narratives, which tend to be crowd scenes. Thus the curtailed field caused by the sway of Christ's body may have contributed to the decision to alter the usual sequence.

24. Both of these images will be discussed in Chapter 6; on the Ascent of the Cross, see also Derbes, "Images East and West: The Ascent of the Cross," in *The Sacred Image: East and West*, ed. R. Ousterhout and L. Brubaker (Urbana, Ill., and Chicago, 1995), 110–31.

25. On the Swooning Virgin, see Derbes, "Siena and the Levant," 193–4. She swoons on the road to Calvary in the *Supplicationes Variae*, fol. 375r. (A. Neff, "Wicked Children on Calvary and the Baldness of St. Francis," *Mitteilungen des Kunsthistorischen Institutes in Florenz* 34 [1990]: 215–44, fig. 1) and in the

Lamentation in the Lower Church at Assisi (Schultze, "Zur Kunst des Franziskusmeisters," fig. 106). Reference to Mary's swoon appears occasionally even in the Nativity, as in a Florentine panel in the Fogg Museum, Cambridge (*Index*, no. 665), where one of the midwives leans behind Mary and supports her shoulders, just as the holy women will during the Passion.

26. For the Magdalen's gesture, see M. Barasch, *Gestures of Despair in Medieval and Early Renaissance Art* (New York, 1976), 57–86.

27. The *Christus Triumphans* lingers well after the introduction of the *Patiens*; even historiated crosses in which the narratives follow the newer, more expressive versions sometimes persist in depicting the central Christ in the traditional triumphant stance. See Note 22.

28. This panel is from the S. Sepolcro cross (Fig. 5); this Passion theme will be discussed in greater detail in Chapter 4.

29. This example is from the cross in the Uffizi, no. 434 (Fig. 7). Again, the type will be discussed at greater length in Chapter 4.

CHAPTER 1

1. For an overview of early Italian writers on the *maniera greca*, see E. Panofsky, *Renaissance and Renascences in Western Art* (Stockholm, 1960), 14–15, 25–7, 34–5; see also E. Kitzinger, "The Byzantine Contribution to Western Art of the Twelfth and Thirteenth Centuries," *Dumbarton Oaks Papers* 20 (1966): 27–9, and R. Corrie, "The Conradin Bible, Ms. 152, The Walters Art Gallery: Manuscript Illumination in a Thirteenth-Century Italian Atelier" (Ph.D. diss., Harvard Univ., 1986), 352. Finally, see also A. Caleca, "A proposito del rapporto Cimabue-Giotto," *Critica d'arte* 43, nos. 157–9 (1978): 42–6, for a discussion of similar passages in Boccaccio and in Ghiberti's *Commentario*.

2. See the papers by R. Nelson, A. Wharton, A. Taylor, and B. Zeitler in a session of the 1992 annual conference of the College Art Association, "The Byzantine and Islamic Other: Orientalism in Art History," chaired by Annabel Jane Wharton; *Abstracts and Program Statements* (New York, 1992), 173–6; M. Camille's review of Belting's *Bild und Kult*, 515, and, for another perspective, A. Cutler, "The Pathos of Distance: Byzantium in the Gaze of Renaissance Europe and Mod-

ern Scholarship," in *Reframing the Renaissance: Visual Culture in Europe and Latin America 1450–1650*, ed. C. Farago (New Haven and London, 1995), 23–46, especially 23–4.

3. As noted in the Introduction, Belting's "New Role of Narrative" disregards the role of the duecento in the development of narrative; in the introduction to his article, he cites Vasari's claim that art history began with Giotto (ibid., 151).

4. C. Bertelli, "Dietro la pittura italiana, Bisanzio," in Castelnuovo, *Pittura*, vol. 2, 541–46, examines the interaction of East and West only on p. 546. Tartuferi, *Pittura*, refers only in passing to Byzantium (e.g., 5). Marques, *Peinture*, disregards it almost entirely. For a Vasarian attitude to Byzantium even in relatively recent art-historical writing, see, for instance, the remarks of U. Baldini and O. Casazza about duecento painting: "It is above all in Tuscany that one may observe these new accents in Western, or Italian, painting which contrast with the tired byzantine tradition. . . . [Cimabue] starts to free himself from byzantine models and to look for vigorous humanity" (in *The Crucifix by Cimabue*, [n.p., 1982], 20; this monograph was produced in conjunction with the exhibition of Cimabue's Sta. Croce Cross at the Metropolitan Museum of Art, New York). The marginal status of Byzantium is seen as well in the holdings of the library of the Kunsthistorisches Institut in Florence, which houses one of the most important collections on Italian art in the world. There volumes on Byzantine art are shelved in a small room on the top floor of the library, along with books on Islamic, Chinese, Japanese, Korean, and Mexican art.

5. O. Demus, *Byzantine Art and the West* (New York, 1970), 208. For Kitzinger, see "Byzantine Contribution."

6. Stubblebine, "Byzantine Influence in Thirteenth-Century Italian Panel Painting," *Dumbarton Oaks Papers* 20 (1966), 97. Despite such characterizations, Stubblebine's article remains a fundamental study. See also his "Byzantine Sources for the Iconography of Duccio's *Maestà*," *Art Bulletin* 57 (1975): 176–85. More recently, other specialists in Italian art have addressed aspects of the question. Rebecca Corrie, whose dissertation is cited in Note 1, has written several impor-

tant studies on the subject; those on central Italian painting in the duecento include: "The Political Meaning of Coppo di Marcovaldo's Madonna and Child in Siena," *Gesta* 19 (1990): 61–75; "The Perugia Triptych and the Transmission of Byzantine Art to the *Maniera Greca*," papers from the XVIII International Congress of Byzantine Studies, August 1992, in press; "Artistic Means to Political Ends: Explaining the *Maniera Greca*," presented at the Dumbarton Oaks Symposium on Byzantium and the Italians, 13th–15th Centuries (May 1993). Several other scholars of Italian art published essays in *Il medio oriente e l'occidente nell'arte del XIII secolo*, ed. H. Belting (Bologna, 1982): C. Smith, "Pisa: A Negative Case of Byzantine Influence," 95–101; M. Jacoff, "The Bible of Charles V and Related Works: Bologna, Byzantium, and the West in the late Thirteenth Century," 163–71; A. Neff, "A New Interpretation of the *Supplicationes Variae* Miniatures," 173–9. Valentino Pace has also written extensively on related issues, but his work focuses primarily on south Italy and Venice, both outside the scope of this study.

7. "Misapprehensions and Misgivings: Byzantine Art and the West in the Twelfth and Thirteenth Centuries," *Medievalia* 7 (1984): 42–5; 71. Robert Nelson raised similar questions in two sessions that he chaired in 1985: "Italian Art and the Levant" at the College Art Association's annual meeting, and "The Byzantine Question" at the Byzantine Studies Conference. See also Note 11.

8. See the Introduction, Note 4. For his comments about the reception of Byzantine art in the duecento, see *The Image and Its Public*, especially chap. VI, 131–85, and appendix C, 203–21. In *Likeness and Presence*, see especially chap. 16, "'In the Greek Manner': Imported Icons in the West," 330–47, as well as chaps. 17 and 18 for further analysis of duecento panel painting. The comments on Belting's work here expand those in my article, "Images East and West." Belting also made important observations in his introduction to the collection *Il medio oriente*, 1–10.

9. *Art Bulletin* 54 (1972): 544.

10. *The Image and Its Public*, 216. In *Likeness and Presence*, Belting similarly stresses Italian painters' attempts to produce "exact replicas" of eastern models (337).

11. At a recent symposium at Dumbarton Oaks (May 1993) on Italy and Byzantium, Anthony Cutler and Robert Nelson expressed doubts about the assumption that Byzantine objects – ivories and manuscripts respectively – circulated in great numbers in Tuscany following the Fourth Crusade. Both pointed out that very few examples of such works can be documented in Tuscany during the thirteenth century (Cutler, "1204 and All That: The Reception of Byzantine Objects at Italian Hands"; Nelson, "Illustrated Greek Manuscripts in the Italian Renaissance"; both essays, now titled "From Loot to Scholarship: Changing Modes in the Italian Response to Byzantine Artifacts, ca. 1200–1750" and "The Italian Appreciation and Appropriation of Illuminated Byzantine Manuscripts, ca. 1200–1450," are forthcoming in the 1995 volume of *Dumbarton Oaks Studies*). Cutler has argued elsewhere that the "influence" of Byzantine objects in Italy in the later Middle Ages has been both exaggerated and undocumented ("La 'questione bizantina' nella pittura italiana: Una versione alternativa della 'maniera greca,'" in C. Bertelli, ed., *La pittura in Italia: L'Altromedioevo* [Milan, 1994], 335–54; pers. comm., 4 April 1994). He is unquestionably correct on both counts, and this study is intended, in part, to address both issues. Though Byzantine "influence" has been exaggerated, it can be visually documented: A careful look at Tuscan painting in the duecento demonstrates that the makers of many of these images had studied Byzantine works very closely. The fact that we have no written records for Byzantine ivories and manuscripts in Tuscany during the thirteenth century does not mean that they did not exist. After all, the existence of most Tuscan painters of the duecento cannot be documented either. For the enormous losses in duecento panel painting, which presumably parallel the likely loss of Byzantine works in Italy, see E. B. Garrison, "Note on the Survival of Thirteenth-Century Panel Paintings in Italy," *Art Bulletin* 54 (1972): 140. Garrison convincingly estimates the loss of panels to be upwards of ninety-nine percent, and he argues that comparable destruction must have occurred in frescoes and manuscripts. See also Derbes, "Documenting the Maniera Greca," The Twentieth Annual Byzantine

Studies Conference, *Abstracts of Papers* (Ann Arbor, 1994). It is likely that Byzantine icons were valued more highly than manuscripts in the duecento, as Nelson suggested, and as Belting implies as well (*Likeness and Presence*, passim, refers only to Byzantine icons in the West). But few icons can be documented in central Italy in the thirteenth century either. Though we cannot assert that Byzantine art in any particular form must have been available to duecento painters, there is no question that Byzantine art in some form was available, in significant quantities.

12. Byzantine and Italian depictions of the Mocking of Christ will be discussed in detail in Chapter 4; examples of Italian reworking of eastern images (specifically, images of the Way to Calvary and Preparations for the Crucifixion) will be analyzed in Chapters 5 and 6.

13. This question was raised by Robert Nelson in the two sessions cited in Note 7. For some consideration of the question, see Derbes, "Siena and the Levant," 190–1, and 200, note 9; idem, "Images East and West"; in the latter essay I suggested several of the responses discussed here. See also Daniel Weiss on the adaptation of Byzantine images in crusader manuscripts; his approach to the issues is in some ways parallel to the one taken here (D. Weiss, "Biblical History and Medieval Historiography: Rationalizing Strategies in Crusader Art," *Modern Language Notes* 108 [1993]: 710–37, especially 736–7).

14. See Hoeniger, "Cloth of Gold and Silver: Simone Martini's Techniques for Representing Luxury Textiles," *Gesta* 30 2 (1991): 154–62; see also the recent paper by Maria Georgopoulou, "Multiculturalism in the Middle Ages: The Question of Style," 82nd Annual Conference, College Art Association, *Abstracts 1994* (New York, 1994), 109.

15. From *The Chronicle of Novgorod, 1016–1471*, describing the looting of Hagia Sophia (trans. R. Mitchell and N. Forbes, Camden 3rd series, vol. 25 [London, 1914], 47).

16. Linda Seidel has written persuasively about the phenomenon of "artistic piracy" in the Middle Ages. Describing the appropriation of Islamic forms in Romanesque Aquitaine, she cites the earlier example of the Dome of the Rock, where Byzantine motifs are inserted into an Islamic structure "to demonstrate the subjugation of the local unbeliever and to declare [Islam's] religious supremacy" (*Songs of Glory* [Chicago, 1981], 81). This reading seems valid as well for thirteenth-century Italy; Tuscans took an active role in the subjugation and colonization of both Constantinople and the territories that became the Crusader States. Of the Tuscan communes, Pisa was most heavily involved in the Latin occupation of the Byzantine Empire. See J. Longnon, "The Frankish States in Greece, 1204–1311," in K. S. Setton, ser. ed., *A History of the Crusades*, vol. 2: *The Later Crusades, 1189–1311*, eds. R. L. Wolff and H. H. Hazard (Madison, Milwaukee, and London, 1969), 243; *I Comuni italiani nel regno crociato di Gerusalemme: Atti del Colloquio [The Italian Communes in the Crusading Kingdom of Jerusalem]* (Jerusalem, 24–28 May 1984), ed. G. Airaldi and B. Z. Kedar (Genoa, 1986). Merchants from Siena, Lucca, and Florence also settled in Acre, capital of the Latin Kingdom of Jerusalem, during the thirteenth century; see J. Folda, *Crusader Manuscript Painting at Saint-Jean d'Acre, 1275–1291* (Princeton, 1976), 5. For a discussion of similar issues in the Venetian colonization of Crete, see M. Georgopoulou, "Late Medieval Crete and Venice: An Appropriation of Byzantine Heritage," *Art Bulletin* 77 (1995): 479–96.

17. D. Freedberg, *The Power of Images: Studies in the History and Theory of Response* (Chicago and London, 1989). See also G. Vikan, "Ruminations on Edible Icons: Originals and Copies in the Art of Byzantium," in *Retaining the Original: Multiple Originals, Copies, and Reproductions*, National Gallery of Art, *Studies in the History of Art*, 20 (Hanover and London, 1989), 47–60.

18. H. Thode, *Franz von Assisi und die Anfange der Kunst der Renaissance in Italien* (Berlin, 1885).

19. H. W. van Os, "St. Francis of Assisi as a Second Christ in Early Italian Painting," *Simiolus* 7 (1974): 115–32. There is now an enormous bibliography on Franciscan patronage, and the following list is far from comprehensive (for additional references on the frescoes in San Francesco, Assisi, see Note 46 in this chapter). I have, however, listed some of the works that I have found especially useful. For Francis and scenes of his life, see J. Stein, "Dating the Bardi St. Francis Master

Dossal: Text and Image," *Franciscan Studies* 36 (1976): 271–95; F. Bisogni, "Iconografia e propaganda religiosa: Due cicli veronesi del Trecento," in *Scritti di storia dell'arte in onore di Ugo Procacci*, eds. M. and P. Dal Poggetto (Milan, 1977), 157–68 (the cycles that he considers are in S. Fermo, Verona, a Franciscan church); J. Gardner, "The Louvre *Stigmatization* and the Problem of the Narrative Altarpiece," *Zeitschrift für Kunstgeschichte* 45 (1982): 217–47; P. Scarpellini, "Iconografia francescana nei secoli XIII e XIV," in *Francesco d'Assisi: Storia e arte* (Milan, 1982), 91–126; D. Blume, *Wandmalerei als Ordenspropaganda: Bildprogramme im Chorbereich franziskanischer Konvente Italiens bis zur Mitte des 14. Jahrhunderts* (Worms, 1983); idem, "Ordenskonkurrenz und Bildpolitik," in *Malerei und Stadtkultur in der Dantezeit*, ed. H. Belting and D. Blume (Munich, 1989); A. Rave, *Christiformitas: Studien zur franziskanischen Ikonographie des florentiner Trecento am Beispiel des ehemaligen Sakristeischrankzyklus von Taddeo Gaddi in Santa Croce* (Worms, 1984); E. Sesti, "L'arte francescana nella pittura italiana dei secoli XIII e XIV," in *Francesco il Francescanesimo e la cultura della nuova Europa*, eds. I. Baldelli and A. M. Romanini (Rome, 1986), 181–97; K. Neil, "St. Francis of Assisi, the Penitent Magdalen, and the Patron at the Foot of the Cross," *Rutgers Art Review* 9–10 (1988–9): 83–110; Goffen, *Spirituality*; Krüger, *Der Frühe Bildkunst*; C. Frugoni, *Francesco e l'invenzione delle stimmate: Una storia per parole e immagine fino a Bonaventura e Giotto* (Turin, 1993). William R. Cook has presented a series of stimulating papers on images of Francis at the International Congress of Medieval Studies in Kalamazoo, Mich. Some of this material is available in his "Fraternal and Lay Images of St. Francis in the Thirteenth Century," in *Popes, Teachers, and Canon Law in the Middle Ages*, ed. J. Sweeney and S. Chodorow (Ithaca, N.Y., and London, 1989), 263–89; idem, "Early Images of St. Francis of Assisi in Rome," in *Exegisti Monumentum Aere Perennius: Essays in Honor of John Francis Charles*, ed. B. Baker and J. Fischer (Indianapolis, 1994), 19–34; idem, "The St. Francis Dossal in Siena: An Important Interpretation of the Life of Francis of Assisi," *Archivum Franciscanum His-toricum* 87 (1994): 3–20; and idem, "Margarito d'Arezzo's Images of St. Francis: A Different Approach to Chronology," *Arte cristiana* 83 (1995): 83–90. His comprehensive catalogue of early images of St. Francis is nearing completion.

A number of other scholars have extended the study of Franciscan art to analyze the Order's patronage of other kinds of images. Amy Neff, whose research I will cite often, has done important work on Franciscan Passion narratives during the duecento. See her dissertation (as Amy Neff McNeary), "The *Supplicationes Variae* in Florence: A Late Dugento Manuscript," Univ. of Pa., 1977; "The *Dialogus Beatae Mariae et Anselmi de Passione Domini*: Toward an Attribution," *Miscellanea Francescana* 86 (1986): 105–8; "Wicked Children on Calvary and the Baldness of St. Francis," *Mitteilungen des Kunsthistorischen Institutes in Florenz* 34 (1990): 215–44. I am grateful to Prof. Neff for helping me obtain copies of her articles. D. Russo, "Saint François, les franciscains et les représentations du Christ sur la croix en Ombrie au XIIIe siècle," in *Mélanges de l'École Français de Rome* 96 (1984): 647–717, is a useful overview, but does not consider narrative images.

Other studies of Franciscan patronage beyond images of Francis include R. Hatfield, "The Tree of Life and the Holy Cross: Franciscan Spirituality in the Trecento and Quattrocento," in *Christianity and the Renaissance*, ed. T. Verdon and J. Henderson (Syracuse, N.Y., 1990), 132–60; L. Schwartz, "Patronage and Franciscan Iconography in the Magdalen Chapel at Assisi," *Burlington Magazine* 133 (1991): 32–6; A. Hoch, "Simone Martini's St. Martin Chapel in the Lower Basilica of San Francesco, Assisi" (Ph.D. diss., Univ. of Pa., 1983), and idem, "St. Martin of Tours: His Transformation into a Chivalric Hero and Franciscan Ideal," *Zeitschrift für Kunstgeschichte* 50 (1987): 471–82; J. C. Long, "Bardi Patronage at Santa Croce in Florence, c. 1320–1343" (Ph.D. diss., Columbia Univ., 1988), and idem, "Salvation through Meditation: The Tomb Frescoes in the Holy Confessors Chapel at Santa Croce in Florence," *Gesta* 34 (1995): 77–88. I have not been able to consult *Atti del I Convegno Internazionale degli Ordini Mendicanti* (Sept. 1991).

For additional bibliography, see the lavishly illustrated volume, *Francesco in Italia, nel mondo* (Milan, 1990), 441.

20. For the reference to Franciscan patronage, see van Os, *Sienese Altarpieces*, 100, note 17; see also ibid., 21. For recent studies of Dominican patronage in the duecento and early trecento, see the fundamental work of J. Cannon, "Dominican Patronage of the Arts in Central Italy: The *Provincia Romana*, c. 1220–c. 1320," (Ph.D. diss., Univ. of London, 1980), and idem, "Simone Martini, the Dominicans, and the Early Sienese Polyptych," *Journal of the Warburg and Courtauld Institutes* 45 (1982): 69–93. See also van Os, *Sienese Altarpieces*, passim; A. Moskowitz, *Nicola Pisano's Arca di San Domenico and its Legacy* (College Art Association Monographs; University Park, Pa., 1994); Hood, *Fra Angelico*; following Cannon, he discusses earlier patterns of patronage for the Dominican order at some length (see especially chap. 3). On the Servites, see van Os, *Sienese Altarpieces*, 23–5, and Corrie, "Political Meaning"; on the Augustinians and Carmelites in duecento Siena, van Os, ibid., 29–30, 37–8; on the Carmelites in the trecento, see H. B. J. Maginnis, "Pietro Lorenzetti's Carmelite Madonna: A Reconstruction," *Pantheon* 33 (1975): 10–16; J. Cannon, "Pietro Lorenzetti and the History of the Carmelite Order," *Journal of the Warburg and Courtauld Institutes* 50 (1987): 18–28; on the same order in the trecento and early quattrocento, C. Gilbert, "Some Special Images for Carmelites, circa 1330–1430," in *Christianity and the Renaissance*, 161–207; on the Augustinians in the trecento, J. Gardner, "The Cappellone di S. Nicola at Tolentino," in *Italian Church Decoration of the Middle Ages and Early Renaissance*, ed. W. Tronzo (Villa Spelman Colloquia, vol. 1; Bologna, 1989), 101–17, and *Arte e spiritualità negli ordini mendicanti*, ed. O. Ruffini (Rome, 1992). Finally, for mendicant patronage in general, see B. Kempers, *Painting, Power and Patronage: The Rise of the Professional Artist in Renaissance Italy* (London, 1993), especially part 1, "Mendicant Orders," 21–80, and for mendicant patronage in Siena, see J. Cannon, "The Creation, Meaning, and Audience of the Early Sienese Polyptych: Evidence from the Friars," in *Italian Altarpieces, 1250–1550*, ed. E. Borsook

and F. S. Gioffredi (Oxford, 1994), 41–62.

21. Gilbert, "Some Special Images for Carmelites," acknowledges that the Carmelites "were a distant third in importance" in central Italy (162); he adds that other groups – he cites the Servites and the Vallombrosans – "never emerged from a local status." On the urban religious orders in Siena, see Van Os, *Sienese Altarpieces*, chap. 2. The hegemony of the two orders continued into the Renaissance: G. Brucker ("Monasteries, Friaries, and Nunneries in Quattrocento Florence," in *Christianity and the Renaissance*, 52) notes that the Observant foundations of the Dominicans and Franciscans "were the most favored, the most generously subsidized, of all religious houses in Florence and its dominion" into the fifteenth century.

In thirteenth-century Sienese patronage, the Dominican role may have outshone the Franciscan: As van Os stresses, "If we are to judge solely by the surviving works of thirteenth-century Sienese art we can only conclude that the Dominicans were far and away the most important donors" (*Sienese Altarpieces*, 25–6). As he notes, "not a single thirteenth-century altarpiece has survived from the church of San Francesco" (21). It is inconceivable that the church was originally bereft of painting; for comments about the decoration of the church, see Cook, "St. Francis Dossal," 18. Still, the Dominicans may have been more active as patrons in Siena than they were elsewhere. The prominence of the Dominicans is striking when one considers that the numbers of Franciscans and Dominicans in Siena were comparable. D. Waley, *Siena and the Sienese in the Thirteenth Century* (Cambridge, 1991), 136, publishes a list of the year 1306, which records ninety-nine Franciscans in Siena, and ninety-six Dominicans. However, a Dominican held the bishopric for twenty years in the later duecento (Tommaso Fusconi, 1253–73), and a second Dominican, Ambrogio Sansedoni (1220–87), was still more important; according to Waley (142), "for the last twenty years of his life he seems to have been the city's most influential cleric. . . ."

22. Cannon, "Simone Martini," 91. For a full discussion of the issues, see her "Dominican Patronage," especially 97–9, 148–9, 168–9, 175 ff., 324–9. She advances powerful argu-

ments and documentation for her case. She observes that Dominican legislation on art was more stringent than that of the Franciscans, who were "less willing, or able, to control display" (98), and that it was only after the Council of Lyons in 1274 that the early restrictions on the possession of property were relaxed. In fact, "only a handful of painted or sculpted works were produced for members of the Order" before the Council (169); she lists them on p. 175. Still another apt observation is that "there were simply far fewer Dominican than Franciscan houses . . . in central Italy. . . . By 1300 there were roughly seven times as many Franciscan foundations as Dominican ones within the area covered by the *Provincia Romana*" (192–3). Even allowing for losses, Cannon's argument, that "art played a recognized role, but not a major one, within a Dominican church" throughout most of the early period (328), is persuasive and important.

23. For the importance of the Dominicans in commissioning images of the Virgin, see Cannon, "Dominican Patronage," especially 233–34, and idem, "Simone Martini"; see also van Os, *Sienese Altarpieces*, chap. 2, and W. Hood, "Fra Angelico at San Marco: Art and the Liturgy of Cloistered Life," in *Christianity and the Renaissance*, 112. For images of the Man of Sorrows, see van Os, "The Discovery of an Early Man of Sorrows on a Dominican Triptych," *Journal of the Warburg and Courtauld Institutes* 41 (1978): 65–75; Cannon, "Simone Martini," 73.

24. Garrison's *Index* includes no panels of Dominic with narratives, and only one central Italian panel of the saint alone, a work close to Guido da Siena in the Fogg Art Museum (no. 204; see also two Campanian panels, nos. 169 and 337). For the handful of other extant duecento images of Dominic – only one a narrative panel, which appears with narratives of three other saints – see Stubblebine, *Guido*, 85–6. He associates the Dominican avoidance of these images with "the Dominican prohibition against decoration of all sorts during the earlier part of the thirteenth century" (85) and notes the strong contrast with the quantities of images of Francis in the duecento (86). See also G. Kaftal, *St. Dominic in Early Tuscan Painting* (Oxford, 1948); he considers the panel in the Fogg (which Stubblebine dates to the 1280s)

the earliest image of St. Dominic. For a fuller analysis, see Cannon, "Dominican Patronage," especially 192 ff., and D. Blume, "Ordenskonkurrenz und Bildpolitik," 149–50, who similarly observes the strong contrast between the kinds of images produced for the two orders. Hood, *Fra Angelico*, 58–9 and plate 46, notes the exceptional nature of Francesco Traini's altarpiece of St. Dominic in Pisa, dated 1345, where the saint appears surrounded by scenes of his life; Hood observes that this type of altarpiece is found in Dominican churches "with remarkable infrequency by comparison with the Franciscan examples" (59). However, a panel of St. Catherine with scenes of her life, now in the Museo Nazionale, Pisa, originally hung in a Dominican church in Pisa; see the discussion in Belting, *Likeness and Presence*, 380–1, fig. 226. Belting suggests (381) that the panel of St. Catherine may have been commissioned in response to the image of St. Francis for S. Francesco, Pisa (fig. 228), painted just a few years earlier. The Dominicans not infrequently commissioned works in emulation of the Franciscans; see Note 121 below for other examples of the Dominicans' appropriation of Franciscan images.

25. This example is provided by a mid-duecento fresco of the Crucifixion in S. Domenico, Pistoia, and its sinopia (*The Great Age of Fresco: Giotto to Pontormo*, ex. cat., Metropolitan Museum of Art [n.p., 1968], figs. pp. 50 and 51). The sinopia depicts the Virgin and John to the left of the cross and a gesticulating soldier to the right. In the fresco, however, the soldier was eliminated, probably, as Umberto Baldini suggested, at the request of the Dominican friars who commissioned the work (ibid., 50–2). For this fresco, see also Cannon, "Dominican Patronage," 227–8, who stresses the Dominican preference for "only the most orthodox and direct version of the scene." In comparison, a near contemporary fresco of the Crucifixion in a convent of the Clares (S. Sebastiano, near Alatri in Latium) teems with figures: Present are not only the Virgin but the holy women as well, not just one gesturing soldier but several. For the fresco at S. Sebastiano, see Prehn, "Decorazione murale," fig. 3, and 86–7, where he links it stylistically with the sinopia in Pistoia.

This is not to suggest that Dominicans

never commissioned narrative cycles. We have already mentioned (Note 24) a hagiographic panel of St. Catherine with narratives of her life, for a Dominican church in Pisa. Some early Dominican frescoes also depict narrative scenes. David Wilkins has published some examples from Sta. Maria Novella, Florence; see "Early Florentine Frescoes in Santa Maria Novella," *Art Quarterly*, n.s. 1, no. 3 (1978): 141–74 (a scene in the Gondi Chapel which he identifies [152–3] as the Shipwreck of Sts. Paul and Luke on Malta and assigns to a follower of Cimabue, and two early trecento narratives in the Rucellai Chapel, a Massacre of the Innocents and a Martyrdom of Ursula). For another example, also from the trecento, see Note 80 below. But these examples are exceptional; as Cannon has stressed, the Dominicans "scarcely participated in one of the major concerns of late 13th and early 14th century central Italian art – the development of narrative fresco cycles" ("Dominican Patronage," 328).

One important Dominican commission that may have included a narrative program is the altarpiece from S. Domenico, Siena, by Guido da Siena (Stubblebine, *Guido*, 30–60). Though Stubblebine assumes an extensive narrative cycle, others have rightly questioned his reconstruction (see, for instance, van Os, *Sienese Altarpieces*, 25, and note 6). Whether the central panel once had lateral panels at all has not been conclusively determined. For further discussion of the narratives associated by Stubblebine with the S. Domenico Madonna, see Chapter 6, pp. 168–9.

26. For a detailed analysis of the two orders' patronage, see Cannon, "Dominican Patronage." She repeatedly stresses the Franciscan sponsorship of narrative cycles, in contrast with the Dominicans (see 272, 328) and notes that the "meditative, nonnarrative quality of the S. Marco fresco [Fra Angelico's Annunciation, cell 3] is one which has been shown to pervade much of the work produced for the *Provincia Romana* Dominicans in the first hundred years of the Order" (332). Van Os similarly notes that "the Dominican approach to religion is decidedly meditative, whereas Franciscan devotion tends to favor the more active, narrative aspects" (*Sienese Altarpieces*, 67). See also

Gardner, "The Louvre *Stigmatization*," especially 242, and Hood, *Fra Angelico*, 21, 53, 126, 175–7. The Franciscan preference for narrative, and Dominican avoidance of it, extended also to writing histories. As Moorman has noted, the Franciscans began early to write the history of the Order; the Dominicans did not (J. Moorman, *A History of the Franciscan Order from its Origins to the Year 1517* [Oxford, 1957], 291). For interesting comments on Franciscan image-making and the stigmata – "within themselves . . . intrinsically narrative" – see Cynthia Hahn, "Absent No Longer: The Sign and the Saint in Late Medieval Pictorial Hagiography," in *Hagiographie und Kunst: Der Heiligenkult in Schrift, Bild und Architektur*, ed. G. Kerscher (Berlin, 1993), 152–73, especially 171 (by typographical error, published as "Absent no Longer: The Saint and the Saint . . ."). I am grateful to Prof. Hahn for sending me a copy of her article.

27. See D. Lesnick, *Preaching in Medieval Florence: The Social World of Franciscan and Dominican Spirituality* (Athens, Ga., and London, 1989), 144–5, regarding the illustrated copies of the Franciscan text, the *Meditationes vitae Christi*. He notes that similar Dominican manuscripts are not densely illustrated like the Franciscan text, and that the Franciscan illustrations convey the "concreteness and palpability of the text," stimulating the involvement of the reader with "both event and image."

28. See, for instance, the comments of T. Verdon, "Christianity, the Renaissance, and the Study of History: Environments of Experience and Imagination," in *Christianity and the Renaissance*, especially 12–21.

29. See her "Franciscan Spirituality: Two Approaches," *Medievalia et Humanistica* 7 (1976): 195–7. J. Fleming similarly stresses that medieval Franciscanism was "in one sense merely the most important and vital institutional expression of the European evangelical revival. . . . There is inevitably much in medieval Franciscan literature which is in no way unique or even markedly distinctive" (*An Introduction to the Franciscan Literature of the Middle Ages* [Chicago, 1977], 11–12).

30. For overviews of late medieval devotion to the Passion, see S. Sticca, "*Officium Passion-*

is Domini: An Unpublished Manuscript of the Fourteenth Century," *Franciscan Studies* 34 (1974): 144–99, especially 154–7; idem, *The "Planctus Mariae" in the Dramatic Tradition of the Middle Ages* (Athens and London, 1988), 7–18; J. Marrow, *Passion Iconography in Northern European Art of the Late Middle Ages and Early Renaissance: A Study on the Transformation of Sacred Metaphor into Descriptive Narrative* (Kontrijk, Belgium, 1979), 8–13; Belting, *The Image and its Public*, 143–85. Marrow points to precedents for this sort of affective spirituality in the late eleventh century (9). For a further discussion of the Passion in both texts and images from the ninth through the eleventh centuries, especially the eleventh, see the cogent analysis of S. Nichols, *Romanesque Signs: Early Medieval Narrative and Iconography* (New Haven and London, 1983), chap. 4, "*Historia* and the Poetics of the Passion," 95–147. For a discussion of thirteenth-century meditation on the Passion, see Freedberg, *Power of Images*, 168–75. All the scholars cited discuss the larger context of devotion to the Passion, but all (except Nichols, who deals with earlier material) also stress the importance of the Franciscans. On the specifically Franciscan contribution, see the study by O. Schmucki von Rieden, "Das Leiden Christi im Leben des Hl. Franziskus von Assisi. Eine quellenvergleichende Untersuchung im Lichte des zeitgenossischen Passionfrömmigkeit," *Collectanea franciscana* 30 (1960): 5–30, 129–45, 241–63, and 353–97. See also the remarks of Verdon, "Christianity," 10–12, who notes the importance of Bernard in the development of affective piety, but then emphasizes that, in contrast to Bernard, "it was Francis who took the new sensibility to the people" (12).

31. Belting asserts that in the early thirteenth century, "the raising of the Host, by which the priest displays the transformed bread to the people, became a fixed element of every mass" (*The Image and Its Public*, 81). This did not necessarily occur immediately in Italy, however. V. L. Kennedy argues that the elevation of the Host, though introduced early in Paris, was adopted only much later in Italy; he states that the first liturgical document of Roman origin to specify the elevation is the *Indutus planeta*, a Franciscan text of directions for the priest saying Mass, written probably c. 1260 ("The Franciscan *Ordo Missae* in the Thirteenth Century," *Medieval Studies* 2 [1940]: 204–22, especially 217 and note 75). Stephen J. P. van Dijk and J. Hazelden Walker, *The Origins of the Modern Roman Liturgy: The Liturgy of the Papal Court and the Franciscan Order* (Westminster, Md., 1960), ascribe the *Indutus planeta* to Haymo of Faversham and date it 1243; they agree with Kennedy that it contains the first known instructions on the elevation of the Host (292–301, 360–61). See also M. Rubin, *Corpus Christi: The Eucharist in Late Medieval Culture* (Cambridge, 1991), who states that the introduction of the elevation "into the Roman missal was mediated through the liturgical books of the new orders, the Franciscan missal of 1243, and the Dominican missal of 1256" (56). A north Italian miniature of 1241 (Oxford, Bodleian Library, Lat. th. b. 4; see Boskovits, *Origins*, fig. 57) depicts the elevation of the host, which suggests that the new rite was in use somewhat before the writing of the *Indutus planeta*.

32. For instance, Angela of Foligno saw Christ "at the display of the Host during mass . . . as if he had just been removed from the cross," and a mid-thirteenth-century French writer described Christ in the tabernacle "as if He were just descending from the Cross." For both, see Belting, *The Image and Its Public*, 240, note 10; see also Rubin, *Corpus Christi*, 302–19, who describes Christ revealing his wounds to saints and mystics to whom he administers communion. For the veneration of the Host and popular perception of images, see M. Camille, *The Gothic Idol* (Cambridge and New York, 1989), 213–19.

33. For a lucid discussion of the connection between the elevation and the development of altarpieces, see van Os, *Sienese Altarpieces*, 12–16. Van Os convincingly associates the *Majestas Domini* in Siena, dated 1215, with the Lateran Council's emphasis on the eucharist; the antependium depicts miracles performed by the Corpus Christi. Van Os, like Belting, assumes that the new rite was instituted immediately after Lateran IV, but see the references to Kennedy and Rubin above, in Note 31. See van Os, 7, also for comments about altarpieces as "liturgical accessories." Some of these issues are addressed as well by K. van der Ploeg, *Art*,

Architecture, and Liturgy: Siena Cathedral in the Middle Ages (Groningen, 1993).

34. See Note 31. On Franciscan eucharistic thought in the thirteenth century, see D. Burr, *Eucharistic Presence and Conversion in Late Thirteenth-Century Franciscan Thought* (Transactions of the American Philosophical Society, vol. 74, part 3; Philadelphia, 1984). On the Franciscan liturgy in the thirteenth century, see R. Corrie, "The Antiphonaries of the Conradin Bible Atelier and the History of the Franciscan and Augustinian Liturgies," *Journal of the Walters Art Gallery* 55 (1993): 65–88. My thanks to Prof. Corrie for sending me a copy of her article.

35. See Rubin, *Corpus Christi*, especially chaps. 2 and 3; for the Dominican involvement with the feast, see E. Borsook's discussion of the cult and the frescoes of Sta. Maria Novella, *The Mural Painters of Tuscany*, 2nd ed., rev. (Oxford, 1980), 48–51. Even in images closely linked to the eucharistic cult, however, Franciscans were much more active as patrons of art than the Dominicans. D. Rigaux, *À la table du Seigneur: L'Eucharistie chez les primitifs italiens (1250–1497)* (Paris, 1989), contrasts the number of images of the Last Supper commissioned by the two orders; she finds that Franciscan images greatly outnumber Dominican examples and notes "la relativement faible participation des frères de Thomas d'Aquin, le docteur eucharistique, dans la commande des images du repas du Seigneur à la fin du Moyen Age" (127–8).

36. The phrase is from a sermon preached by Odo of Chateauroux in 1262: "The marks of the Passion of our Lord Jesus Christ were made visible on his body. . . . It was truly said and can be said now that he was made in the image and likeness of Christ in his sufferings" (E. Doyle, trans., *The Disciple and the Master: St. Bonaventure's Sermons on St. Francis of Assisi* [Chicago, 1983], 151).

37. For Elias's letter, and for the controversy surrounding the stigmata, see the important study by A. Vauchez, "Les stigmates de saint François et leurs détracteurs dans les derniers siècles du Moyen Age," *Mélanges d'archéologie et d'histoire* 80 (1968): 595–625. For Thomas of Celano (*Vita prima*, chap. VIII, 110), see M. Habig, ed., *St. Francis of Assisi: Writings and Early Biographies. English Omnibus of the Sources for the Life*

of *St. Francis* (hereafter cited as *Omnibus*; Chicago, 1973), 325–6. Bonaventure, in his *Legenda maior*, devotes an entire chapter to the stigmata (chap. XIII, 1–10, in Habig, *Omnibus*, 729–36). For the sermon, which was intended to defend the reality of the stigmata, see the comments of Doyle, *Disciple and the Master*, 50, and for the passages quoted here, ibid., 82–3. For the passage from the *Legenda maior* quoted here (from part II, chap. I, 1), see *Omnibus*, 747. For similar observations on the special emphasis Bonaventure placed on Francis's stigmata, see also Goffen, *Spirituality*, 15; E. R. Daniel, *The Franciscan Concept of Mission in the High Middle Ages* (Lexington, Ky., 1975; reprint New York, 1992), 30–1; A. Haase, "Bonaventure's *Legenda Maior*: A Redaction Critical Approach (St. Francis of Assisi)," Ph.D. diss., Fordham Univ., 1990, 336–41.

38. For Franciscan efforts to thwart other saints' claims to the stigmata, see Goffen, *Spirituality*, 21, and Gardner, "Louvre *Stigmatization*," especially 221–5.

39. *Legenda maior*, chap. XIII, 2; the passage refers to Francis's stigmatization: "So Francis understood that he must become like Christ in the distress and the agony of his Passion before he left the world, just as he had been like him in all that he did during his life" (*Omnibus*, 730).

40. M. Miles, *Image as Insight* (Boston, 1985), 65, discusses the power of images to convert and refers to Francis's "conversion" before the San Damiano cross. See also Goffen, *Spirituality*, 24, for Francis's response to images and the importance of "visual language" to his followers.

41. In this context, Bonaventure's statement about one of the purposes of images is telling: "Our emotion is aroused more by what is seen than what is heard" (*Expositio in quatuor libros sententiarum*, lib. 3, dist. 9, qu. 2; see also Freedberg, *Power of Images*, 163; Derbes, "Images East and West," 119–20 and note 64.

42. Borsook, *Mural Painters*, xvii, asserts that frescoes appeared in Tuscany only toward the end of the thirteenth century; she holds that the Crucifixion in Pistoia (see Note 25) was "exceptional" and that "the favoured medium was mosaic." However, several other fresco cycles by Tuscan painters in the third quarter of the century – works like the fresco

cycle in the crypt of the Cathedral in Siena and the frescoes painted by a Tuscan or Umbrian painter in San Sebastiano, Latium (on both, see the Introduction, Note 8), and still others by the Lucchese painter Marco di Berlinghiero (on which see Ayer, "Thirteenth-Century Imagery," 184–96) – suggest that Tuscan fresco cycles existed in greater quantity than she implies; they simply were less durable than mosaic. Boskovits, *Origins*, 151–7, also mentions a number of fresco cycles in Florence from the twelfth and thirteenth centuries. See also the comments of Wilkins, "Early Florentine Frescoes," 141–2. He cites Borsook's remarks and a number of comparable statements by other scholars (note 2), and also questions the validity of this view, arguing for a much more significant tradition of frescoes in Tuscany, especially in Florence (141–2 and 166, note 4).

43. For S. Sebastiano and S. Pietro in Vineis, see the Introduction, Note 8; for Sta. Maria dei Angeli, see Toscano, "Maestro delle Palazze" (especially 16, note 5, for the site as a Clarisse convent). One Passion cycle from the period appeared outside a Franciscan context: the frescoes in the crypt of the Cathedral of Siena (see the Introduction, Note 8). Sta. Croce, the Franciscan church in Florence, originally had at least one fresco cycle from the mid-duecento, but only fragments survive; it was a narrative program of some sort, but the subject cannot be determined (see Wilkins, "Early Florentine Frescoes," note 4).

44. On S. Antonio, see Caselli, *Il monastero*. The church was founded by Beatrice d'Este; Pope Innocent IV directed the women to assume the Benedictine rule, but assigned them to the care of the "religiosos viros. . .ordinis Fratrum Minorum" (G. Manini-Ferranti, *Compendio della storia sacra e politica di Ferrara* [Ferrara, 1808], 2, 144, cited by Caselli, 22). Pope Alexander IV confirmed the arrangement in 1256. For a further discussion of the founding of S. Antonio and the *cura monialium* of the Franciscans, see Caselli, especially 21–4.

45. On Francis as *Alter Christus*, see van Os, "St. Francis," 115–32; Goffen, *Spirituality*, 13–22. The scenes that most emphatically stress the parallels will be discussed in Chapter 6. For the authorship and dating of these frescoes, see the Introduction, Note 8.

46. The date and attribution of these frescoes, the work of several painters, is still a matter of debate; Marques has recently ascribed some of the Passion scenes to Duccio (*Peinture*, 153–62). He dates the cycle c. 1280–2; it is more often placed in the late 1280s to early 1290s. See the bibliography cited in the Introduction, Note 8. On the larger program in the context of Bonaventure's writing, also see C. Mitchell, "The Imagery of the Upper Church at Assisi," in *Giotto e il suo tempo*, Congresso Internazionale Assisi-Padua-Florence, 1967, 113–34; A. Smart, *The Assisi Problem and the Art of Giotto* (Oxford, 1971); for Cimabue's frescoes in the Upper Church and Bonaventure, see Marques, *Peinture*, 115–19, and I. Carlettini, "L'Apocalisse di Cimabue e la meditazione escatologica di S. Bonaventura," *Arte medievale* 7 (1993): 105–28.

47. The repetition of the two frescoes of the Crucifixion in the transept at Assisi is unusual; presumably the intention was for the friars seated on both sides of the choir to have an unobstructed view of the Crucifixion. For photographs of the two, see M. Chiellini, *Cimabue* (Florence, 1988), figs. 38, 48. One point that distinguishes the two is the position of the Virgin, who stands erect in the version by Cimabue, but swoons in the other, attributed to his shop. A precedent of sorts appears in a Franciscan context: In the Lucchese diptych from Sta. Chiara, Lucca (Fig. 1), the Virgin appears twice beneath the cross; on the left, she collapses into the arms of the holy women, and on the right, she stands upright with St. John.

48. For this fresco cycle, see C. Frugoni, *Pietro and Ambrogio Lorenzetti* (Florence, 1988), 16–30; C. Volpe, *Pietro Lorenzetti*, ed. M. Lucco (Milan, 1989), 24–9, 36–8, 60–84, and 91–5 (additional bibliography in Chapter 2, Note 19). There are sixteen Passion scenes; inserted into the Passion cycle, just below the Betrayal of Christ, is the Stigmatization of St. Francis. A Crucifixion appears in the north transept as well. Other instances of fresco cycles of the Passion for the Order in the trecento appear in the nuns' choir of Sta. Maria Donnaregina, Naples, 1307–20 (see E. Carelli and S. Casiello, *Sta. Maria Donnaregina in Napoli* [Naples, 1975]; R. A. Genovese, *La chiesa trecentesca di Donna Regina* [Naples, 1993]; J. White, *Art and Architecture in Italy*

1250–1400, 2nd. ed. [London, 1987], 161–2); the sacristy of Sta. Croce, Florence; and the chapter house of S. Francesco, Pisa, from the 1390s (on these, see Hood, *Fra Angelico*, 176–7). Passion narratives for the Franciscans continued at least into the Renaissance; a Franciscan pilgrimage site in Tuscany, S. Vivaldo, in 1516 had thirty-four small chapels, each with a Passion scene in painted terracotta. On S. Vivaldo, see J. Shearman, *Only Connect . . . : Art and the Spectator in the Italian Renaissance* (Princeton, 1992), 40–3.

49. On this manuscript, see A. Neff McNeary, "Supplicationes Variae," and (as Amy Neff) two later works: "New Interpretation," 173–9, and "Wicked Children," 215–44. For the Franciscan connections of the manuscript, see "*Supplicationes Variae*," 7–8, and "Wicked Children," 228, where she writes: "Although the *Supplicationes Variae* is not a Franciscan liturgical manuscript, several of its offices and devotional texts are clearly Franciscan." For the Passion scenes in the manuscript, "the most fully treated" of all the illuminations, see "*Supplicationes Variae*," 101. The provenance of the manuscript is unknown; it was made for use in Genoa ("New Interpretation," 173).

50. The discussion in this paragraph does not include painted crosses; a consideration of the crosses follows shortly.

51. Neil considers the figure a Franciscan patron rather than Francis himself, noting that he is not haloed ("St. Francis of Assisi," 103–5). However, the stigmata can be seen on the feet and left hand of the saint.

52. The Franciscan provenance of the San Diego dossal will be discussed in greater detail in the Conclusion. Other panels for Franciscans include an Umbrian tabernacle in Assisi, Sta. Chiara (*Index*, no. 325; for a color photograph, see Castelnuovo, *Pittura*, vol. 2, fig. 676, or Todini, *Pittura umbra*, vol. 1, color plate III, and see the forthcoming study by Jeryldene Wood on the Clares); a triptych from a Franciscan priory near Lucca, now in the Frick Art Museum, Pittsburgh (*Index*, no. 327; for the provenance, see W. Hovey, *Treasures of the Frick Art Museum* [Pittsburgh, 1975], 33; color plate p. 31); panels from a dossal in Assisi and Perugia, at times assumed to come from the high altar of the Lower Church at Assisi, but probably from

S. Francesco al Prato, Perugia (*Index*, nos. 440–3; see Garrison's reconstruction, *Index*, 171; Schultze, "Zur Kunst des 'Franziskusmeisters'," 141–4, fig. 122; Marques, *Peinture*, 61–3; for the probable origins at S. Francesco at Prato, see D. Gordon, "A Perugian Provenance for the Franciscan Double-Sided Altarpiece by the St. Francis Master," *Burlington Magazine* 124 [1982]: 70–7; and the catalogue entry by S. Romano in C. Bon Valsassina and V. Garibaldi, *Dipinti, sculture e ceramiche della Galleria Nazionale dell'Umbria* [Florence, 1994] cat. 4, 58–62, color plate p. 59; a Sienese triptych in the Fogg Art Museum, which includes the Stigmatization (*Index*, no. 326); a Sienese tabernacle in the museum of Wellesley College, with the Funeral of St. Clare below the Ascent of the Cross (*Index*, no. 342; Stubblebine, *Guido*, fig. 59); and a Sienese triptych in Crakow, with Francis and Clare (*Index*, no. 347; Stubblebine, fig. 56). Finally, fragments of a Lucchese altarpiece – three panels of the Crucifixion, Deposition, and Lamentation – now in the Yale University Art Gallery (*Index*, no. 679) have been traced by Boskovits to the Franciscan church in S. Miniato; see *Origins*, 74–6 and note 147. Though the new provenance is an important contribution, Boskovits dates the altarpiece to the middle or late 1220s, which seems to me unlikely; iconographic details such as the three-nail Crucifixion and the Y-cross do not become common in Tuscan painting until the middle of the century, as in the Lucchese diptych in the Uffizi (Fig. 1). Further, we have very few Franciscan works as early as the 1220s, for reasons discussed above (pp. 23–4).

At times, panels commissioned by Franciscans included a fuller christological cycle, with one or more scenes from the Infancy or Ministry of Christ, or both, as well as the Passion. For instance, the extant panels of a now-dismembered diptych, variously described as Tuscan or Venetian (see Boskovits, *Thyssen*, cat. no. 21), include three Passion themes as well as the Annunciation and the Last Judgment; Francis kneels at the foot of the cross in the Crucifixion. The tabernacle in Assisi (no. 325) includes three Infancy scenes, and an Umbrian triptych in Perugia, which may have been, like the Assisi tabernacle, intended for the Clares (both Francis and Clare

appear on the exterior shutters) includes all three cycles (*Index*, no. 348; Stubblebine, *Guido*, fig. 90; however, P. Scarpellini [cat. entry in Bon Valsassina and Garibaldi, *Dipinti*, cat. 7, 68–73, color plate on 70–1] proposes that the triptych was commissioned by the Templars and was originally destined for S. Bevignate in Perugia). And occasionally, Franciscan panels have christological cycles that include only a single Passion scene, as in a pair of Florentine tabernacle shutters in a private collection (*Index*, no. 322A; see also Tartuferi, *Pittura a Firenze*, fig. 145). Finally, though Venice and south Italy are both beyond the scope of this study, several trecento Venetian panels with Passion scenes are also Franciscan: See Garrison's *Index*, nos. 245, 246, 287, 300, 343; see also a south Italian example from Sta. Chiara, Palma, no. 387.

Of course, other clients also commissioned Passion narratives. But of those published by Garrison, far fewer examples can be securely assigned, and the surviving examples tend to be fairly late. One example, in which the central panel depicts the Thebiad, may have been commissioned by the Carmelites (no. 351; see Gilbert, "Some Special Images for Carmelites," 173, and on the panel itself, see Marques, *Peinture*, fig. 262). However, other orders were similarly interested in the theme; see E. Callman, "Thebiad Studies," *Antichità Viva* 14 (1975), 3–22, especially 18–20. As she notes, John Climacus's *Ladder of Perfection*, the major source for the Thebiad, was translated by Angelo Clareno, a Franciscan Spiritual (11–12).

Some panels with Passion scenes were commissioned by patrons who venerated both Francis and Dominic. For instance, both saints appear in a portable triptych with a Crucifixion, now in New Haven (Yale University Gallery; *Index*, no. 330). Similarly, in a small triptych with four Passion narratives in the wings, the Virgin and Child are flanked by both saints (London, Agnew collection; Tartuferi, *Pittura a Firenze*, fig. 222).

Garrison's *Index* includes a few other works with Passion narratives that are unlikely to have been intended for Franciscans: Both depict saints, but no saint associated with the order (e.g., Francis, Clare, Anthony of Padua) is included. For instance, in a small triptych, c. 1265–70, now in the Metropolitan Museum (*Index*, no. 282; F. Zeri with E. Gardner, *Italian Paintings: A Catalogue of the Collection of the Metropolitan Museum of Art, Florentine School* [New York, 1971], 4–5, fig. on p. 4), Sts. Peter and Paul flank the central image of the Virgin and Child. A problematic example is a triptych of which the central panel is in Oxford, Christ Church Museum; the whereabouts of the wings are unknown (*Index*, nos. 354–5; Marques, *Peinture*, fig. 258; and Note 11 in the Introduction). The triptych is probably from the end of the duecento (see Marques, 205), rather than the early trecento, as Garrison believed. It too includes Sts. Peter and Paul, along with two unidentified female saints. However, the triptych includes a number of iconographic connections with Franciscan works; see Chapter 3, Note 86. See also a pair of shutters in Basel, also with Peter and Paul (*Index*, no. 320). Rarely, there is a curious absence of Franciscan saints, and the presence of others, in unquestionably Franciscan commissions; see the comments of Hood (*Fra Angelico*, 176–7) about the chapter house of S. Francesco, Pisa. See also J. Gardner, "Altars, Altarpieces, and Art History: Legislation and Usage," in *Italian Altarpieces 1250–1550*, 5–19, especially 17, for the importance of Peter and Paul to the mendicant orders; for the Franciscans and Peter and Paul, see Cook, "Early Images," 28.

Finally, in a number of panels published by Garrison there is no immediately obvious indication of patronage (nos. 283, 303, 412, 664, 673, 674–5, and the narratives from Badia Ardenga by Guido da Siena). I will argue in the Conclusion that four of these works (412, 664, 674–5, and Guido's narratives) were probably intended for Franciscans; all include themes found almost exclusively in Franciscan monuments.

53. For this comparison, see Hood, *Fra Angelico*, 55–7. Ugolino's polyptych dates c. 1325; the Dominican work with which Hood compares it is Simone Martini's altarpiece for Sta. Caterina in Pisa, c. 1320. The Dominican example consists of fourteen bust-length saints and, in the center, the Man of Sorrows.

54. A now-lost cross of 1236 by Giunta Pisano, commissioned by Brother Elias for S. Francesco, Assisi, was an important early exemplar of the type. On Giunta, see Sandberg-Vavalà, *Croce dipinta*, 681–91;

Tartuferi, *Giunta Pisano*; Boskovits, *Origins*, 76–81.

55. A kneeling figure of Francis may have appeared in Giunta's cross for Brother Elias in 1236; see Sandberg-Vavalà (*Croce dipinta*, 123–4). However, no surviving example of the motif is earlier than the second half of the century. For painted crosses which include it – a type especially popular in Umbria – see Garrison, *Index*, nos. 533, 542, 549, 552, 559, 562, 565, 571. In one especially interesting example, the cross of c. 1260 over the high altar of Sta. Chiara, Assisi (*Index*, no. 542), Clare and the Abbess Benedetta appear with Francis. For further discussion of the type, see Neil, "St. Francis of Assisi"; Cook, "Fraternal and Lay Images"; and Krüger, *Der Frühe Bildkunst*, 150–67. Rarely, the kneeling suppliant is a Dominican; for one example, see Garrison, no. 585. For a discussion of the origins of the figure kneeling at Christ's feet, see Note 109. None of the examples noted above is historiated.

Only rarely do Francis and Clare appear elsewhere on painted crosses of either type. One exception is a painted cross, without historiation, from Spoleto in which Francis and Clare appear at the end of the cross arms (described by Krüger as an "Einzelfall" in *Der Frühe Bildkunst*, 161, fig. 314). Equally exceptional is the Sta. Bona cross, a historiated example, in which Bona appears in the terminal of the right arm; her presence probably identifies the cross as a work for the Clares (see Note 57 below).

56. Garrison, *Index*, no. 527; for a color photograph, see P. Torriti, *La Pinacoteca Nazionale di Siena: I dipinti* (Genoa, 1990), fig. 2. The cross was not destined for Sta. Chiara from the beginning. The Clares had a convent in Siena in 1219, but at Sta. Petronilla; the first documentary record of Sta. Chiara, Siena, is evidently not until 1345, though the convent was then in existence (J. Moorman, *Medieval Franciscan Houses* [New York, 1983], 664); see also Boskovits, *Origins*, 61, note 115, who dates the foundation of Sta. Chiara to 1307 and suggests that the cross was painted for Sta. Petronilla). The date of the cross is uncertain. Garrison placed it in the second quarter of the century, but it is more frequently dated to the first. See, for instance, Carli, *Sienese Painting*

(New York, 1983), 3; Torriti, 9. A date much before 1230 is difficult to reconcile with a Franciscan provenance; very few surviving Franciscan commissions predate Gregory IX's bull of 1230 authorizing the use of images (the date of one image of Francis, said to be 1228, has been questioned; see Note 79). Alternatively, if Garrison's assessment of the painter as "retardatary" (31) is correct, it may well be a work of the early 1230s. Though it depicts Christ as *Christus Triumphans*, so does the cross for Sta. Bona, which, as Stubblebine has shown, was intended for the Clares (see Note 57). So, too, does a cross in the treasury of S. Francesco, Assisi (*Index*, 460), which Garrison dates to the 1230s. Though the two earlier crosses may have been produced before the *Christus Patiens* became established in Franciscan houses, it is also possible that the *Triumphans* remained in use in certain quarters. The fact that the cross from S. Damiano, Assisi (*Index*, no. 459), which is said to have spoken to Francis, depicts Christ as *Triumphans* may have encouraged the continuation of this type. The Clares were established in the church of S. Damiano very early – Clare herself lived there – and the use of the *Triumphans* for Clarissan houses may have been intended to evoke that highly venerated cross in the care of the Clares.

57. Stubblebine, "A Crucifix for Saint Bona," *Apollo* 125 (1987): 160. This cross was recently purchased by the Cleveland Museum of Art. As Stubblebine pointed out, Bona's relics were in the custody of the Clares; the fact that the saint appears in the right terminal panel of one of the crosses makes the link of this cross with the Clares more secure. For the early history of S. Martino, which began as an Augustinian foundation, see the discussion in Stubblebine; see also A. Da Morrona, *Pisa illustrata nelle arti del disegno* (Livorno, 1812), 3, 256–9; G. Sainati, *Diario Sacro Pisano* (Siena, 1886), 204–8; F. Paliaga and S. Renzoni, *Le chiese di Pisa: Guida alla conoscenza del patrimonio artistico* (Pisa, 1991), 132–6. For the Franciscans and Sta. Bona, see *Acta Sanctorum*, May, vol. 7 (Paris, 1866), 141–2. A new church and convent for the Clares replaced the earlier church of S. Martino; the construction began in 1332 (Da Morrona, 258). See also E. Tolaini, *Forma Pisarum: Problemi e ricerche per una*

storia urbanistica della città di Pisa (Pisa, 1967), 25, for S. Martino and its district in duecento Pisa.

58. Garrison, *Index*, no. 529. Garrison attributes the cross to a Pisan. It is now in Volterra, Museo dell'Opera del Duomo.

59. Carli and Imberciadori, *San Gimignano*, 65. In this case, the likely date of the cross – it has traditionally been dated on stylistic grounds between 1250 and 1260 – corroborates the provenance: The Clarisse house in S. Gimignano was founded c. 1261. For the founding of the Clares there, see P. B. Bughetti, "Tabulae Capitulares, Provinciae Tusciae," *Archivum Francescanum Historicum* 10 (1917): 413–97, especially 446, and P. F. Gaddori, "Inventaria Clarissarum," *Archivum Franciscanum Historicum* 9 (1916): 294–346, especially 298. The 1317 inventory of the S. Gimignano Clares, published by Gaddori, refers to a cross on the altar, but does not provide any details; it is listed simply as "unam crucem" (299). See, however, the recent comments of Boskovits, *Origins*, 524, who suggests that the cross mentioned there may be the present one.

60. The single exception is the cross in Siena, certainly the earliest of the group, which presumably was executed before the reformulation of the narratives took place; see Note 56. Nonetheless, the episodes chosen for the apron are very similar to those in other, later, crosses.

61. The interconnections of text and image are much discussed today. For a recent overview, see B. Cassidy, "Introduction: Iconography, Texts, and Audience," in *Iconography at the Crossroads*, Papers from the Colloquium Sponsored by the Index of Christian Art, Princeton University, 23–4 March 1990 (Princeton, 1993), 3–16. Camille, *Gothic Idol*, xxvii, stresses "the complex interdependence of scriptural and visual traditions" – a useful description of the relationship between text and image. See also the comments of Camille in his review of Belting's *Bild und Kult*; and see J. Hamburger's review of Camille's *Images on the Edge: The Margins of Medieval Art* (Cambridge, Mass., 1992), in *Art Bulletin* 75 (1993): 319–26, especially 320.

62. For Francis's Office, see Habig, *Omnibus*, 140–55. Bonaventure was also the author of an office; see *Opera Omnia*, vol. 14 (Paris,

1868), 155–61. For the earliest liturgical books for the Order, see S. J. P. Van Dijk, *Sources of the Modern Roman Liturgy*, vol. 1 (Leiden, 1963), 42–5.

63. For Bonaventure's *Lignum vitae*, 1259–60 (*The Tree of Life*), see *The Works of Bonaventure*, trans. J. de Vinck, vol. 1 (Paterson, N.J., 1960), 95–144; for the *Vitis mystica* (*Mystical Vine*), ibid., 145–205; for *De perfectione vitae ad sorores* (*On the Perfection of Life Addressed to Sisters*), ibid., 207–55. For the *Lignum vitae*, see also P. F. O'Connell, "The *Lignum Vitae* of Bonaventure and the Medieval Devotional Tradition" (Ph.D. diss., Fordham Univ., 1985).

64. See the translation by I. Ragusa and R. Green, *Meditations on the Life of Christ: An Illustrated Manuscript of the Fourteenth Century* (Princeton, 1961). The text is unquestionably Franciscan, but the authorship and date are not certain. The traditional attribution to Giovanni di Caulibus, a Tuscan Franciscan active toward the end of the century, is accepted by Lesnick, *Preaching*; for his discussion of this text, see 143–71. A recent study by E. S. Varanelli ("Le *Meditationes Vitae Nostri Domini Jesu Christi* nell'arte del duecento italiano," *Arte Medievale* 6 [1992]: 137–48) questions the attribution and dates the text c. 1260, arguing that details of Nicola Pisano's Pisa pulpit and Siena pulpits, among other works, were derived from it. F. L. Pickering maintains that it was written about the time of the true Bonaventure's death in 1274 (*Literature and Art in the Middle Ages* [Coral Gables, Fla., 1970], 238). S. McNamer, "Further Evidence for the Date of the Pseudo-Bonaventuran *Meditationes Vitae Christi*," *Franciscan Studies* 50 (1990): 235–61, proposes a much later date, c. 1336–60. For the audience to whom the text was addressed, see Note 68.

65. For Pseudo-Anselm, c. 1240, see J. P. Migne, ed., *Patrologia cursus completus. Series latina.* 221 vols. (Paris, 1841–1903), vol. 159, cols. 289ff. (hereafter cited as *P. L.*). For the date, see A. Neff, "Dialogus," who persuasively ascribes the text to a Franciscan. Pseudo-Bede, *P. L.*, vol. 94, cols. 561–8, has been called Cistercian (e.g., W. Baier, *Untersuchungen zu den Passionsbetrachtungen in der "Vita Christi" des Ludolf von Sachsen* [Salzburg, 1977], 2, 275) but it is almost certainly of Franciscan authorship; it opens with

a reference to the first rule of the Order and later includes a specifically Franciscan insertion into the narrative of the Passion. For the reference to the rule of the Order, see Chapter 5, pp. 129–30; for the Franciscan insertion, Chapter 6, pp. 154–5. As for the date of this text, J. Marrow, "*Circumdederunt me canes multi*: Christ's Tormentors in Northern European Art of the Late Middle Ages and Early Renaissance," *Art Bulletin* 59 (1977): 197, places it in the thirteenth century and considers it among the sources of Pseudo-Bonaventure's more comprehensive *Meditationes vitae Christi*. In his later study, *Passion Iconography*, Marrow describes Pseudo-Bede as the most important of several texts predating the *Meditationes* (12) and again places it in the thirteenth century (27). Lesnick, *Preaching*, 269, note 46, believes that Pseudo-Bede's text was "composed probably during the second half of the thirteenth century." Marrow is undoubtedly correct that the text predates the *Meditationes*; given the many similarities between mid-century Passion images and the descriptions in Pseudo-Bede (on which see especially Chapters 2, 4, 5, and 6), a date towards the middle of the century seems plausible.

66. Gerard's polemic, *Contra adversarium perfectionis christianae*, was written in 1269. For the *Apologia pauperum* (*Defense of the Mendicants*), see De Vinck, *Works*, vol. 4 (Paterson, N.J., 1966). For background, see M. D. Lambert, *Franciscan Poverty: The Doctrine of the Absolute Poverty of Christ and the Apostles in the Franciscan Order, 1210–1323* (London, 1961), 126–40; J. Châtillon, "*Nudum Christum Nudus Sequere*: Note sur les origines et la signification du thème de la nudité spirituelle dans les écrits de Saint Bonaventure," in *S. Bonaventura, 1274–1974* (Grottaferrata, 1973), vol. 4, 719–72, especially 755–60, and Moorman, *History*, 129–30.

67. See the edition by F. M. Delorme (Florence, 1929). See also the comments of Moorman, *History*, 262, and Fleming, *Literature*, 68. Daniel has stressed the eschatological content of the text, calling it "the fullest expression of the christological character of Franciscan eschatology" (*Franciscan Concept*, 35).

68. The precise audience for these texts is only occasionally explicit. Bonaventure's *Apologia pauperum*, c. 1269–70, the most overtly political of the writings considered here, was directed at Gerard of Abbeville and others who challenged the friars, in particular their vow of poverty; he addressed the Order, however, not Gerard, to whom he refers as "a calumniator" and whose writings are "like a loathsome and horrible exhalation from the bottomless pit" (De Vinck, *Works*, vol. 4, 1). The text was so influential that it became the official statement on poverty of the Order and the papacy (Lambert, *Franciscan Poverty*, 127). As to the meditative guides, there is no indication either in the *Lignum vitae*, 1259–60, or in the *Vitis mystica* of the person or group to whom Bonaventure wrote. However, his *De perfectione vitae ad sorores*, also from around 1260, was addressed to Isabella, sister of Louis IX, who founded a convent of Minoresses at Longchamp; it was presumably intended for the nuns under her care. But most of these circulated widely, even in Bonaventure's lifetime; see Fleming, *Literature*, 210.

Most of the devotional texts by the various pseudonymous writers – Pseudo-Anselm, Pseudo-Bede, and Pseudo-Bonaventure – were likewise probably intended first for circulation in Franciscan communities: Their frame of reference is distinctly Franciscan. But they were also intended for a wider audience of the laity, just as Franciscan sermons were directed both to friars and to the public. See Marrow, *Passion Iconography*, 11, on the "heterogeneity of education and temperament" among those for whom these tracts were intended.

The audience of the fullest of these tracts, that by Pseudo-Bonaventure, is known more precisely; the writer addressed one of the Clares. The text states: "If you read about. . .the Blessed virgin Clara, your mother and leader, . . ."(Ragusa and Green, *Meditations*, 2; see also the comments of the translators, xxvii). Because it was circulated so extensively, however – well over 200 copies of the text are known (see Ragusa and Green, xxii, note 4) – it seems probable that a wider readership was intended.

The fact that at least two of the meditations were intended for the Clares, coupled with the Passion cycles and images found in so many Clarisse foundations, calls to mind Caroline Bynum's association between a specifically female spirituality and medita-

tions upon the humanity of Christ ("And woman His humanity: Female Imagery in the Religious Writing of the Later Middle Ages," in Bynum, S. Harrell, and P. Richman, eds., *Gender and Religion: On the Complexity of Symbols* [Boston, 1986], 257–88; reprinted in Bynum, *Fragmentation and Redemption: Essays on Gender and the Human Body in Medieval Religion* [New York, 1991], 79–118; see also Bynum's other essays in that collection). The tradition of male writers directing such meditative guides to women can be traced to the eleventh century; a monk writing in 1080 advised a devout woman named Eva to meditate on the Passion of Christ (see Marrow, *Passion Iconography*, 9). See also the comments of Fleming, *Franciscan Literature*, 19, who notes that women were "the defining audience for much late medieval literature."

Women were also the audience for much late medieval art, in particular Passion images. Specialists in Italian art are only now beginning to recognize the extent to which these works were produced for a female audience. For instance, Boskovits has recently noted that extant historiated crosses were largely for female communities (*Origins*, 40, note 66), a point that I also made in a paper delivered at the International Congress of Medieval Studies, Kalamazoo, May 1994 ("The Clares and Passion Images"). The topic deserves much fuller consideration than it has received thus far. Jeryldene Wood is now completing a study of the patronage of the Clares; her work will address some of these issues, such as the stress on narrative in some early panel painting for the Clares. I am grateful to Prof. Wood for making portions of her work available to me in typescript.

69. See Marrow, *Passion Iconography*, 10–11, for the various approaches of these meditative guides. See also the forthcoming work of Richard Kieckhefer; in a recent paper ("Varieties of Late Medieval *Vita Christi*") presented at the 29th International Congress on Medieval Studies, Western Michigan Univ., Kalamazoo, Mich., May 1994, he stressed the differences in forms of devotional texts.

70. Several examples of this pattern will be noted, especially in Chapters 2 and 6. This sort of flexibility – a visual corollary for which is seen in Franciscan images depicting

the Virgin both erect and swooning at the Crucifixion (see Note 47) – is one example of the sensitivity to a diverse audience which Marrow has observed (see Note 68). The tolerance for alternate versions of episodes in the Passion cycle contrasts with the imposition of one authorized biography of Francis, Bonaventure's *Legenda maior*; all other versions of Francis's life were prohibited in 1266. For interesting remarks about the imposition of "clerically codified images" in the thirteenth century, see Camille, *Gothic Idol*, xxviii.

71. "Bonaventure's Life of St. Francis and the Frescoes in the Church of San Francesco: A Study in Medieval Aesthetics," *Franziskanischen Studien* 59 (1977): 29–37, especially 31. An important example occurs in Bonaventure's account of the Stigmatization of Francis; though Celano described the agent as a seraph, for Bonaventure it was Christ himself (on this see also Goffen, *Spirituality*, 15–16). Still more blatant manipulations to stress the parallels between the lives of Christ and Francis were noted by van Os, "St. Francis." As he observed, frescoes by Benozzo Gozzoli depict the birth of Francis taking place in a stable, as an ox and an ass look on (131–2). For Bonaventure's reworking of Franciscan stories to stress typological parallels, see also W. Cook, "Tradition and Perfection: Monastic Typology in Bonaventure's *Life of St. Francis*," *The American Benedictine Review* 33 (1982): 1–20.

72. Haase, "Bonaventure's *Legenda Maior*," 240ff.; see also Daniel, *Franciscan Concept*, 26, 29–30, 48–50.

73. See Blume, *Wandmalerei*; idem, "Ordenskonkurrenz und Bildpolitik"; Bisogni, "Iconografia e propaganda," 157–68.

74. See, for instance, Goffen, *Spirituality*, 21–2. She suggests that Giunta's cross of 1236 for S. Francesco was "perhaps the first Italian example of the [*Christus Patiens*]" (22). Similarly, Belting notes: "A number of reasons arguing for the reformulation of the image of the crucified Christ occurred at the behest of the Franciscans. . . . Above all, the new portrayal of Christ symbolized the Passion meditation of the Franciscans, who contemplated the suffering and death of Christ from the new perspective of their affective experiential replication, from the standpoint of *compassio*" (*Image and Its Public*, 145).

There is some dispute about whether Giunta Pisano's cross for S. Francesco predates his cross for S. Domenico, Bologna (Tartuferi [*Giunta*, 14, 32] and Boskovits [*Origins*, 80, note 151] both place the S. Dominico cross c. 1230, though it has traditionally been dated c. 1250–5 [Garrison, *Index*, no. 546; Marques, *Peinture*, 4]). But if we cannot confidently state that the Franciscans commissioned the first example of the suffering Christ in Italy, few scholars doubt that the Order promoted the use of the new image.

75. Moorman, *Medieval Franciscan Houses*, 691.

76. Ibid., 34.

77. On the bull, see Lambert, *Franciscan Poverty*, 75–88; R. Huber, *A Documentary History of the Franciscan Order from the Birth of St. Francis to the Division of the Order under Leo X (1182–1517)* (Milwaukee and Washington, D.C., 1944), 102–3. See also H. Grundmann, "Die Bulle 'Quo Elongati' Papst Gregors IX," *Archivum Franciscanum Historicum* 54 (1961): 3–5 (for the text of the bull, 20–5); and E. Pasztor, "Franciscanesimo e papato," in *Francesco, il francescanesimo e la cultura della nuova Europa*, eds. I. Baldelli and A. M. Romanini (Rome, 1986), 103–29, especially 104–8. Goffen nicely describes the bull as an "escape clause" from the restrictions of the Testament of Francis (*Spirituality*, 48). Just as there would have been no need for altarpieces early in Franciscan history, van Dijk and Walker note that the friars had little need for liturgical books; since they had no churches of their own, mass was celebrated in parish churches (*Origins*, 237–8).

78. Moorman's *Medieval Franciscan Houses* provides a useful measure of the spread of the Order. The construction of new Franciscan churches began at Assisi with S. Francesco; the foundation of the Lower Church was laid in 1228, and the Upper Church was built between 1231 and 1236 and consecrated in 1253 (Moorman, 35). Elsewhere in central Italy, friars were typically given a church in the 1230s and began building a new church in the 1240s, '50s, and '60s. For instance, the Sienese friars were given an existing church in 1236 and started construction on their own church in 1246 (ibid., 450); the Perugians similarly took over a church in 1236 and began to build a new one in 1253 (ibid., 377). In Pisa, friars were given a church in the late 1220s but did not take possession of it until 1247; they built a larger church in 1261 (ibid., 386). In Florence, a group of friars had settled in an existing church at Sta. Croce by 1228, but evidently did not build a new church until 1252 (ibid., 183; see also Goffen, *Spirituality*, 2–4). On this "*Bauboom*," see also Blume, *Wandmalerei*, 9; he dates the height of the boom to 1240–60.

Lambert, *Franciscan Poverty*, especially 89–102, provides a context for the "*Bauboom*." He notes, first, that the chapter at Rome in 1239 issued decrees excluding lay brothers from office, and that newly dominant clergy pushed for the construction of churches in which to serve congregations (89–90). He also observes some relaxation of strict observation of poverty under Haymo of Faversham (Minister General from 1240–4) and even more under his successor Crescenzio da Jesi (1244–7); further, as he notes, Pope Innocent IV, the reigning pope, was "a man who cared little for Franciscan poverty" (96). Innocent's bull, *Ordinem vestrum*, issued in 1245, weakened the vow beyond Gregory IX's *Quo elongati*; for a discussion, see Lambert, 96–102.

79. On this panel, from S. Francesco, Pescia, see Goffen, *Spirituality*, 14–15. This is not, however, the earliest image of Francis. Perhaps the earliest, a fresco in Subiaco, c. 1226, was painted in a Benedictine monastery for Gregory IX; for the circumstances, see Goffen, *Spirituality*, 79–81. Another which is sometimes considered an early image of Francis is a now-lost panel from S. Miniato al Tedesco, "purportedly" dated 1228, as noted by Garrison, *Index*, no. 410. On the panel, see also Frugoni, *Francesco*, 321–2, fig. 129. Cook, "St. Francis Dossal," 3, note 1, suggests that the panel may actually have been made in the 1250s. Shortly after 1230, Franciscan iconography spread widely; a Stigmatization appears in a stained glass window of the early 1230s at Erfurt (Gardner, "Louvre Stigmatization," 225).

80. See Note 52. In the fourteenth century, we have more examples of Passion narratives for non-Franciscan patrons. At this date there is more evidence that the Dominicans sponsored Passion narratives, especially in con-

nection with the cult of the *Corpus Christi*; the propagation of the cult was assigned to them in 1304. For instance, a Passion cycle appears in the chapter house of Sta. Maria Novella, Florence (see Note 35).

81. See Derbes, "Siena and the Levant," 190–6, with further bibliography; see also Folda, *Crusader Manuscript Illumination*, 5. For the icons produced by Italian painters in the Crusader States and on their importance for duecento Italy, see K. Weitzmann, "Icon Painting in the Crusader Kingdom," *Dumbarton Oaks Papers* 20 (1966): 51–83, especially 74–83 (reprinted in his *Studies in the Arts at Sinai* [Princeton, 1982], 291–315); "Crusader Icons and la 'Maniera Greca,'" in *Il Medio Oriente*, 71–7; and an expanded version of that paper, called "Crusader Icons and Maniera Greca," in *Byzanz und der Westen*, ed. I. Hutter (Vienna, 1984), 143–70. For a Byzantine painter at work in Italy in the early fourteenth century, see R. Nelson, "A Byzantine Painter in Trecento Genoa: The *Last Judgment* at S. Lorenzo," *Art Bulletin* 67 (1985): 548–65.

82. There is a considerable bibliography on Franciscan activity in the Mediterranean East. See especially G. Golubovich, *Biblioteca bio-bibliografica della Terra Santa e dell'Oriente Francescano* (Quaracchi-Florence, 1906); R. Wolff, "The Latin Empire of Constantinople and the Franciscans," *Traditio*, 2 (1944), 213–37; M. Roncaglia, *St. Francis of Assisi and the Middle East* (Cairo, 1957).

83. See Roncaglia, *St. Francis*, 25–30; C. Maier, *Preaching the Crusades: Mendicant Friars and the Cross in the Thirteenth Century* (Cambridge, 1994), 9–17.

84. Daniel, *Franciscan Concept*.

85. Wolff, "Latin Empire"; see 213–14 for the early establishment of the Order; 214–21 for John of Brienne.

86. For Franciscan houses in the Levant, see Roncaglia, *St. Francis*, 31–58. On the papal legates, see Wolff, "Latin Empire," 228, for Franciscan John of Palmo Carpini, envoy to the Mongols in 1245; and Wolff, 228–29 for Dominic of Aragon, who visited Syria, Armenia, Palestine, and Egypt, then settled for some months in Constantinople.

87. Golubovich, *Biblioteca*, 3, 309, notes that the Order was custodian of the church by 1327. See also Roncaglia, *St. Francis*, 13–17; G. Ordoardo, "La custodia francescana di Terra Santa nel VI centenario della sua costituzione (1342–1942)," *Miscellanea francescana* 43 (1943): 217–56.

88. Huber, *Documentary History*, 137. For Gregory IX, see also the dissertation of R. Spence, "Pope Gregory IX and the Crusade" (Syracuse Univ., 1978), especially 216. John of Parma's interest in union is discussed also by van Dijk and Walker, *Origins*, 389.

89. Van Dijk and Walker, *Origins*, 389. The saints, Ignatius and Margaret, were both venerated at Antioch; van Dijk and Walker note that the Greek patriarchate of Antioch submitted to the Apostolic See in 1246, and they suggest that the saints' introduction into the calendar was one result.

90. For the Franciscan role in reunification under Bonaventure, see D. Geanakoplos, "Bonaventura, the Two Mendicant Orders, and the Greeks at the Council of Lyons," in *Studies in Church History*, 13: *The Orthodox Churches and the West* (Oxford, 1976), 183–211.

91. On the papal legates and the affinities between Franciscan spirituality and Orthodoxy, see Geanakoplos, "Bonaventura," 188–9. He points specifically to Bonaventure's "emphasis on prayer and contemplation leading to a kind of mystical union with God . . ., his essentially antipathetic attitude to the scholastic, Aristotelian approach of the Dominicans, the Franciscan emphasis on Mariology, and the possible Franciscan use of the so-called 'Jesus prayer' – the latter of which apparently had its genesis in the Byzantine East." Though other orders had likewise sent missions to the Levant (for the Dominicans, see Geanakoplos, "Bonaventure," 186, and M. D. Papi, "Santa Maria Novella di Firenze e l'Outremer domenicano," in *Toscana e Terrasanta nel Medioevo*, ed. F. Cardini [Florence, 1982], 87–102; for the Cistercians, B. Bolton, "A Mission to the Orthodox? The Cistercians in Romania," in *Studies in Church History*, 13, 169–81), this compatibility between Orthodoxy and Franciscan spirituality made the selection of the Franciscans to instruct Michael Palaeologus a singularly shrewd choice.

92. See Daniel, *Franciscan Concept*, 55–8.

93. Wolff, "Latin Empire," 230. Robert Grosseteste of Oxford (1168/9–1253) assembled a large collection of Byzantine manuscripts; see R. W. Hunt, "The Library of Robert Grosseteste," in *Robert Grosseteste*, ed. D. A.

Callus (Oxford, 1955); K. D. Hill, "Robert Grosseteste and his Work of Greek Translations," in *Studies in Church History* 13, 213–22. Grosseteste was lector of Oxford's Franciscan convent, to which he left his collection of manuscripts. On Franciscan libraries, see Moorman, *History*, 367–8.

94. For the gifts of John of Brienne, see *Il Tesoro della Basilica di San Francesco ad Assisi* (Assisi, 1980), 14, 80–1; for the manuscript in the Vatican (Chigi R. VII. 52), see M. Bernabò, "Un manoscritto bizantino e i francescani a Costantinopoli," in *Biblioteca del Sacro Convento di Assisi*, vol. 1: *I libri miniati di eta romanica e gotica*, ed. M. Assirelli, M. Bernabò, and G. B. Lulla (Assisi, 1988), 23–31. The manuscript bears this inscription: "Ego leodegarius archidiaconus constantinopolitanus dono librum istum ecclesie sancti Francisci et mitto eum per manum fratris Iacobi. . . " (fol. 1v.; Bernabò, 28).

95. For the manuscript, see Geanakoplos, "Bonaventura," 186, note 14; for the icons, ibid., 195, citing G. Pachymeres, *De Michaele et Andronico Paleologis*, ed. J. Bekker (Bonn, 1835), 394–5. Though the ship carrying the icons sank, it is most unlikely that this was the sole instance in which icons were offered by the Byzantines to the pope or his representatives. In fact, one Byzantine object, a wooden reliquary box with an image of the Crucifixion, probably reached Italy as some sort of diplomatic gift, perhaps from an emperor to a pope. On the box, now in the Vatican, Museo Cristiano, see F. E. Hyslop, "A Byzantine Reliquary of the True Cross from the Sancta Sanctorum," *Art Bulletin* 16 (1934): 333–40, fig. 1. Hyslop dates the box to the twelfth century and suggests that an inventory of 1181 may refer to it (339–40). For a more recent discussion, see R. Cormack, "Painting After Iconoclasm," in *Iconoclasm: Papers Given at the Ninth Spring Symposium of Byzantine Studies* (University of Birmingham, March 1975), ed. A. Bryer and J. Herrin (Birmingham, 1977), 147–63; reprinted in *The Byzantine Eye: Studies in Art and Patronage* (London, 1989), 1–15, especially 5–6. Cormack dates it to c. 920 and suggests that it was a gift from the Patriarch of Constantinople to the pope. See also A. Kazhdan and H. Maguire, "Byzantine Hagiographical Texts as Sources on Art,"

Dumbarton Oaks Papers 45 (1991): 1–22, especially 19; they describe the image on the box as tenth century in style and accept the 1181 inventory as a reference to it. Kazhdan and Maguire also believe that it was a gift from Byzantium.

96. See a recent catalogue of nineteen illuminated manuscripts used in the convent of St. Savior, Jerusalem, produced in the West from the thirteenth through the seventeenth century (N. Bux, *Codici liturgici latini di Terra Santa – Liturgic Latin Codices of the Holy Land* [Fasano, 1990]). On Kalenderhane Camii, see C. L. Striker and Y. D. Kuban, "Work at Kalenderhane Camii in Istanbul: Preliminary Reports I–V," *Dumbarton Oaks Papers* 21 (1967): 267–71; 22 (1968): 185–93; 25 (1971): 251–8; 29 (1975): 306–18; C. L. Striker, "Crusader Painting in Constantinople: The Findings at Kalenderhane Camii," in *Il medio oriente*, 117–21; W. Goez, "Franziskus-Fresken und Franziskaner in Konstantinopel," in *Festschrift Herbert Siebenhüner*, eds. E. Hubala and G. Schweikhart (Wurzburg, 1978), 31–40; Blume, *Wandmalerei*, 18–20.

97. The fresco appears on the northwest pillar of the church. See M. Borboudakis, *Panaghia Kera: Byzantine Wall Paintings at Kritsa* (Athens, n.d.), fig. 38. I am grateful to Sharon Gerstel for calling this image to my attention. Borboudakis dates the construction of the church to the middle of the thirteenth century (caption to fig. 13), and the frescoes to the early fourteenth century. For the Franciscans in Crete, see M. Georgopoulou, "Franciscan Devotion and the Union of the Churches (1439): The Artistic Record," *Nineteenth Annual Byzantine Studies Conference. Abstracts of Papers* (4–7 November 1993, Princeton Univ.), 64; idem, "Late Medieval Crete," 481–3.

98. H. Evans, "Manuscript Illumination at the Armenian Patriarchate in Hromkla and the West" (Ph.D. diss., Institute of Fine Arts, New York Univ., 1991), especially 75–146; idem, "Cilician Manuscript Illumination: The Twelfth, Thirteenth, and Fourteenth Centuries," in *Treasures in Heaven: Armenian Illuminated Manuscripts*, ed. T. F. Mathews and R. S. Wieck (New York, 1994), 66–83, especially 73–80. Carr presented her work on the Franciscans in Cyprus at the symposium at Dumbarton Oaks in May 1993 ("Byzan-

tines and Italians in Cyprus: Images from Art"); see her article of the same title in *Dumbarton Oaks Papers*, 1995.

99. Derbes, "Siena and the Levant."

100. For general comments on the interpenetration of East and West in the art of the Mediterranean basin in the thirteenth century, see Belting's Introduction to *Il medio oriente*, 1–10. 197–8. For the migration of images from West to East in the thirteenth century, see Derbes, "Images East and West"; A. W. Carr and L. J. Morrocco, *A Byzantine Masterpiece Recovered: The Thirteenth-Century Murals of Lysi, Cyprus* (Austin, 1994), 100–1. For both the thirteenth and the fourteenth centuries, see the work of Doula Mouriki, who has examined these issues at some length: *Thirteenth-Century Icon Painting in Cyprus* (Athens, 1986; reprinted from *The Griffon*, 1–2 [1985–6]), 9–77; idem, "Palaeologan Mistra and the West," in *Byzantium and Europe* (First International Byzantine Conference, Delphi, 1985; Athens, 1987), 209–46; idem, "The Wall Paintings of the Pantanassa at Mistra: Models of a Painter's Workshop in the Fifteenth Century," in *The Twilight of Byzantium*, ed. S. Čurčić and D. Mouriki (Princeton, 1991), 217–31, especially 225–31. See also M. Vassilakis, "Western Influence on the Fourteenth Century Art of Crete," *Jahrbuch der Osterreichischen Byzantinistik* 32/5 (1982): 301–11.

Though these questions must be approached with much caution, it remains true that eastern images were much more frequently adapted in the West than were western images in the East. Especially outside areas like Armenian Cilicia, Cyprus, and the Crusader States, where contacts between East and West were most frequent and intimate, thirteenth-century examples remain, for now, fairly exceptional. Though Mouriki, "Palaeologan Mistra," 239, demonstrated the presence of western elements in architecture and sculpture at Mistra, she expressed more skepticism about painting: "The refined Constantinopolitan tradition of the period, . . . in religious painting, remains on the whole immune to Western intrusions in so far as figural style and iconographic types of scenes and portraits of saints are concerned" (239). She suggests three possible reasons for this phenomenon: Orthodox fear that iconographic changes "might entail alterations in dogma and doctrinal error"; Byzantine pride in its own tradition of painting; the Orthodox "conviction that a static hieratic approach was the only one proper to religious painting" (239).

A final consideration in this complex issue is the extreme hostility to the West among many Greek Orthodox – a hostility fanned anew by the attempted union of the churches in 1274. For the intensely antiwestern sentiment in the Orthodox Church in the later thirteenth century, see Geanakoplos, *Emperor Michael Palaeologus and the West, 1258–1262: A Study in Byzantine-Latin Relations* (Cambridge, Mass., 1959), 270–6. See also B. Zeitler, "Cross-Cultural Interpretations of Imagery in the Middle Ages," *Art Bulletin*, 76 (1994), 680–94, especially 680–81, for a fifteenth-century anti-unionist Orthodox response to western images. This hostility might suggest that western images would not have been consciously adopted in Orthodox communities. Yet in Venetian Crete, intense resistance to the papacy coexisted with an acceptance, and occasionally an embracing, of the Franciscan order; see Georgopoulou, "Franciscan Devotion."

101. The prominent place of these images, in the crossing of the Upper Church, attests to the centrality of missionizing to the Order. See E. Battisti, *Cimabue* (University Park, Pa., and London, 1967), 32. In a somewhat similar vein, Daniel Weiss discusses crusader manuscript illumination for the crusading king Louis IX, who was also closely associated with the Franciscan order: See "The Three Solomon Portraits in the Arsenal Old Testament and the Construction of Meaning in Crusader Painting," *Arte Medievale* 6 (1992): 15–36, especially 31–3. See also his dissertation, "The Pictorial Language of the Arsenal Old Testament: Gothic and Byzantine Contributions and the Meaning of Crusader Art" (Johns Hopkins Univ., 1992). Hayden Maginnis has noted references to Jerusalem in Pietro Lorenzetti's Passion cycle in the Lower Church of S. Francesco, Assisi, convincingly linking them to the Franciscan involvement in the Holy Land ("Places Beyond the Seas: Trecento Images of Jerusalem," *Source* 13 [1994]: 1–8).

102. The cross was badly damaged in the flood of 1966; this photograph, taken before the

flood, provides a fairly clear idea of its original appearance. I am most grateful to Louis Jordan for his thoughtful comments on this portion of the chapter.

103. Marques, *Peinture*, 102, dates the cross c. 1270. Few other scholars place it so early, however; see, for example, White, *Art and Architecture*, 183.

104. See, for instance, the discussion by B. Cole, *Giotto and Florentine Painting, 1280–1375* (New York, 1976), 30–1, or Baldini and Casazza, *The Crucifix*, 24, where they refer to the loincloth as "the first of its kind in painting." White, *Art and Architecture*, 183–4, discusses the two in somewhat similar terms, referring to the "unprecedented softness of the flesh and diaphanous sensitivity of the draperies"; White, however, suggests that the Arezzo cross may not be Cimabue's but the work of an anonymous master. For other studies of the cross, see Battisti, *Cimabue*, 57–60; E. Sindona, *L'opera completa di Cimabue e il momento figurativo pregiottesco* (Milan, 1975), 114–15 ("il perizoma di velo trasparente, di materia appena percettibile [il primo dipinto cosi]"); Marques, *Peinture*, 103–8; Chiellini, *Cimabue*, 13–15. For additional bibliography for both crosses, see Tartuferi, *Pittura*, 95–6.

105. Demus, *Byzantine Art and the West*, 208. For further discussion of Sopoćani and duecento painting, see Demus, ibid., 225–7. On Sopoćani see also the monograph by V. Djurić, *Sopoćani* (Leipzig, 1967).

106. See K. Weitzmann, *The Icon* (New York, 1978), 90, plate 26.

107. For Hosios Lukas, see C. Connor, *Art and Miracles in Medieval Byzantium: The Crypt at Hosios Lukas and its Frescoes* (Princeton, 1991); for the icon with Passion narratives, see K. Weitzmann, "Byzantine Miniature and Icon Painting in the Eleventh Century," in *Studies in Classical and Byzantine Manuscript Illumination*, ed. H. Kessler (Chicago and London, 1971), fig. 300, 271–313, especially 296–7. The translucent loincloth is fairly common by the late twelfth century, appearing, for instance, in the Lamentation at Nerezi (Demus, *Byzantine Art and the West*, fig. 249).

108. Kazhdan and Maguire, "Byzantine Hagiographical Texts," discuss the shift in Crucifixion iconography from the colobium-garbed Christ to the depiction of Christ in only a loincloth, and they associate this shift with written accounts that refer to Christ's nakedness. They specifically cite a hymn, c. 1000, by Simeon the Theologian and note that the substitution of the loincloth for the colobium became established during the eleventh century (11). For the shift from colobium to loincloth, and accounts of Christ's nakedness on the cross, see also K. Corrigan, "Text and Image on an Icon of the Crucifixion at Mount Sinai," in *The Sacred Image: East and West*, ed. R. Ousterhout and L. Brubaker (Urbana and Chicago, 1995), 45–62, especially 48–57. Neither of these articles, however, considers the greater step toward nudity implied by the translucent loincloth, as in the mosaic at Hosios Lukas. See also the oration of Psellos, cited below, Note 110. I am grateful to Annemarie Weyl Carr, John Cotsonis, and Sharon Gerstel for their generous assistance in discussing this problem with me.

109. Still another example of Cimabue's use of an ultimately Byzantine motif for the Franciscans (though not the Franciscan first use of the device; see Note 55) appears in the famous frescoes in the Upper Church depicting Francis kneeling at the foot of the cross. The Virgin appears in a comparable (though somewhat more restrained) stance in Byzantine art. See, for instance, the image of the Crucifixion on the reliquary box in the Vatican, cited in Note 95. Hyslop, "Byzantine Reliquary," cites a ninth-century sermon by George of Nicomedia, which states of the Virgin: "Approaching boldly so close as to be able to grasp the cross, she kissed His unblemished feet" (339; J. P. Migne, ed. *Patrologia cursus completus. Series graeca.* 116 vols. [Paris, 1857–1903], vol. 100, col. 1469; hereafter cited as *P. G.*). The stance, in fact, appeared quite early in the Levant; see the sixth-century Palestinian pilgrimage flasks discussed by R. Deshman, "Servants of the Mother of God in Byzantine and Medieval Art," *Word and Image* 5 (1989): 33–70, especially 47–8. As Deshman notes, the stance signals the humility of the kneeling suppliant before the humility of Christ, who humbled himself to die on the cross. As will be discussed at length here, the virtue of humility was of central importance to the Franciscan order, and the double emphasis on this virtue thus helps to explain the Fran-

ciscan interest in the image.

110. E. Fisher, "Icon and Rhetoric: Psellos on the Crucifixion," *Abstracts of Papers*, Eighteenth Annual Byzantine Studies Conference, University of Illinois, October 1992; for a French translation of the oration, see P. Gautier, "Un discours inédit de Michel Psellos sur la crucifixion," *Revue des études byzantines* 49 (1991): 5–66, especially 1–12. Gautier compares the ekphrasis with several Middle Byzantine images of the Crucifixion, noting the strongest correspondences with the mosaic at Hosios Lukas; he does not, however, discuss the use of the word "naked" (Υυμνὸς line 1256 of the oration) nor does he mention the translucent loincloth seen in the mosaic. I am grateful to Elizabeth Fisher for her generous assistance.

111. Lambert, *Franciscan Poverty*, 61. Similarly, see Caroline Bynum's observation that "nakedness was a key metaphor" for Francis (Bynum, *Holy Feast and Holy Fast: The Religious Significance of Food to Medieval Women* [Berkeley, 1987], 98–9; see also G. Dickson, "The Flagellants of 1260 and the Crusades," *Journal of Medieval History* 15 (1989): 239, and Goffen, *Spirituality*, 40–1, 65–7).

112. These texts and the closely related narrative theme, the Stripping of Christ, will be discussed in Chapter 6. The *Meditatio pauperis*, 10–14, likewise includes a number of references to Christ as *"nudatus"* or *"denudatus,"* and to other biblical instances of nudity, such as the nakedness of Noah. The presence of this relatively unusual episode on the Sistine Ceiling, for the Franciscan pope Julius II, may be due in part to its special relevance for the Order.

113. For a full consideration of this theme in Bonaventure's writing, see Châtillon, *"Nudum Christum Nudus Sequere,"* 719–72. Ascetic nakedness has a long history in Christian thought, traceable to the patristic period; Margaret Miles cites a fourth-century episode of a monk stripping to renounce the things of the world (M. Miles, *Carnal Knowing* [New York, 1989], 63). See also C. Eisler, "The Athlete of Virtue: The Iconography of Asceticism," in *De Artibus Opuscula XV: Essays in Honor of Erwin Panofsky*, ed. M. Meiss (New York, 1961), vol. 1, 82–97.

114. De Vinck, *Works*, vol. 1, 223. The emphasis is Bonaventure's; the underlinings refer to

specific biblical passages.

115. De Vinck, *Works*, vol. 4, 163, 185. Similarly: "The nakedness of this unconquered Leader" (163). The equation of poverty and nakedness extends also to the followers of Christ: "In your nakedness you will follow the naked cross, . . . you will glory in the poverty of your spirit and your works" (203). For an interesting image of a nearly naked Christ in a different context, see J. Hamburger, *The Rothschild Canticles: Art and Mysticism in Flanders and the Rhineland circa 1300* (New Haven, 1991), 73–4.

116. De Vinck, *Works*, vol. 4, 49; 133. Bonaventure provides a lengthy discussion of nakedness in chap. 7, on "voluntary and strict poverty"; see especially 145–8. See also 163, 185, 209.

117. See L. Steinberg, *The Sexuality of Christ in Renaissance Art and Modern Oblivion* (New York, 1983), 17–23, for Michelangelo's loincloth-less Risen Christ. For a discussion in a different vein of the nudity of Christ on the cross, see Richard Trexler, "Gendering Jesus Crucified," in *Iconography at the Crossroads*, 107–19.

118. Chiellini, *Cimabue*, 15.

119. See, for instance, an Umbrian cross from S. Francesco, Castiglion Fiorentino (*Index*, no. 552); a Sienese cross from S. Francesco, Grosseto (ibid., no. 564). In several similar cases (e.g., a Florentine cross now in Baltimore, Walters Art Gallery; ibid., no. 544; a Sienese cross now in S. Gimignano, ibid., no. 581), the provenance of the cross is unknown.

120. For the cross, see Offner, *Corpus*, sect. 3, vol. 6, 9–12. Steinberg, *Sexuality of Christ*, 132, refers to Giotto's cross, but states that Giotto and Duccio "introduced the diaphanous loincloth." Elsewhere (34) Steinberg briefly alludes to the role of Franciscan piety in stimulating interest in the naked Christ, but he does not develop the idea.

121. For instance, occasionally a Dominican kneels at the foot of the cross; far more often, one finds a Franciscan or Francis himself (see Notes 55 and 109). For another example, the children stoning Christ in Passion narratives, see Neff, "Wicked Children," 215–44. See also the comments of Blume, "Ordenskonkurrenz," 149. This phenomenon was not limited to Passion imagery. Hood, *Fra Angelico*, observes that Dominicans writing the life of their founder bor-

rowed episodes liberally from Bonaventure's *Legenda maior* (184). However, he also notes an instance in which Franciscans usurped images that originated with the Dominicans (52). See also the remarks of Anita Moskowitz (*Arca*, 7–8 and 23–5) for the rivalry between the two orders and the ways in which images depicted in the Arca di San Dominico were derived from the *Legenda maior*.

122. On the two factions at Sta. Croce, see Goffen, *Spirituality*, 1–10. However, see also the review of her monograph by William Cook in *American Historical Review* 95 (1990), 1179, where he criticizes Goffen's assumption that the factions were formally defined fairly early in the century. Most specialists in the history of the Order do not consider the factions as formal entities until after 1274. For a general overview of the debate about poverty, see Moorman, *History*, 140–54; for a more detailed study, see Lambert, *Franciscan Poverty*, and, more recently, D. Burr, *Olivi and Franciscan Poverty: The Origins of the "Usus Pauper" Controversy* (Philadelphia, 1989), 1–37.

123. On the statutes, see M. Bihl, "Statuta Generalia Ordinis edita in Capitulis Generalibis Celebratis Narbonae an. 1260, Assisii an. 1279 atque Parisiis an. 1292," *Archivum Franciscanum Historicum* 34 (1941): 13–94, 284–358.

124. *Opera Omnia*, vol. 8, 393; Moorman, *History*, 152.

125. See Battisti, *Cimabue*, 57–8; Chiellini, *Cimabue*, 13–14.

126. Goffen, *Spirituality*, 5.

127. Ibid., 7. Interestingly, Ubertino also wrote at length on Christ's nudity on the cross; see his *Arbor vitae crucifixae Jesu* (Venice, 1485), book 3, chap. 9 ("Jesus pro nobis indigens"), especially columns 13 and 14.

128. Similarly, Cimabue's fresco in the Lower Church of S. Francesco, Assisi, depicts St. Francis wearing a patched habit – another visual response to contemporary debates about poverty, again in a lavish Conventual church; on this point, see Cook, "Margarito," 86. Goffen has noted that the Spiritual saint Louis of Toulouse is honored at Sta. Croce; she suggests that "by honoring Saint Louis, the Conventuals were co-opting that Spiritual hero, as it were, laying claim thereby to the ascetic ideal that he represented and control-

ling (or taming) it at the same time" (*Spirituality*, 10). The Sta. Croce cross may be a more subtle example of co-optation. For further discussion of the conflicting impulses within the Order in the late duecento and early trecento, and their implications for Franciscan patronage, see Schwarz, "Zerstört."

129. See also Cook's comments in "Fraternal and Lay Images," in which he stresses that the Order used images to communicate with the laity. He observes: "As the order grew and its expanding role in the church was challenged about midcentury, it became necessary for the order to assure the laity that the friars were living in accord with the ideals of their saintly founder" (270). Though his article concentrates on images of Francis, his comments might apply equally to the Sta. Croce cross; the congregation of Sta. Croce might well have needed reassuring about the friars' commitment to the vow of poverty.

130. Because a major purpose of this study is to consider the connections between Italian and Byzantine images, one of the most common Passion scenes, the Flagellation of Christ, will not be considered here; the subject is very rare in Byzantine art.

131. Belting has rightly asserted that the shift to the *Christus Patiens* was "not left to the discretion of an artist" (*Image and Its Public*, 145), and the comparable changes in Passion narratives, at least initially, must have also required guidance from patron to painter. There is, of course, evidence that medieval artists at times functioned with more autonomy; see the recent discussion of the respective roles of artist and patron by I. Forsyth, "The Monumental Arts of the Romanesque Period: Recent Research," in *The Cloisters: Studies in Honor of the Fiftieth Anniversary*, ed. E. Parker with M. Shepard (New York, 1992), 3–25, especially 14–16; see also C. Gilbert, "A Statement of the Aesthetic Attitude around 1230," *Hebrew University Studies in Literature and the Arts* 13 (1985): 125–52. But there is also evidence that Franciscans at times spelled out the details of commissions to the painters in their employ. Van Os, "St. Francis," 123–4, cites a contract between the Franciscans of Borgo and Sassetta in 1437 in which the painter was told to follow his clients' instructions in the choice of figures and narrative scenes. For further evidence of explicit directives from patron to

painter, see D. Rigaux, "The Franciscan Tertiaries at the Convent of Sant'Anna at Foligno," *Gesta* 31 (1992): 92–8, especially 92–3; Cook, "Fraternal and Lay Images," 270, note 32; E. Hall and H. Uhr, "Patrons and Painter in Quest of an Iconographic Program: The Case of the Signorelli Frescoes in Orvieto," *Zeitschrift für Kunstgeschichte* 55 (1992): 35–56.

CHAPTER 2

1. The events that occur earlier in the Passion story, such as the Entry into Jerusalem, the Last Supper, the Washing of the Feet, and the Agony in the Garden, are depicted only infrequently in thirteenth-century Tuscan and Umbrian painting. Several were included earlier in Tuscan Passion cycles, however; for instance, the Last Supper on the twelfth-century S. Sepolcro cross in Pisa (Fig. 5; for a detail, see Sandberg-Vavalà, *Croce dipinta*, fig. 164); the Washing of the Feet on the same cross and on another twelfth-century cross in the Uffizi, no. 432 (ibid., fig. 183); and the Agony in the Garden on a Pisan cross in S. Frediano (ibid., fig. 381). Only toward the end of the thirteenth century, when narrative cycles often expand considerably, are these themes represented with any frequency.

2. More specifically, the Betrayal almost always introduces the Passion cycle on extant historiated crosses painted after c. 1240. One rare exception to this rule is the Florentine cross in the Uffizi, no. 434 (Fig. 7), in which the first of the narratives depicts Christ before the Sanhedrin. Aside from the Uffizi cross, the only thirteenth-century crosses that exclude the Betrayal predate 1240 by several decades. The theme also commonly appears on other types of altarpieces. Garrison's *Index* includes ten altarpieces that depict more than two Passion scenes; the Betrayal occurs in eight of these (nos. 282, 325, 327, 348, 367, 390, 422, 697).

3. See Habig, *Omnibus*, 140. The Betrayal also introduces the *Officium Passionis Domini* written by Bonaventure; see Chapter 1, Note 62, and Sticca, "*Officium Passionis Domini*," 146, 160.

4. The Sarzana cross was destined for Sta. Maria, Luni; see the Introduction, Notes 13 and 14. On Gullielmus, see Sandberg-Vavalà, *Croce dipinta*, 519–37; E. B. Garrison,

"Toward a New History of Early Lucchese Painting," *Art Bulletin* 33 (1951): 11–31; Garrison, "A Lucchese Passionary related to the Sarzana Crucifix," *Art Bulletin* 35 (1953): 109–19; Ayer, "Thirteenth-century Imagery," 7–10.

5. The provenance of the Uffizi cross is controversial. It has often been attributed to Pisa; see, for instance, Carli, *Pittura medievale pisana*, 23–4; Marques, *Peinture*, 20. For the arguments supporting attribution to Florence, see R. Offner, "The 'Mostra del Tesoro di Firenze Sacra' – I," *Burlington Magazine*, 63 (1933), 75; Garrison, *Index*, 18. See also the recent discussion by Boskovits, *Origins*, 40–5 and 246–59.

 The Rosano cross and the Uffizi cross are generally ascribed to the same center. Thus Carli, 23–4, and Marques, 20, view it as Pisan, while Offner, 75, Garrison, 18, and Boskovits, 19–30 and 206–17, ascribe it to Florence.

 For the cross in Siena from Sta. Chiara, see Chapter 1, Note 56.

6. *Index*, no. 510; Ayer, "Thirteenth-century Imagery," 201–6; Boskovits, *Origins*, 98–9 and 398–401. Much of the cross has been extensively repainted, but the narratives were spared. The cross is said to have come from S. Martino, Bori, a church destroyed in the fourteenth century.

7. On the Berlinghieri family and early Lucchese painting, see Ayer, ibid.; see also two articles by Garrison on the Berlinghieri: "New History," 11–13, and "A Berlinghieresque Fresco in S. Stefano, Bologna," *Art Bulletin* 28 (1946): 211–32.

8. In the triptych in the Metropolitan Museum by the Florentine Magdalen Master (cited in Chapter 1, Note 52), Peter and Malchus are more conspicuous; they kneel in the lower left. Even here, however, Christ does not gesture to Peter, commanding him to desist, as in the pre-duecento examples.

9. See the Introduction, Note 22.

10. Coor, "Coppo," 6–7.

11. See the Introduction, Note 22.

12. For Enrico, see the Introduction, Note 16. Closely related to Enrico is an anonymous Pisan, called "the Castellare Crucifix Master" by Garrison, who painted two versions of the Betrayal: one on his eponymous cross, now in very poor condition, and the other on the dossal in the Bargello (Fig. 2). Similar

examples appear on the Sta. Bona cross (see Chapter 1, Note 57) and a cross in Pisa, Sta. Marta, probably from the 1280s (*Index*, no. 523; Marques, *Peinture*, 211, fig. 268). On Enrico and the Castellare Master, see Garrison, "Post-War Discoveries – I," *Burlington Magazine* 80 (1947): 147–52; Carli, *Pittura medievale pisana*, 36–9, 46–51.

13. See Chapter 1, Note 52.

14. Siena, Pinacoteca; Stubblebine, *Guido*, 49.

15. See, for instance, a fresco in the crypt of Siena (see the Introduction, Note 8); a mosaic in the Baptistery of Florence (Stubblebine, *Guido*, fig. 86); a triptych in Sta. Chiara, Assisi; an Umbrian triptych in Perugia (for both, see Chapter 1, Note 52); and the dossal in Perugia (Fig. 3).

16. For the literature on the Assisi frescoes, see the Introduction, Note 8.

17. For the panel, see the catalogue entry by R. Mencarelli in Bon Valsassina and Garibaldi, *Dipinti*, cat. 24, 127–9, color plate p. 128. The panel is part of a double-sided dossal depicting the Madonna and saints on one side and Passion scenes on the reverse; it probably dates after 1317. Sandberg-Vavalà, *Croce dipinta*, 236, fig. 200, reproduces the Betrayal, but identifies it as a detached fresco. A similar example is found in a panel formerly in the Stocklet collection, Brussels; for the attribution of this panel to the circle of Salerno, see Marques, *Peinture*, 84; fig. 103; on p. 208, he dates the panel to 1275–80. Garrison, however, ascribed it to an Umbro-Marchigian or Umbro-Abruzzese painter active c. 1315–35 (*Index*, no. 382). A miniature in a *Supplicationes Variae* manuscript in Florence, Biblioteca Laurenziana, Plut. XXV.3, fol. 373 v., is very close to the Assisi fresco, even in the treatment of the mountainous landscape. The manuscript has strong Franciscan affiliations; see Neff McNeary, "*Supplicationes Variae*."

18. The attribution of the diptych to which this panel originally belonged has ranged from a follower of Cimabue to a Greek painter to a Venetian; for a recent review of the literature see Boskovits, *Thyssen*, 134–6. Though Boskovits concludes that the diptych is Venetian, in many respects it seems closer to Pisa (as noted by R. Salvini, "Postilla a Cimabue," *Rivista d'Arte* 26 [1950]: 54, and R. Longhi, "Giudizio sul Duecento," *Proporzione* 2 (1948): 5–30, especially 45–6). In

particular, it recalls the Pisan painter known as the San Martino Master, possibly Raniero di Ugolino (for his eponymous work, a panel depicting the Virgin and Child flanked by scenes of Joachim and Anna, with Martin at the base, see Marques, *Peinture*, fig. 103). Compare, for instance, the facial types and the white highlighting of the drapery. However, the similarities stem in part from the dependence of both painters on the Palaeologan mode of the late thirteenth century.

19. H. Maginnis, "Assisi Revisited: Notes on Recent Observations," *Burlington Magazine* 117 (1975): 511–17; idem, "Pietro Lorenzetti: A Chronology," *Art Bulletin* 66 (1984): 183–211, especially 208. In "Assisi Revisited," he dates the frescoes between 1316 or 1317 and 1319; in "Chronology," he again gives 1319 as a terminus for the cycle, arguing that the political upheavals of 1319 must have made continuation of the project impossible, and that there is no evidence that work on the cycle was abruptly halted. See also idem, "The Passion Cycle in the Lower Church of San Francesco, Assisi: The Technical Evidence," *Zeitschrift für Kunstgeschichte* 39 (1976): 193–208. Maginnis's dating is accepted by Frugoni, *Pietro and Ambrogio Lorenzetti*, 20. Van Os, *Sienese Altarpieces*, 74, also states that Pietro worked on the Assisi frescoes before going to Arezzo in 1320. Carli, *Sienese Painting*, 33, argues that he began the work in the mid-teens but returned to do the Crucifixion, Deposition, and Entombment in the mid-twenties. White, *Art and Architecture*, 374–6, grants that the cycle was likely begun before the Arezzo altarpiece of 1320, but challenges Maginnis's premise that the civil turmoil in Assisi would have stopped work on the frescoes. None of these scholars questions the dating of the Betrayal to the teens, a date that also seems most likely in the context of the history of the order at that time, as will be discussed later in this chapter (see pp. 69–71).

20. For a discussion of the exiting apostles, see Sandberg-Vavalà, *Croce dipinta*, 241, note 27; she notes that this group is most common in Siena and Umbria.

21. *Recherches sur l'iconographie de l'évangile* (1916; reprint Paris, 1960), 326–41.

22. For examples, see Millet, *Recherches*, 330–1, and G. Schiller, *Iconography of Christian Art*, vol. 2 (Greenwich, Conn., 1972), 51–6;

figs. 158–66.

23. The Khludov Psalter (Moscow, Historical Museum, ms. 129D, fol. 54v.; Schiller, *Iconography*, vol. 2, fig. 162; K. Corrigan, *Visual Polemics in the Ninth-Century Byzantine Psalters* [Cambridge and New York, 1992]), of the second half of the ninth century, still depicts the Kiss and Arrest as two episodes; in a Cappadocian fresco of c. 900 (Göreme, Chapel 15a; see M. Restle, *Die byzantinische Wandmalerei in Kleinasien* [Recklinghausen, 1967], vol. 3, fig. 554), the two are fused. And in a fresco in Cimitile in South Italy, executed in the first decade of the tenth century, Malchus and Peter join the composite scene (see Belting, *Die Basilica dei SS. Martiri in Cimitile und ihr frühmittelalterlicher Freskenzyklus* [Wiesbaden, 1962], 52–8, fig. 25).

24. Millet, *Recherches*, 327–44; Belting, *Cimitile*, 53–8. See also L. Réau, *Iconographie de l'art chrétien*, vol. 3, part 2 (Paris, 1957), 431–7; Schiller, *Iconography*, vol. 2, 51–6; and J. Thuner, "Verrat des Judas," *Lexikon der christlichen Ikonographie* (1972). None, however, attempts to analyze the different types of the scene. For Sandberg-Vavalà's discussion of the scene, see Note 25 below.

25. Millet posited two types: Hellenistic (among which he included sarcophagi, the mosaic at Sant'Apollinare Nuovo, Ravenna, and Byzantine examples) and Oriental (Syrian, Armenian, Coptic, and Cappadocian works). The primary point of distinction is Judas's position: In the first, he approaches from the left, in the second from the right. But the categories do not bear close scrutiny. For instance, Millet published five Middle Byzantine examples of the scene (*Recherches*, figs. 341–5); in only two is Judas on the left. Sandberg-Vavalà was among the first to reject Millet's principle of Hellenistic and Oriental types: "In verità questa composizione si presta poco alla divisione netta fra tipi ellenistici ed orientali" (*Croce dipinta*, 232). Belting avoided geographical distinctions altogether, terming his categories simply "Type A" and "Type B" (54), and distinguished between types not on the basis of Judas's placement but on the basis on Christ's position. In his "Type A," which includes both the sarcophagi and the Syrian Rabbula Gospels, Christ faces Judas and embraces him. The two thus form a "pyramidale Zweiergruppe" (54). In "Type B," exemplified by the Ravenna mosaic, Christ does not embrace Judas but is quiet and frontal. But Belting's distinction, while clearly valid in the case of the Ravenna and Rabbula scenes, is also, at times, difficult to maintain. For instance, Schiller, who follows Belting in this regard (*Iconography*, vol. 2, 52–3), considers the Betrayal in the Stuttgart Psalter a descendant of the Ravenna type (vol. 2, 53; fig. 164), in contrast to a contemporary book-cover from Metz (fig. 165), which she says stems from the sarcophagus type. Yet the two are almost iconographic twins.

26. See R. Garrucci, *Storia dell'arte cristiana nei primi otto secoli della chiesa*, vol. 5 (Prato, 1879), 57–8. The sarcophagus was produced about A.D. 400; I am grateful to Alice Christ for her help with the date of this work.

27. Though Millet assumes the figure on the left is Judas (*Recherches*, 326), Schiller correctly identifies it as Christ (*Iconography*, vol. 2, 52). The two are admittedly difficult to distinguish, but in the other scenes of the Verona sarcophagus, and in most other sarcophagi as well, Christ is depicted with relatively long hair which curls at the nape of his neck; Judas's hair, by contrast, is cropped short in the back. Further, here Christ is slightly taller than Judas, as he almost always is in sarcophagi.

28. Thus in the Visitation, for instance, Mary is generally placed on the left, Elizabeth on the right; it was Mary who went to see her cousin. See Schiller, *Iconography*, vol. 1, figs. 59, 75, 99, 111, 131–5. Similarly, in the Entry into Jerusalem, Christ almost always rides from left to right. See Millet, *Recherches*, figs. 235–67; Schiller, vol. 2, figs. 31–49.

29. See, for instance, A. Grabar, *Christian Iconography: A Study of its Origins* (Princeton, 1968), 132; Schiller, *Iconography*, vol. 2, 1–9.

30. Among them are reliefs on several other sarcophagi published by Garrucci, *Storia dell'arte*, vol. 5: Arles, St. Maximim, plate 352 (4); Arles, Museum, plate 399 (5); Rome, Sant'Agnese, plate 402 (4). A miniature in the Gospels of St. Augustine, c. 600 (Cambridge, Corpus Christi College, fol. 125r.; Schiller, *Iconography*, vol. 2, fig. 11) also represents Christ, on the left, embracing Judas; there, soldiers are strewn in the lower right corner of the composition, a motif probably derived

from the account of St. John.

31. Florence, Biblioteca Laurenziana, Plut. I. 56, 586; see C. Cecchelli, *The Rabbula Gospels* (Olten, Switz., 1959).

32. See G. Bovini, *Mosaici di Sant'Apollinare Nuovo di Ravenna* (Florence, 1958).

33. *Kontakia of Romanos, Byzantine Melodist*, vol. 1, trans. M. Carpenter (Columbia, Mo., 1970), 169. Similarly in the same *kontakion*, Romanos wrote: "Christ, sold through jealousy, God voluntarily seized"; "the one being sold . . . was sold voluntarily" (for both, see p. 176). This emphasis continues in the *Lenten Triodion* (trans. Mother Mary and A. K. Ware [London, 1978]): The description of betrayal and arrest comes from John, who tells us that Christ initiated the action (574–5, quoting John 18:1–28). Elsewhere the text of the *Triodion* continues: "As Thou camest to Thy voluntary Passion. . ." (577). For the stress on the voluntary Passion in these texts, see also Derbes, "Images East and West," 114.

34. The image of Christ dead on the cross probably first appeared in Byzantine art around the end of the seventh century. For an analysis of the evidence and the larger theological issues and their role in the Iconoclastic Controversy, see Kartsonis, *Anastasis*, especially 33–81. See also the discussion in Corrigan, *Visual Polemics*, especially 81–90.

35. As Millet rightly noted (*Recherches*, 338).

36. New York, Pierpont Morgan Library, ms. 639. See K. Weitzmann, "The Constantinopolitan Lectionary, Morgan 639," in *Studies in Art and Literature for Bella da Costa Greene*, ed. D. Miner (Princeton, 1954), 358–73; he dates the manuscript to the 1070s (359–60). For an overview of Byzantine Gospel lectionaries, see J. C. Anderson, *The New York Cruciform Lectionary* (University Park, Pa., 1992), 1–12.

37. Mount Athos, Monastery of Dionysiou, ms. 587; generally dated 1059. See S. Pelikanides, et al., *The Treasures of Mount Athos – Illuminated Manuscripts*, vol. 1 (Athens, [1974–5]), 434–6. The date of 1059 has been questioned by J. Cotsonis, "On Some Illustrations in the Lectionary, Athos, Dionysiou 587," *Byzantion* 59 (1989): 5–19; he would assign the lectionary to the eleventh century, however.

38. Vatican Museum, ms. gr. 1156. Weitzmann ("Byzantine Miniature and Icon Painting in the Eleventh Century," in *Studies in Classical and Byzantine Manuscript Illumination*, ed. H. Kessler [Chicago, 1971], 295) dates the manuscript to the third quarter of the eleventh century. Other instances of the type can be found in a Gospel book in Paris, Bibliothèque Nationale, ms. gr. 74, fols. 55r., 96v., and 158v.; (see H. Omont, *Évangiles avec peintures byzantines du XIe siècle* [Paris, 1908], vol. 1, plates 41, 84; vol. 2, plate 136; the manuscript is dated by Weitzmann, "Byzantine Miniature," 280, to the 1060s); and in two icons on Mt. Sinai, Monastery of St. Catherine; see G. and M. Soteriou, *Icones du Mont Sinai* (Athens, 1956), vol. 2, figs. 66 and 146-9.

39. As in, for instance, Paris gr. 74, cited in Note 38.

40. As in the Theodore Psalter, London, British Library, Add. ms. 19352, 1066, fol. 45v.; S. Der Nersessian, *L'Illustration des psautiers grecs du Moyen Âge*, vol. 2: *Londres, Add. 19352*, Bibliothèque des Cahiers Archéologiques, 5 (Paris, 1970), fig. 78, or the mosaic at Nea Moni, Chios, in the 1050s (D. Mouriki, *The Mosaics of Nea Moni on Chios* [Athens, 1985], vol. 2, plate 106).

41. See also a Gospel book in Parma, Biblioteca Palatina, ms. 5, fol. 90r.; J. Beckwith, *Early Christian and Byzantine Art* (Baltimore, 1970), 116–17.

42. Peter and Malchus are clearly separated from the crowd only occasionally, as in Paris 74 (see Note 38), or Vat. gr. 1156 (Fig. 29).

43. This type may reflect monumental prototypes, conceivably the lost mosaic in the Church of the Holy Apostles in Constantinople (which will be discussed later in this chapter, p. 51). One characteristic of this formulation, the tendency to subsume Peter and Malchus into the composition as a whole, may also be related to the general characteristic of Middle Byzantine church decoration, icon painting, and lectionary illumination to deemphasize narrative detail in order to focus on the dogmatic content of a scene. See Weitzmann, "Byzantine Miniature and Icon Painting," especially 289–313; idem, "The Narrative and Liturgical Gospel Illustrations," 247–70.

44. An interest in Christ's death on the cross emerged as early as the late seventh century; see the works cited in Note 34. See also J. Martin, "The Dead Christ on the Cross in

Byzantine Art," in *Late Classical and Medieval Studies on Honor of Albert Matthias Friend, Jr.*, ed. K. Weitzmann (Princeton, 1955), 189–96. In the eleventh and twelfth centuries, an increased concern with emotional content in art and literature emerged; this change can be felt in descriptions and images of the Passion. For an overview of these developments in literature and art, see A. P. Kazhdan and A. W. Epstein, *Change in Byzantine Culture in the Eleventh and Twelfth Centuries* (Berkeley, 1985), 210–30. The emphasis on Christ's suffering during the Passion is particularly strong in the late twelfth and thirteenth centuries; see T. Velmans, "Les valeurs affectives dans la peinture murale byzantine au XIIIe siècle et la manière de les representer," in *L'Art byzantin du XIIIe siècle. Symposium de Sopoćani*, ed. V. J. Djurić (Belgrade, 1967), 47–57, and H. Maguire, "The Depiction of Sorrow in Middle Byzantine Art," *Dumbarton Oaks Papers* 31 (1977): 123–74.

45. For the text of the *Christos Paschon*, see A. Tuilier (*Gregoire de Nazianze, La Passion de Christ* [Paris, 1969], 143). Tuilier revived the old ascription of this work to Gregory of Nazianzus, but most scholars now date it to the twelfth century; see, for instance, H. Hunger, *Die hochsprachliche profane Literatur der Byzantiner* (Munich, 1978), vol. 2, 102–4.

46. N. Mesarites, *Description of the Church of the Holy Apostles at Constantinople*, translated by G. Downey (Philadelphia, 1957), 881–2; for the account as *ekphrasis*, a rhetorical description, see A. W. Epstein, "The Rebuilding and Redecoration of the Holy Apostles in Constantinople," *Greek, Roman, and Byzantine Studies* 23 (1982): 79–92.

47. Some Middle Byzantine versions of the Betrayal are almost identical to the Early Christian reliefs in the placement, stance and gestures of the protagonists, such as an early twelfth-century Gospel book in Florence, Biblioteca Laurenziana, Plut. VI, 23, fol. 55r.; see T. Velmans, *La Tetraévangile de la Laurentienne*, Bibliothèque des Cahiers Archéologiques, vol. 6 (Paris, 1971), fig. 112.

48. Examples include the mosaic at Nea Moni cited in Note 40, several Cappadocian frescoes (Restle, *Die byzantinische Wandmalerei*, vol. 2: Qeledjlar Kilise, c. 900, plate 271; Tchauch In, 936–69, pl. 302; Tchareqle

Kilise, c. 1150–1200, plate l; Elmale Kilise, c. 1190–1200, plate 181; Qaranlek, c. 1200–10, plate 236), and an image in a manuscript ascribed to Palestine or Cyprus, the Rockefeller-McCormick New Testament, fol. 32r.; see A. W. Carr, "The Rockefeller-McCormick New Testament: Studies Toward the Reattribution of Chicago, University Library, Ms. 965" (Ph.D. diss., Univ. of Michigan, 1973), 213, 317; idem, "A Group of Provincial Manuscripts from the Twelfth Century," *Dumbarton Oaks Papers* 36 (1982): 39–81, cat. no. 4; idem, *Byzantine Illumination 1150–1250: The Study of a Provincial Tradition* (Chicago and London, 1987), cat. no. 38.

49. For the frescoes at Asinou, see M. Sacopolou, *Asinou en 1106 et sa contribution à l'iconographie* (Brussels, 1966); for a reproduction of the Betrayal, see W. H. Buckler et al., "The Church of Asinou, Cyprus, and its Frescoes," *Archaeologia* 73 (1933), plate C-1 (2). For the Gospel book in Berlin, Staatliche Museum, qu. 66, see Carr, *Byzantine Illumination*, 81–105. She dates the text to just after 1204 (94). H. Buchthal, "Studies in Byzantine Illumination of the Thirteenth Century," *Jahrbuch der Berliner Museen* 25 (1983): 27–102, notes the soldiers in chain mail in this illumination of the manuscript (88), which he ascribes to Nicaea (99). However, in his conclusions, he states that all of the manuscripts he discusses are "completely free of Latin influence" (101).

50. Interestingly, A. W. Carr has noted a similar tendency to carelessness in the text of the Berlin manuscript; she notes that "pages are dotted with errors" and that "redundancies and even erasures abound" (*Byzantine Illumination*, 91).

51. C. Mango and E. Hawkins, "The Hermitage of St. Neophytos and its Wall Paintings," *Dumbarton Oaks Papers* 20 (1966): 121–206. For the date of the frescoes in the naos, where the Passion cycle appears, see Mango and Hawkins, 201. Cypriot images of the Betrayal are the subject of an article by A. and J. Stylianou, "The Militarization of the Betrayal and its Examples in the Painted Churches of Cyprus," in *Euphrosynon: Aphierōma ston Manolē Chatzēdakē*, ed. E. Kypraiou (Athens, 1992), vol. 2, 570–81. I am grateful to John Cotsonis for calling this article to my attention.

52. Another appears in a lectionary in San Giorgio dei Greci, Venice, fol. 280r. (photograph available at the Index of Christian Art, Dumbarton Oaks Research Library, Washington, D.C.). The manuscript was dated to the eleventh century by Carr in "The Rockefeller-McCormick New Testament," 215, note 1.

53. On the possible attribution of Berlin 66 to Cyprus, see Carr, *Byzantine Illumination*, 104–5.

54. A. Mahr, *The Cyprus Passion Play* (Notre Dame, Ind., 1947); for the passages on the Betrayal, see 159–63. For the date of c. 1260–70, see Mahr, 12.

55. *Art of Empire: Painting and Architecture of the Byzantine Periphery* (University Park, Pa., and London, 1988), 53–90. For thirteenth-century Cypriot painting, see also Carr, *Byzantine Masterpiece*, chaps. 3 and 4.

56. On this period, see Carr, *Byzantine Illumination*.

57. See K. Maxwell, "Paris, Bibliothèque Nationale, Codex Grec 54: An Analysis of the Text and Miniatures" (Ph.D. diss., Univ. of Chicago, 1986). There she dates this manuscript to the 1280s (301). Her more recent research on the manuscript has suggested a possible date in the 1270s; I am grateful to her for discussing this point with me.

58. On Staro Nagoričino, see G. Millet and A. Frolow, *La peinture du moyen âge en Yougoslavie*, vol. 3 (Paris, 1962), plate 85; R. Hamann-MacLean and H. Hallensleben, *Die Monumentalmalerei en Serbien und Makedonien vom 11. bis zum frühen 14. Jahrhundert* (Giessen, 1963), vol. 1, 273–315. For Arilje, 1296, see S. Petković, *Arilje* (Belgrade, 1965); Hamann-MacLean and Hallensleben, 143–58; or Millet and Frolow, vol. 2, plates 76–7. For a very similar composition, see the fresco at Curtea de Arges, Romania, from the early fourteenth century; O. Tafrali, *Monuments byzantins de Curtea de Arges* (Paris, 1931), vol. 2, plate LXXVIII (2). A church in Ivanovo, Bulgaria, with frescoes of c. 1232–5, provides some evidence that these changes began earlier; the Betrayal there features similar experimentation with space, and similar violence in the crowd attacking Christ. For a photograph, see A. Tschilingirov, *Christliche Kunst in Bulgarien, von der Spätantike bis zum Ausgang des Mittelalters* (Berlin, 1978), fig. 106. Most extant examples of this image are found later, in Serbia and Macedonia; see, for instance, the Betrayals at the Peribleptos (St. Clement), Ohrid, c. 1295 (Millet and Frolow, vol. 3, plate 7); St. Nicholas, Prilep, c. 1295 (ibid., vol. 3, plate 23); and at Čučer, (ibid., vol. 3, plate 43). For a discussion of the frescoes at each site, see Hamann-MacLean and Hallensleben, *Monumentalmalerei*: on Ohrid, 160–81; on Prilep, 159; on Čučer, 221–4.

59. See also the frescoes at Prilep, from the end of the thirteenth century, and Čučer, cited in Note 58.

60. The same stance appears at Curtea, cited in Note 58.

61. Belting, *Cimitile*, 130; see also Note 23.

62. Ibid. For the Egbert Codex, Trier, Stadbibliothek, Cod. 24, c. 980, see H. Schiel, *Codex Egberti di Stadbibliothek Trier* (Basel, 1960); Schiller, *Iconography*, vol. 2, fig. 169.

63. Examples include a Cassinese breviary of 1099–1105, now in Paris, Bibliothèque Mazarine, cod. 363, fol. 24r.; see M. Avery, *The Exultet Rolls of South Italy* (Princeton, 1936); a mosaic at Monreale (Demus, *Mosaics of Norman Sicily* [London, 1950], fig. 70); an early twelfth-century fresco in Sardinia, Sta. Trinità, Saccargia, published by M. Accascina, "Gli affreschi di Santa Trinità di Saccargia," *Bollettino d'arte* 38 (1953): 21–30, fig. 9, and a miniature in a lectionary from a Basilian monastery in south Italy, now in Milan, Biblioteca Ambrosiana, D. 67r sup., fol. 74r.; Millet, *Recherches*, fig. 350.

64. Representative examples are published by Schiller, *Iconography*, vol. 2, figs. 164–8, 170, 175–6.

65. Montecassino had owned property in Lucca since 1056, when S. Giorgio in Lucca was transferred to the Benedictine monastery. See H. Schwarzmaier, *Lucca und das Reich bis zum Ende des 11. Jahrhunderts* (Tubingen, 1972), 380–1. For south Italian painters working in Italy, see Garrison, "Additional Certainly, Probably, and Possibly Lucchese Manuscripts I: Two Manuscripts of S. Michele di Guamo," *Bibliofilia* 74, pt. 2 (1972): 129–55. For other evidence of artistic ties between Lucca and south Italy, see Garrison, "Lucchese Passionary," 113.

66. As Sharon Gerstel pointed out to me, the figure with the knotted belt at the far left recalls similar figures in the Paris Psalter. The iconographic type seen here was introduced to

northern Europe at exactly the same time. The Betrayal (fol. 47r.) in the St. Blasien Psalter, dated 1230–5 (private collection; H. Bober, *The St. Blasien Psalter* [New York, 1963], plate VII) also strongly resembles that in the Dionysiou lectionary (Fig. 28). But the Gothic illuminator deviates from his source in deemphasizing the semicircular disposition of the mob and in omitting such details as the bounding figure on the far left.

67. G. Millet and A. Frolow, *La peinture du moyen âge en Yougoslavie*, vol. 1 (Paris, 1954), plate 89 (1). They state that the church was built just before 1170 and that the frescoes were executed just after its construction.

68. Strassburg, Bibliothèque de la Ville, fol. 138v. (illustrated in A. Straub and G. Keller, *Herrade de Landsberg, Hortus Deliciarum* [Strassburg, 1899], plate XXXV).

69. Weitzmann has stressed the unusual character of this image, noting that "in the rather numerous examples of this theme in Middle Byzantine art none corresponds exactly with that of the Morgan miniature" ("Constantinopolitan Lectionary," 366).

70. See, for instance, a fresco in Cappadocia, at Qaranlek Kilise (cited in Note 48). Christ's gesture of greeting is common to both works, as is the torpor that has beset all the participants. Most interesting is the conspicuous presence in the fresco of the priest. Just as in Enrico's Betrayal, the one to the right is unusually tall, noticeably taller than Christ; in the fresco a second priest stands between the two principal pairs of figures, appears in profile, has dark hair and beard, and wears a patterned garment – much like the corresponding figure in Enrico's panel. For Carli's association of Enrico with Cappadocian painting, see *Italian Primitives*, 24. See also Caleca, "Pittura." Bonanno Pisano's relief for the bronze doors of the Cathedral of Pisa (A. Boeckler, *Die Bronzetüren des Bonanus von Pisa und des Barisanus von Trani* [Berlin, 1953], plate 22) also resembles the Cappadocian fresco in the curious enervation of the participants, in the placement of Judas on the right, and in the diminutive size of Malchus. Bonanno did not, however, include the priests who figure so prominently in both the fresco and Enrico's panel.

71. The soldier is seen from the back at Assisi and may have been in the manuscript, but its con-

dition makes it difficult to be sure. R. Mellinkoff has recently identified the dorsal view as signifying evil; see her *Outcasts: Signs of Otherness in Northern European Art of the Late Middle Ages* (Berkeley, 1993), vol. 1, 213. For the conical helmets, see Note 72 below.

72. A. and J. Stylianou, "The Militarization of the Betrayal," 574; J. F. Haldon, "Some Aspects of Byzantine Military Technology from the Sixth to the Tenth Centuries," *Byzantine and Modern Greek Studies* 1 (1975): 26, 37–8. For Carr's suggestion that the manuscript is Cypriot, see Note 53.

73. On Mileševa, see Hamann-MacLean and Hallensleben, *Die Monumentalmalerei*, vol. 1, 82–98.

74. For Macedonian examples, see a fresco at St. Nicholas Orphanos in Thessaloniki (A. Xyngopolous, *Hoi toichographies tou Hagiou Nikolaou Orphanou Thessalonikes* [Athens, 1964], plate 23); a fresco at the church of Christos, Veroia, 1315 (S. Pelekanides, *Kallierges holes Thettalias aristos zographos* [Athens, 1973], plate 24); and a fresco in Athens, Asomatos Taxiarches. For Romania, see the fresco at Curtea, Note 58.

75. See also Ohrid, St. Clement (cited in Note 58).

76. Again, see Note 58.

77. The fact that so many comparable examples appears in monumental painting is interesting. Perhaps this is merely an accident of survival; it is possible that similar compositions occurred in now-lost portable works, such as icons or manuscripts. Copies in the form of model books or large drawings may also account for Italian painters' knowledge of monumental works. D. Blume has argued that full-scale drawings of the "official" life of Francis must have been passed among Franciscan houses to insure the correct representation of the images (*Wandmalerei als Ordenspropaganda*); possibly copies of Byzantine works, seen by Franciscans in their travels to the East or to the Balkans, were similarly circulated. We know, too, that Byzantine painters made cartoons or *anthibola* of wall paintings by the Late Byzantine period if not before; see S. Kalopissi-Verti, "Painters in Late Byzantine Society: The Evidence of Church Inscriptions," *Cahiers Archeologiques* 42 (1994): 139–58, especially 194, for a discussion of such drawings mentioned in the will of a painter in 1436. I am

indebted to Sharon Gerstel for discussing *anthibola* with me, and for this reference. For model-books, see also H. Buchthal, *The "Musterbuch" of Wolfenbüttel and its Position in the Art of the Thirteenth Century* (Vienna, 1979), and the entry, "Models and Model-Books," by Anthony Cutler in the *Oxford Dictionary of Byzantium* (1991). See also J. Cannon's review of Blume, *Wandmalerei als Ordenspropaganda*, *Burlington Magazine* 127 (1985): 234–5, for the dissemination of copies of the Assisi frescoes.

78. Hrabanus wrote: "Aliter, auris pro Domino amputata et a Domino sanata significat auditum ablata vetustate renovatum, ut sit in novitate spiritus et non in vetustate litterae. . . (*P.L.*, vol. 107, column 1117). Alcuin, Hrabanus's teacher, referred to the miraculous healing in almost exactly the same terms (*P.L.*, vol. 100, column 970). To both theologians, then, the miracle becomes almost a paradigm of the miracle of salvation.

79. See S. Sticca, *The Latin Passion Play: Its Origins and Development* (Albany, N. Y., 1970), 63.

80. See Note 63 for some of the south Italian examples. A. Wharton has pointed out (*Art of Empire*, 137) that Peter was especially venerated in south Italy, presumably because of the proximity to Rome. Conceivably the interest in this saint may have also prompted the adoption of this eastern image.

81. The cross by Giunta Pisano, which Brother Elias of Cortona gave to San Francesco in 1236, is widely believed to have been an early example of the *Christus Patiens*; see Chapter 1, Note 74.

82. The cross has long been considered a Berlinghieresque work; Boskovits has recently suggested that the cross is the work of two hands, Bonaventura di Berlinghiero and another painter, whom he identifies as the painter of cross no. 434 in the Uffizi (*Origins*, 74, note 146). Bonaventura is the painter of the well-known St. Francis panel in Pescia; the St. Francis panel in the Bardi Chapel, Sta. Croce, is also strongly Berlinghieresque. The Tereglio cross has been ascribed to Barone di Berlinghiero fairly often, a possibility raised most recently by Ayer ("Imagery in Transition," 123; for the literature, see Boskovits, *Origins*, 398–401). Barone has been identified as a Franciscan friar (U. Thieme, F. Becker, and H. Vollmer, eds., *Allgemeines Lexikon*

der bildenden Künste von der Antike bis zur Gegenwart, vol. 3, 422), but the evidence for this claim is elusive.

83. See the Introduction, Note 22. Some fifty years ago, Coor, "Coppo," 18, note 12, suggested that the cross was a Franciscan commission.

84. See Chapter 1, Note 57, for the crosses from S. Martino, and Chapter 1, Note 52, for the Lucchese panel.

85. Habig, *Omnibus*, 140-55.

86. Ibid., 140.

87. Ibid., 141-2. The numbers in parentheses refer to the psalms from which the verses are taken.

88. *P.L.*, vol. 94, columns 561-68. For the authorship and approximate date, see Chapter 1, Note 65.

89. Pseudo-Bede devotes more than ten lines to the apostles' "separation" from Christ. He then continues: "O quoties respiciebant, videntes qualiter Dominus suus ligatus et sine honore trahebatur. . . . o Domine Jesu . . . ibas inter lupos et te mordebant canes pessimi, et non clamabas, and tanquam agnus innocens ad mortem ibas."

90. *Works*, trans. De Vinck, vol. 1, 116. Another Franciscan work, the *Dialogus Beatae Mariae et Anselmi de Passione Domini*, similarly stresses Christ's voluntary participation in the Arrest. This account takes the form of a dialogue in which Mary describes the events of the Passion to Anselm. The description of the Arrest follows the gospel of St. John: Christ forthrightly approaches the crowd, thus initiating the action. Only after the mob falls back in astonishment does Judas come forward to kiss Christ. The episode of Peter and Malchus follows next: "Then Peter drew his sword and cut of the ear of the servant of the high priest, who was called Malchus." At this point, Anselm asks: "Did a great miracle happen then?" Mary assures him that it did: "My son touched the servant and healed his ear, and said to Peter, Put your sword in its sheath. For all who live by the sword shall die by the sword. Do you suppose that I cannot appeal to my Father, who would at once send to my aid more than twelve legions of angels? But then how could the scriptures be fulfilled, which say that this must be?" (Matt. 26: 51–4). The account goes on to describe Mary's sorrow when she learned of the Arrest, but she also refers to the ultimate outcome of the Passion: "The human race must

be redeemed." As in Bonaventure's account, the emphasis is on Christ's willingness to sacrifice himself, and on the miracle, rather than on his plight at the hands of his captors. For the Franciscan authorship of the *Dialogus*, see Neff, "*Dialogus*."

91. This event is presented in the text as a separate episode; here Bonaventure's language shifts away from St. John and towards St. Francis ("shamelessly dragging to the sacrifice the Lamb most meek and silent, as if He were a criminal"; De Vinck, *Works*, vol. 1, 118). The Betrayal is similarly subdivided into two compositions in the Office of the Passion by Bonaventure (Sticca, "*Officium Passionis Domini*," plates VII, VIII). The first shows the Betrayal in a somewhat Giottesque manner, with Judas's cloak enfolding Christ. However, Peter and Malchus are much more prominent here; unlike Giotto's fresco, Malchus kneels and Peter bends to cut off the ear. The second depicts Christ with hands bound, being led by a rope tied around his neck. The significance of the rope around Christ's neck for Franciscans is discussed in Chapter 5, pp. 132–5.

92. In an Armenian manuscript in the Freer Gallery of Art, F.32.18, the arresting soldiers are depicted falling to the ground, as Bonaventure stressed. Helen Evans has persuasively associated this image with Franciscan influence in Armenia Cilicia ("Manuscript Illumination," 131–2).

93. See especially chap. 4, in De Vinck, *Works*, 61–77. For the references to Gerard, see the introduction to the text, p. 6. For a discussion of these issues, see the overview in Moorman, *History*, 127–31; see also Daniel, *Franciscan Concept*, 52–4. The *Apologia pauperum* and the debates that prompted it will be discussed further in Chapter 6, pp. 151–3.

94. De Vinck, *Works*, vol. 4, 61. Bonaventure also stresses Christ's willingness to suffer and die in his *Breviloquium* (*Works*, vol. 2). In chap. 8, "On the State of the Suffering Christ," he writes:

> No innocent person is morally obliged to suffer against his will, since this would contradict the order of divine justice. . . . [Christ] was not to suffer against His rational will, since He not only lived in the state of beatitude and

of union with the omnipotent Godhead through which He could repel any evil, but He also possessed perfect innocence which, according to the order of natural justice, cannot be obligated to suffer.

He goes on to say that Christ was to suffer "against His instinctive will: that is, against the sensible impulse and desire of His flesh." But, he stresses, Christ "conformed His rational will to the will of His Father, thus placing reason above instinct, when He said: 'Not My will but Thine be done'" (168–9).

95. The Crucifixion from the same diptych depicts Francis kneeling at the foot of the cross (Boskovits, *Thyssen*, plate on p. 131).

96. Ragusa and Green, *Meditations*, 325.

97. For a color photograph, see Frugoni, *Pietro and Ambrogio Lorenzetti*, fig. 22. An interesting corollary has been proposed by Hans Belting, who notes the unusual brown garment of the Christ child in a panel of the Virgin and Child in Cleveland (*Image and Likeness*, fig. 212, 367); Belting suggests that it may have been intended to evoke the Franciscan habit.

98. Lambert develops this idea in some detail, noting that Francis, in his *Verba admonitionis*, refers to bad friars as those who "make a bag for themselves to the peril of their soul." He argues that Francis's term for money bag, "*loculi*" (the singular is used in English, the plural in Latin), is also the term used in the Vulgate for Judas's bag, and indeed that the word appears in the Vulgate only in reference to Judas's bag (*Franciscan Poverty*, 62–6). For the text of the *Verba admonitionis*, see *Omnibus*, 77–87.

99. De Vinck, *Works*, vol. 4, 217.

100. *Defense*, chap. 7; De Vinck, *Works*, vol. 4, 159. See also Lambert, *Franciscan Poverty*, 136.

101. De Vinck, *Works*, vol. 1, 116.

102. Ragusa and Green, *Meditations*, 325. As Offner noted, Pacino di Bonaguida's *Tree of Life*, originally painted for the Clares at Monticelli and today in the Accademia, Florence, opens its extensive Passion narrative with Judas taking a bribe from the high priests. Offner convincingly connects this image with Bonaventure's stress on Judas's avarice (for Offner's discussion, see *Corpus*,

sect. 3, vol. 6, 127; for a reproduction, see Offner, *Corpus*, sect. 3, vol. 2, part 1, plate II–7a).

103. Numerous critics, noting the friars' rapidly mounting wealth, charged them with both avarice and hypocrisy. Even Francis was branded an avaricious merchant by a parish priest in 1289; see Camille, *Gothic Idol*, 265; Vauchez, "Les stigmates," 614. See also L. Little, *Religious Poverty and the Profit Economy in Medieval Europe* (Ithaca, N.Y., 1978), 201–2. For satirical references to mendicant greed in fourteenth-century Gothic manuscripts, see Camille, 266–7.

104. For the events leading up to the bull, see Lambert, *Franciscan Poverty*, 184–201. Moorman (*History*, 308–9) argues that many Spirituals greeted the bull with enthusiasm, and that the pope's stance toward the Spirituals was sympathetic. Lambert, however, stresses that the bull was a compromise that failed to satisfy the Spirituals fully.

105. For the statutes and the accompanying letter, see Moorman, *History*, 308–10. The attempt to reconcile the two factions ended badly. Though some of the Spirituals supported the Minister General, a group of twenty-five dissented, and four were burnt at the stake in 1318. John XXII, for whom obedience to papal authority took precedence over vows of poverty, declared in 1323 that the notion of Christ's poverty was heretical; eventually he had Michael arrested and deposed as Minister General (Moorman, 311–22).

106. For the date, see Note 19. Kempers maintains that these years marked a brief moment of harmony between the Spirituals and Conventuals, and associates the allegories of poverty, chastity, and obedience in the Lower Church with this moment of reconciliation (*Painting, Power and Patronage*, 32–3).

107. For the suicide of Judas, see Frugoni, *Pietro and Ambrogio Lorenzetti*, fig. 23. She notes that the graphic depiction of the corpse was probably taken from Pietro's observing the bodies of hanged criminals (21). The suicide appears similarly on Pacino's panel in the Accademia, cited above (Note 102); see also Offner's discussion, in *Corpus*, sect. 3, vol. 6, 127–8.

CHAPTER 3

1. Matthew 27:1–26; Mark 15:1–15; Luke 23:1–6, 13–25; John 18:28–40, 19:1–16. The best-known apocryphal account is the *Acta Pilati*; see M. R. James, *The Apocryphal New Testament* (Oxford, 1926).

2. For Sta. Maria Antiqua, see G. Matthiae, *Pittura romana del medioevo* (Rome, 1965), 116-29; for the rest, see Sandberg-Vavalà, *Croce dipinta*, chart pp. 428-9. At times, as at S. Marco, the Trial before Pilate does not appear in its full narrative form; rather it, the Carrying of the Cross, and the Mocking of Christ are conflated into a single scene.

3. For this cross, in S. Frediano, Pisa, see Carli, *Pittura medievale pisana*, 19-23; Sandberg-Vavalà, *Croce dipinta*, fig. 381. There the scene appears in combination with the Flagellation.

4. I know of only one example in Italian painting from the tenth through the twelfth century: fol. 27r. from the "Second Hamilton Psalter" (Berlin, Staatliche Museum, 78.A.5), dated by Garrison c. 1175 ("A Checklist of North Italian Geometrical Manuscripts," in *Studies in the History of Medieval Italian Painting*, vol. 4, nos. 3 and 4 [Florence, 1962], 375). Even in this example the exact subject of the scene is ambiguous: Christ appears before two seated judges, but one is probably Pilate, the other either Annas or Caiaphas. The page illustrates Psalm 27:12: "Liars stand up to give evidence against me, breathing malice." Following this line, the text inserts a reference to "Pylat, Anna et Caypha," then continues with the psalm. The psalter illustration shares little iconographically with the depiction of Christ before Annas and Caiaphas as it appears in the painted crosses.

5. Pilate does appear in the Flagellation in several painted crosses; see Sandberg-Vavalà, *Croce dipinta*, chart pp. 428-9. It has been suggested that the Trial before Pilate appeared in the Upper Church at Assisi (Poeschke, *San Francesco*, fig. 117), but the image is almost entirely obliterated. Other scholars (e.g., White, *Art and Architecture*, 200) have identified the scene as the Flagellation, a theme that is far more often included in duecento Passion cycles. The procurator may have been included in the Flagellation, as in the images noted above.

6. For the crosses in the Uffizi, San Gimignano, and Pistoia, see the Introduction, Note 22. For the Sta. Marta cross, see Marques, *Peinture*, 208-12. Coor, "Coppo," 8, suggested

that the Sta. Marta cross derives from the Pistoia cross. The provenance of the Sta. Marta cross is somewhat uncertain. The church in which the cross hangs was once occupied by nuns of the Penance of St. Dominic; see G. Kaftal, *Iconography of the Saints in Tuscan Painting* (Florence, 1952), 683; Paliaga and Renzoni, *Chiese*, 43–5. The Order was established formally in 1285; see G. G. Meersseman, *Dossier de l'Ordre de la Pénitence au XIII siècle* (Fribourg, 1961), 23. However, the church of Sta. Marta was founded only in 1342 (Paliaga and Renzoni, *Chiese*, 43). On the church, see also Da Morrona, *Pisa illustrata*, 3, 191–3.

7. On this panel, see the Introduction, Note 11. Annas and Caiaphas also appear in a Mocking of Christ, attributed to the same painter (Marques, *Peinture*, 263–4).

8. Pilate is also present at the Flagellation and at the Crowning with Thorns. See J. Stubblebine, *Duccio di Buoninsegna and his School* (Princeton, 1979), vol. 2, plates 104–9.

9. See, for instance, Bede's *Paraentica*: "Consuetudinis judaicae est, cum aliquid blasphemiae et quasi contra Deum audierint, scindere vestimenta sua (*P.L.*, vol. 94, column 401; quoted by Sticca, "*Officium Passionis*," 169). See also P. Parker, "The Trial of Jesus," *The Interpreter's Dictionary of the Bible* (New York, 1962).

10. The Trial on the Sta. Marta cross resembles the version by Salerno. Salerno's modifications of the basic type – the elimination of the striking soldier and the addition of the figure who holds Christ by the shoulder – recur here, and the crowd has been even further pared down. The attitudes of Annas and Caiaphas have become more expressive, however; the two lean back, as if recoiling in horror. It is difficult to credit this generally unimaginative painter with such an innovation; more likely it stems from another source. The Cimabuesque facial types used by this painter suggest the possibility that a work by Cimabue may have been the source. On Cimabue, the San Gaggio Master, and the Sta. Marta Master, see Marques, *Peinture*, 208–12.

11. For the Oxford panel, see Marques, *Peinture*, 205; Tartuferi, *Pittura*, 109, with bibliography.

12. For S. Apollinare Nuovo, see Schiller, *Iconography of Christian Art*, vol. 2, figs. 185, 208; for Qeledjlar Kilise, see Restle, *Wandmalerei*, vol. 2, plates 272–3. Other monuments include the Constantinopolitan Gospel books in Paris, gr. 74, fols. 55v., 56v., 57r., 57v., 87v., 89r., 159v., 160v., 203v., 204r., 204v. (Omont, *Évangiles*, vol. 1, plates 46-8, 85–6; 2, pls. 138, 173-5) and in Florence, Plut. VI, 23, fols. 56r., 57r., 160r., 161r., 206v., 208r. (Velmans, *Tetraévangile*, figs. 114, 116–7, 262–3, 296–7); a Coptic Gospel book in Paris, Copte 13 (see S. Shenouda, "The Miniatures of the Paris Manuscript 'Copte 13'" [Ph.D. diss., Princeton Univ., 1956], 110-4); Russian fresco cycles (Pskov, Spaso-Mirozhsky Monastery, c. 1156 [Fig. 51] and Nereditsa, Church of the Savior, 1199; on Pskov, see Lasareff, *Old Russian Murals and Mosaics* [London, 1966], 100-4; on Nereditsa, ibid., 116-30); and several cycles in Serbia and Macedonia: possibly Mileševa, Church of the Ascension (see Hamann-MacLean and Hallensleben, *Monumentalmalerei*, plan 12, IV, 133, 135), Ohrid, Peribleptos (Millet and Frolow, *Peinture*, vol. 3, plate 8), Staro Nagoričino, St. George (Millet and Frolow, vol. 3, plates 75, 86) and Gračanica, monastery church (Hamann-MacLean and Hallensleben, plates 341–2). At St. Nicholas Orphanos in Thessaloniki, Christ appears first before Caiaphas, then before Pilate (Xyngopoulos, *Hoi Toichographies*, plates 45–8).

13. Millet, *Recherches*, 44–5, was the first to note the existence of these two patterns; he suggested that the inclusion of Pilate indicated a Syrian recension, the priests a Hellenistic recension. But chronology rather than the hypothetical origin of a recension seems to determine the choice of theme. The overwhelming majority of Early Christian examples depict Christ before Pilate rather than the high priests. Some twenty-five sarcophagi include the former (E. C. Colwell and H. R. Willoughby, *The Four Gospels of Karahissar* [Chicago, 1936], 237), while the latter occurs only very rarely, as in the Brescia lipsanothek (Schiller, *Iconography*, vol. 2, fig. 10).

In Early Byzantine art this pattern continues. For instance, both the Rossano Gospels (fols. 8r., v.) and the Rabbula Gospels (fol. 12v.) depict only Christ before Pilate (see W. Loerke, "The Miniatures of the Trial in the Rossano Gospels," *Art Bulletin* 43 [1961]:

171-95; Rossano, fig. 1; Rabbula, fig. 4). From the mid-ninth through the early thirteenth centuries, the priests increasingly replace Pilate in limited cycles. Thus one or both of the priests, not Pilate, typically appear in psalter illustrations (e.g., the Khludov, Pantocrator, and Theodore Psalters; on all see note 19), in lectionaries (e.g., Dionysiou 587, fol. 95r.; see Pelekanides, *Treasures of Mount Athos*, plate 228); and in fresco cycles throughout the empire (in Cappadocia: Ihlara, Kokar; Ihlara, Purenli Seki; see Restle, *Wandmalerei*, vol. 3, plates 482, 487; in Russia: Kiev, Sta. Sophia; see Lasareff, *Old Russian Murals*, 45). Occasionally in the fourteenth century, we find a similar substitution of the priests for Pilate, as at Čučer (Millet and Frolow, *Peinture*, 3, plate 43) and Veroia (see Pelekanides, *Kallierges*, plates 7, 25).

Exceptions, which include Pilate and omit the priests, occur occasionally; among them are three tenth-century Cappadocian frescoes (at Tokali Kilise, Tchaouch-In and Sinassos-Mustafa Pasa Koy [Restle, *Wandmalerei*, vol. 2, plate 75; vol. 3, plate 310; vol. 3, plate XV]); two icons from Mt. Sinai (Weitzmann, *Studies in Classical and Byzantine Manuscript Illumination*, figs. 300, 302); the lectionary in the Vatican, ms. gr. 1156, fol. 194v.; and a Cypriot fresco at St. Neophytos, Paphos (Mango and Hawkins, "Hermitage of St. Neophytos," plate 30). The St. Neophytos fresco may reflect a special interest in Pilate characteristic of Cyprus; a Cypriot Passion play of the mid-thirteenth century similarly spotlights the procurator. See Mahr, *Cyprus Passion Play*, 171–83, 187–9.

14. The tendency to exonerate Pilate and focus all blame on the Jews is discussed at length by Loerke, "Miniatures of the Trial." See also S. Radojčić, "The Judgement of Pilate in Byzantine Painting from the Beginning of the Fourteenth Century," *Srpska Akademija Nauka, Belgrad. Zbornik Radova* 13 (1971), 293-312 (in Serbo-Croatian, with French summary). The author of the *Christos Paschon* also minimizes Pilate's culpability: He cites Pilate's admiration for Christ, his "eloquent words" in Christ's defense (Tuilier, ed., 159–61). The Coptic and Ethiopic churches went so far as to consider Pilate a saint; see O. V. Volkoff, "Un saint oublié: Ponce Pilate," *Bulletin de la Société*

d'archéologique copte 20 (1969–70): 167–75. For other assessments of Pilate's guilt or innocence, see T. F. Mathews and A. K. Sanjian, *Armenian Gospel Iconography: The Tradition of the Glajor Gospel* (Washington, D.C., 1991), 111–12.

15. See her dissertation ("The Ninth-Century Byzantine Marginal Psalters: Moscow, Historical Museum Cod. 129; Mt. Athos, Pantocrator 61; Paris, Bibliothèque Nationale gr. 20," Univ. of Calif., Los Angeles, 1984) and her subsequent monograph (*Visual Polemics*). For the specific manuscripts, see Note 19. My initial work on the antisemitic content of these ninth-century images ("Byzantine Art and the Dugento," [1980], chap. 2) was done without the benefit of her much more thorough study. Marion Roberts first suggested that I look into contemporary antisemitism as a context for the shift from Pilate to the priests; I am grateful to her for this suggestion.

16. On Basil's persecution of the Jews, see A. Scharf, *Byzantine Jewry from Justinian to the Fourth Crusade* (London, 1971), 82–92. Corrigan, *Visual Polemics*, 43, discusses Basil's policy of forcing Jews to be baptized.

17. C. Mango, *The Art of the Byzantine Empire 312-1453: Sources and Documents* (Englewood Cliffs, N. J., 1972), 200.

18. For the first passage, see Downey, trans., *Description*, 880, and Millet, *Recherches*, 45. For the second, see Downey, *Description*, 884-5.

19. For the Pantocrator Psalter (Mount Athos, Monastery of the Pantocrator, Cod. 61), see S. Dufrenne, *L'Illustration des psautiers grecs du Moyen Age* (Paris, 1966), vol. 1, plate 5; for the Khludov Psalter (Moscow, Historical Museum, Cod. 129), see Grabar, *Iconoclasme byzantin* (Paris, 1957), 135–98. For both psalters, see also Corrigan, *Visual Polemics*, passim. The Theodore Psalter (fol. 39r.; S. Der Nersessian, *L'Illustration des psautiers grecs*, vol. 2, fig. 67), the Barberini Psalter (Rome, Vatican Museum, Barb. gr. 372, fol. 54r), and a second psalter in the Vatican (gr. 1927, fol. 57r.; E. De Wald, *The Illustrations in the Manuscripts of the Septuagint*, vol. 3: *Psalms and Odes*, vol. 1: *Vaticanus Graecus 1927* [Princeton, 1941] plate XVI) also illustrate Psalm 35 with the scene; the Theodore Psalter and the Barberini Psalter, however, add Pilate to the group. Fol.

2r. of the Theodore Psalter (Der Nersessian, *L'Illustration des psautiers grecs*, vol. 2, fig. 3) also uses the Trial before Annas and Caiaphas to illustrate Psalm 2:2 ("the rulers take counsel against the Lord").

20. See Note 12.

21. Both Schiller, *Iconography of Christian Art*, vol. 2, 57, and Sandberg-Vavalà, *Croce dipinta*, 244, are misleading in indicating that the pairing was common in the West. The Index of Christian Art lists twenty-one examples of the Trial before Annas and/or Caiaphas in western art from the sixth through the twelfth centuries; of these, twenty depict but one of the priests, usually Caiaphas. E. Lucchesi-Palli, *Die Passions- und Endszenen Christi auf der Ciboriumsaule von San Marco in Venedig* (Prague, 1942), 62, correctly notes the rarity of the paired priests in the West. For other iconographic studies consult Réau, *Iconographie*, part 2, 444–46; K. Laske, "Synedrium," *Lexikon der christlichen Ikonographie* (Rome and Freiburg, 1972); Sticca, "Officium Passionis," 168–70.

22. Some later frescoes, such as the cycles at Staro Nagoričino and Gračanica, also depict Christ's appearances before the priests separately; for these and for Paris gr. 74, see Note 12. The narrative expansion of Late Byzantine painting will be discussed later in this chapter; see p. 85.

23. For instance, as in the Qeledjlar Kilise fresco (see Note 12) and a manuscript in Paris, gr. 115, noted by Millet (*Recherches*, 138, 641).

24. Examples include a fresco in Nereditsa (see Note 12); a manuscript in Rome, Vat. gr. 1927, fol. 37v.; two twelfth-century steatite plaques, at the Walters Gallery, Baltimore, and the Benaki Museum, Athens, on which see I. Kalavrezou-Maxeiner, *Byzantine Icons in Steatite* (Vienna, 1985), vol. 1, 154–5; vol. 2, figs. 58, 59; Morgan ms. 692, fols. 222r. and 223 r.; British Library, Add. ms. 7170, fol. 145r. (see J. Leroy, *Manuscrits syriaques à peintures conservés dans les bibliothèques d'Europe et d'Orient* [Paris, 1964]); the fresco at Čučer (see Note 13). Finally, in a miniature in St. Petersburg, ms. 105 (Fig. 52), two judges also appear, but here they are Annas and Pilate; see Note 27.

25. Ottonian manuscripts typically depict him before Caiaphas this way; see Schiller, *Iconography of Christian Art*, vol. 2, figs.

186, 188–9, 200. See also the examples of Christ bound before Pilate, ibid., figs. 212–7. Ottonian painters took much from Byzantine manuscripts, and the bound hands of Christ in some of these instances were probably derived from Byzantium. However, I am not aware of Byzantine images of the Trial in which Christ is dragged by the arms; this seems to be a western formulation. As noted above, Christ's bound hands derive from biblical accounts; according to both Matthew (26:2) and Mark (15:1), Christ was bound before he was led to Pilate, and according to John (18:24), Christ was sent bound from Annas to Caiaphas.

26. For S. Apollinare Nuovo, see Note 12; for the Rabbula Gospels, fol. 12v., see Note 13.

27. This image depicts Christ before Pilate and a single high priest, probably Annas. For the identification of the subject, see Colwell and Willoughby, *Four Gospels*, vol. 1, 242; on the manuscript, see Carr, "A Group of Provincial Manuscripts," catalogue no. 6; idem, *Byzantine Illumination*, catalogue no. 59, 239–41. Carr ("Group of Provincial Manuscripts," 63–6) places the "Chicago subgroup," to which St. Petersburg 105 belongs, between the 1150s and the 1180s, and the St. Petersburg manuscript itself to the 1180s (55).

28. As in the Dionysiou lectionary, fol. 95r. (Pelekanides, *Treasures of Athos*, vol. 1, fig. 228).

29. Another example of Christ bound before Caiaphas appears in Vat. gr. 1927, fol. 57r. (see Note 19). Colwell and Willoughby, *Four Gospels*, vol. 1, 241, observe that the earlier representations depict Christ unbound, and that only later are his hands tied. Mesarites, writing at the end of the twelfth or beginning of the thirteenth century, described Christ "seized by lawless hands like a criminal, and bound" (Downey, *Description*, 880).

30. The motif is ultimately Byzantine – it appears, for instance, in the Florence Gospel book and in Copte 13 (for both, see Note 12) – but was introduced early to the West, as Ottonian manuscripts testify (Schiller, *Iconography*, vol. 2, fig. 189). The soldier is equipped with scabbard and sword, as in the Uffizi cross and in a contemporary German altarpiece from St. Egidius, Quedlinburg; see ibid., fig. 215. That panel, however, represents Christ before Pilate.

31. As in Paris 74, fol. 204r., Omont, *Évangiles*, vol. 2, plate 173.

32. Among the monuments that exclude the motif are the Florence Gospel book (see Note 12); the Theodore Psalter and the Barberini Psalter (for both see Note 19); Vat. gr. 1156 (Note 13) and Vat. gr. 1927 (Note 19); and two Cappadocian frescoes at Ihlara, Kokar Kilise and Purenli Seki Kilise (Note 13).

33. The figure also appears in two fragmentary steatite plaques and at Nereditsa (1199). For the steatite plaques, see Note 24. For the fresco at Nereditsa, see Note 12.

34. Omont, *Évangiles*, vol. 1, plate 48 (2).

35. Coor, "Visual Basis," 239.

36. In the Khludov Psalter and the Pantocrator Psalter (see Note 19) the priest simply sits, impassive and motionless. In a number of other monuments – among them, frescoes at Qeledjlar Kilise (see Note 12), Kiev (Millet, *Recherches*, 641), and Nereditsa (see Note 12), and the psalter in the Vatican, gr. 1927 (see Note 19) – the priests are partially concealed by a table placed in front of them, which makes it difficult to tell if they are seated or standing. The table was originally an attribute of Pilate; see Loerke, "Miniatures of the Trial," 178. But this sort of interpolation of images is not at all uncommon; the striking soldier, for instance, which technically should appear only in the scene of Christ before Annas (see John 18:22), also surfaces in the Trial before Pilate (e.g., in a Sinai icon; Weitzmann, *Studies in Classical and Byzantine Manuscript Illumination*, fig. 302).

37. Examples include Paris, gr. 115, fol. 132r. (noted by Millet, *Recherches*, 641); Dionysiou 587, fol. 95r. (see Note 13); the Florence Gospel book, fol. 56r. (see Note 12); the Theodore Psalter, fol. 2r. (see Note 19); and Paris suppl. gr. 914, fol. 146v. (noted by Millet, ibid., 641).

38. These monuments include the frescoes at Qeledjlar Kilise (see Note 12), Ihlara, Kokar (Note 13), Kiev (Note 13), and Nereditsa (Note 12); Coptic and Syriac manuscripts (Copte 13, fol. 80v. [Note 12]; British Library, Add. 7170, fol. 145r. [Note 24]); and frescoes at Ivanovo in Bulgaria, c. 1232–5 (Tschilingirov, *Christliche Kunst in Bulgarien*, fig. 107), Čučer, St. Nikita (Note 13) and Staro Nagoričino (Note 12).

39. It appears in Ottonian manuscripts of the eleventh century; given the occurrence of the gesture there and in later Byzantine art, my assumption is that the Ottonian painters took the motif from Byzantium (for examples, see Schiller, *Iconography*, vol. 2, figs. 186, 188–9).

40. See T. Velmans, *La peinture murale byzantine à la fin du Moyen Âge*, vol. 1, Bibliothèque des Cahiers Archéologiques, 11 (Paris, 1977), 223–4.

41. Mango and Hawkins, "Hermitage of St. Neophytos," plate 30.

42. This painter, a follower of Cimabue, may have encountered these eastern details in a lost Passion cycle by Cimabue or his shop.

43. *Four Gospels*, 243.

44. For Duccio, see Stubblebine, *Duccio*, vol. 2, fig. 106; for Staro Nagoričino, see Millet and Frolow, *Peinture*, vol. 3, plate 88 (1). For the various trials at Staro Nagoričino, see ibid., plates 86 (1,4), 87 (4). Stubblebine has demonstrated Duccio's use of Palaeologan sources for the *Maestà*; he did not, however, note that Duccio's expansion of the trial sequence also occurs in Late Byzantine narratives (see "Byzantine Sources," 176–85, and *Duccio*, vol. 1, 48–52).

45. At Staro Nagoričino, two of Peter's denials are shown taking place at an upper and lower level of the palace (Millet and Frolow, *Peinture*, vol. 3, plate 87 [1]). Duccio's two-tiered composition, depicting the Denial of Peter below the Trial before Annas, was likely inspired by something similar (Stubblebine, *Duccio*, vol. 2, fig. 104). One detail shared by both is the small windows, brightly lit on the outer edges and deeply shadowed inside, along the lower wall of each scene.

46. On the church of Christos, Veroia, see S. Pelekanides, *Kallierges*; D. Mouriki, "Stylistic Trends in Monumental Painting of Greece at the Beginning of the Fourteenth Century," in *L'art byzantin au debut du XIV siècle*, Symposium de Gračanica, 1973 (Belgrade, 1978), 55-84, especially 66–8; G. Gounaris, *The Church of Christ in Veria* (Thessaloniki, 1991). I am grateful to Sharon Gerstel for calling my attention to Gounaris's monograph.

47. In this respect, the Veroia fresco (Fig. 55) is not as close to Giotto as other late Byzantine examples; in addition to the Čučer fresco (Fig. 54), see those at Staro Nagoričino, Millet and Frolow, *Peinture*, vol. 3, plate 86 (1,

2); St. Nicholas Orphanos (Xyngopolous, *Toichographies*, plates 46–7; Hagios Athanasios, Kastoria (S. Pelekanides, *Kastoria* [Athens, 1985], 116, fig. 10).

48. *Byzantine Art and the West*, 227–8.

49. Smart, *Assisi Problem*, 99, suggests that Giotto may have derived aspects of his composition from ancient relief-sculpture, citing in particular a silver cup that depicts the submission of captives to Augustus (Smart, plate 21b). However, the Byzantine images cited here are closer to Giotto's fresco visually, thematically, and chronologically.

50. For a general discussion of this shift, see S. Grayzel, *The Church and the Jews in the XIIIth Century*, rev. ed. (New York, 1966), 9–21; for papal letters on the policy towards Jews, see 85–195; for policy promulgated by Church councils, 298–337. See also S. Simonsohn, *The Apostolic See and the Jews: A History* (Toronto, 1991), especially 17–21, for the language of Innocent III, who referred to Jews as "demons" (21). Simonsohn argues that the viciousness of this language is new. For K. Stow, however, "what was new in the thirteenth century was the scope of the papal Jewry policy" rather than the policy itself ("Hatred of the Jews or Love of the Church: Papal Policy toward the Jews in the Middle Ages," in *Antisemitism Through the Ages*, ed. S. Almog [Oxford, 1988], 77–8). On the worsening of antisemitism in the thirteenth century, see also Simonsohn, 47–58. J. Cohen, *The Friars and the Jews: The Evolution of Medieval Anti-Judaism* (Ithaca and London, 1982) and "The Jews as Killers of Christ in the Latin Tradition, from Augustine to the Friars," *Traditio* 39 (1983): 1–27, also argues cogently that the thirteenth century was a turning point in the history of medieval antisemitism. His thesis, that "the major changes in anti-Jewish polemic. . . came. . . in the thirteenth century with the inquisitorial and missionary efforts of Dominican and Franciscan friars" (*Friars and the Jews*, 32), is important for this study and will be considered at greater length later in this chapter (see pp. 89–90). Finally, see also R. Chazan, *Daggers of Faith: Thirteenth Century Christian Missionizing and Jewish Response* (Berkeley and Los Angeles, 1989), and the review by J. Cohen, *American Historical Review* 95 (1990): 1509–10.

51. See Chazan, *Daggers of Faith*, 35, for a dis-

cussion of the priorities of the Church in its push to convert non-believers. For the linking of Jews and Muslims, see B. Z. Kedar, "*De Iudeis et Sarracenis*: On the Categorization of Muslims in Medieval Canon Law," in his collected essays, *The Franks in the Levant, 11th to 14th Centuries* (Norfolk, 1993), 207–13; A. and C. Cuttler, *The Jew as Ally of the Muslim: Medieval Roots of Anti-Semitism* (Notre Dame, Ind., 1986). For the linking of Jews and heretics, see S. Lipton, "Jews, Heretics, and the Sign of the Cat in the *Bible moralisée*," *Word and Image* 8 (1992): 362–77; idem, "Jews in the Commentary Text and Illustrations of the Early Thirteenth-Century Bibles Moralisées" (Ph.D. diss., Yale Univ., 1991), especially chap. 5, "Jews and Heretics."

52. For the early history of the Inquisition and the friars, see Cohen, *Friars and the Jews*, 44–6; Simonsohn, *Apostolic See*, 343. Cohen notes the origins of the Inquisition in the late twelfth century, but observes that it "commenced with the establishment of permanent judicial machinery to fight heresy outside the diocesan hierarchy" in the early 1230s (45). For the early involvement of the Franciscans and their greater role under Innocent IV, see Moorman, *History*, 302–3. For a more thorough discussion, see several studies by Mariano d'Alatri: "L'inquisizione francescana nell'Italia centrale nel secolo XIII," *Collectanea francescana* 22 (1952): 225–50; idem, *L'inquisizione francescana nell'Italia centrale nel secolo XIII* (Rome, 1954); idem, *Eretici e inquisitori in Italia*, vol. 1: *Il duecento* (Rome, 1986), 102–12. His view is similar to Moorman's: He suggests that in Italy, Franciscans were "coinquisitori" with Dominicans initially, though the Dominican role was at first more important ("L'inquisizione francescana," 226–8; see also D. Corsi, "Aspetti dell'inquisizione fiorentina nel '200," in *Eretici e ribelli del XIII e XIV sec.: Saggi sullo spiritualismo francescano in Toscana* [Pistoia, 1974], ed. D. Maselli 65–92, especially 68–79).

53. On Jews as targets of the Inquisition, see S. Grayzel, "Popes, Jews, and Inquisition, from 'Sicut' to 'Turbato,'" in *Essays on the Occasion of the Seventieth Anniversary of the Dropsie Univ. (1909–1979)* (Philadelphia, 1979), 151–88; Cohen, *Friars and the Jews*, 44–50; Simonsohn, *Apostolic See*, 343–52; K.

Stow, *Alienated Minority: The Jews of Medieval Latin Europe* (Cambridge, Mass., and London, 1992), 259–67.

54. For Jews as protectors of heretics, and further discussion of the Inquisition's persecution of Jews, see S. W. Baron, *A Social and Religious History of the Jews*, 2nd. ed. (New York and London, 1965), vol. 9, 57–62; Cohen, *Friars and the Jews*, 48–51.

55. Cohen, *Friars and the Jews*, 62; for the texts of the papal letters, see Grayzel, *Church and the Jews*, 240–3. The letters were sent to France, England, Spain, and Portugal; the absence of similar documentation for Italy is curious. Grayzel implies that Italy participated as well, stating that the confiscation was to take place "in all lands of Christian Europe" (ibid., 30).

56. *Daggers of Faith*, 34. Chazan credits Yitzhak Baer, "The Disputations of R. Yehiel of Paris and of Nahmanides," [in Hebrew], *Tarbiz* 11 (1939–40): 188–206, with initially comparing this trial to the Inquisition (Chazan, 187, note 19). Similarly, see J. Cohen, "Scholarship and Tolerance in the Medieval Academy: The Study and Evaluation of Judaism in European Christendom," *American Historical Review* 91 (1986): 592–613, especially 606–9; he refers to the charge of "talmudic heresy" (609).

57. See Cohen, *Friars and the Jews*, 78–85. For the increase in hostility to the Jews in the 1230s and 1240s, see also Chazan, *Daggers of Faith*, 30–7. D. E. Timmer, "Biblical Exegesis and the Jewish Christian Controversy in the Early Twelfth Century," *Church History* 58 (1989): 309–21, argues that the twelfth century also saw much aggressiveness towards Jewish communities, though he acknowledges that "a threshold was crossed in the thirteenth century" (311).

58. Quoted by Grayzel, *Church and the Jews*, 253.

59. On this text, see Chazan, *Daggers of Faith*, 55–6.

60. For an overview of the Jewish communities in Tuscany, see Baron, *Social and Religious History*, vol. 10, 271–7. For the Jewish population in Umbria, see A. Toaff, *The Jews in Umbria*, vol. 1: *1245–1435* (Leiden and New York, 1993).

61. Baron, *Social and Religious History*, vol. 10, 248.

62. Ibid., vol. 10, 248.

63. See C. Dinora, "Aspetti dell'inquisizione fiorentina nel '200," in *Eretici e ribelli del XIII e XIV secolo: Saggi sullo spiritualismo francescano in Toscana*, ed. D. Maselli (Pistoia, 1974), 65–91, especially 77–9; H. C. Lea, *A History of the Inquisition of the Middle Ages* (New York, 1955), vol. 2, 210–13. Pisa, by contrast, evidently avoided the obsession with heretics that fanned the activities of the Inquisition; for the apparent absence of heretics in thirteenth-century Pisa, see A. Murray, "Archbishop and Mendicants in Thirteenth-Century Pisa," in *Stellung und Wirksamkeit der Bettelorden in der städtischen Gesellschaft*, ed. K. Elm (Berlin, 1981), 19–75, especially 43. As Murray notes, the archbishop, Federigo Visconti (1254–77), referred in one sermon to Pisa's "purity of faith" and in another claimed there was "no land as free of heretics as Pisa" (Murray, 43). The comparative lack of interest in the Trial of Christ in Pisa (of extant Pisan Passion cycles, the theme appears only in the Sta. Marta cross) may be related to the evident lack of concern there with threats to orthodoxy.

64. Goffen, *Spirituality*, 87, note 13; C. Davis, "Education in Dante's Florence," *Speculum* 40 (1965): 413–35; R. Davidsohn, *Forschungen zur Geschichte von Florenz*, vol. 4, part 3 (Berlin, 1908; reprint, 1969), 93. For the bull of 1254, see Mariano d'Alatri, "L'inquisizione francescana," 231–4.

65. "The Jews as Killers of Christ," 1. See also *Friars and the Jews*. At the 29th International Congress on Medieval Studies, May 1994, Western Michigan Univ., Kalamazoo, Mich., Larry J. Simon organized three sessions entitled "*The Friars and the Jews*, Twelve Years After," and Jeremy Cohen spoke at length in the final session. In his remarks, he moderated his earlier position slightly, noting that he might better have titled his study "Friars and Jews"; however, he still maintained that a new type of anti-Jewish polemic emerged in the thirteenth century, and that the friars bore some responsibility for it. Despite some quibbles, most speakers acknowledged Cohen's fundamental contribution; Simon's paper, for instance, was entitled: "Medieval Anti-Judaism and the Cohen Thesis: The Evolution of a Modern Classic." For other response to Cohen, see Note 68.

66. For the shift in attitude, see *Friars and the*

Jews, 2–3; for Bonaventure, 19. For the passage in the *Commentary* (20, 19), see *Opera Omnia*, vol. 7, 506.

67. Thus he notes (*Apostolic See*, 24), describing Clement IV's comments about the Jews' role in the Crucifixion, that it expressed "thirteenth-century Christian thought (chiefly of the friars), which added malice aforethought to Jewish responsibility for the death of Christ – and, therefore, implied a much higher degree of intentionality, culpability, and guilt than had been attributed to Jews until that time." He discusses antisemitism among the friars also on pp. 26–30. Chazan analyzes Cohen's study at some length, (Chazan, *Daggers of Faith*, 170–81) and questions his "assertion of a new theological view regarding Judaism and the Jews" (177); however, he agrees that the mendicants, "in their general activities and in their specific anti-Jewish programs, reflected this newly aggressive ambience and, at the same time, reinforced it considerably" (177).

68. Daniel, *Franciscan Concept*, 166.

69. Ibid., 58–9. On mission and conversion, see also Simonsohn, *Apostolic See*, 257–60.

70. See Habig, *Omnibus*, 43–4. The Rule of 1223 similarly includes a chapter (chap. 12) on "Saracens and other unbelievers"; Habig, 64.

71. Non-Christian "others" were closely linked in visual images as well. For instance, in Guido da Siena's image of Clare repulsing the Saracen invaders at Assisi, among the Saracens are men depicted with the covered heads and beards that identify the Jews in Passion narratives, including those by Guido (see Stubblebine, *Guido*, fig. 6, for the panel of Clare, and fig. 28 for Guido's Crucifixion); see also Mellinkoff, *Outcasts*, 59–69, for head shawls as a sign of Jewishness in Italian art.

72. Daniel, *Franciscan Concept*, 55–9. For Grosseteste's tract, designed to aid Christians in disputations with Jews, see Daniel, 58. It is possible that the cult of the Corpus Christi, promoted by Franciscans and others, also fanned antisemitism in Italy at this time. K. Biddick, "Genders, Bodies, Borders: Technologies of the Visible," *Speculum* 68 (1993): 389–418, especially 402–11, discusses the link between eucharistic devotion and outbreaks of antisemitism. For instance, in thirteenth-century Germany, shrines to the eucharist were erected at sites where Jews had been killed (Biddick, 402–3).

73. On Jewish-Christian disputation in the twelfth and thirteenth centuries, see D. Berger, "Mission to the Jews and Jewish-Christian Contacts in the Polemical Literature of the High Middle Ages," *American Historical Review* 91 (1986): 576–91, especially 587–91. For the expanding Franciscan control of the Inquisition in Florence during the 1240s, see the discussion in this chapter (pp. 88–9). A very unusual image in the St. Louis Art Museum, a Pisan panel, c. 1310–20, identified by the museum as "The Witness of John the Baptist," similarly seems to attest to the church's attempt to impose orthodoxy, especially on the Jews. It depicts a heated dispute between John and a group of non-believers, one of whom wears the Jewish prayer-shawl; John gestures emphatically toward a smaller Christ, as the shawled man points in the opposite direction. The provenance of the panel, a fragment of a larger work, is unknown; see N. W. Desloge and L. L. Meyer, *Italian Paintings and Sculpture, Bulletin of the Saint Louis Art Museum*, vol. 19, 1 (1988), 6–8. I am grateful to Judith Mann, Assistant Curator of Early European Art at the museum, for sending me a copy of the *Bulletin*.

74. Ragusa and Green, *Meditations*, 290.

75. Ibid., 291.

76. On the authorship of Pseudo-Bede's tract see Chapter 1, Note 65; for the text of Matins see *P.L.*, vol. 94, columns 563–64; Prime, 564–5; Terce, 565–6. The Meditation for Terce includes, in addition, the Trial before Herod, the Flagellation, the Crowning with Thorns, and the Way to Calvary.

77. *De perfectione vitae*; De Vinck, *Works*, vol. 1, 209-55; for the passage cited, see 241.

78. De Vinck, *Works*, vol. 1, 160. The language recalls the description of the Holy Apostles in Constantinople by Mesarites, c. 1200, in which the mob "comes forth murderously and wildly." See Chapter 2, Note 46. G. Dahan has cited numerous anti-Jewish passages occur in Bonaventure's writing (on the Passion, see especially 397–402) and observes that he was in Paris during one of the most virulent outbreaks of antisemitism, the burning of the Talmud in 1240 ("Saint Bonaventure et les Juifs," *Archivum Franciscanum Historicum* 77 [1984]: 369–405). He con-

cludes, however, that for Bonaventure, Jews remained "une entité abstraite" and that Bonaventure was not truly antisemitic (402–3).

79. Pseudo-Bonaventure's account simply states: "He is led, then, to Pilate, and those women who cannot draw near follow at a distance. At this time He was accused by them of many things, and Pilate sent Him to Herod" (Ragusa and Green, *Meditations*, 329). Next follows a description of the trial before Herod, Pilate's order of the flagellation, the scourging itself, the crowning with thorns, and the Ecce Homo. The final reference to Pilate's sentence concludes this section: "Then the whole multitude of Jews demands that He be crucified; and thus He is condemned by Pilate, the miserable judge" (ibid., 330).

80. Ibid., 326. Franciscan antisemitism escalated in the fourteenth and fifteenth centuries, as D. O. Hughes has described; see her "Distinguishing Signs: Ear-rings, Jews, and Franciscan Rhetoric in the Italian Renaissance City," *Past and Present* 112 (1986): 3–59.

81. Though the provenance of the Uffizi cross is unknown, the Conclusion will argue that it was probably a Franciscan commission.

82. Nor is medieval antisemitism unique to Italian painting. Michael Camille has incisively analyzed antisemitic images in French Gothic manuscripts; see chap. 4, "The Idols of the Jews," in *Gothic Idol*. See also the recent work of Sara Lipton: "Jews in the Commentary Text and Illustrations," and "Jews, Heretics, and the Sign of the Cat." A briefer mention of an antisemitic image is especially relevant: B. Jones, "A Reconsideration of the Cloisters Ivory Cross with the Caiaphas Plaque Restored to its Base," *Gesta* 30 (1991): 65–88, especially 82, associates the choice of Caiaphas rather than Pilate or Herod with contemporary hostility to Jews.

For a thorough study of antisemitic content in later images, see E. Zafran, "The Iconography of Antisemitism: A Study in the Representation of the Jews in the Visual Arts of Europe, 1400–1600" (Ph.D. diss., New York Univ., Institute of Fine Arts, 1973). The first chapter (6–28) provides a useful overview of medieval antisemitic images. I am grateful to Diane Wolfthal for calling my attention to this dissertation. W. C. Jordan, "The Last Tormentor of Christ: An Image of

the Jew in Ancient and Medieval Exegesis, Art and Drama," *The Jewish Quarterly Review* 78, nos. 1–2 (July–Oct., 1987): 21–47, discusses antisemitic imagery in the Crucifixion, especially in the figure of the sponge-bearer; I owe this reference to Sara Lipton. For antisemitism in Byzantine art, see, in addition to Kathleen Corrigan's study, I. Dujčev, "Traits de polémique dans la peinture murale de Zemen," *Zbornik za Likovne umetnosti* 8 (1972): 117–28.

83. De Vinck, *Works*, vol. 1, 157–8.

84. For the Rule of 1221, see Habig, *Omnibus*, 32–3; for the Rule of 1223, ibid, 58. Both Rules discuss the garb of friars and novices in chap. 2. The cord was considered the identifying attribute of the Order in the duecento; thus a record of 1277 describes female tertiaries in Florence as "ladies who live by the Church of Sta. Croce and who are garbed with the cord of the friars minor" (G. Holmes, *Florence, Rome and the Origins of the Renaissance* [Oxford, 1986], 61–2; Davidsohn, *Forschungen*, vol. 4, 78). As L. Bracaloni has shown, the knotted cord also appears on early *stemmi* of the order ("Lo stemma francescano nell'arte," *Studi francescani* 7 [1921]: 221–6, figs. 2–4).

85. "*Et cingulum*, funem utique, quia dicitur in Isaia [III, 24]: *Erit pro zona funiculus, et cingulum sacci*. Hoc cingulum funiculus est, quia sacci funibus cingi solent. Credo autem S. Franciscum istud cingulum elegisse, quia legitur in Matthaeo: Vinctum duxerunt eum, et tradiderunt eum Pontio Pilato" (*Expositio*, chap. II; *Opera Omnia*, vol. 14, 566). Bonaventure's reference to Isaiah 3:24 is noteworthy; the full passage, on stripping away worldly refinements, must have been read by Francis with keen interest. It refers not only to the use of a rope in place of a belt, but also to baldness instead of hair elegantly coiffed (suggesting the tonsure of the Franciscans; see also J. Fleming, *From Bonaventure to Bellini: An Essay in Franciscan Exegesis* [Princeton, n.d. (c. 1982)], 137–8) and a haircloth instead of a mantle. The passage in the Vulgate reads:

Et pro zona funiculus,
Et pro crispanti crine calvitium
Et pro fascia pectorali civicium

Another Franciscan text that refers to Isaiah 3:24 is the *Meditatio pauperis*: "Therefore [Francis] took for himself 'a rope instead of a

girdle,' 'baldness instead of coiffured hair,' and assumed 'a hair-shirt instead of clothing with decorated bands,' as is described in Isaiah 3:24. . . " (see Delorme, *Meditatio Pauperis*, 146–8; cited by A. Neff, "Wicked Children," 234.) See also the discussion in Chapter 6, Note 55.

86. Garrison compares several unusual details with two Franciscan works – the *Tree of Life* by Pacino in the Accademia and the *Vita Christi* manuscript in the Morgan Library by a close follower of Pacino ("Oxford," 343). Christ's bound hands would thus be additional evidence of the panel's connections with Franciscan imagery. Moreover, on the exterior of the left wing of the panel, formerly in Milan, is an image of the Stripping of Christ from the third quarter of the fourteenth century ("Oxford," fig. 4). As will be discussed in Chapter 6, this is a subject that appears most frequently in Franciscan commissions. The right wing of the panel ("Oxford," fig. 5) depicts the Madonna of Mercy sheltering supplicants under her cloak. The panel may therefore have been commissioned by a confraternity with Franciscan affiliations. The only saints depicted are Peter and Paul, and two unidentified female saints. As noted earlier (Chapter 1, Note 86), Gardner, "Altars, Altarpieces, and Art History," 17, observes that Peter and Paul are often found in mendicant altarpieces, because the orders were directly under papal authority.

87. In the Boston manuscript, Christ's hands are bound before him in two moments of the judicial procedure, when he appears before Annas (Sticca, "*Officium Passionis*," plate IX) and when he is led to Caiaphas (plate X); in other scenes, his hands are behind his back (before Caiaphas, plate XI; before Herod, plate XV.)

CHAPTER 4

1. These examples include three versions attributed to the San Gaggio Master: one on the altarpiece in Oxford, c. 1285–90 (Marques, *Peinture*, fig. 258); one on the right wing of a triptych depicting the Thebiad, in the collection of the Earl of Crawford and Balcarres, c. 1285 (ibid., figs. 262, 264); and the third on a panel of the 1290s, now in San Diego, Timken Museum of Art (Fig. 4). The fourth, a fragment of an altarpiece, is in the Harris collection; Garrison, *Index*, no. 673. All

show the influence of Cimabue, as does the Sta. Marta cross (on which see Note 8); it is possible that he painted a now-lost Passion cycle that included this scene.

2. For the *Supplicationes Variae* manuscript, see Neff, "New Interpretation," fig. 154, and Chapter 1, Note 49. For the fresco cycle from Sta. Maria degli Angeli, see Toscano, "Maestro delle Palazze," 3–23, figs. 1 and 2; the Mocking of Christ was detached and is now at S. Agata, Spoleto. For S. Antonio in Polesine, see Caselli, *Il monastero*, color plate 8. The imagery of several of the frescoes from Sta. Maria degli Angeli, a Clarissan foundation, is unusual. The cycle includes a Crucifixion with the cross as the Tree of Life, a dramatically gesturing Magdalen and the swooning Virgin (now in the collection of the Worcester Art Museum); a Last Judgment with the Virgin of Mercy (now in the Pitcairn Collection); and a Last Supper with a small image of Gethsemane inserted (also in Worcester). All of this seems distinctly Franciscan; the Crucifixion with the gesturing Magdalen and swooning Virgin, and the Virgin of Mercy, all appear in the Levant under western, and probably Franciscan, influence. See Derbes, "Siena and the Levant." The image of Gethsemane, curiously inserted into the Last Supper, looks much like the Stigmatization of Francis, which it is probably meant to evoke. For the association of the Stigmatization and the Agony in the Garden, see Gardner, "Louvre *Stigmatization*," 224.

3. Minor variations occur in the accounts of the evangelists. First, according to Luke, this episode takes place before rather than after Christ's appearance before the high priest. Second, Matthew does not mention the blindfold alluded to by Mark ("they covered His eyes") and specifically noted by Luke. Otherwise the descriptions of the synoptics are identical. John omits this incident altogether.

4. Only Matthew mentions the reed that served as Christ's scepter; aside from this detail, his text and Mark's are identical. John abbreviates this episode by leaving out some of the soldiers' actions. Luke does not discuss the episode at all, but does observe that Christ was mocked by Herod's troops (Luke 23:11).

5. As Sandberg-Vavalà observed, "I due principali episodi della Derisione vanno inestricabil-

mente confusi" (*Croce dipinta*, 245). Confusion between the two episodes also occurs in written accounts, such as the Benediktbeuren Passion Play of c. 1200: "Then they dress Christ in a purple vestment and crown of thorns. Then the Jews say, 'Hail, king.' Then, 'Prophesy, who is it who hit you?'" (quoted by K. Young, *Drama of the Medieval Church* [Oxford, 1933], vol. 1, 528). In addition to Sandberg-Vavalà's discussion of the Mocking (242–50, "Il processo di Cristo," passim), other accounts of the scene can be found in general iconographic sources. See Millet, *Recherches*, 606, 640; Schiller, *Iconography*, vol. 2, 58, 69–73; K. Laska, "Verspottung Jesu," *Lexikon der Christlichen Ikonographie* (1972); E. Lucchesi-Palli and R. Haussher, "Dornenkronung," *Lexikon der Christlichen Ikonographie* (1968).

6. Because of the state of the cross, its panel of the Mocking is not reproduced here; for a color photograph, see Torriti, *Pinacoteca Nazionale*, fig. 2. For further discussion of the cross, see Chapter 1, Note 56.

7. A different version appears, however, in Enrico di Tedice's S. Martino cross (Sandberg-Vavalà, *Croce dipinta*, fig. 209). Enrico clearly represents the Buffeting of Christ rather than the Crowning with Thorns. Christ, now shown in profile, walking from left to right, is blindfolded, and his tormentors, none of whom is specifically identified as a soldier, raise their arms to strike him. But if the moment differs from the Florentine versions, the mood is comparable. Christ again bows his head as if to shield himself from the blows; further, his hands are now bound, so that he cannot gesture in affirmation. Much the same sort of composition appears in Byzantine art, as in fully illustrated Gospel books such as Florence, Plut. VI. 623 and Paris 74; fol. 58r. and 160r. of the former (Velmans, *Tetraévangile*, fig. 118, 262) particularly resemble Enrico's version in the isocephalic composition and the stance of Christ, who is shown in both walking from left to right. This sort of image was introduced in the West as early as the mid-eleventh century, as in Ottonian manuscripts like the Golden Gospels of Henry III, fol. 82r.; Schiller, *Iconography*, vol. 2, fig. 239. Christ appears blindfolded, as in Enrico's composition, in an English Book of Hours of c. 1240 illuminated by W. de Brailes (London, British Library, Add. ms. 49999, fol. 11r.); see C. Donovan, *The de Brailes Hours: Shaping the Book of Hours in Thirteenth-Century Oxford* (Toronto and Buffalo, 1991), fig. 13, and Donovan, 24, for the date of the manuscript.

Christ also appears standing in two works from the end of the century: the *Supplicationes Variae* manuscript in Florence and in the fresco at S. Antonio in Polesine, Ferrara; for both, see Note 2.

8. See, for instance, the version in the Sta. Marta cross (Marques, *Peinture*, fig. 268). The fresco in Sta. Maria degli Angeli (cited in Note 2) is similar to Coppo's, but there Christ is not blindfolded. As noted (Note 7), Christ is at times shown standing, especially towards the end of the century. Like Coppo, the San Gaggio Master, in his altarpiece now in the Crawford collection (Marques, *Peinture*, fig. 264; see also Note 1), depicted Christ seated and blindfolded, but added the high priests to the right, as Duccio and Giotto would as well. In Giotto's fresco, the priests join Pilate. For Giotto, see J. Stubblebine, ed., *Giotto: The Arena Chapel Frescoes* (New York, 1969), fig. 44. Duccio includes both the Buffeting and the Crowning with Thorns, carefully distinguishing the two; see Stubblebine, *Duccio*, vol. 2, figs. 105, 108. In the first, Caiaphas presides to the right, and in the second, Pilate occupies the same position.

9. The infusion of such hieratic elements into Middle Byzantine iconography has been discussed at length by Weitzmann, who relates the phenomenon to the popularity of the lectionary; Weitzmann specifically stresses the impact of a lectionary cycle on Paris 74. See his "Narrative and Liturgical," 247–70, and "Byzantine Miniature and Icon Painting," 289–313.

10. For instance, in the Sienese panel, the S. Angelo fresco and Paris 74, two or more men kneel before Christ; in the S. Sepolcro cross, a single kneeling figure appears. In none of the three does Christ raise his left hand, as he does in the S. Sepolcro cross. For other examples of the scene in twelfth-century Italy, see the chart in Sandberg-Vavalà, *Croce dipinta*, 428–9.

11. Zillis, in the Grisons, was a German territory in the twelfth century; see E. Murbach, *The Painted Romanesque Ceiling of St. Martin in*

Zillis (New York, 1967), 5. Murbach, 34, suggests a date in the 1160s. For other German examples in which the crowning is shown in progress, see Schiller, *Iconography*, vol. 2, figs. 241, 243–4.

12. Aachen, Cathedral Treasury. Similarly, see the slightly later Gospel book from St. Peter, Salzburg, now in the Pierpont Morgan Library (Schiller, *Iconography*, vol. 2, fig. 241). Both images are discussed by H. Mayr-Harting, *Ottonian Book Illumination* (London and New York, 1991), vol. 1, 109–11; for the Gospel book from Salzburg, see his fig. 64.

13. For instance, the staffs held by the mob recur in the Golden Gospels of Henry III (Schiller, *Iconography*, vol. 2, fig. 239); the hats – variations of *Judenhut* – worn by the mockers in a number of manuscripts, such as an early thirteenth-century psalter in Donaueschingen (see O. Homburger, "Über zwei deutsche Bilderhandschriften des 13. Jahrhunderts," *Festschrift für Erich Meyer zum sechzigsten Geburtstag* [Hamburg, 1959], 75–84, fig. 10) and two mid-thirteenth century examples (a Franconian miniature [Schiller, vol. 2, fig. 244] and a psalter from the Upper Rhine now in Besançon [ibid., fig. 245]); and the plaited appearance of the crown of thorns in a late twelfth-century Rhenish manuscript, the Prayer Book of Hildegard of Bingen (ibid., fig. 243). For *Judenhut* as worn by Christ's persecutors, see Mellinkoff, *Outcasts*, vol. 1, 65–8; see also her comments on 91–4.

14. D. Herlihy, *Pisa in the Early Renaissance* (New Haven, 1958), 32. Stylistic connections between the S. Sepolcro cross and German manuscripts were proposed sixty years ago by W. Arslan, "Su alcuni croci pisani," *Rivista d'arte* 18 (1936): 215–30; Boskovits, *Origins*, 35–9, recently linked the cross with miniatures from the Rhineland and Salzburg, among others. Knut Berg raised the possibility of German artists at work in Pisa in connection with a Pisan evangelary of the 1160s (*Studies in Twelfth Century Tuscan Illumination* [Oslo, 1968]).

15. Besides the works of Giotto and Duccio cited above (Note 8), trecento examples include Barna da Siena's fresco in San Gimignano (Schiller, *Iconography*, vol. 2, fig. 249); in the quattrocento, see Fra Angelico's fresco in San Marco (Schiller, vol. 2, fig. 250). See also the chart compiled by Sandberg-Vavalà, *Croce dipinta*, 428–37.

16. For a similar twelfth-century example, Vatican, gr. 1927, fol. 57r., see De Wald, *Septuagint*, vol. 3, part 1. For the late twelfth-century Gelat Gospel book (Tbilisi, Institute of Manuscripts; fol. 163v.), see V. Lasareff, *Storia della pittura bizantina* (Turin, 1967), 123, with bibliography, and a forthcoming study by Jean-Guy Violette. For additional late Byzantine examples, see Čučer, St. Nikita: Hamann-MacLean and Hallensleben, *Monumentalmalerei*, vol. 1, fig. 223); Curtea de Arges, St. Nicholas: Tafrali, *Monuments byzantins*, vol. 2, plate LXXVIII (1).

17. Christ is shown seated in the Mocking in a manuscript from Armenian Cilicia of 1262 (Baltimore, Walters Gallery, ms. 539, fol. 195r.; S. Der Nersessian, *Armenian Manuscripts* [Baltimore, 1973], plate 67; idem, *Miniature Painting in the Armenian Kingdom of Cilicia from the Twelfth to the Fourteenth Century*, with introduction by A. W. Carr [Washington, D.C., 1993], vol. 2, fig. 277), and his face is covered with a veil in a Gospel book of the same region and approximate date (Washington, D.C., Freer Gallery, ms. 32, 18, p. 516; Der Nersessian, *Miniature Painting*, vol. 2, fig. 268). But Cilicia during the thirteenth century was in constant contact with the West, specifically with Franks from the Crusader States just to the south. Der Nersessian noted that the Walters image was stylistically related to western manuscripts and stated that there was no doubt about "[its] ultimate, Western source" (vol. 1, 73). For a thorough discussion of Armenian interaction with the West and its consequences for Cilician illumination, see H. Evans, "Manuscript Illumination"; she has stressed the likelihood that much of the western imagery in Cilicia arrived via the Franciscans. For this manuscript, see Evans, 107–20; on this image specifically, see Evans, 114.

18. Schiller, one of the few scholars who examines the question at all, simply states that "it is typical of the period to bring the image of the exalted Christ, the Majestas Domini, into scenes of the Passion" (*Iconography*, vol. 2, 71). Pickering, *Literature and Art*, 111, notes that Jeremiah sat alone (Lamentations 3:28) – a passage adopted by the liturgy of Holy Week and linked with the Mocking of Christ.

19. Fig. 63: Job mocked by his friends, *Catena in*

Job, Rome, Vatican Museum, gr. 749, fol. 179v. The manuscript is written in Greek but was probably illustrated, in the ninth century, by Romans; see Weitzmann, *Die byzantinische Buchmalerei des X. und XI. Jahrhunderts* (Berlin, 1935), 77-80; Garrison, "Contributions to the History of Twelfth-Century Umbro-Roman Painting VIII. Supplement, IV. Precursors of the Revival," *Studies*, vol. 4, no. 2, 179–98; L. Ayres, "An Italian Romanesque Manuscript of Gregory the Great's *Moralia in Job*," in *Florilegium in Honorem Carl Nordenfalk Octogenarii Contextum* (Stockholm, 1987), 33–46.

Fig. 64: Job mocked by his wife, *Moralia in Job*, Bamberg, Staatsbibliothek, ms. bibl. 41, fol. 29. The Bamberg Moralia is dated 1090–1100 by Garrison, "Precursors," 182. See also the discussion in Ayres, 33–46. The copyist, whose debt to Ottonian sources Garrison points out ("Precursors," 183), has omitted the dung heap, so that Job hovers in defiance of gravity; otherwise the visual link between this scene and that in Vat. gr. 749, and the link of both works with the Aachen Mocking, is fairly clear.

For a similar example, see Job mocked by his friends, Pantheon Bible, Rome, Vatican Museum, lat. 12958, fol. 257. Garrison assigns this manuscript to a Roman scriptorium and dates it between 1125 and 1140 ("Contributions to the History of Twelfth-Century Umbro-Roman Painting VIII. The Italian Byzantine-Romanesque Fusion in the Second Quarter of the Twelfth Century," *Studies*, vol. 4, no. 2, 118); he suggests a "special connection" between the Bible and Vat. gr. 749 (ibid., 130).

In connection with the new type, it should be noted that one text does specify that Christ was seated for part of his ordeal: According to the apocryphal Gospel of Peter, "they put on him a purple robe and made him sit on the seat of judgement" (James, *Apocryphal New Testament*, 91). This text would not, however, explain the rubble heap on which the Aachen Christ sits. Most later medieval texts do not describe Christ as seated (Bernard of Clairveau, *P. L.*, vol. 184, column 746; Peter Comestor, *P. L.*, vol. 198, columns 1628-9; Pseudo-Anselm, *P. L.*, vol. 154, columns 279-80; Pseudo-Bonaventura, Ragusa and Green, *Meditations*, 329); see, however, the discussion of Pseudo-Bede

below, p. 108.

20. On the *Moralia*, see L. L. Besserman, *The Legend of Job in the Middle Ages* (Cambridge, Mass., and London, 1979), 51–6. On the association between the imagery of Job and the Passion of Christ, see G. von der Osten, "Job and Christ," *Journal of the Warburg and Courtauld Institutes* 16 (1953): 153-8; he cites many patristic sources to establish the textual tradition for the parallel. Réau (*Iconographie*, vol. 2, part 2, 315) and Schiller (*Iconography*, vol. 2, 68) relate the Mocking of Job to the Mocking of Christ. See also an early thirteenth-century moralized Bible in Oxford, Bodleian Library, 270b., fol. 208r. (A. de Laborde, *La Bible moralisée*, vol. 2 [Paris, 1912], plate 208), in which the medallion depicting the Mocking of Christ is placed between two scenes of Job on the dunghill, and a fourteenth-century altarpiece published by Schiller (vol. 2, fig. 251), which similarly juxtaposes the two scenes.

21. See, for instance, Oxford, Bodleian 270b., fols. 10r., 119v.; Laborde, *Bible moralisée*, vol. 1, plates 10, 119; Paris, Bibliothèque Nationale, lat. 11560, fols. 171v., 240r. – Laborde, vol. 2, plates 359, 428; London, British Library, Harley 1526–27, fols. 55v., 58r. – Laborde, vol. 3, plates 526, 529.

22. For the St. Albans Psalter (perhaps better termed the Psalter of Christina of Markyate; see M. Caviness, "Anchoress, Abbess and Queen: Donors and Patrons or Intercessors and Matrons," in *The Cultural Patronage of Medieval Women* [Athens, Ga., forthcoming]), see O. Pächt, C. R. Dodwell, and F. Wormald, *The St. Albans Psalter* [London, 1960], plate 27b; Pächt, 90–1, suggests that the motif originated with the Albani Master. Among other examples, see the Bury Bible (Cambridge, Pembroke College, ms. 120, fol. 3v.), c. 1130, and the leaf from Canterbury (Victoria and Albert 661), c. 1140 (on the Bury Bible, see E. Parker, "A Twelfth-Century Cycle of New Testament Drawings from Bury St. Edmunds Abbey," *Proceedings of the Suffolk Institute of Archaeology* 31 [1969]: 263–302, plate XXXVI; on the Canterbury leaf, see C. M. Kauffmann, *Romanesque Manuscripts 1066–1190, A Survey of Manuscripts Illuminated in the British Isles*, vol. 3 [London, 1975], cat. 66, figs. 179–180). The blindfold remains common in

England; in the second half of the thirteenth century, it occurs repeatedly (e.g., in the Salvin Hours, British Library, Add. 48985, fol. 35r.; P. Brieger, *English Art 1216–1307* [Oxford, 1957], 221, plate 87; British Library, Add. 50000; Brieger, 180–1).

23. For this manuscript (New York, Pierpont Morgan Library, ms. 101), see G. Haseloff, *Die Psalterillustration im 13. Jahrhundert* (Kiel, 1938), 58, 116–17; R. Branner, *Manuscript Painting in Paris during the Reign of St. Louis: A Study of Styles* (Berkeley and Los Angeles, 1977), 126, 129. Branner dates this psalter c. 1255–60 – a bit later than the Uffizi cross of c. 1240–45 – but states that the group that produced it developed first in the 1230s and 1240s (118). The blindfold appears in other French psalters at about the same time, as in a miniature in Liège, Bibliothèque de l'Université, ms. 431, fol. 175v. (Haseloff, 70, 122–3).

24. For the stained-glass window, see M. Aubert et al., *Corpus vitrearum medii aevi, France*, vol. 1: *Les vitraux de Notre-Dame et de la Sainte-Chapelle de Paris* (Paris, 1959), plate 52. At the Ste.-Chapelle, the window appears in a prominent position, directly above the altar; its prominence is not surprising, since there Christ wears the crown of thorns, the relic that the chapel was built to house.

25. For English examples, see those cited in Note 22. Thirteenth-century German painting similarly represents Christ with head erect; two works published by Schiller (*Iconography*, vol. 2, figs. 244–5) are typical.

26. The anonymous author of the *Meditationes* may have had some such image in mind when he described Christ's ordeal: "See how, with bent neck, He receives the sharpest blows . . . " (Ragusa and Green, *Meditations*, 329).

27. One important link was provided by the Via Francigena, the main route between France and Rome, which passed directly through Tuscany; see Herlihy, *Pisa*, 99.

28. For the Franciscan school in Paris, see Moorman, *History*, 124–33.

29. For the missal, see *Tesoro della Basilica*, 63–8; for Louis's other gifts, see *Tesoro*, 16. For a stylistic analysis of the missal see Branner, *Manuscript Painting*, 122–6; he places both it and the Beauvais psalter in the "Ste. Chapelle group." A number of other French objects – ivories, reliquaries, and manuscripts

– are also preserved at the Museo del Tesoro, S. Francesco. Louis's patronage of the Franciscans began as early as the 1230s; see Moorman, *History*, 160. See also L. K. Little, "Saint Louis' Involvement with the Friars," *Church History* 33 (1964): 125–48. Louis is often said to have become a Franciscan tertiary before his death, but Little disputes this claim (146). But his deep sympathy with the Order, and generous support of it, is beyond question.

30. Stubblebine, "Byzantine Influence," 100.

31. Examples include a Mocking in an icon at Mt. Sinai (Weitzmann, *Studies in Classical and Byzantine Manuscript Illumination*, fig. 300) and the fresco at Prilep (Fig. 61).

32. The motif, taken up by Coppo and the Sta. Marta Master, recurs fairly frequently during the trecento. As in the duecento, it was most common in Florence; for examples, see a panel by the Master of S. Martino alla Palma from the Barlow collection, Manchester (Offner, *A Corpus of Florentine Painting*, sect. III, vol. 5 [New York, 1947], 21–2, plate IV-a); a tabernacle in Tucson, Univ. of Arizona, by Pacino di Bonaguido (Offner, *Corpus*, sect. III, vol. 6 [New York, 1956], 149–52, plate XLIII–b); and a second panel by Pacino, the Chiarito tabernacle, now at the Getty Museum, Malibu; Offner, *Corpus*, sect. III, vol. 6, 141–8, plate XLII-b. (For the first two, see also Note 58 below.) It is at times seen in quattrocento painting as well, as in a panel by the school of Fra Angelico in the Accademia. In each case, the horn-blower is the only musician present.

33. For the frescoes at Čucer and Curtea, see Note 16.

34. See, for instance, Psalm 150:3-4: "Praise him with sound of trumpet: praise him with psaltery and harp. Praise him with timbrel and choir: praise him with strings and organs. . . ."

35. These dancing children do not appear only with the musicians; they occur in several earlier works as well, before the introduction of the musical ensemble. At times the dancers are clearly meant to be children; at times they appear as adolescents or young men. Examples can be found in the Florence Gospel book (see Note 7) and the icon cited in Note 31. On mocking children in another context, see Neff, "Wicked Children."

36. See, for instance, Pseudo-Origen's commen-

tary on Job, with a lengthy comparison between the suffering of Job and the Passion of Christ (Migne, *P.G.*, vol. 17, columns 374–5), or Didymus of Alexandria (*P.G.*, vol. 39, column 1122). An apocryphal text, the *Testamentum in Job*, specifically associates Job with music; see Kathi Meyer, "St. Job as a Patron of Music," *Art Bulletin* 36 (1954): 21–31; Pickering, *Literature and Art*, 344–5. Meyer cites a Byzantine *Catena in Job*, Vat. gr. 1231, fol. 285v., of the thirteenth or fourteenth century (22, note 19), in which Job is beset by children dancing and playing musical instruments. Musicians appear in the Mocking of both Job and Christ in northern Europe as well; this imagery is rare before the fifteenth century. For examples in the Mocking of Job, see Meyer, figs. 8, 10, 15; in the Mocking of Christ, Schiller, *Iconography*, vol. 2, figs. 195, 253. For a discussion of the horn-blower in late medieval Passion images in northern Europe, see Marrow, *Passion Iconography*, 153–61.

Another interpretation of the musicians and dancers mocking Christ at Staro Nagoričino is proposed by S. Radojčić, who argues that the imagery is to be connected with Byzantine religious drama; he also links the image with Byzantine court ceremonial, in which the standing emperor was entertained by musicians and dancers ("Ruganje Hristu na fresci u Starom Nagoričinu," in his collected essays, *Uzori I dela starih srpskih umetnika* [Belgrade, 1975], 155–79). I am grateful to Smiljka Gabelić for calling my attention to the article and for providing me with an English summary.

37. At Studenica, in a fresco of the sixteenth or seventeenth century (Hamann-MacLean and Hallensleben, *Monumentalmalerei*, 20–2; plate 76), a single horn-player is depicted. The fact that the motif is fully developed only in the East – I know no western example that includes more than two musicians – suggests a Byzantine origin for the concept rather than the assimilation of western ideas in the Macedonian and Serbian frescoes. For a more extensive discussion of cultural exchange between East and West in the thirteenth and fourteenth centuries, see Chapter 1, Note 99, and Derbes, "Images East and West."

38. The Pisan painter of the Sta. Marta cross (see Note 8) seems to have worked from still another Byzantine version, one close to the fresco at Čučer (see Note 16). Compare the smaller crowds, the high corniced wall, and the upraised arm of the man on the left in each scene.

39. Daniel Weiss has described a very similar process in the construction of new images in crusader manuscripts in the mid-thirteenth century. Writing about the Arsenal Bible, he notes that the illuminator "did not merely copy models. . . [but] actively modified and adapted his diverse sources into a new conception suited to the religious, political, and social circumstances of crusader Palestine" ("Pictorial Language," 46).

40. Habig, *Omnibus*, 141.

41. Ibid., 145.

42. The Latin text reads: "Tunc mediteraberis et in spiritu videbis, qualiter Dominus tuus sederit inter inimicos, quia derelictus a suis discipulis et amicis. Ecce credo quod dices: O Domine Jesu, quomodo sedes ita et tam despectus, et tam inhonoratus?" (*P.L.*, vol. 94, column 563).

43. De Vinck, *Works*, vol. 1, 196–7. Other passages in this text include these: "He is made a spectacle and a shame to the world. . . and to me, as a portent. . . to many, and a laughingstock among the peoples" [citing 1 Cor. 4:9 and Ps. 70:7] (165); "Behold how many times you have been struck and humiliated. . . ." (166); "mocked and spat upon, scourged and crucified" (166). See also 158–60 for a lengthy discussion of the Mocking and the Crowning with Thorns.

44. In the *Lignum vitae*, Christ is described as "covered in derision"; he "suffered blows as if he were a lowly slave." (both: De Vinck, *Works*, vol. 1, 120); the mob was "inflicting insults innumerable" (121); "the savage soldiers were not content to crucify the Savior; first they must humiliate Him to the soul with the shame of mockery" (122). In *De perfectione vitae*: "Consider first, honorable handmaid of God, that the death of your Spouse Jesus Christ was UTTERLY DEGRADING" (240). Bonaventure develops this line of thought at some length (240–1), concluding that "He humbled himself, becoming obedient to death, even death on a cross, 'since this is most debasing,' as the gloss explains." Elsewhere, he refers to Christ's "sorrow, abuse, spittle, blows, mockeries. . . " (243).

45. T. Reist, *Saint Bonaventure as a Biblical Commentator: A Translation and Analysis of his Commentary on Luke, XVIII, 34–XIX, 42* (Lanham, Md., and London, 1985), 95–6. Bonaventure's gloss on Luke 55:32 reads: "'And will be mocked,' as a fool whose figure is found in Job: 'Now they make sport of me, men who are younger than I, whose fathers I would have disdained to set with the dogs, etc.' (Job 30, 1)... 'And he will be spit upon,' as one who is impure. . . .'They keep aloof from me; they do not hesitate to spit at the sight of me' (Job 31:10). . . ." Bonaventure cites the Mocking of Job in still another context; in the *Apologia pauperum* he compares the Franciscan order to Job, and the attacks of the secular clergy to the taunts of Job's friends (De Vinck, *Works*, vol. 4, 238).

46. Ragusa and Green, *Meditations*, 326–31, passim.

47. See, for instance, Thomas of Celano, *Vita prima*, in Habig, *Omnibus*, 238: "They began to revile him miserably. Shouting that he was mad and demented, they threw the mud of the street and stones at him. . ."; they dragged him "shamelessly and disgracefully" to his home, and there he was taunted and mocked by his father (239); Francis and his disciples were "many times. . .insulted and ridiculed, stripped naked, beaten, bound, imprisoned. . . ," and Francis was "insulted and beaten" by the soldiers of the sultan (277); Bonaventure, in the *Legenda maior*, repeats all these episodes and elaborates, adding that Francis was "overjoyed when he was insulted. He liked to have people scorn him. . .and hated to be praised. . . . When people praised the height of his sanctity, he used to command one of the friars to do the opposite and heap insults upon him" (ibid., 671).

48. See Neff, "Wicked Children," 215–44.

49. For the sermon, see Doyle, *Disciple and Master*, 107–9; for the other references, see Habig, *Omnibus*, 738; 837.

50. Doyle, *Disciple and Master*, 149.

51. The first quotation is from *De Perfectione evangelica* (1256); the second from a sermon of 1255; see Doyle, *Disciple and Master*, 74–5.

52. Sermon 4, ibid, 111.

53. Sermons 1–4; ibid.

54. The close stylistic ties between the Bardi dossal and the Uffizi cross have long been recognized; see, for instance, Garrison, *Index*, 12, 18. Goffen, *Spirituality*, 30, notes that the cross is "considered close to the master [of the Bardi dossal], if not actually by him." See also the recent comments of Boskovits, *Origins*, 112–16 and 472–507; Boskovits attributes the panel to the young Coppo di Marcovaldo, who was, he believes, trained in the workshop of the painter of the Uffizi cross (116).

55. Celano, *Vita prima*, chap. I, 52, in Habig, *Omnibus*, 272–3; *Legenda maior*, chap. VI, 2, *Omnibus*, 672. For Celano as the source of the image, see Stein, "Dating the Bardi St. Francis," 285; Goffen, *Spirituality*, 41. However, Cook, in his review of Goffen's *Spirituality in Conflict* in the *American Historical Review*, 1179, points out a number of discrepancies between Celano's narrative and the Bardi scenes and finds the argument that Celano is the source of the dossal "not convincing." Stein observes certain discrepancies as well; others will be noted (pp. 109–10).

56. This image is from a manuscript from the second half of the twelfth century in Florence, Biblioteca Laurenziana, Plut. VII, dext. 11; Tartuferi, *Pittura*, fig. 8, identifies it as Florentine; Boskovits, *Origins*, 42, fig. 22, as possibly Roman.

57. For Celano, see Habig, *Omnibus*, 273–4; for Bonaventure, ibid., 672.

58. The Mocking in the Florence manuscript, cited in Note 2, includes an unusual motif: a rope tied around Christ's neck. I will discuss the probable Franciscan origins of this detail in the next chapter (pp. 132–5). For the *Officium Passionis*, see Sticca, "Officium Passionis," plate VIII. For the altarpiece in Bologna, see M. Gregori and R. Longhi, "La pittura umbra della prima metà del Trecento, lezioni di Roberto Longhi nell'anno accademico 1953–1954," *Paragone* no. 281 (1973): 3–44. Other trecento examples of the Mocking for Franciscan patrons appear in a tabernacle in Tucson attributed to Pacino di Bonaguida (here the Franciscan origins are indicated by a Clarissan nun who kneels at the foot of the cross in the same polyptych; see Offner, *Corpus*, sect. III, vol. 6, plate XLIII-b); Pacino's *Tree of Life* in the Accademia, from the Convento delle Clarisse di Monticelli (Offner, *Corpus*, sect. III, vol. 2, part 1, plate II-13b); and a panel by the Mas-

ter of San Martino alla Palma, formerly in Manchester, Barlow collection; according to Boskovits, the panel formed part of a Clarissan diptych (Boskovits, *Gemäldegalerie, Berlin, Katalog. Frühe Italiensiche Malerei* [Berlin, 1988], cat. 50, 128–31, fig. 191). It appears as well in the Passion cycle at Sta. Maria Donnaregina, Naples, a Clarissan foundation (Carelli and Casiello, *Sta. Maria Donnaregina*, fig. 47).

59. De Vinck, *Works*, vol. 1, 121.

60. Ibid., 122–3.

61. For a discussion of the image on this cross, see Note 7.

CHAPTER 5

1. The mid-duecento crosses include the cross in the Uffizi, no. 434; Enrico's S. Martino cross; the Castellare cross; the Castelfiorentino cross; a Tuscan cross from the Tolomei collection (Garrison, *Index*, no. 517); and the Sta. Bona cross, now in Cleveland. We will discuss the first three in this chapter; for the Castelfiorentino cross, now in Volterra, Museo dell'Opera del Duomo, see Garrison, *Index*, no. 529, and for the cross in Cleveland, see Stubblebine, "A Crucifix for Saint Bona," 160–5. Other mid-duecento examples of the scene appear on the Castellare Master's panel in the Bargello, also to be discussed in this chapter (Fig. 2), and the Magdalen Master's triptych in the Metropolitan Museum (Garrison, *Index*, no. 282).

Coppo substitutes the Ascent of the Cross, taken from a Byzantine image, the Preparation for the Crucifixion, for the Way to Calvary. A similar substitution occurs in the Passion cycle at Monreale: There the Preparation for the Crucifixion, compositionally very close to Coppo's scene, replaces the Way to Calvary. We will discuss Coppo's transformation of this Byzantine image in the next chapter. The substitution of the Preparation for the Crucifixion (or more specifically, the Stripping of Christ) for the Way to Calvary also takes place in the fresco cycle by the St. Francis Master in S. Francesco, Assisi (see Chapter 6).

2. These include the panels by the San Gaggio Master in Oxford (Marques, *Peinture*, fig. 258) and in San Diego (Fig. 4), and the panel formerly in the Harris collection, London (Garrison, *Index*, no. 673), which has also been ascribed to a painter close to the San Gaggio Master (Tartuferi, *Pittura*, fig. 216).

3. For the S. Frediano cross, see Carli, *Pittura*, 19–21, fig. 1; for the twelfth-century cross in the Uffizi, no. 432, see Chapter 1, Note 5.

4. For brief accounts of the scene, see Millet, *Recherches*, 362–79; Sandberg-Vavalà, *Croce dipinta*, 266–73; Colwell and Willoughby, *Four Gospels*, 344–6; Réau, *Iconographie*, vol. 2, part 2, 463–4; Schiller, *Iconography*, vol. 2, 78–82; H. Laag and G. Jaszai "Kreuztragung Jesu," *Lexikon der Christlichen Ikonographie* (1970). For fuller studies, consult U. Ulbert-Schede, *Das Andachtsbild der kreuztragenden Christus in der deutschen Kunst* (Munich, 1968), 5–40; and B. Wilk, *Die Darstellung der Kreuztragung Christi und verwandter Szenen bis zum 1300* (Tubingen, 1969). As Wilk has observed (99), the frequency of the type in the East probably reflects the fact that three of the four Evangelists record that Simon carried the cross. Of the handful of Middle Byzantine examples in which Christ himself carries the cross, most, like Paris 74, fol. 206v., specifically illustrate the text of St. John. A similar situation developed in the iconography of the Betrayal: There, too, the text of John (who describe the arresting soldiers falling prostrate before Christ) differs considerably from that of the synoptics, and this dissenting account was depicted only rarely in East and West.

5. The Index of Christian Art lists fifteen northern European examples of the scene which date from c. 500 to c. 1095. Twelve represent Simon as cross-bearer, two represent both Simon and Christ carrying the cross, and only one represents Christ alone.

6. Sandberg-Vavalà, *Croce dipinta*, refers to "[il] tipo in cui Cristo stesso porta la croce, tipo preferito. . .nell'arte occidentale in tutte le epoche" (267); Pächt states that "Christ carrying the cross Himself. . . is, from an early date, a characteristic of the Western tradition" (*St. Albans*, 92); Réau, too, associates the type with the West, without distinguishing between earlier and later medieval representations (*Iconographie*, vol. 2, part 2, 464). The early predominance of the first type is recognized by Ulbert-Schede (*Andachtsbild*, 12) and Schiller (*Iconography*, vol. 2, 80); Wilk (*Darstellung*) documents it at some length. In fact, revised dating of some of the monuments she cites makes her argument even stronger. For instance, she dates two

works in which Christ carries the cross earlier than subsequent scholars do: The Gospel book of Matilda, fol. 101r., is now thought to have been executed c. 1100 (Garrison, "Lucchese Passionary," 191), and not earlier in the eleventh century (Wilk, cat. no. 125); the fresco at S. Urbano alla Caffarella, also c. 1100 instead of 1011, as the repainted inscription states (Garrison, "Pictorial Histories XII: A Gradual of S. Stefano, Bologna," *Studies*, vol. 4, 107; Wilk, cat. no. 166). Because of her early dating, Wilk considers both works aberrations, yet both in fact corroborate her statement that the new type is a phenomenon of the twelfth century (191).

7. For the Cimitile fresco, see Belting, *Cimitile*, fig. 4; for S. Angelo, see Schiller, *Iconography*, vol. 2, fig. 210. For other examples, see Wilk, *Darstellung*, table 4, 270.

8. The motif actually goes back to the fifth century; a relief on the doors of Sta. Sabina, Rome, depicts Christ with hands bound (Schiller, *Iconography*, vol. 2, fig. 281). Exceptions occur in the rare Byzantine monuments in which Christ carries the cross, and in Cappadocia, where he is led by the neck (on this point, see below, pp. 124–5). Paris 74 is unusual in that Christ's hands are tied behind his back; they are far more commonly tied in front.

9. The manuscript is now in New York, Pierpont Morgan Library, ms. 781, fol. 178v.; see G. Swarzenski, *Die Salzburger Malerei* (Leipzig, 1908), vol. 2, fig. 55.

10. See, for instance, the Aachen antependium, Schiller, *Iconography*, vol. 2, fig. 282.

11. Garrison has suggested that Gullielmus was familiar with Ottonian painting ("Lucchese Passionary," 117), and that from these and from Montecassino came his Byzantine motifs (113).

12. The motif does appear in the Byzantine sphere during the fourteenth century; for instance, the *Arma* appear at Gračanica (O. Bihalji-Merin, *Fresken und Ikonen: Mittelalterliche Kunst in Serbien und Makedonien* [Munich, 1958], plate 5b) and Lesnovo (G. Millet and T. Velmans, *La peinture du Moyen Age en Yougoslavie*, vol. 4 [Paris, 1969], plate 15 [33]). But intrusions from western iconography were not unknown in the Balkans at this time. See O. Demus, "The Style of the Kariye Djami and its Place in the Development of Paleologan Art," in *The Kariye Djami*, vol. 4, ed. P. Underwood (Princeton, 1975), 136. See also the discussion in Chapter 1, pp. 26–7. The fact that the nails in both frescoes are carried in a basket suggests possible reliance on an Italian model; according to Wilk (*Darstellung*, 181), this detail occurs only in Italy. At the church of Zemen, in Bulgaria, is an extremely rare scene, the Preparation of the Nails of the Cross. On this scene, see Dujčev, "Traits de polémique," 119–27, fig. 2; he dates the frescoes c. 1340–60 (121) and notes references to the legend of the nails in French, English, and German texts c. 1300. I am grateful to Smiljka Gabelić for her help with the fresco at Zemen.

13. On the S. Zeno panel, see G. H. Crichton, *Romanesque Sculpture in Italy* (London, 1954), plate 20-a, 34–6. For the relief at Le Puy, also executed around 1100, see W. Cahn, *The Romanesque Wooden Doors of Auvergne* (New York, 1974), fig. 24.

14. Besides the Verona relief, the Sarzana cross and Uffizi no. 432, the *Arma Christi* appear only rarely in Italian works until c. 1240. Examples include a relief from the Pontile of Modena (W. Stoddard, *The Facade of Saint-Gilles-du-Gard* [Middletown, Conn., 1973], fig. 231), which is, further, said to derive from a French source, the relief at St.-Gilles-du-Gard (Stoddard, fig. 230, 197), and a relief at Monte S. Angelo, Foggia (A. Kinsley Porter, *Romanesque Sculpture of the Pilgrimage Roads* [Boston, 1923], fig. 198). Most other twelfth- and thirteenth-century examples of the motif listed in the Index of Christian Art are French.

15. On the *Arma Christi* and the cult of relics, see Schiller, *Iconography*, vol. 2, 169–90; R. Berliner, "Arma Christi," *Münchner Jahrbuch der bildenden Kunst* 6 (1955): 35–152.

16. On the discovery of the Holy Lance, see S. Runciman, "The Holy Lance Found at Antioch," *Analecta Bollandiana* 68 (1950): 197–209. The promoters of the relic's authenticity suffered a slight setback when its discoverer, a peasant from southern France, failed the trial by fire, but the Lance was nevertheless widely venerated by the devout in Provence. On the display of relics to rally support for the Crusade of 1101, see J. L. Cate, "The Crusade of 1101," in *A History of the Crusades*, ed. K. Setton, vol. 1: *The*

First Hundred Years (Madison, Wisc., 1969), 348–9. Further connections between the crusades and the iconography of the Way to Calvary will be discussed below, pp. 121–2.

17. S. Runciman, *A History of the Crusades*, vol. 1 (Cambridge, 1951), 245, notes that the relic of the lance was described as a nail by a contemporary chronicler.

18. One especially relevant text, by Theofrid of Echternach (d. 1110), is cited by Berliner, "Arma Christi": "O quam praeclara dominicorum clavicorum et salutaris lanceae specialis materies. . . . O quam sancta, quam pretiosa, quam dulcis, quam amabilis et delectabilis ferri materia, unde clavi. . . . " He refers to others, also in circulation at the beginning of the twelfth century, on p. 129, note 41.

19. The nail and the lance appear at Verona around 1100 (see Note 13); the lance is also displayed in the Le Puy relief, also c. 1100 (see Note 13). The nail appears as well in an altar depicting the Lamb of God, also c. 1100, in the cathedral treasury of Modena (Berliner, "Arma Christi," 42; 184, note 1). At Le Puy, at least, the finding of the Holy Lance seems a likely motivation for including the motif; Raymond of Aguilers, a crusader and an enthusiastic supporter of the lance, was a canon of the cathedral of Le Puy. See A. Derbes, "A Crusading Fresco Cycle at the Cathedral of Le Puy," *Art Bulletin* 73 (1991): 561–76, especially 575.

20. See the Introduction, Note 14.

21. The earliest surviving examples of the new type all date around 1100. These include the miniature in the Gospel book of Matilda (see Note 6), the fresco at Sant'Urbano (Note 6), and the door panels at Verona and Le Puy (Note 13).

22. The Index of Christian Art lists twenty-eight northern European examples of the scene from the twelfth century; Christ carries the cross in twenty-two, Simon in only six. Occasional thirteenth-century monuments such as the Bibles Moralisées in Oxford (Bodleian Library, ms. 279b, fol. 76; Laborde, *Bibles moralisées*, vol. 1, plate 76) and in London (British Library, Harley 1526–27, fol. 58; Laborde, vol. 3, plate 529) still depict Simon as cross-bearer. See also Wilk, *Darstellung*, table IV, p. 270.

23. Ulbert-Schede, *Andachtsbild*, 12–13. For various accounts of the words of Urban at Cler-

mont, see A. Krey, *The First Crusade: The Accounts of Eye-Witnesses and Participants* (Gloucester, Mass., 1958), 24–43. The biblical passage recurs very similarly in Luke 9:23; Krey's note (285, note 13) gives the passage as Luke 16:24, but either Matthew 16:24 or Luke 9:23 must have been intended.

Ulbert-Schede was not the first to link the preaching of the crusades with the image of Christ Bearing the Cross. She credits it to K. A. Kneller, *Geschichte der Kreuzwegandacht von der Anfangen bis zum volligen Ausbildung* (Freiburg, 1906), 46. Wilk suggests other factors: a new interest in Christ's humanity and in the cross as "Martyrholz" (*Darstellung*, 191), and typological parallels with the Sacrifice of Isaac, who carried the wood to the sacrificial altar (44–5). But while both developments may have contributed to the later popularity of the theme, neither would account for the rapidity with which the new image displaced the old, and neither applies directly to the specific period under discussion: the turn of the twelfth century.

24. The connection is already explicit in Origen's commentary on Matthew, *P.G.*, vol. 13, column 1038 (Wilk, *Darstellung*, 29).

25. In fact, two of the earliest examples of the new image, those at Le Puy (Note 13) and in the Gospel book of Matilda (Note 6), can be linked with Urban II and the First Crusade. The connection is most obvious at Le Puy. Its bishop, Adhémar of Monteil, was perhaps the staunchest of Urban's supporters and the first to take the cross; Urban rewarded him by appointing him legate of the First Crusade in 1095. On Adhémar, and on other images at Le Puy as an expression of crusading ideology, see Derbes, "Crusading Fresco Cycle," 561–76. Matilda, too, was closely affiliated with Urban – one of his few allies, in fact, in all Italy (Runciman, *Crusades*, vol. 1, 101). That some of the first depictions of Christ Bearing the Cross occur in monuments commissioned by close associates of Urban seems more than fortuitous.

26. See, for instance, the Preparation for the Crucifixion in a miniature from the Hortus Deliciarum, fol. 143v. (J. Walter, *Herrade de Landsberg, "Hortus Deliciarum"* [Strassburg and Paris, 1952], plate 26a). On the ladder in general, see Wilk, *Darstellung*, 180.

27. As in, for instance, windows from Laon (M.

Aubert et al., *Le vitrail français sous la haute direction du Musée des Arts Decoratifs de Paris* [Paris, 1958], fig. 95) and Chartres (Y. Delaporte, *Les vitraux de la cathédrale de Chartres* [Chartres, 1926], vol. 2, plate CLVI).

28. Bibliothèque Nationale, N. Acq. lat. 1392, fol. 10v.; V. Léroquais, *Les psautiers manuscrits latins des bibliothèques publiques de France* (Macon, 1940–1), 137; pls. LXIII-LXVI.

29. A. Martindale, *Simone Martini: Complete Edition* (New York and Oxford, 1988), cat. no. 2, 171–3, plate 119.

30. The Index of Christian Art lists twenty-seven northern European versions of the Way to Calvary in which the Virgin and/or holy women appear; in none of these does a member of the mob threaten them. The motif does appear in the Way to Calvary in the Limbourg Brothers' *Très Riches Heures*, fol. 147r. (J. Longnon, *The Très Riches Heures of Jean, Duke of Berry* [New York, 1969], plate 111).

31. Velmans, *Tetraévangile*, 13. She notes, however, that several deviations from the text occur.

32. J. Donehoo, *The Apocryphal and Legendary Life of Christ* (New York, 1903), 346. The episode is not mentioned in any other source that I know of, despite the fact that a number of eastern texts stressed the Virgin's presence on the road to Golgotha. Among these are the Kontakion of Romanos (Carpenter, *Kontakia of Romanos*, vol. 1, 196–8); accounts by George of Nicomedia (*P.G.*, vol. 100, columns 1462–63), Simeon Metaphrastes (*P.G.*, vol. 115, column 551), and the Cyprus Passion Play (Mahr, *Passion Play*, 193). Presumably texts like these influenced the western writers who placed still greater emphasis on the Virgin's role: Peter Comestor (*P.L.*, vol. 198, columns 1629–30), Pseudo-Bernard (*P.L.*, vol. 189, column 1135), Pseudo-Bede (*P.L.*, vol. 94, column 565–66), Pseudo-Anselm (*P.L.*, vol. 159, column 281) and Pseudo-Bonaventure (Ragusa and Green, *Meditations*, 331–2).

33. See Chapter 4, Note 7.

34. Millet, *Recherches*, 363; Sandberg-Vavalà, *Croce dipinta*, 271; Wilk, *Darstellung*, 167. See, for instance, a tenth-century fresco at Goreme, Elmali Kilise, Schiller, *Iconography*, vol. 2, fig. 283.

35. Fol. 83; see A. Marava-Chatzēnikolaou and C. Touphexē-Paschou, *Katalogos Mikrographiōn Vyzantinōn Cheirographōn tes Ethnikēs Vivliothēkēs tēs Hellados*, vol. 1 (Athens, 1978), plate 636; Colwell and Willoughby, *Four Gospels*, 241.

36. For the frescoes at Veroia, see Chapter 3, Note 46. Another Palaeologan example appears at Prilep; see Millet and Frolow, *Peinture*, vol. 3, plate 24 (3).

37. Wilk, *Darstellung*, 113, 124. A description of the liturgy used in Jerusalem can he found in the *Peregrinatio* of Silvia, a late fourth-century pilgrim to the Holy Land. The text has been published by L. M. Duchesne, *Christian Worship: Its Origins and Evolution* (London, 1903), 490–523.

38. Pseudo-Bede, *P.L.*, vol. 94, column 565: "Considera etiam quomodo postea duxerint eum ad Pilatum, manibus post tergum ligatis vel ante, et, ut dicitur, catenam in collo ejus, quae postea ostendebatur in Hierusalem peregrinis pro magna devotione. . . ." Though one might argue that the motif could have originated with a passage like this, or with pilgrims' reports, the Castellare Master's composition closely resembles eastern images of the scene. For instance, Christ is led by a double cord rather than the usual single cord, and this use of a double cord recurs in the East (as in a Cappadocian fresco at Kokar Kilise representing Christ led to Pilate).

39. See the discussion in K. Weitzmann, *The Monastery of Saint Catherine at Mount Sinai*, vol. 1, *The Icons*, no. 1: *From the Sixth to the Tenth Century* (Princeton, 1976), 58.

40. A closely related image in a duecento manuscript, Vat. lat. 39, fol. 64v., represents a slightly later moment, the Preparation for the Crucifixion; there Christ stands before the cross wearing a sleeveless colobium, with a double cord tied around his neck (for this manuscript, see Chapter 6, pp. 142–3). Not only these two motifs but such details as the dotted pattern of the priest's cloak recall Palestinian versions; the dotted pattern recurs repeatedly in icons that Weitzmann ascribes to Palestine (*Icons*, vol. 1, passim), and Weitzmann describes it, in fact, as a "trademark" of the school (ibid., 67). The identical pattern also occurs in the work of both Enrico di Tedice and the Castellare Master (see

Figs. 70–1) – another indication of their reliance on Palestinian sources.

41. For the manuscript in Athens, fol. 84r., see Marava-Chatzēnikolaou and Touphexē-Paschou, *Katalogos*, plate 92 (where it is reproduced in color); for the date, see Carr, *Byzantine Illumination*, 58. For St. Neophytos, see Mango and Hawkins, "Hermitage of St. Neophytos," plate 31. In other works, such as the miniature in Berlin 66 (Fig. 79), the suggestion of physical suffering is less pronounced, but still present in Christ's downcast eyes and stooped shoulders.

42. This development actually occurred earlier, around the middle of the eleventh century. Millet suggests (*Recherches*, 371) that the change was prompted by the *Acta Pilati*, which states that Christ was led to Calvary in a red garment. Whatever the origins of the garment, its meaning to western writers is clear: It was meant to evoke Christ's suffering and thus his humanity. Peter of Capua (d. 1242), for instance, associates it with Christ's flesh and his human nature (cited by Wilk, *Darstellung*, 163).

43. Velmans's "Valeurs Affectives" notes that in Byzantine representations of the Way to Calvary from the late twelfth century, Christ is transformed from "un roi de gloire triomphant sur la mort, en un être souffrant, qui franchit peniblement les diverses étapes vers le supplice finale" (50).

44. Schiller, *Iconography*, vol. 2, 80, states that they are "nearly always" present.

45. For the fresco at St. Neophytos, see Note 41. Weitzmann has characterized this type of landscape, with its soaring forms conveyed with fluid, rippling brushstrokes, as "emotionalized" and considers it an extension of the fascination with human behavior that pervades late Comnenian painting; he further notes the adoption of such landscapes in mid-duecento painting ("Byzantium and the West around the Year 1200," in *The Year 1200: A Symposium* [New York, 1975], 61).

46. For Berlin 66, see Chapter 1, Note 49. Mellinkoff, *Outcasts*, vol. 1, 20, notes that striped stockings are often worn by Christ's executioners in thirteenth- and fourteenth-century northern European Passion images; the same use of distinctive patterns to signify evil would seem to occur here as well.

47. *P.L.*, vol. 94, column 566: "Deinde ponunt crucem super humeris ejus, ut portet ipsam.

Certe, carissime, bene faceres si juvares Dominum tuum, et diceres, 'Date, obsecro, crucem Dominum mei, et portabo eam': O Domina mea, credo quod tu libenter portares eam, si posses;" Gothic painters frequently depicted the Virgin trying to support the cross, as Sandberg-Vavalà has noted (*Croce dipinta*, 270); this motif is taken up by Tuscan painters by the end of the duecento (as in the panel in the Harris collection; ibid, fig. 229).

48. See De Vinck, *Works*, vol. 1, 123, for both passages from the *Lignum vitae*. Similarly, in the *Vitis mystica* (ibid., 161), he writes: ". . . let us therefore go forth to our spouse, Jesus. . . bearing with Him the reproach of the cross and the harshness of the bonds." In *De perfectione vitae ad sorores* (ibid., 241) he repeats: "They make You carry the cross along the road. . . ."

49. Ragusa and Green, *Meditations*, 331–2: "They place on His shoulders the venerable wood of the long, wide, very heavy cross, which the most gentle Lamb patiently takes and carries. . . . Look at Him well, then, as He goes along bowed down by the cross and gasping aloud. . . . When [the Virgin] encountered Him, for the first time seeing Him burdened by such a large cross. . . ." Eventually Christ cannot go on, and Simon, here identified merely as "someone else," carries the cross the rest of the way.

50. For the quotation from Bonaventure, see Habig, *Omnibus*, 639. Both Ulbert-Schede, *Andachtsbild*, 15, and Wilk, *Darstellung*, 35, associate Franciscan thought with the image of Christ carrying the cross.

51. Habig, *Omnibus*, 31.

52. Kaftal, *Iconography*, 386.

53. *P.L.*, column 94, vol. 562: "*Domine, quo ibimus, et ipse tibi in spiritu respondebit: Ibimus ad Passionem meam. . . Quicunque voluerit venire post me, . . . tollat crucem suam, et sequatur me.*" For another aspect of the text that strongly suggests Franciscan authorship, see Chapter 6, pp. 154–5.

54. For Innocent's strategy of labeling warfare against political enemies as crusades, see J. Strayer, "The Political Campaigns of the Thirteenth Century," in K. Setton, *A History of the Crusades*, vol. 2: *The Later Crusades* (Madison, Wis., 1969), especially 343–48.

55. For Francis as a new soldier of Christ, see Thomas of Celano, *Vita prima*, chap. IV, 9

(Habig, *Omnibus*, 236). For Francis as a second Martin, and for Thomas of Celano's and Bonaventure's characterization of Francis as "*miles Christi*," see J. Brink, "Sts. Martin and Francis: Sources and Meaning in Simone Martini's Montefiore Chapel," in *Renaissance Studies in Honor of Craig Hugh Smyth*, ed. A. Morrogh et al., vol. 2 (Florence, 1985), 79–96. The *Legenda Sancti Francisci versificata*, written in 1232, describes Francis similarly; for the text and a discussion of Francis's "exchange of the sword for the spiritual armor of Christ," see Smart, *Assisi Problem*, 231.

56. *Legenda maior*, chap. XIII, 9 and 10; in Habig, *Omnibus*, 735. On this passage, see Cook and Herzman, "Bonaventure's Life," and Mitchell, "Imagery," 118–19.

57. See B. Z. Kedar, *Crusade and Mission: European Approaches toward the Muslims* (Princeton, 1984), 142, 148; for the text of Gregory's letter, see 213.

58. Some influential Franciscans, such as Roger Bacon, believed that conversion of "infidels" through preaching was preferable to waging war; see the discussion in Daniel, *Franciscan Concept*, 61–6. For Francis's own attitudes to warfare, see the discussion in Kedar, *Crusade and Mission*, 129–31. However, Maier, *Preaching the Crusades*, argues that Francis was a supporter of the crusades (16–17) and stresses that both the Franciscans and the Dominicans were central to papal crusading efforts throughout the century.

59. For Franciscans accompanying crusading armies, see Kedar, *Crusade and Mission*, 139; Little, "Saint Louis," 130. For Franciscans as propagandists for the crusades, see P. F. Delorme, "De Praedicatione cruciatae saec. XIII per fratres Minores," *Archivum Franciscanum Historicum* 9 (1916): 98–117, which documents Franciscan preaching of the crusades from 1234 (99) and especially from 1245 to 1267. The year 1262 saw a flurry of papal bulls on preaching the crusades; six are preserved in the archives of S. Francesco, Assisi (see L. Alessandri, "Bullarium Pontificium quod exstat in Archivo Sacri Conventus S. Francisci Assisiensis," *Archivum Franciscanum Historicum* 10 [1917]: 185–6). See also Maier, *Preaching the Crusades*, passim.

60. The occurrence of the theme on the seal of the Minorites has been documented by Ulbert-Schede, who assembled twenty-four seals of mendicant orders with the image of Christ carrying the cross. Of these eleven are Franciscan, six are Dominican; other orders are represented by only one or two. See *Andachtsbild*, 23–4 and, for a catalog of the seals, 141–53. The earliest Franciscan seal to use the motif dates from 1238 (143). On seals in general, see G. Pedrick, *Monastic Seals of the Thirteenth Century* (London, 1902). On the Dominican use of the theme, see also Note 65.

61. For the S. Martino cross, see Fig. 6. For the other cross for S. Martino, the Sta. Bona cross, see Chap. 1, Note 57. Other crosses with the Way to Calvary in this position include a cross from the Tolomei collection (Garrison, *Index*, no. 517), of unknown provenance; the cross in the Uffizi, no. 434 (Fig. 7); and the one in Volterra, from Castelfiorentino, Sta. Chiara (ibid., no. 529). The diptych in the Uffizi also includes two other motifs that have been associated with Franciscan spirituality, the swooning Virgin and the single nail piercing Christ's feet. On the connections of both with the Order, see Derbes, "Siena and the Levant," 197.

62. F. Martin, *Die Apsisverglasung der Oberkirche von S. Francesco in Assisi: Ihre Entstehung und Stellung innerhalb der Oberkirchenausstattung* (Worms, 1993), fig. 45.

63. For the examples in Sta. Croce, see *Sta. Croce: Kirche, Kapellen, Kloster, Museum* (Stuttgart, 1985); for the sacristy, 152–3, for the refectory, 348. (J. Dunkerton et al., *Giotto to Dürer: Early Renaissance Painting in the National Gallery* [New Haven and London, 1991], 224, refer to the cross in Ugolino's Way to Calvary as the "spiritual and compositional pivot of the entire altarpiece"; I am grateful to Adrian Hoch for this reference.) The theme is found as well in the Clarissan church, Sta. Maria Donnaregina, Naples (Carelli and Casiello, *Sta. Maria Donnaregina*, fig. 47); in the chapter house of S. Francesco, Pisa (Paliaga and Renzoni, *Le chiese di Pisa*, 42); and in S. Francesco, Bologna. The frescoes in Bologna, signed by Francesco da Rimini, are badly damaged; see A. Corbara, "Il ciclo francesco di Francesco da Rimini," in *Romagna arte e storia*, 4, 12 (1984). The Way to Calvary is also included in numerous Franciscan panels, such as a

tabernacle in the Stocklet collection, Brussels (Garrison, *Index*, no. 300) and a panel from a Clarissan diptych by the Master of San Martino alla Palma (Boskovits, *Gemäldega-lerie*, fig. 187).

64. On the Munich diptych, a Riminese work of the early trecento, see D. Benati, "Pittura del Trecento in Emilia Romagna," in Castelnuovo, *Pittura*, 1, 200.

65. See the seals noted before, a few of which date from the duecento (Note 60); in the trecento, see two frescoes at Sta. Maria Novella, Florence (in the Spanish Chapel and the Farmacia); and an altarpiece ascribed to Barna da Siena in the Frick Museum for a Dominican donor (for the frescoes, see U. Baldini, *Sta. Maria Novella: la basilica, il convento, i chiostri monumentali* [Florence, 1981], figs. on pp. 114, 118 [Spanish Chapel], and pp. 310–11 [Farmacia]); for the panel in the Frick, see S. Delogu Ventroni, *Barna da Siena* [Pisa, 1972], fig. 70). Despite the Dominican appropriation of the image (and their use of Matthew 16:24, on which see Cannon, "Simone," 72), the interpretation in Dominican monuments is typically far more restrained, with the suppression of the narrative elements and dramatic tenor favored by the Franciscans. Compare, for instance, the rendition of the theme in the Spanish Chapel with Simone's in the Orsini polyptych. In particular, details with particular significance to the Franciscans (the mocking children, the rope around Christ's neck) do not appear in the Spanish Chapel; children are present, but merely observe the proceedings soberly rather than taunting Christ. On the significance of the mocking children, see Neff, "Wicked Children"; J. Polzer, "Andrea di Bonaiuto's *Via Veritatis* and Dominican Thought in Late Medieval Italy," *Art Bulletin* 77 (1995): 265–89, especially 272. For the rope, see the discussion in this chapter, pp. 132–5.

For images of penitents taking up crosses to follow Christ – some Franciscan, some for other patrons – see F. O. Büttner, *Imitatio Pietatis: Motive der christlichen Ikonographie als Modelle zur Verähnlichung* (Berlin, 1983), figs. 44–53; these examples postdate the thirteenth century.

66. Thomas of Celano, *Vita prima*, vol. 1, 52; Habig, *Omnibus*, 272–3. For the Latin text, see *S. Francisci Assisiensis, Vita et Miracula*

(Rome, 1906), 54.

67. R. Brooke, ed., *Scripta Leonis, Rufini et Angeli Sociorum S. Francisci: The Writings of Leo, Rufino and Angelo Companions of St. Francis*, Oxford Medieval Texts (London, 1970), 156–9; Goffen, *Spirituality*, 41.

68. See the description of *diminutio capitis* in S. Y. Edgerton, *Pictures and Punishment: Art and Criminal Prosecution during the Florentine Renaissance* (Ithaca and London, 1985), 65. For this image in the Bardi dossal, see Goffen, *Spirituality*, 40–1, and for a color plate of the dossal, see Goffen, plate 1. Just as the seated Francis suggests the seated Christ in the Mocking, in other ways this image may also have been meant to summon up episodes of the Passion. The column to which Francis is tied is mentioned nowhere by his biographers. As noted, it evokes the punishment of actual criminals; possibly, however, it may also allude to the Flagellation of Christ, just as the prominently discarded cloak suggests the Stripping. Further, this image is found just beneath the Stigmatization of Francis – the episode in which his *imitatio Christi*, and in particular his imitation of Christ's Passion, is most obviously implied. The image, then, especially in combination with others in the dossal, may have been read as a kind of *summa* of the themes of *Franciscus Alter Christus*, a conjuring of multiple Passion themes in a single image. In the dossal, the imagery of *Alter Christus* goes still farther. Immediately to the right of the Stigmatization is Francis Caring for Lepers (Goffen, 43–4; fig. 36). It is probably not accidental that he is depicted washing their feet; the scene bears an unmistakable resemblance to Christ washing the feet of the apostles. *Franciscus Alter Christus* seems to be implied as well in the scenes just to the left of the Stigmatization and Penance of Francis, in which Francis ransoms lambs (Goffen, 40; figs. 32–3). Celano tells us that the stories reveal Francis's love for Christ, the Lamb of God; they also call to mind the familiar image of Christ as Good Shepherd, who "lays down his life for his sheep." Thus five of the panels at the base of the dossal – those closest to the stigmatized right foot, as Goffen (41) noted about the Stigmatization – evoke Christ's sacrifice, and specific episodes in the Passion of Christ.

69. Bonaventure specifically minimized this

episode of extreme asceticism as a model for friars' behavior; see Cook, "Fraternal and Lay Images," 266–7, who cites Bonaventure, *Legenda maior*, VI, 2: "His action certainly seemed to have been intended rather as an omen reminiscent of the prophet [Isaiah] than as an example." A somewhat analogous development is the replacing of images of the bearded Francis with a clean-shaven Francis in the late thirteenth century, when beards became associated with the economically and socially marginal (L. Bellosi, "La barba di San Francesco. [Nuove proposte per il 'problema di Assisi']," *Prospettiva* 22 (1980): 11–34; but see the comments of Cook, "Early Images," 29). Another example of Francis with a rope around his neck appears in an illustrated copy of the *Legenda maior*; here the saint, clad only in a loincloth, conspicuously resembles images of Christ just before the Crucifixion. For the manuscript (Rome, Istituto Storico dei Cappucini), see *Francesco in Italia*, fig. 389.

70. Pseudo-Bede, *P.L.*, column 94, vol. 565: "Considera etiam quomodo postea duxerint eum ad Pilatum, manibus post tergum ligatis vel ante, et, ut dicitur, catenam in collo ejus, quae postea ostendebatur in Hierusalem peregrinis pro magna devotione. . . ."

71. Ragusa and Green, *Meditations*, 332. For the Latin text of Celano, see *Legendae S. Francisci Assisiensis saeculis XIII et XIV conscriptae* (Rome, 1906), 54; for Pseudo-Bonaventure, see Bonaventure, *Opera Omnia*, vol. 12, 605. The references to thieves recur in Franciscan tracts. Thus for Bonaventure, Christ was "linked with robbers" during the Passion, and he "hung on a tree like a robber and a thief" at the Crucifixion. (The first quotation is from the *Lignum vitae* [De Vinck, *Works*, vol. 1, 124–25]; the second from *De perfectione vitae ad sorores* [ibid., 240]). The *Meditatio pauperis in solitudine*, a Franciscan text of c. 1282, also refers to Christ's being hung among thieves (Delorme, ed., 71). Other Franciscan authors, such as Pseudo-Bonaventure, also stress the presence of the thieves; see the discussion in Chapter 6, pp. 153–4.

72. Boskovits, "Opera probabile," 81; E. Staaff, "Le laudario de Pise du Ms. 8521 de la Bibliothèque de l'Arsenal de Paris," in *Skrifter utgivna av K. Humanistiska Vetenkops Semfundet i Uppsala* 21 (Uppsala, 1935), 84, note

35. Fleming describes the *lauda* as "the most ancient and authentic form of the Franciscan lyric" (*Literature*, 180). The Pisan origin of this *lauda* is interesting, given the motif's early appearance in a Pisan panel.

73. See Goffen, *Spirituality*, 46, fig. 42; Goffen, following Stein, "Dating the Bardi St. Francis," 292, and W. Miller, "The Franciscan Legend in Italian Painting of the Thirteenth Century," Ph.D. diss., Columbia Univ., 1961, identifies the penitents as the sailors whose miraculous rescue by Francis is shown in the panel below. However, see Cook's review of Goffen in *American Historical Review* (1179). The rope around the neck appears at times in non-Franciscan devotion as well; Beato Gallerani, a Dominican tertiary, once tied a rope around his neck and attached the other end to a rafter to keep himself from falling asleep during meditation (Stubblebine, *Guido*, 70, and fig. 35).

74. P. M. della Porta et al., *Guide to Assisi, History and Art* (Assisi, 1992), 24.

75. See Goffen, *Spirituality*, 96, note 23; L. Bracaloni, "Lo stemma francescano nell'arte," *Studi francescani* 7 (1921): 221–26, especially 222. The related term *cordigeri* was also used to designate the friars in late medieval Italy. As noted earlier (Chapter 3, Note 84), a 1277 record describes tertiaries as "garbed with the cord of the friars minor." *Corda* and *funis* could be used interchangeably to designate the robe-belt; in the mid-1250s Federigo Visconti, bishop of Pisa, wrote: "Quare habent Fratres tres nodos in corda? Et ideo triplicem nodum habet in corda, sive fune . . ." (cited by Frugoni, *Francesco*, 275).

76. For the Flagellation, see Carli, *Pittura medievale pisana*, fig. 69. The ropes are difficult to see in the reproduction, but quite obvious in the panel itself. I am grateful to Julia Miller for this observation.

77. For a reproduction of the Mocking, fol. 375r., see Neff, "New Interpretation," fig. 154; for the Way to Calvary, fol. 375v., see Neff, "Wicked Children," fig. 1. The rope around Christ's neck in the Calvary scene is obscured by the cross, but part of the rope can be seen emerging from the beam of the cross; the end is held by the man at the head of the procession. The rope is much easier to see in the Mocking.

78. I am grateful to Julia Miller for this observa-

79. On the thieves, see Note 71. The prominence of the thieves in Franciscan devotional tracts and Passion images will be considered further in Chapter 6, pp. 153–4.

80. For the *Vita Christi* manuscript, New York, Morgan Library, ms. 643, fol. 11, see Offner, *Corpus*, sect. 3, vol. 2, part 1, plate VIII-10; for the panel in the Accademia, *Corpus*, sect. 3, vol. 2, part 1, plate II, 13-b; discussed by Offner in *Corpus*, sect. 3, vol. 6, 122–35, and by J. Wood in her forthcoming study on the Clares; for the Tucson panel, Offner, *Corpus*, sect. 3, vol. 6, plate XLIII, 149–52. For the Boston manuscript, where Christ is shown led by the neck after the Arrest, see Sticca, "*Officium Passionis*," plate VIII. Sticca suggests that the image derives from Pseudo-Bonaventure, who emphasizes that Christ was led about by his captors. For Ugolino's altarpiece for Sta. Croce, see Stubblebine, *Duccio*, vol. 1, 164–8; vol. 2, fig. 411. For the frescoes in Naples and in Sta. Croce, see Note 63. Offner, *Corpus*, sect. 3, vol. 6, 144 and note 21, discusses the motif in the *Supplicationes Variae* manuscript and in trecento painting, noting that after Pacino, it "does not reappear in Florence until the fresco in the sacristy of S. Croce by an assistant of Spinello Aretino." He also remarks on its occurrence at S. Maria Donnaregina, Naples, and in Siena. Pacino used it as well in the Chiarito tabernacle now in the Getty Museum; Offner, sect. 3, vol. 6, plate XLII-b, 141–8. The origins of this panel are unclear. M. Boskovits, *Corpus*, section III, vol. IX: *The Painters of the Miniaturist Tendency* (Florence, 1984), notes that the panel was probably not originally destined for the "Convento del Chiarito," but that Chiarito del Voglio is likely to have commissioned it, either for himself or for some religious foundation (49, note 167). See also A. Hoch, "The *Chiarito Tabernacle*: A Study of Trecento Vision Imagery," Twenty-Third International Congress on Medieval Studies, Western Michigan Univ., Kalamazoo, Mich., 1988. For the panel from S. Antonio da Padova, Paciano, see Bon Valsassina and Garibaldi, *Dipinti*, 127–9, fig. on p. 128. A fragment of an inscription, on the lower cornice of the panel, refers to the thieves: TAMQUAM. AD. LATRONE[M] EXISTIBUS (127).

The motif also appears in the shutter of a tabernacle in Siena, c. 1310–15 (Stubblebine, *Duccio*, vol. 2, figs. 240 and 244). The tabernacle was presumably commissioned by the kneeling donor, recently identified by H. Maginnis as Pietro of Eboli, brother of Robert of Anjou ("Tabernacle 35," *Source* 12 [1993]: 1–4). Maginnis notes that Francis is one of many saints depicted in the tabernacle. Though Maginnis does not pursue the Franciscan connections of the panel further, Pietro's brother Robert was a Franciscan tertiary, Robert's wife, Sancia di Maiorca, was a devout supporter of the Order, and another illustrious brother, the Franciscan Louis of Toulouse, was soon to be canonized. For Robert and Sancia as patrons of the Order, see White, *Art and Architecture*, 281. Finally, the rope appears on the well-known panel for Simone Martini from the Orsini polyptych, now in Antwerp. For other Franciscan imagery in that panel, and the Franciscan associations of the likely owner, Cardinal Napoleone Orsini, see Neff, "Wicked Children," 223–8; J. Brink, "Cardinal Napoleone Orsini and Chiara della Croce: A Note on the *Monache* in Simone Martini's *Passion Altarpiece*," *Zeitschrift für Kunstgeschichte* 46 (1983): 419–24. As Brink notes, the Franciscan Spiritual Ubertino da Casale was Orsini's chaplain (422).

81. For works of unknown provenance, see Stubblebine, *Duccio*, vol. 2, figs. 219 and 223 (a tabernacle in the Metropolitan Museum, which includes Francis as well as Dominic in the predella); ibid., fig. 224 (a tabernacle by the Monte Oliveto Master); see also the chart in Sandberg-Vavalà, *Croce dipinta*, 440–5.

For non-Franciscan works that include the motif, see Pacino di Bonaguida's Chiarito tabernacle (cited in Note 80) and the fresco traditionally ascribed to Barna da Siena in the Collegiata of San Gimignano (S. Delogu Ventroni, *Barna da Siena* (Pisa, 1972), figs. 61–2). Interestingly, however, neither of the two frescoes at Sta. Maria Novella, the Dominican church in Florence, includes the motif, despite its widespread circulation in Tuscany by mid-trecento (for these, see Note 65).

82. Habig, *Omnibus*, 143.

83. Ragusa and Green, *Meditations*, 331.

84. *P.L.*, vol. 159, column 281.

85. Ragusa and Green, *Meditations*, 331.

86. M. Meiss, *Painting in Florence and Siena after the Black Death* (Princeton, 1951), 128–9. Meiss believed the dossal to date from c. 1325; it is now usually dated to the 1290s. For the passage cited by Meiss, see Ragusa and Green, *Meditations*, 305–6.

87. G. K. Anderson, *The Legend of the Wandering Jew* (Providence, R.I., 1965), 18. For a study of the theme in art, see Diane Wolfthal, "The Wandering Jew: Some Medieval and Renaissance Depictions," in *A Tribute to Lotte Brand Philip* (New York, 1985), 217–27. I am grateful to Prof. Wolfthal for giving me a copy of her article.

88. Anderson, *Legend*, 22.

89. Ragusa and Green, *Meditations*, 332.

90. *Lignum vitae*; De Vinck, *Works*, vol. 1, 121.

91. Wolfthal, "Wandering Jew," 221, fig. 5. See also Donovan, *The de Brailes Hours*, 78–80, fig. 47.

CHAPTER 6

1. For this theme, see Sandberg-Vavalà, *Croce dipinta*, 279–80; Kosloff, "Ikonographie," 45–51; Boskovits, "Un'opera probabile di Giovanni di Bartolommeo Cristiani e l'iconografia della 'Preparazione alla Crocifissione,'" *Acta Historiae Artium* 11 (1965): 69–94; Schiller, *Iconography*, vol. 2, 83–5; Sticca, "*Officium Passionis*," 173–4; S. L. Smith, "The Bride Stripped Bare: A Rare Type of the Disrobing of Christ," *Gesta* 34 (1995): 126–46. Among the unusual instances of the image predating the Italian examples is a miniature in a Book of Hours made in Oxford, c. 1240, by William of Brailes, London, British Library, Add. 49999, fol. 43v. (Donovan, *The de Brailes Hours*, fig. 47; for the date, see Donovan, 24). Christ was also stripped after he was mocked, before he was led away (Matthew 27:31; Mark 14:20); this episode is again very unusual (for one example, see a moralized Bible in London, Harley 1526–7; fol. 57v.; Laborde, *Bibles Moralisées*, vol. 3, plate 528).

2. "Una decorazione murale," 3-9. However, see also Iazeolla, "Gli affreschi di S. Sebastiano ad Alatri," 468, who notes stylistic links with Umbrian painters.

3. It may be that the Virgin was included as a model to the women housed at the convent; she figures prominently in other Passion images produced for the Clares. For instance, the diptych in the Uffizi, for Sta. Chiara in Lucca (Fig. 1) depicts her repeatedly in its Passion scenes. She appears twice at the base of the cross, once swooning and once standing erect; she also appears in the Way to Calvary and in the Deposition. We will return to this subject in the Conclusion, pp. 167–8.

4. The Bible was earlier in the collection of Dyson Perrins, then passed to the Abbey collection. See G. Warner, *Descriptive Catalogue of Illuminated Manuscripts in the Library of C. W. Dyson Perrins* (Oxford, 1920), vol. 1, 139–40; vol. 2, plate 53; and J. J. G. Alexander and A. C. de la Mare, *The Italian Manuscripts in the Library of Major J. R. Abbey* (New York, 1969), 12–19. It was sold at Sotheby's, London, on June 19, 1989, to Quartich, presumably acting for a private collector. I am most grateful to Elizabeth Teviotdale of the Getty Museum for her kind assistance with the history of the manuscript after the dispersal of the Perrins collection.

5. Stiftsbibliothek; formerly ms. 1633, now ms. 1903. On the manuscript, see H. Swarzenski, *Die lateinischen Illuminierten Handschriften des XIII. Jahrhunderts* (Berlin, 1936), vol. 1, 163–4. Swarzenski notes that this composition has "keine Parallelen nordlich der Alpen von dem XIV. Jahrh." (vol. 1, 163, n. 6) – a point corroborated by the Index of Christian Art. Swarzenski (ibid., vol. 1, 76) dates the manuscript shortly after 1255.

6. This explicit fusion of the Stripping and the Ascent also occurs in Italy, in a late thirteenth-century fresco in S. Vittore, Ascoli Piceno (Millet, *Recherches*, fig. 414). The Stripping occurs as well in two manuscripts that were probably intended for Ascoli: the Bolognese Bible mentioned above (see Note 4) and a fourteenth-century *Officium Passionis* in the Boston Public Library (see below, Note 9). The presence of the theme in the three monuments suggests that it was especially important in this Marchigian town.

7. See the Introduction, Note 9.

8. For the Faenza Master's panel in Bologna, see Garrison, *Index*, no. 664; Boskovits, "Opera probabile," fig. 9. For the Master of Forlì's panel (current whereabouts unknown), see Garrison, *Index*, no. 674; Boskovits, fig. 10; for the panel in the Vatican, see Boskovits, "Opera probabile," fig. 18. For the tabernacle to which the Master of Forlì's panel once belonged, see also Boskovits, *Thyssen*, cat.

no. 22, 138–45; for his reconstruction of the tabernacle, see fig. 1, pp. 140–1. In the reconstruction, the panel proposed as the left outer shutter of the tabernacle depicts Francis with three other saints (*Thyssen*, 142, and fig. 2a). The tabernacle thus seems to have been a Franciscan commission. Boskovits considers the painter to be influenced by Emilian and Venetian painting (142).

9. Sticca, "*Officium Passionis*," 145-6; plate XVII.

10. See I. Field, "Pietro Cavallini and his School: A Study in Style and Iconography of the Frescoes in Rome and in Naples" (Ph.D. diss., Univ. of Wisconsin, 1958); she rightly notes how unusual this proliferation of images is (150, 156, 159). For a reproduction of the second example, see Carelli and Casiello, *Sta. Maria Donnaregina*, fig. 47. The first, preceding the Flagellation, is not reproduced by Carelli and Casiello; see G. Chierici, *Il restauro della chiesa di S. Maria Donnaregina a Napoli* (Naples, 1934), plate XXVII; see also Field's description, 149–51. I am indebted to Adrian Hoch for these references.

11. The Stripping is now in the Pinacoteca, Siena. For the reconstruction and a photograph, see G. Freuler and M. Mallory, "Der Altar des Beato Philippino Ciardelli in S. Francesco in Montalcino, 1382," *Pantheon* 47 (1989): 21–35; reconstruction, fig. 2; Stripping, fig. 17. The reconstruction was questioned by P. Harpring, *The Sienese Trecento Painter Bartolo di Fredi* (London and Toronto, 1993), 77, note 32; I am grateful to Adrian Hoch for this reference.

12. For the Bolognese manuscript's Franciscan elements, see Warner, *Descriptive Catalogue*, vol. 1, 139. Warner assumes that the manuscript was commissioned by the Dominican order because the calendar mentions a number of Dominican feast days. See also Alexander and de la Mare, 19. It is interesting, however, that this coexistence of references to the two rival orders is characteristic of the Marches, especially of Ascoli: see Sticca, "*Officium Passionis*," 146. The Franciscan order was very strong in Ascoli; the Franciscan house there was said to have been founded by Francis himself (on which see Moorman, *History*, 157). See also Cannon's discussion of Dominic and Francis represented together; she argues that in Dominican works painted before the Council of Lyons (1274), Dominic "tends to be accompanied by Francis" ("Dominican Patronage," 209).

The Melk manuscript may also have some ties to the Franciscans. Swarzenski (*Die lateinischen Handschriften*, vol. 1, 76) points out that a psalter produced in the same workshop at the same time includes St. Francis and St. Clare in its representation of the Crucifixion (on this see also Coor, "Coppo," 18, note 21).

13. Weitzmann, "Byzantine Miniature and Icon Painting," *Studies*, 297, fig. 300. On the Preparation for the Crucifixion, see Millet, *Recherches*, 381–5; he cites many examples but none earlier than the late twelfth century. The term "Preparation for the Crucifixion" seems somewhat inappropriate: The Byzantine type does not, at least initially, even show preparations such as the affixing of the cross, but only the silent confrontation between Christ and the high priest. Nevertheless the literature almost invariably refers to the scene in this way; a more satisfactory substitute does not seem to exist. On the development of the scene, consult, in addition to Millet, Sandberg-Vavalà, *Croce dipinta*, 278–9, 281–2; O. Kosloff, "Die Ikonographie der Passionsmomente zwischen der Kreuztragung und dem Tode Christi," *Het Gildeboek* (1934): 1–25; Wilk, *passim*; Schiller, *Iconography*, vol. 2, 82–3.

14. For the reliquary, see P. Cséfalvay, *The Treasury of Esztergom Cathedral* (Budapest, 1984), cat. no. 2. On the manuscript, see L. Eleen, "Acts Illustration in Italy and Byzantium," *Dumbarton Oaks Papers* 31 (1977): 253–78. She argues that the manuscript was destined for Verona and dates from the first quarter of the thirteenth century. See also Boskovits, "Opera probabile," fig. 8. Another image, from the Church of the Holy Cross at Pelendri, c. 1200, published by D. Mouriki (*Thirteenth-Century Icon Painting*, fig. 15), is a particularly interesting example of the theme, in which the Virgin and John appear to the right. Though Mouriki identifies it as "The Way to the Cross," it actually depicts Christ at the foot of the cross, with all the usual figures seen in other examples of the Preparation for the Crucifixion: the man leading Christ, the gesturing high priest, the man affixing the cross. On this image, see also the comments of A. W. Carr, *Byzantine*

Masterpiece, 99–100; she connects it with "the removal in 1196 of a very famous icon of the same subject from Monemvasia in Greece to Constantinople by the then emperor Isaac Angelos."

15. "Narrative and Liturgical," 241ff.

16. See the illustrations of Psalm 22:16 in, for instance, the Theodore Psalter (fol. 23r.); S. Der Nersessian, *L'Illustration des psautiers grecs*, fig. 41.

17. For color photos of Iviron 5, see Pelekanides, et al., *Treasures of Athos*, vol. 2, figs. 11–49. The Preparation for the Crucifixion is not reproduced there, however; for a line drawing, see Millet, *Recherches*, fig. 410.

18. The conjunction of the two scenes is suggested as well by the fresco in Ascoli, cited in Note 6, and by the fresco in Naples (Fig. 85), though there Christ does not climb the ladder but is hoisted up by the soldiers.

19. For a discussion of the Ascent of the Cross, see Derbes, "Images East and West." For an early example of the theme in the East, see Mathews and Sanjian, *Armenian Gospel Iconography*, 131–2. The subject was also discussed in some detail by Boskovits, "Opera probabile," 69–94. Boskovits, however, alludes only briefly to Coppo and concentrates on the development of the scene in the late duecento and early trecento.

20. Though the bloodstains are not visible in photographs, they can be seen on the panel itself.

21. For a more extensive discussion of Guido's Sienese reinterpretation of this image, see Derbes, "Images East and West," 117–8.

22. For other examples, see Derbes, "Images East and West" and Boskovits, "Opera probabile"; see also the works cited in Note 47.

23. On the psalters, see Note 16.

24. See Straub and Keller, *Hortus*, vol. 3, plate 38.

25. On the *disciplinati*, see Dickson, "Flagellants"; C. Barr, *The Monophonic Lauda and the Lay Religious Confraternities of Tuscany and Umbria in the late Middle Ages* (Kalamazoo, Mich., 1988), 3–7. For the flagellants' practice of scourging their bare flesh "ad effusionem sanguinem," see Dickson, 238–9.

26. Another detail found in Coppo's composition but not in Byzantine images is the hammer and nails brandished by the executioners. For the *Arma* in the Way to Calvary, see Chapter 5, p. 121.

27. Mathews and Sanjian, *Armenian Gospel Iconography*, 131–2.

28. The origins of the image have been debated for some time; most of the extant eastern instances date from the end of the thirteenth century, two decades or so after the appearance of the theme in Italy, and many scholars have assumed that the subject first appeared in the West and was then adapted by eastern painters. For a summary of the literature, see Mathews and Sanjian, *Armenian Gospel Iconography*, 131–2. However, Mathews's discovery of the theme in an early Armenian manuscript, dated by colophon to the eleventh century, would seem to settle the matter, if the illuminations date from the eleventh century as well; Helen Evans has expressed some doubts about the early date of the illuminations, however. For a fuller discussion of the issues, additional arguments for the image's eastern provenance (regardless of the ultimate resolution of the date of the illuminations in Mathews' manuscript), and detailed treatment of the eastern examples, see Derbes, "Images East and West."

29. *P.L.*, vol. 159, column 282: "Nudaverunt Jesum unicum filium meum totaliter vestibus suis. . .tamen velamen capitis mei accipiens circumligavi lumbis suis."

30. *P.L.*, vol. 94, column 565: "Cogita quod usque ad locum Calvariae populus clamans venit, et tunc ibi videntibus omnibus, expoliatur suis vestibus, et cum maximo dolore, quia vestis interior adhaerebat ei fortiter propter sanguinem flagellationes, et tunc apparuit corpus ejus, tam eleganter figuratum, totum cruentatum. O quantus dolor tibi erat, mater sanctissima, cum aspiceres ista."

31. De Vinck, *Works*, vol. 1, 164–5.

32. Ragusa and Green, *Meditations*, 329–30; 333.

33. Ibid., 333.

34. See Chapter 1, pp. 30–2.

35. The quotation is from Celano, *Vita prima*, chap. VI, 15; Habig, *Omnibus*, 241; see also Goffen, *Spirituality*, 35. For a fuller treatment, see R. Trexler, *Naked before the Father: The Renunciation of Francis of Assisi* (New York, 1989).

36. Both are described in the first chapter of the *Legenda maior*. For the knight, see Habig, *Omnibus*, 637; for the beggars, ibid., 639.

37. Brooke, ed., 297.

38. See Goffen, *Spirituality*, 35–41, and figs. 25,

33, 35.

39. On the typological pairing of the Stripping of Christ and Francis Renouncing his Patrimony at Assisi, see Derbes, "Byzantine Art and the Dugento," 187; more recently, see G. Ruf, *Das Grab des hl. Franziskus: Die Fresken der Unterkirche von Assisi* (Freiburg, Basel, Vienna, 1981), 70–1; Neff, "'Dialogus," 107; Lavin, *Place of Narrative*, 30; M. V. Schwarz, "Zerstört und Wiederhergestellt. Die Ausmalung des Unterkirche von S. Francesco in Assisi," *Mitteilungen des Kunsthistorischen Institutes in Florenz* 37 (1994): 1–28, especially 2. Lavin notes that the Order had kept several of Francis's habits and concludes that the Stripping of Christ was included in reference to these relics. On the motif of the Virgin covering Christ and its treatment in Pseudo-Anselm, see the 1986 article by A. Neff, "*Dialogus*," 105–8. Neff concludes that the text is Franciscan because of the inclusion of the Virgin covering Christ with her veil. I similarly discussed the Franciscan origins of these texts (Pseudo-Bede in particular) and images in "Byzantine Art and the Dugento," 185–7. For another view of the motif and its motivations, see R. Trexler, "Gendering Jesus Crucified," in *Iconography at the Crossroads*, Papers from the Colloquium Sponsored by the Index of Christian Art, Princeton Univ., 23–4 March 1990 (Princeton, 1993), 112.

40. See Chapter 1, Note 124. The appearance of the stripping of Christ just after the council of Narbonne is interesting as well in the context of the legend of the nude Christ at Narbonne. See K. Wessel, "Der Nackte Crucifixus von Narbonne," *Rivista di archeologia cristiana*, 43 (1967), 333–45. The legend is recounted in Gregory of Tours, *Miraculorum libri* VII. I am grateful to Genevra Kornbluth for this reference.

41. On the relaxation of the Narbonne statutes in the 1270s and 1280s, see Burr, *Olivi*, 8–9; for the same period, see Moorman, *History*, chap. 16, "Privilege and Poverty," 177–87.

42. For the background, see the discussion in Chapter 1, pp. 31–2. Much of the *Apologia* specifically addresses poverty, "voluntary" and "strict" to Bonaventure.

43. On this bull, see Lambert, *Franciscan Poverty*, 141–8; Moorman, *History*, 179–81. For the role of the Spiritual leader Peter John Olivi in the bull, see Burr, *Olivi*, 39 and 61–3; Burr argues that his involvement with the bull has been overstated.

44. For the three branches (the others in Provence, under Peter John Olivi, and in Tuscany, under Ubertino da Casale) and the history and eschatology of the Spirituals in the thirteenth and fourteenth centuries, see Lambert, *Franciscan Poverty*; Daniel, *Franciscan Concept*, 81–100; Moorman, *History*, 188–204; Burr, *Olivi*.

Ubertino, like Bonaventure, stressed Christ's stripping and nakedness on the cross; see his *Arbor vitae*, book 3, chap. 9, especially columns 13 and 14, and book 4, chap. 12, column 3.

45. Sta. Chiara was founded by Sancia di Maiorca, daughter-in-law of Mary of Hungary, the patron of Sta. Maria Donnaregina. For the intense Spiritual sympathies in the Angevin royal family, see Lambert, *Franciscan Poverty*, 181; for the two churches and the Spirituals protected by Sancia, see C. Bruzelius, "Hearing is Believing: Clarissan Architecture, ca. 1213–1340," *Gesta* 31 (1992): 83–91, especially 86–7. See also R. Musto, "Queen Sancia of Naples (1286–1345) and the Spiritual Franciscans," in *Women of the Medieval World: Essays in Honor of John H. Mundy*, ed. J. Kirshner and S. Wemple (Oxford, 1985), 179–214; A. Hoch, "Sovereignty and Closure during the Trecento: Queen Sancia's Patronage of the Poor Clares in Naples," forthcoming, which argues that Queen Mary and Sancia were, in fact, rivals, and that this rivalry colored their patronage of the two foundations.

46. It is true that the duecento image of the Stripping in the Lower Church was allowed to remain, and its typological parallel, Francis renouncing his father's patrimony, continued to be depicted in Conventual churches, such as Sta. Croce in Florence. It is also true that the period when the cycle was executed, the mid-teens, was a time of reform at Assisi; one might think that Michael of Cesena, the Minister General, would be especially interested in this image. So the absence of the Stripping in the Lorenzetti cycle is somewhat puzzling. Perhaps it was, by then, identified too closely with the Spirituals. For some of the complexities of these issues, see Schwarz, "Zerstört und Wiederhergestellt"; Goffen, *Spirituality*, especially her discussion of the Spiritual saint Louis of Toulouse (55–7;

81–3), and the review of her book by A. Ladis in *Renaissance Quarterly* 45 (1992): 370–2. Ladis raises important questions about Conventual tolerance for earlier images with probable Spiritual ramifications, and about the still largely unexplored question of the Spirituals' patronage of, and tolerance for, art. Carl Strehlke has also touched on this question in "A Celibate Marriage and Franciscan Poverty Reflected in a Neapolitan Trecento Diptych," *The J. Paul Getty Journal* 15 (1987): 79–96. He observes that the diptych, which he rightly terms a luxury object, was, paradoxically, commissioned by or for a woman who was "slightly fanatical . . . in her renunciation of worldly wealth" (96).

47. Gertrude Coor has already observed that the Ascent seems to have been popularized by the Franciscans; see her "Coppo," 18, note 21; she developed the thesis in greater detail in her dissertation, "Coppo di Marcovaldo: His Art in Relation to his Time" (New York Univ., 1948), 157 and 263, note 224.

For the Wellesley panel, see Stubblebine, *Guido*, fig. 59; Boskovits, "Opera probabile," fig. 17; and Derbes, "Images East and West," fig. 66; for the fresco at S. Antonio in Polesine, see Caselli, *Monastero*, plate 9; for the *Vita Christi*, Boskovits, "Opera probabile," fig. 13; Derbes, "Images East and West," fig. 67; for a color plate, B. Boehm, "Scenes from the Life of Christ and Life of the Blessed Gerard of Villamanga," in *Painting and Illumination in Early Renaissance Florence, 1300–1450*, exh. cat., Metropolitan Museum of Art (New York, 1994), fig. on p. 54; for the manuscript in Florence, see Neff, "Wicked Children," fig. 2. The Franciscan connections of the two images uniting the Stripping and the Ascent, the Melk miniature and the Ascoli fresco, have already been discussed; see Note 11. The conjunction of the Ascent of the Cross and the Funeral of St. Clare is interesting; as we will see, thirteenth-century preachers used the Ascent of the Cross as a metaphor for traveling "from the world to the Father." The image thus probably implied Clare's triumphant ascent to heaven; she becomes almost a Franciscan martyr. Stubblebine described the juxtaposition of the two scenes as being "as curious as anything we find in the entire Guidesque oeuvre," adding that Clare's devotion to the

cross might explain it (*Guido*, 103–4).

48. For a discussion of the rope around Christ's neck as a device popularized by the Order, see Chapter 5, pp. 132–5.

49. The Utrecht panel is one of a group of narratives, formerly in Badia Ardenga, ascribed to Guido. For the Badia Ardenga panels and the traditional assumption that they originally flanked the Madonna and Child for San Domenico, see Stubblebine, *Guido*, 54–60 and fig. 16. For challenges to this assumption, see van Os, *Sienese Altarpieces*, 24–8, with bibliography; for a reconstruction of the narratives and central panel, see Van Os, fig. 25.

50. *De perfectione vitae ad sorores*; De Vinck, *Works*, vol. 1, 240–1. See also the discussion of the theme in Chapter 5, pp. 133–4.

51. Ragusa and Green, *Meditations*, 333.

52. Ibid., 334.

53. ". . . In iniquorum loco inter ipsos etiam latrones suspensus ab ipsis iniquis blasphematur. . . ." Delorme, *Meditatio pauperis*, 71.

54. On this image see Schwartz, "Patronage and Franciscan Iconography," 33.

55. Ultimately, the images of the thief and Francis – both seated, nude, on the ground – call to mind the passage in Isaiah 3:24–6. The passage describes the stripping away of worldly goods – rope for a belt, baldness for an elegant coiffure, a sack-cloth for a mantle – and concludes: "Et desolata in terra sedebit." "Desolata" can be translated stripped, deprived (of the finery detailed in the passage above). As noted before, the passage is replete with imagery that the Franciscan order would identify with closely, and it is not surprisingly cited in thirteenth-century Franciscan texts (Bonaventure's *Expositio in Regulam Fratrum Minorum*; the *Meditatio pauperis*; for the use of Isaiah 3:24 in both, see Chapter 3, Note 85).

56. *P.L.*, vol. 159, column 289: "Ascendit arborem crucem." In this reference, Pseudo-Anselm draws on a body of exegetical tradition, though the canonical Gospels are silent on this subject, and the apocrypha provide little more (the *Acta Pilati*, Recension B notes that after Christ was stripped, the Jews and soldiers "raised Him and drew Him upon the cross" [Donehoo, *Apocryphal and Legendary Life of Christ*, 350]). Brief references to Christ's ascent of the cross appear occa-

sionally in the writings of the early Fathers of the Church. St. Ambrose, for instance, writes in a commentary on Luke, "Non enim suam, sed nostram crucem Christus ascendit" (*P.L.*, vol. 15, column 1923). Ambrose also states (*P.L.*, vol. 15, column 1924), that Christ ascended the cross as "currum suum triumphator ascendit," as a victor ascends a triumphal chariot. Another early reference to the theme appears in the ritual of the *Adoratio Crucis*, known in Jerusalem from the fourth century and in the West from the seventh or eighth, which states: "Domine Ihesu Christi, adoro te in cruce ascendentem. . . . " (Young, *Drama*, vol. 1, 117-19). For other references see Derbes, "Images East and West."

57. *Opera Omnia*, vol. 14, 229: "Erecta cruce Jesus ascendit et extendit bracchia; manus et pedes clavantur; quae videns piisima Mater, prae dolor deficit. . . ." Bonaventure refers even more briefly to the ascent in his *Passio Christi*, where he presents the reader with two alternatives: "Aut enim crucem erexerunt, et Christus ascendit ad crucem, aut certe crucem posuerunt in terram, et ibi eum clavis affixerunt" (*Opera Omnia*, vol. 14, 152). In his *Lignum vitae*, however (see De Vinck, *Works*, vol. 1, 123), Bonaventure describes only the nailing of Christ to the cross. Like the *Passio Christi*, Pseudo-Anselm, Pseudo-Bonaventure, and Ubertino da Casale all present the two versions. In Pseudo-Anselm, the Virgin first tells Anselm that Christ was nailed to the cross before it was erected (*P.L.*, vol. 159, column 281); only later does the author refer to Christ ascending the cross. Pseudo-Bonaventure, too, obligingly offers the reader both accounts. After describing Christ ascending the cross, he continues, "Or, if you prefer. . .," and recounts the second version (Ragusa and Green, *Meditations*, 334). See also Ubertino (*Arbor vitae*, chap. 12, column 3, lines 2–13); he first describes Christ extended and nailed to the cross on the ground, then shifts: "or whether he ascended the cross with ladders. . ." ("sive etiam per scalas crucem ascenderit. . ."), concluding that "ex evangelica historia non declaratur aperte."

58. *P.L.*, vol. 94, column 565: "Deinde parata cruce dicunt ei, Ascende, Jesu, ascende. O quam libenter ascendit, o quanto amore ista omnia pro nobis sustinuit, o quanta patien-

tia, o quanta mansueto!. . . Sic totus nudus in cruce elevatur et extenditur. Sed mater ejus amantissima velum suum, quod habebat in capite suo, posuit circa eum plena anxietate, et involvit locum verecundium. . . . Sic crudeliter elevatur, extenditur, et toto sacro corpore distenditur et dissipatur."

59. *P.L.*, vol. 184, column 752; vol. 182, column 932. On the typological link with Elisha, see Schiller, *Iconography*, vol. 2, 87; Derbes, "Byzantine Art and the Dugento," 192–3, note 24; and Neff, "Wicked Children," passim.

60. P. Cole, *The Preaching of the Crusades to the Holy Land, 1095–1270* (Cambridge, Mass., 1991), 169; the quotation is from Roger of Salisbury. For Cole's discussion of Roger, see 168–9; for the text, 227–31. For Eudes, see Cole, 179–81; for the text, 235–9. Cole also notes the typological connection to Elisha (169). She suggests that similar language appeared in a third sermon of 1283 (174–5).

61. Neff, "Wicked Children," passim.

62. On this text, see Chapter 1, Note 67.

63. Neff, "Wicked Children," 234.

64. See also Fleming, *From Bonaventure to Bellini*, 138–9, who similarly discusses the notion of ascent as a metaphor for entering the Franciscan order and embracing poverty. He, too, notes the typological importance of Elisha and the passage "Ascende, calve; ascende, calve." As he observes (138), the *Meditatio pauperis* "finds a crucial significance in the fact that the Apocalypse says *ascendentem* ab ortus solis" and not *descendentem*. The 'coming up from the east' speaks of the special mystery of Franciscan poverty, since the East, the land of sumptuous material life, means the world's riches that Francis rises above."

Interestingly, the passage from St. Ambrose's commentary on St. Luke mentioned above (Note 56) discusses Christ's Ascent of the Cross just after quoting Luke 9:23: "Take up your cross and follow me." As noted earlier, pp. 129–30, a closely related biblical passage (Matthew 16:24) was of central importance to the Order. The same commentary also refers to Christ's nudity ("vestimenta deposuit," *P.L.*, vol. 15, col. 1923; "Refert ergo considerare qualis ascendit. Nudum video: talis ergo ascendat qui saeculum vincere parat. . . ," *P.L.*, vol. 15, column 1924).

65. For the passage from the *Legenda maior*, see Habig, *Omnibus*, 698. For the sermon, see Doyle, *Disciple and the Master*, 138–40. Bonaventure's linking of this ascent of the ladder with Christ's Ascension is interesting; the Ascent of the Cross and Ascension were associated in the Byzantine liturgy, and Byzantine images of the Ascent of the Cross may have been formulated initially with the image of the Ascension in mind. See Derbes, "Images East and West," 142.

66. De Vinck, *Works*, vol. 4, 203. The association of the ladder to the cross and Jacob's ladder has a long history in Christian thought; see Mathews and Sanjian, *Armenian Gospel Iconography*, 132, and Derbes, "Images East and West," note 12. The ladder was also used as a metaphor for asceticism by John Climacus, on which see J. Martin, *The Illustration of the Heavenly Ladder of John Climacus* (Princeton, 1954), and Eisler, "The Athlete of Virtue," especially 84–5. As Eisler notes (85), Sts. Francis, Dominic, and Bonaventure all espoused asceticism; the imagery of ladders and ascent occurs often in Bonaventure (e.g. "Christ, our ladder" – De Vinck, *Works*, vol. 1, 10; "since we have to ascend the ladder of Jacob – ibid., 13; see also Fleming, *Literature*, 201). It is interesting, too, that the *Heavenly Ladder* was translated by the Franciscan Spiritual Angelo Clareno (see Chapter 1, Note 52), again suggesting that the imagery of ladders and ascent might have had reformist overtones.

67. De Vinck, *Works*, vol. 4, 61.

68. Ibid., *Works*, vol. 4, 6; see also Daniel, *Franciscan Concept*, 52–3, and the discussion in Chapter 2, pp. 65–7.

69. For Franciscan monuments in which the image appears, see Note 47. In another Franciscan work, the diptych from Sta. Chiara, Lucca, of c. 1255–60 (Introduction, Fig. 1), the notion of Christ's ascent to Calvary is cleverly implied: He places a foot on the hill on which the cross is erected. Elisha is similarly depicted walking uphill to Bethel in images of his mocking; for an example, see Neff, "Wicked Children," fig. 5. The notion of Francis as new Elisha also explains the unusual depictions of the Stigmatization of Francis in Sienese painting (Stubblebine, *Guido*, figs. 100–1), in which bears climb in trees and on rocks near the Poverello. As the biblical text notes, after the children mocked Elisha, bears promptly emerged from the woods to devour them. Stubblebine had noted the presence of the bears, but associated them with the remote locale of the Stigmatization and Francis's legendary empathy for animals (ibid., 22). Cook, "St. Francis Dossal," 13, suggests the possibility of a link between the bears and Francis as Elisha.

70. For Coor's argument that the cross was Franciscan, based on her assumption that the Ascent appeared in Franciscan contexts, see "Coppo," 18, note 21.

71. The fresco at Sta. Maria Donnaregina (Fig. 85), which depicts Christ being hoisted up to the cross rather than climbing the ladder, may indicate the final stage of the action, as described by Pseudo-Bede: "Then cruelly He is raised, extended, and with His entire sacred body He is spread and stretched apart" (*P.L.*, column 94, vol. 565).

The free embrace of martyrdom, so powerfully suggested by the Guidesque image, was also more directly expressed in the trecento; the execution of four Franciscans in India in 1321 provided a new and vivid exemplum, and this subject soon appeared in Franciscan monuments, such as the cloister of S. Francesco, Siena (see M. Seidel, "Gli affreschi di Ambrogio Lorenzetti nel Chiostro di San Francesco a Siena: riconstruzione e datazione," *Prospettiva* 18 [1979]: 10–20; for this cycle and other images of Franciscan martyrs, see also Frugoni, *Pietro and Ambrogio Lorenzetti*, 59–62).

CONCLUSION

1. *The Interpretation of Cultures* (New York, 1973), 89. Geertz's definition of culture, and its relevance for the study of medieval art, was noted by A. Cutler, *Imagery and Ideology in Byzantine Art* (Brookfield, Vt., 1992), vii.

2. Ragusa and Green, *Meditations*, 330.

3. *Franciscan Concept*, 33.

4. Offner, *Early Florentine Dossal*, 13–14, is the source of the provenance. He observed on the back of the panel an inscription, "probably of the eighteenth century," recording that "Francesca Teresa Capponi, abbess of an unspecified convent, had the frame readjusted at her expense, had provided the two principals with silver crowns, and had the whole adorned with glass ornaments" (13). Offner found an abbess, who "bore the

Christian names both of Francesca and Teresa," in an account of the Capponi family; the abbess (1705–75) was associated with the Augustinian convent of Sta. Maria dei Candeli in Florence. On the basis of the inscription, the reference to the abbess, and an eighteenth-century reference (to a "*tavola antichissima*" by Buonamico Buffalmacco in the old church of Sta. Maria dei Candeli), Offner assumed that the painting was destined for the church from the beginning. He then concluded:

> There is in fact nothing in the picture itself to invalidate this inference save possibly the appearance in it of St. Francis (at the foot of the Crucifixion). Since he is the only post-evangelical saint in these scenes and the only one inessential to the narrative, his presence raises the question of whether he was not introduced to celebrate the church for which the panel was painted (in which case the church may have been Franciscan) unless indeed his image simply commemorates the altar for which the panel was destined.

On Sta. Maria dei Candeli, see also W. and E. Paatz, *Die Kirchen von Florenz*, vol. 3 (Frankfort am Main, 1952), 178–84. The church was described in a papal bull of 1258 as a Camoldolite foundation, but a document of 1367 refers to it as Augustinian.

On Offner's authority, the Timken Museum's records ascribe the panel to this Augustinian church; I am grateful to James Peterson of the museum for providing me with a copy of the files. The internal evidence that the dossal was, in fact, a Franciscan commission is not discussed by most of the more recent writers to consider the panel (see the bibliography in the Introduction, Note 11).

The main question about the provenance is whether or not the panel was intended originally for Sta. Maria dei Candeli. Even if the panel hung in that church in the eighteenth century, we know nothing of its earlier history. It is also possible that Sta. Maria dei Candeli once housed a community of Clarisses. Though I know no textual evidence, suggestive visual evidence is provided by a trecento altarpiece of the Madonna della Misericordia in the Accademia, Florence (inv. 1890, no. 8562). The panel comes from Sta. Maria dei Candeli, and it depicts the Virgin sheltering a large group of nuns under her mantle. The nuns appear to wear Clarissan habits; they closely resemble the habit worn by Clare in Pacino di Buonaguida's *Tree of Life* panel also in the Accademia. See G. Bonsanti, *The Galleria della Accademia, Florence: Guide to the Gallery and Complete Catalogue* (Florence, 1987), 66. I am indebted to Adrian Hoch and Margaret Flansburg for their assistance with these points.

Thus the assertion that the San Diego panel came from Sta. Maria dei Candeli seems more plausible. The possible presence of the Clares in a convent invariably described as Augustinian is not as surprising as it may appear. Women's houses were strikingly fluid in their religious affiliations, as a look at Moorman's *Medieval Franciscan Houses* reveals. It was not at all uncommon for a convent to begin with one affiliation and change later in its history. For instance, the Clares of Cividale became Benedictines in 1427 (Moorman, 573); the Clares of S. Angelo di Panso, Assisi, united with the Cistercians in 1464 (ibid., 547). More specifically, a group of devout women at Montefalco settled in Sta. Croce in 1290 as Augustinians, but they dressed as Clares and were under the protection of Franciscan friars; in the fifteenth century, the convent housed twenty Clares and three Augustinians (ibid., 623–4). Another group of Augustinian canonesses at Sta. Magdalena, Montefalco, became Clares in 1329, then in 1502 reverted to their earlier Augustinian status (ibid., 624). A similar mix of Clarisses and Augustinians may account for the presence of explicitly Franciscan panels in an Augustinian church.

These frequent shifts may attest to the precarious financial situations of some of these female houses; their vow of poverty often did not exist in name only. A group of Florentine Clares at S. Francesco appealed to Cosimo de' Medici in 1465 for funds (ibid., 587). By 1470, the membership of the Clares at San Gimignano had dwindled to six. The banding together with other groups of women thus is readily understandable; it was a means of survival. For the hand-to-mouth existence of many female houses in fifteenth-century Florence, see G. Bruckner, "Monas-

teries, Friaries, and Nunneries in Quattrocento Florence," in *Christianity and the Renaissance: Image and Religious Imagination in the Quattrocento*, ed. T. Verdon and J. Henderson (Syracuse, N.Y., 1990), 54–5; by contrast, "most male monasteries and friaries were in moderately good economic condition throughout the fifteenth century" (51). Bruckner refers to the poverty of the Augustinian nuns at Sta. Maria dei Candeli on p. 55.

5. See Garrison's section XIX, "Horizontal Rectangular Dossals," *Index*, 139; he lists twenty-three examples of this type (nos. 357–79). The San Diego dossal is the only one with this disposition of scenes.

6. Smart, *Assisi Problem*, 17–29; Mitchell, "Imagery of the Upper Church," 113–34.

7. See Derbes, "Byzantine Art and the Dugento," chaps. 6 and 7.

8. Offner, *Early Florentine Dossal*, 10.

9. De Vinck, *Works*, vol. 4, 198.

10. See H. Maguire, *Art and Eloquence in Byzantium* (Princeton, 1981), chap. 3.

11. See Derbes, "Byzantine Art and the Dugento," chaps. 6 and 7.

12. Curiously, the first dated cross, the twelfth-century Lucchese example by Gullielmus, has the same program as the mid-thirteenth century Pisan cross for Sta. Bona. Both aprons consist, on the left, of the Betrayal, Flagellation, and Way to Calvary, and on the right, the Deposition, Entombment, and Three Marys. The Pisan Castellare cross (Garrison, *Index*, no. 514) might well have been identical, but its sixth apron panel is missing.

13. There were very probably only three episodes of the Passion before the Crucifixion: the Betrayal, the Flagellation, and the Ascent of the Cross. See Chapter 1, Note 25, for reconstructions.

14. For the links with the Perugia triptych, see Stubblebine, *Guido*, 54–5. Given the frequency with which Passion narratives were produced for the Clares, it may be that this altarpiece was originally in one of the Clarissan foundations in Siena. Sta. Petronilla, founded in 1219, was the oldest of the Clarissan houses in Siena; a second Sienese house, Sta. Maria at Ravacciano, was taken over by the Clares in 1257 (Moorman, *Franciscan Houses*, 664). The Perugia triptych was probably also for the sisters, as the presence of Clare on the shutter suggests.

15. See the Introduction, Note 22.

16. Boskovits, *Origins*, 40, note 66.

17. See the Introduction, p. 8.

18. Goffen, *Spirituality*, 30. She also considers the cross in the Uffizi and a second cross by the same painter (or a very similar hand) as indications of "the master's understanding and, as one may imagine, his sympathy with Franciscan spirituality"; both depict the central Christ as *Christus Patiens*.

19. If this cross was in fact a Clarissan commission, it may have been belonged to Monticelli, the major Clarissan establishment in Florence during the thirteenth century (on which see Moorman, *Franciscan Houses*, 586–7, and the forthcoming monograph on the Clares by J. Wood).

SELECTED BIBLIOGRAPHY

Airaldi, G., and B. Z. Kedar, eds. *I Comuni italiani nel regno crociato di Gerusalemme: Atti del Colloquio [The Italian Communes in the Crusading Kingdom of Jerusalem]* (Jerusalem, 24–8 May 1984). Genoa, 1986.

Alessandri, L. "Bullarium Pontificium quod exstat in Archivo Sacri Conventus S. Francisci Assisiensis." *Archivum Franciscanum Historicum* 10 (1917): 185–6.

Alexander, J. J. G., and A. C. de la Mare. *The Italian Manuscripts in the Library of Major J. R. Abbey.* New York, 1960.

Anderson, G. K. *The Legend of the Wandering Jew.* Providence, R.I., 1965.

Antony de Witt, A. *I mosaici del battistero di Firenze.* 5 vols. Florence, 1954–9.

Aubert, M., et al. *Corpus vitrearum Medii Aevi, France.* Vol. 1: *Les vitraux de Notre-Dame et de la Sainte-Chapelle de Paris.* Paris, 1959.

Aubert, M. et al., *Le vitrail français sous la haute direction du Musée des Arts Decoratifs de Paris.* Paris, 1958.

Avery, M. *The Exultet Rolls of South Italy.* Princeton, 1936.

Ayer, E. "Thirteenth-Century Imagery in Transition: The Berlinghiero Family of Lucca." Ph.D. diss., Rutgers University, 1991.

Ayres, L. "An Italian Romanesque Manuscript of Gregory the Great's *Moralia in Job.*" In *Florilegium in Honorem Carl Nordenfalk Octogenarii Contextum.* Stockholm, 1987.

Baldini, U., and O. Casazza. *The Crucifix by Cimabue.* N.p., 1982.

Barasch, M. *Gestures of Despair in Medieval and Early Renaissance Art.* New York, 1976.

Baron, S. W. *A Social and Religious History of the Jews.* 2nd. ed. New York and London, 1965.

Barr, C. *The Monophonic Lauda and the Lay Religious Confraternities of Tuscany and Umbria in the late Middle Ages.* Kalamazoo, Mich., 1988.

Battisti, E. *Cimabue.* University Park, Pa., and London, 1967.

Beckwith, J. *Early Christian and Byzantine Art.* Baltimore, 1970.

Bellosi, L. "La barba di San Francesco. (Nuove proposte per il 'problema di Assisi')." *Prospettiva* 22 (1980): 11–34.

Belting, H. *Die Basilica dei SS. Martiri in Cimitile und ihr frühmittelalterlicher Freskenzyklus.* Wiesbaden, 1962.

Belting, H. *Bild und Kult: Eine Geschichte des Bildes vor dem Zeitalter der Kunst.* Munich, 1990. Translated by E. Jephcott as *Likeness and Presence: A History of the Image before the Era of Art.* Chicago and London, 1994.

Belting, H. *Das Bild und sein Publikum im Mittelalter: Form und Funktion früher Bildtafeln der Passion.* Berlin, 1981. Translated by M. Bartusis and R. Meyer as *The Image and Its Public in the Middle Ages: Form and Func-*

tion of Early Paintings of the Passion New Rochelle, N.Y., 1990.

Belting, H. "The New Role of Narrative in Public Painting of the Trecento: *Historia* and Allegory." In *Pictorial Narrative in Antiquity and the Middle Ages*. National Gallery of Art, Studies in the History of Art, 16. Edited by H. Kessler and M. S. Simpson. Hanover, N.H., and London, 1985.

Belting, H. *Die Oberkirche von San Francesco in Assisi: Ihre Dekoration als Aufgabe und die Genese einer neuen Wandmalerei*. Berlin, 1977.

Belting, H. Review of *Byzantine Art and the West*, by O. Demus. *Art Bulletin* 54 (1972): 542-4.

Belting, H., ed. *Il medio oriente e l'occidente nell'arte del XIII secolo*. Bologna, 1982.

Berg, K. *Studies in Twelfth Century Tuscan Illumination*. Oslo, 1968.

Berger, D. "Mission to the Jews and Jewish-Christian Contacts in the Polemical Literature of the High Middle Ages." *American Historical Review* 91 (1986): 576-91.

Berliner, R. "Arma Christi." *Münchner Jahrbuch der bildenden Kunst* 6 (1955): 35-152.

Bernabò, M. "Un manoscritto bizantino e i francescani a Costantinopoli." In *Biblioteca del Sacro Convento di Assisi*. Vol. 1: *I libri miniati di eta romanica e gotica*. Edited by M. Assirelli, M. Bernabò, and G. B. Lulla. Assisi, 1988.

Bianchi, A. "Affreschi duecenteschi nel S. Pietro in Vineis in Anagni." In *Roma Anno 1300. Atti della IV settimana di studi di storia dell'arte medievale dell'Università di Roma "La Sapienza."* Edited by A. M. Romanini. Rome, 1983.

Bihalji-Merin, O. *Fresken und Ikonen: Mittelalterliche Kunst in Serbien und Makedonien*. Munich, 1958.

Bihl, M. "Statuta Generalia Ordinis edita in Capitulis Generalibis Celebratis Narbonae an. 1260, Assisii an. 1279 atque Parisiis an. 1292." *Archivum Franciscanum Historicum* 34 (1941): 13-94, 284-358.

Bisogni, F. "Iconografia e propaganda religiosa: Due cicli veronesi del Trecento." In *Scritti di storia dell'arte in onore di Ugo Procacci*. Edited by M. and P. Dal Poggetto. Milan, 1977.

Black, C. "The Origin of the Lucchese Cross Form." *Marsyas* 1 (1941): 27-40.

Blume, D. "Ordenskonkurrenz und Bildpolitik." In *Malerei und Stadtkultur in der Dantezeit*. Edited by H. Belting and D. Blume. Munich, 1989.

Blume, D. *Wandmalerei als Ordenspropaganda: Bildprogramme im Chorbereich franziskanischer Konvente Italiens bis zur Mitte des 14. Jahrhunderts*. Worms, 1983.

Bonaventure. *Opera Omnia*. 10 vols. Quaracchi-Florence, 1882-1902.

Bonsanti, G. *The Galleria della Accademia, Florence: Guide to the Gallery and Complete Catalogue*. Florence, 1987.

Bon Valsassina, C., and V. Garibaldi, *Dipinti, sculture e ceramiche della Galleria Nazionale dell'Umbria*. Florence, 1994.

Borboudakis, M. *Panaghia Kera: Byzantine Wall Paintings at Kritsa*. Athens, n.d.

Borsook, E. *The Mural Painters of Tuscany*. 2nd rev. ed. Oxford, 1980.

Boskovits, M. *Gemäldegalerie, Berlin, Katalog. Frühe Italienische Malerei*. Berlin, 1988.

Boskovits, M. "Gli affreschi della Sala dei Notari a Perugia e la pittura in Umbria alla fine del XIII secolo." *Bollettino d'Arte* 66 (1981): 1-41.

Boskovits, M. "Un'opera probabile di Giovanni di Bartolommeo Cristiani e l'iconografia della 'Preparazione alla Crocifissione.'" *Acta Historiae Artium* 11 (1965): 69-94.

Boskovits, M. *The Origins of Florentine Painting, 1100-1270*. Section 1, Vol. 1 of R. Offner, *Critical and Historical Corpus of Florentine Painting*. Florence, 1993.

Boskovits, M. *The Thyssen-Bornemisza Collection: Early Italian Painting 1290-1470*. New York, 1990.

Bracaloni, L. "Lo stemma francescano nell'arte." *Studi francescani* 7 (1921): 221-6.

Branner, R. *Manuscript Painting in Paris during the Reign of St. Louis: A Study of Styles*. Berkeley and Los Angeles, 1977.

Brink, J. "Cardinal Napoleone Orsini and Chiara della Croce: A Note on the *Monache* in Simone Martini's *Passion Altarpiece*." *Zeitschrift für Kunstgeschichte* 46 (1983): 419-24.

Brink, J. "Sts. Martin and Francis: Sources and Meaning in Simone Martini's Montefiore Chapel." In *Renaissance Studies in Honor of Craig Hugh Smyth*. Edited by A. Morrogh et al. Vol. 2. Florence, 1985.

Brooke, R. ed. *Scripta Leonis, Rufini et Angeli Sociorum S. Francisci: The Writings of Leo, Rufino, and Angelo, Companions of St. Fran-*

cis. Oxford Medieval Texts. London, 1970.

Bruckner, G. A. "Monasteries, Friaries, and Nunneries in Quattrocento Florence." In *Christianity and the Renaissance: Image and Religious Imagination in the Quattrocento*. Edited by T. Verdon and J. Henderson. Syracuse, N.Y., 1990.

Bruzelius, C. "Hearing is Believing: Clarissan Architecture, ca. 1213–1340." *Gesta* 31 (1992): 83–91.

Buchthal, H. "Studies in Byzantine Illumination of the Thirteenth Century." *Jahrbuch der Berliner Museen* 25 (1983): 27–102.

Bughetti, P. B. "Tabulae Capitulares, Provinciae Tusciae." *Archivum Franciscanum Historicum* 10 (1917): 413–97.

Burr, D. *Eucharistic Presence and Conversion in Late Thirteenth-Century Franciscan Thought.* Transactions of the American Philosophical Society, vol. 74, part 3. Philadelphia, 1984.

Burr, D. *Olivi and Franciscan Poverty: The Origins of the "Usus Pauper" Controversy.* Philadelphia, 1989.

Burresi, M., and A. Caleca. *Le croci dipinte.* Pisa, 1993.

Büttner, F. O. *Imitatio Pietatis: Motive der christlichen Ikonographie als Modelle zur Verähnlichung.* Berlin, 1983.

Bux, N. *Codici liturgici latini di Terra Santa – Liturgic Latin Codices of the Holy Land.* Fasano, 1990.

Bynum, C. "And woman His humanity: Female Imagery in the Religious Writing of the Later Middle Ages." In *Gender and Religion: On the Complexity of Symbols*, edited by C. Bynum, S. Harrell, and P. Richman. Boston, 1986. Reprinted in C. Bynum, *Fragmentation and Redemption: Essays on Gender and the Human Body in Medieval Religion.* New York, 1991.

Bynum, C. "Franciscan Spirituality: Two Approaches." *Medievalia et Humanistica* 7 (1976): 195–7.

Bynum, C. *Holy Feast and Holy Fast: The Religious Significance of Food to Medieval Women.* Berkeley, 1987.

Caleca, A. "Pittura del Duecento e del Trecento a Pisa e a Lucca." In *La pittura in Italia: Il Duecento e il Trecento.* Vol. 1. Edited by E. Castelnuovo. Milan, 1985.

Caleca, A. "A proposito del rapporto Cimabue-Giotto." *Critica d'arte* 43, nos. 157–9 (1978): 42–6.

Callman, E. "Thebiad Studies." *Antichità Viva* 14 (1975): 3–22.

Camille, M. *The Gothic Idol.* Cambridge and New York, 1989.

Camille, M. Review of *Bild und Kult: Eine Geschichte des Bildes vor dem Zeitalter der Kunst*, by H. Belting. *Art Bulletin* 74 (1992): 514–17.

Campini, D. *Giunta Pisano Capitini e le croci dipinti romaniche.* Milan, 1966.

Cannon, J. "The Creation, Meaning, and Audience of the Early Sienese Polyptych: Evidence from the Friars." In *Italian Altarpieces, 1250–1550.* Edited by E. Borsook and F. S. Gioffredi. Oxford, 1994.

Cannon, J. "Dating the Frescoes by the Maestro di S. Francesco at Assisi." *Burlington Magazine* 124 (1982): 65–9.

Cannon, J. "Dominican Patronage of the Arts in Central Italy: The *Provincia Romana*, c. 1220–c. 1320." Ph.D. diss., University of London, 1980.

Cannon, J. "Pietro Lorenzetti and the History of the Carmelite Order." *Journal of the Warburg and Courtauld Institutes* 50 (1987): 18–28.

Cannon, J. Review of *Wandmalerei als Ordenspropaganda: Bildprogramme im Chorbereich franziskanischer Konvente Italiens bis zur Mitte des 14. Jahrhunderts*, by D. Blume. *Burlington Magazine* 127 (1985): 234–5.

Cannon, J. "Simone Martini, the Dominicans, and the Early Sienese Polyptych." *Journal of the Warburg and Courtauld Institutes* 45 (1982): 69–93.

Carelli, E., and S. Casiello. *Sta. Maria Donnaregina in Napoli.* Naples, 1975.

Carlettini, I. "L'Apocalisse di Cimabue e la meditazione escatologica di S. Bonaventura." *Arte medievale* 7 (1993): 105–28.

Carli, E. "Affreschi senesi del Duecento." In *Scritti di storia dell'arte in onore di Ugo Procacci.* Edited by M. and P. dal Poggetto. Milan, 1977.

Carli, E. *Italian Primitives: Panel Painting of the Twelfth and Thirteenth Centuries.* New York, 1965.

Carli, E. *Pittura medievale pisana.* Milan, n.d.

Carli, E. *Sienese Painting.* New York, 1983.

Carli, E., and J. Vichi Imberciadori. *San Gimignano.* Milan, 1987.

Carpenter, M., trans. *Kontakia of Romanos, Byzantine Melodist.* 2 vols. Columbia, Mo., 1970.

Carr, A. W. *Byzantine Illumination 1150–1250: The Study of a Provincial Tradition.* Chicago and London, 1987.

Carr, A. W. "Byzantines and Italians in Cyprus: Images from Art." Paper presented at the Dumbarton Oaks Symposium on Byzantium and the Italians, 13th–15th Centuries, May 1993; forthcoming, *Dumbarton Oaks Papers*, 1995.

Carr, A. W. "A Group of Provincial Manuscripts from the Twelfth Century." *Dumbarton Oaks Papers* 36 (1982): 39–81.

Carr, A. W. "The Rockefeller-McCormick New Testament: Studies Toward the Reattribution of Chicago, University Library, Ms. 965." Ph.D. diss., University of Michigan, 1973.

Carr, A. W., and L. J. Morrocco. *A Byzantine Masterpiece Recovered: The Thirteenth-Century Murals of Lysi, Cyprus.* Austin, Tex., 1994.

Caselli, L. *Il monastero di S. Antonio in Polesine.* Ferrara, 1992.

Cassidy, B. "Introduction: Iconography, Texts, and Audience." In *Iconography at the Crossroads*, Papers from the Colloquium Sponsored by the Index of Christian Art, Princeton University, 23–4 March 1990. Princeton, 1993.

Castelnuovo, E., ed. *La pittura in Italia: Il duecento e il trecento.* 2 vols. Milan, 1985.

Châtillon, J. "*Nudum Christum Nudus Sequere*: Note sur les origines et la signification du thème de la nudité spirituelle dans les écrits de Saint Bonaventure." In *S. Bonaventura, 1274–1974.* Vol. 4. Grottaferrata, 1973.

Chazan, R. *Daggers of Faith: Thirteenth Century Christian Missionizing and Jewish Response.* Berkeley and Los Angeles, 1989.

Chiellini, C. *Cimabue.* Florence, 1988.

Chierici, G. *Il restauro della chiesa di S. Maria Donnaregina a Napoli.* Naples, 1934.

Cohen, J. *The Friars and the Jews: The Evolution of Medieval Anti-Judaism.* Ithaca and London, 1982.

Cohen, J. "The Jews as Killers of Christ in the Latin Tradition, from Augustine to the Friars." *Traditio* 39 (1983): 1–27.

Colwell, E. C., and H. R. Willoughby. *The Four Gospels of Karahissar.* 2 vols. Chicago, 1936.

Connor, C. *Art and Miracles in Medieval Byzantium: The Crypt at Hosios Lukas and its Frescoes.* Princeton, 1991.

Cook, W. R. "Early Images of St. Francis of Assisi in Rome." In *Exegisti Monumentum Aere Perennius: Essays in Honor of John Francis Charles.* Edited by B. Baker and J. Fischer. Indianapolis, 1994.

Cook, W. R. "Fraternal and Lay Images of St. Francis in the Thirteenth Century." In *Popes, Teachers, and Canon Law in the Middle Ages.* Edited by J. Sweeney and S. Chodorow. Ithaca, N.Y., and London, 1989.

Cook, W. R. "Margarito d'Arezzo's Images of St. Francis: A Different Approach to Chronology." *Arte Cristiana* 83 (1995): 83–90.

Cook, W. R. Review of *Spirituality in Conflict*, by R. Goffen. *American Historical Review* 95 (1990): 1179.

Cook, W. R. "The St. Francis Dossal in Siena: An Important Interpretation of the Life of Francis of Assisi." *Archivum Franciscanum Historicum* 87 (1994): 3–20.

Cook, W. R. "Tradition and Perfection: Monastic Typology in Bonaventure's *Life of St. Francis.*" *The American Benedictine Review* 33 (1982): 1–20.

Cook, W. R., and R. Herzman. "Bonaventure's Life of St. Francis and the Frescoes in the Church of San Francesco: A Study in Medieval Aesthetics." *Franziskanischen Studien* 59 (1977): 29–37.

Coor, G. "Coppo di Marcovaldo: His Art in Relation to the Art of his Time." *Marsyas* 5 (1947–9): 1–21.

Coor, G. "Coppo di Marcovaldo: His Art in Relation to his Time." Ph.D. diss., New York University, 1948.

Coor, G. "A Visual Basis for the Documents Relating to Coppo di Marcovaldo and his Son Salerno." *Art Bulletin* 28 (1946): 233–47.

Cormack, R. "Painting After Iconoclasm." In *Iconoclasm: Papers Given at the Ninth Spring Symposium of Byzantine Studies* (University of Birmingham, March 1975). Edited by A. Bryer and J. Herrin. Birmingham, 1977. Reprinted in *The Byzantine Eye: Studies in Art and Patronage.* London, 1989.

Corrie, R. "The Antiphonaries of the Conradin Bible Atelier and the History of the Franciscan and Augustinian Liturgies." *Journal of the Walters Art Gallery* 55 (1993): 65–88.

Corrie, R. "Artistic Means to Political Ends: Explaining the *Maniera Greca.*" Paper presented at the Dumbarton Oaks Symposium

on Byzantium and the Italians, 13th–15th Centuries, May 1993.

Corrie, R. "The Conradin Bible, Ms. 152, The Walters Art Gallery: Manuscript Illumination in a Thirteenth-Century Italian Atelier." Ph.D. diss., Harvard University, 1986.

Corrie, R. "The Perugia Triptych and the Transmission of Byzantine Art to the *Maniera Greca*." Papers from the XVIII International Congress of Byzantine Studies, August 1992, in press.

Corrie, R. "The Political Meaning of Coppo di Marcovaldo's Madonna and Child in Siena." *Gesta* 19 (1990): 61–75.

Corrigan, K. *Visual Polemics in the Ninth-Century Byzantine Psalters*. Cambridge and New York, 1992.

Corsi, D. "Aspetti dell'inquisizione fiorentina nel '200." In *Eretici e ribelli del XIII e XIV sec.: Saggi sullo spiritualismo francescano in Toscana* Toscana. Edited by D. Maselli. Pistoia, 1974.

Cotsonis, J. "On Some Illustrations in the Lectionary, Athos, Dionysiou 587." *Byzantion* 59 (1989): 5–19.

Cottas, V. *L'Influence du drame "Christos Paschon" sur l'art chrétien d'Orient*. Paris, 1931.

Cutler, A. "1204 and All That: The Reception of Byzantine Objects at Italian Hands." Paper presented at the Dumbarton Oaks Symposium on Byzantium and the Italians, 13th–15th Centuries, May 1993. Forthcoming in *Dumbarton Oaks Papers*, 1995, as "From Loot to Scholarship: Changing Modes in the Italian Response to Byzantine Artifacts, ca. 1200–1750."

Cutler, A. *Imagery and Ideology in Byzantine Art*. Brookfield, Vt., 1992.

Cutler, A. "Misapprehensions and Misgivings: Byzantine Art and the West in the Twelfth and Thirteenth Centuries." *Medievalia* 7(1984): 41–77.

Culter, A. "The Pathos of Distance: Byzantium in the Gaze of Renaissance Europe and Modern Scholarship." In *Reframing the Renaissance: Visual Culture in Europe and Latin America 1450–1650*. Edited with an Introduction by C. Farago. New Haven and London, 1995.

Cutler, A. "La 'questione bizantina' nella pittura italiana: Una versione alternativa della 'maniera greca.'" In *La pittura in Italia: L'Altromedioevo*. Edited by C. Bertelli. Milan, 1994.

Cuttler, A. and C. *The Jew as Ally of the Muslim: Medieval Roots of Anti-Semitism*. Notre Dame, Ind., 1986.

Da Morrona, A. *Pisa illustrata nelle arti del disegno*. Livorno, 1812.

Dahan, G. "Saint Bonaventure et les Juifs." *Archivum Franciscanum Historicum* 77 (1984): 369–405.

Daniel, E. R. *The Franciscan Concept of Mission in the High Middle Ages*. Lexington, Ky., 1975. Reprint, New York, 1992.

Davidsohn, R. *Forschungen zur Geschichte von Florenz*. Vol. 4. Berlin, 1908. Reprint, 1969.

Davis, C. "Education in Dante's Florence." *Speculum* 40 (1965): 415–35.

Della Porta, P. M., E. Genovesi and E. Lunghi. *Guide to Assisi, History and Art*. Assisi, 1992.

Delorme, P. F. "De Praedicatione cruciatae saec. XIII per fratres Minores." *Archivum Franciscanum Historicum* 9 (1916): 98–117.

Delorme, F. M., ed. *Meditatio pauperis in solitudine*. Florence, 1929.

Demus, O. *Byzantine Art and the West*. New York, 1970.

Demus, O. *Mosaics of Norman Sicily*. London, 1950.

Demus, O. "The Style of the Kariye Djami and its Place in the Development of Paleologan Art." In *The Kariye Djami*. Vol. 4: *Studies in the Art of the Kariye Djami and Its Intellectual Background*. Edited by P. Underwood. Princeton, 1975.

Der Nersessian, S. *Armenian Manuscripts*. Baltimore, 1973.

Der Nersessian, S. *L'Illustration des psautiers grecs du Moyen Âge*. Vol. 2: *Londres, Add. 19352*. Bibliothèque des Cahiers Archéologiques, 5. Paris, 1970.

Der Nersessian, S. *Miniature Painting in the Armenian Kingdom of Cilicia from the Twelfth to the Fourteenth Century*. With an introduction by A. W. Carr. Washington, D.C., 1993.

Derbes, A. "Byzantine Art and the Dugento: Iconographic Sources of the Passion Scenes in Italian Painted Crosses." Ph.D. diss., University of Virginia, 1980.

Derbes, A. "Documenting the Maniera Greca." *Abstracts of Papers*. Twentieth Annual Byzantine Studies Conference, University of Michigan, October 1994.

Derbes, A. "Images East and West: The Ascent of the Cross." In *The Sacred Image: East and*

West. Edited by R. Ousterhout and L. Brubaker. Champaign, Ill., 1995.

Derbes, A. "The Pistoia Lamentation." *Gesta* 23 (1984): 131–5.

Derbes, A. "Siena and the Levant in the Later Dugento." *Gesta* 28 (1989): 190–204.

Deshman, R. "Servants of the Mother of God in Byzantine and Medieval Art." *Word and Image* 5 (1989): 33–70.

De Vinck, J., trans. *The Works of Bonaventure.* 4 vols. Paterson, N.J., 1960.

De Wald, E. *The Illustrations in the Manuscripts of the Septuagint.* Vol. 3: *Psalms and Odes.* Vol. 1: *Vaticanus Graecus 1927.* Princeton, 1941.

Dickson, G. "The Flagellants of 1260 and the Crusades." *Journal of Medieval History* 15 (1989): 227–67.

Dijk, S. Van. *Sources of the Modern Roman Liturgy.* Leiden, 1963.

Dijk, S. Van, and J. Hazelden Walker. *The Origins of the Modern Roman Liturgy: The Liturgy of the Papal Court and the Franciscan Order.* Westminster, Md., 1960.

Dinora, C. "Aspetti dell'inquisizione fiorentina nel '200." In *Eretici e ribelli del XIII e XIV secolo: saggi sullo spiritualismo francescano in Toscana.* Edited by D. Maselli. Pistoia, 1974.

Djurić, V. *Sopoćani.* Leipzig, 1967.

Donehoo, J. *The Apocryphal and Legendary Life of Christ.* New York, 1903.

Donovan, C. *The de Brailes Hours: Shaping the Book of Hours in Thirteenth-Century Oxford.* Toronto and Buffalo, 1991.

Downey, G., trans. *Description of the Church of the Holy Apostles at Constantinople,* by N. Mesarites. Philadelphia, 1957.

Doyle, E., trans. *The Disciple and the Master: St. Bonaventure's Sermons on St. Francis of Assisi.* Chicago, 1983.

Dufrenne, S. *L'Illustration des psautiers grecs du Moyen Age.* Vol. 1. Paris, 1966.

Dujčev, I. "Traits de polémique dans la peinture murale de Zemen." *Zbornik za Likovne umetnosti* 8 (1972): 117–28.

Dunkerton, J., et al. *Giotto to Dürer: Early Renaissance Painting in the National Gallery.* New Haven and London, 1991.

Eisler, C. "The Athlete of Virtue: The Iconography of Asceticism." In *De Artibus Opuscula XV: Essays in Honor of Erwin Panofsky.* Vol. 1. Edited by M. Meiss. New York, 1961.

Epstein, A. W. "The Rebuilding and Redecoration of the Holy Apostles in Constantinople." *Greek, Roman, and Byzantine Studies* 23 (1982): 79–92.

Evans, H. "Cilician Manuscript Illumination: The Twelfth, Thirteenth, and Fourteenth Centuries." In *Treasures in Heaven: Armenian Illuminated Manuscripts.* Edited by T. F. Mathews and R. S. Wieck. New York, 1994.

Evans, H. "Manuscript Illumination at the Armenian Patriarchate in Hromkla and the West." Ph.D. diss., Institute of Fine Arts, New York University, 1991.

Field, I. "Pietro Cavallini and his School: A Study in Style and Iconography of the Frescoes in Rome and in Naples." Ph.D. diss., University of Wisconsin, 1958.

Fisher, E. "Icon and Rhetoric: Psellos on the Crucifixion," *Abstracts of Papers.* Eighteenth Annual Byzantine Studies Conference, University of Illinois, October 1992.

Fleming, J. F. *From Bonaventura to Bellini: An Essay in Franciscan Exegesis.* Princeton, n.d. (c. 1982).

Fleming, J. *An Introduction to the Franciscan Literature of the Middle Ages.* Chicago, 1977.

Folda, J. *Crusader Manuscript Illumination at Saint-Jean d'Acre, 1275–1291.* Princeton, 1976.

Francesco in Italia, nel mondo. Milan, 1990.

Freedberg, D. *The Power of Images: Studies in the History and Theory of Response.* Chicago and London, 1989.

Freuler, G., and M. Mallory. "Der Altar des Beato Philippino Ciardelli in S. Francesco in Montalcino, 1382." *Pantheon* 47 (1989): 21–35.

Frugoni, C. *Francesco e l'invenzione delle stimmate: Una storia per parole e immagine fino a Bonaventura e Giotto.* Turin, 1993.

Frugoni, C. *Pietro and Ambrogio Lorenzetti.* Florence, 1988.

Gaddori, P. F. "Inventaria Clarissarum." *Archivum Franciscanum Historicum* 9 (1916): 294–346.

Gardner, J. "Altars, Altarpieces, and Art History: Legislation and Usage." In *Italian Altarpieces, 1250–1550.* Edited by E. Borsook and F. S. Gioffredi. Oxford, 1994.

Gardner, J. "The Cappellone di S. Nicola at Tolentino." In *Italian Church Decoration of the Middle Ages and Early Renaissance: Functions, Forms, and Regional Traditions.* Edited by W. Tronzo. Villa Spelman Colloquia, Vol. 1. Bologna, 1989.

Gardner, J. "The Louvre *Stigmatization* and the

Problem of the Narrative Altarpiece." *Zeitschrift für Kunstgeschichte* 45 (1982): 217–47.

Garrison, E. B. "Additional Certainly, Probably, and Possibly Lucchese Manuscripts I: Two Manuscripts of S. Michele di Guamo." *Bibliofilia* 74, part 2 (1972): 129–55.

Garrison, E. B. "A Berlinghieresque Fresco in S. Stefano, Bologna." *Art Bulletin* 28 (1946): 211–32.

Garrison, E. B. "A Checklist of North Italian Geometrical Manuscripts." In *Studies in the History of Medieval Italian Painting*. Vol. 4, nos. 3 and 4. Florence, 1960.

Garrison, E. B. "Contributions to the History of Twelfth-Century Umbro-Roman Painting VIII. The Italian Byzantine-Romanesque Fusion in the Second Quarter of the Twelfth Century." In *Studies in the History of Medieval Italian Painting*. Vol. 4, no. 2. Florence, 1961.

Garrison, E. B. "Contributions to the History of Twelfth-Century Umbro-Roman Painting VIII. Supplement IV. Precursors of the Revival." In *Studies in the History of Medieval Italian Painting*. Vol. 4, no. 2. Florence, 1961.

Garrison, E. B. *Italian Romanesque Panel Painting: An Illustrated Index*. Florence, 1949. Reprint, New York, 1976.

Garrison, E. B. "A Lucchese Passionary related to the Sarzana Crucifix." *Art Bulletin* 35 (1953): 109–19.

Garrison, E. B. "Note on the Survival of Thirteenth-Century Panel Paintings in Italy." *Art Bulletin* 54 (1972): 140.

Garrison, E. B. "The Oxford Christ Church Library Panel and the Milan Sessa Collection Shutters. A Tentative Reconstruction of a Tabernacle and a Group of Romanizing Florentine Panels." *Gazette des Beaux-Arts* 88 (1946): 321–46.

Garrison, E. B. "Pictorial Histories XII: A Gradual of S. Stefano, Bologna." In *Studies in the History of Medieval Italian Painting*. Vol. 4, no. 1. Florence, 1960.

Garrison, E. B. "Post-War Discoveries. Early Italian Paintings. I." *Burlington Magazine* 89 (1947): 147–52.

Garrison, E. B. "Toward a New History of Early Lucchese Painting." *Art Bulletin* 33 (1951): 11–31.

Garrucci, R. *Storia dell'arte cristiana nei primi otto secoli della chiesa*. Vol. 5. Prato, 1879.

Gautier, P. "Un discours inédit de Michel Psellos sur la crucifixion." *Revue des études byzantines* 49 (1991): 5–66.

Geanakoplos, D. "Bonaventura, the Two Mendicant Orders, and the Greeks at the Council of Lyons." In *Studies in Church History*, 13: *The Orthodox Churches and the West*. Oxford, 1976.

Geanakoplos, D. *Emperor Michael Palaeologus and the West, 1258–1262: A Study in Byzantine-Latin Relations*. Cambridge, Mass., 1959.

Genovese, R. A. *La chiesa trecentesca di Donna Regina*. Naples, 1993.

Georgopoulou, M. "Late Medieval Crete and Venice: An Appropriation of Byzantine Heritage." *Art Bulletin* 77 (1995): 479–96.

Gilbert, C. "Some Special Images for Carmelites, circa 1330–1430." In *Christianity and the Renaissance: Image and Religious Imagination in the Quattrocento*. Edited by T. Verdon and J. Henderson. Syracuse, 1990.

Gilbert, C. "A Statement of the Aesthetic Attitude Around 1230." *Hebrew University Studies in Literature and the Arts* 13 (1985): 125–52.

Goez, W. "Franziskus-Fresken und Franziskaner in Konstantinopel." In *Festschrift Herbert Siebenhüner*. Edited by E. Hubala and G. Schweikhart. Wurzburg, 1978.

Goffen, R. *Spirituality in Conflict: Saint Francis and Giotto's Bardi Chapel*. University Park, Pa., and London, 1988.

Golubovich, G. *Biblioteca bio-bibliografica della Terra Santa e dell'Oriente Francescano*. Quaracchi-Florence, 1906.

Gordon, D. "A Perugian Provenance for the Franciscan Double-Sided Altarpiece by the St. Francis Master." *Burlington Magazine* 124 [1982]: 70–7.

Gounaris, G. *The Church of Christ in Veria*. Thessaloniki, 1991.

Grabar, A. *Christian Iconography: A Study of its Origins*. Princeton, 1968.

Gravina, D. B. *Il Duomo di Monreale*. Palermo, 1859.

Grayzel, S. "Popes, Jews, and Inquisition, from 'Sicut' to 'Turbato.'" In *Essays on the Occasion of the Seventieth Anniversary of the Dropsie University (1909–1979)*. Philadelphia, 1979.

Grayzel, S. *The Church and the Jews in the XIIIth Century*. Rev. ed. New York, 1966.

Gregori, M., and R. Longhi. "La pittura umbra

della prima metà del Trecento, lezioni di Roberto Longhi nell'anno accademico 1953–1954." *Paragone* no. 281 (1973): 3–44.

Grundmann, H. "Die Bulle 'Quo Elongati' Papst Gregors IX." *Archivum Franciscanum Historicum* 54 (1961): 3–5; 20–25.

Haase, A. "Bonaventure's *Legenda Maior*: A Redaction Critical Approach (St. Francis of Assisi)." Ph.D. diss., Fordham University, 1990.

Habig, M., ed. *St. Francis of Assisi: Writings and Early Biographies. English Omnibus of the Sources for the Life of St. Francis.* Chicago, 1973.

Hager, H. *Die Anfange des italienischen Altarbildes.* Munich, 1962.

Hahn, C. "Absent No Longer: The Sign and the Saint in Late Medieval Pictorial Hagiography." In *Hagiographie und Kunst: Der Heiligenkult in Schrift, Bild und Architektur.* Edited by G. Kerscher. Berlin, 1993. [by typographical error, published as "Absent no Longer: The Saint and the Saint. . ."]

Hall, M. "The Italian Rood Screen: Some Implications for Liturgy and Function." In *Essays Presented to Myron P. Gilmore,* vol. 2. Florence, 1978.

Hall, M. "The *Tramezzo* in Santa Croce, Florence, Reconstructed." *Art Bulletin* 56 (1974): 325–41.

Hallensleben, H. "Zur Frage des byzantinischen Ursprungs des monumentalen Kruzifixe, 'wie die Lateiner sie verehren.'" In *Festschrift für Eduard Trier zum 60. Geburtstag.* Berlin, 1981.

Hamann-MacLean, R., and H. Hallensleben. *Die Monumentalmalerei en Serbien und Makedonien vom 11. bis zum frühen 14. Jahrhundert.* Giessen, 1963.

Hamburger, J. Review of *Images on the Edge: The Margins of Medieval Art,* by M. Camille. *Art Bulletin* 75 (1993): 319–26.

Hamburger, J. *The Rothschild Canticles: Art and Mysticism in Flanders and the Rhineland circa 1300.* New Haven, 1991.

Hatfield, R. "The Tree of Life and the Holy Cross: Franciscan Spirituality in the Trecento and Quattrocento." In *Christianity and the Renaissance: Image and Religious Imagination in the Quattrocento.* Edited by T. Verdon and J. Henderson. Syracuse, N. Y., 1990.

Herlihy, D. *Pisa in the Early Renaissance.* New Haven, 1958.

Hoch, A. "St. Martin of Tours: His Transformation into a Chivalric Hero and Franciscan Ideal." *Zeitschrift für Kunstgeschichte* 50 (1987): 471–82.

Hoch, A. "Simone Martini's St. Martin Chapel in the Lower Basilica of San Francesco, Assisi." Ph.D. diss., University of Pennsylvania, 1983.

Hoch, A. "Sovereignty and Closure during the Trecento: Queen Sancia's Patronage of the Poor Clares in Naples," forthcoming.

Hoeniger, C. S. "Cloth of Gold and Silver: Simone Martini's Techniques for Representing Luxury Textiles." *Gesta* 30 (1991): 154–62.

Homburger, O. "Über zwei deutsche Bilderhandschriften des 13. Jahrhunderts." In *Festschrift für Erich Meyer zum sechzigsten Geburtstag.* Hamburg, 1959.

Hood, W. *Fra Angelico at San Marco.* New Haven and London, 1993.

Hood, W. "Fra Angelico at San Marco: Art and the Liturgy of Cloistered Life." In *Christianity and the Renaissance: Image and Religious Imagination in the Quattrocento.* Edited by T. Verdon and J. Henderson. Syracuse, N. Y., 1990.

Hovey, W. *Treasures of the Frick Art Museum.* Pittsburgh, 1975.

Huber, R. *A Documentary History of the Franciscan Order from the Birth of St. Francis to the Division of the Order under Leo X (1182–1517).* Milwaukee and Washington, D.C., 1944.

Hughes, D. O. "Distinguishing Signs: Ear-rings, Jews, and Franciscan Rhetoric in the Italian Renaissance City." *Past and Present* 112 (1986): 3–59.

Hyslop, F. E. "A Byzantine Reliquary of the True Cross from the Sancta Sanctorum." *Art Bulletin* 16 (1934): 333–40.

Iazeolla, T. "Gli affreschi di S. Sebastiano ad Alatri." In *Roma Anno 1300. Atti della IV settimana di studi di storia dell'arte medievale dell'Università di Roma "La Sapienza."* Edited by A. M. Romanini. Rome, 1983.

Jacoff, M. "The Bible of Charles V and Related Works: Bologna, Byzantium, and the West in the late Thirteenth Century." In *Il medio oriente e l'occidente nell'arte del XIII secolo.* Edited by H. Belting. Bologna, 1982.

James, M. R. *The Apocryphal New Testament.* Oxford, 1926.

Kaftal, G. *Iconography of the Saints in Tuscan Painting.* Florence, 1952.

Kaftal, G. *St. Dominic in Early Tuscan Painting.* Oxford, 1948.

Kartsonis, A. *Anastasis: The Making of an Image.* Princeton, 1986.

Kazhdan, A., and A. W. Epstein. *Change in Byzantine Culture in the Eleventh and Twelfth Centuries.* Berkeley, 1985.

Kazhdan, A., and H. Maguire. "Byzantine Hagiographical Texts as Sources on Art." *Dumbarton Oaks Papers* 45 (1991): 1–22.

Kedar, B. Z. *Crusade and Mission: European Approaches toward the Muslims.* Princeton, 1984.

Kedar, B. Z. "*De Iudeis et Sarracenis*: On the Categorization of Muslims in Medieval Canon Law." In *The Franks in the Levant, 11th to 14th Centuries.* Norfolk, 1993.

Kempers, B. *Painting, Power and Patronage: The Rise of the Professional Artist in Renaissance Italy.* London, 1993.

Kennedy, V. L. "The Franciscan *Ordo Missae* in the Thirteenth Century." *Medieval Studies* 2 (1940): 204–22.

Kieckhefer, R. "Varieties of Late Medieval *Vita Christi*." Paper presented at the 29th International Congress on Medieval Studies, Western Michigan University, Kalamazoo, Mich., May 1994.

Kitzinger, E. "The Byzantine Contribution to Western Art of the Twelfth and Thirteenth Centuries." *Dumbarton Oaks Papers* 20 (1966): 25–48.

Kosloff, O. "Die Ikonographie der Passionsmomente zwischen der Kreuztragung und dem Tode Christi." *Het Gildeboek* (1934): 1–25.

Krüger, K. *Der Frühe Bildkunst des Franziskus in Italien: Gestalt- und Funktionswandel des Tafelbildes im 13. und 14. Jahrhunderts.* Berlin, 1992.

Laborde, A. de. *La Bible moralisée.* Vol. 2. Paris, 1912.

Ladis, A. Review of *Spirituality in Conflict*, by R. Goffen. In *Renaissance Quarterly* 45 (1992): 370–2.

Lambert, M. D. *Franciscan Poverty: The Doctrine of the Absolute Poverty of Christ and the Apostles in the Franciscan Order, 1210–1323.* London, 1961.

Lasareff, V. *Old Russian Murals and Mosaics.* London, 1966.

Lavin, M. A. *The Place of Narrative: Mural Decoration in Italian Churches, 431–1600.* Chicago and London, 1990.

Lea, H. C. *A History of the Inquisition of the Middle Ages.* Vol. 2. New York, 1955.

Legendae S. Francisci Assisiensis saeculis XIII et XIV conscriptae. Rome, 1906.

Lesnick, D. *Preaching in Medieval Florence: The Social World of Franciscan and Dominican Spirituality.* Athens, Ga., and London, 1989.

Lipton, S. "Jews, Heretics, and the Sign of the Cat in the *Bible moralisée*." *Word and Image* 8 (1992): 362–77.

Lipton, S. "Jews in the Commentary Text and Illustrations of the Early Thirteenth-Century Bibles Moralisées." Ph.D. diss., Yale University, 1991.

Little, L. *Religious Poverty and the Profit Economy in Medieval Europe.* Ithaca, 1978.

Little, L. K. "Saint Louis' Involvement with the Friars." *Church History* 33 (1964): 125–48.

Loerke, W. "The Miniatures of the Trial in the Rossano Gospels." *Art Bulletin* 43 (1961): 171–95.

Long, J. "Bardi Patronage at Santa Croce in Florence, c. 1320–1343." Ph.D. diss., Columbia University, 1988.

Long, J. "Salvation through Meditation: The Tomb Frescoes in the Holy Confessors Chapel at Santa Croce in Florence." *Gesta* 34 (1995): 77–88.

Longhi, R. "Giudizio sul Duecento." *Proporzione* 2 (1948): 5–30.

Maginnis, H. "Assisi Revisited: Notes on Recent Observations." *Burlington Magazine* 117 (1975): 511–17.

Maginnis, H. "The Passion Cycle in the Lower Church of San Francesco, Assisi: The Technical Evidence." *Zeitschrift für Kunstgeschichte* 39 (1976): 193–208.

Maginnis, H. "Pietro Lorenzetti: A Chronology." *Art Bulletin* 66 (1984): 183–211.

Maginnis, H. "Places Beyond the Seas: Trecento Images of Jerusalem." *Source* 13 (1994): 1–8.

Maginnis, H. "Tabernacle 35." *Source* 12 (1993): 1–4.

Maguire, H. *Art and Eloquence in Byzantium.* Princeton, 1981.

Maguire, H. "The Depiction of Sorrow in Middle Byzantine Art." *Dumbarton Oaks Papers* 31 (1977): 123–74.

Mahr, A. *The Cyprus Passion Play.* Notre Dame, Ind., 1947.

Maier, C. *Preaching the Crusades: Mendicant Friars and the Cross in the Thirteenth Century.*

Cambridge, 1994.

Mango, C., and E. Hawkins, "The Hermitage of St. Neophytos and its Wall Paintings." *Dumbarton Oaks Papers* 20 (1966): 121-206.

Marava-Chatzēnikolaou, A., and C. Touphexē-Paschou. *Katalogos Mikrographiōn Vyzantinōn Cheirographōn tes Ethnikēs Vivliothēkēs tēs Hellados.* Vol. 1. Athens, 1978.

Mariano d'Alatri, P. *Eretici e inquisitori in Italia.* Vol. 1: *Il duecento.* Rome, 1986.

Mariano d'Alatri, P. "L'inquisizione francescana nell'Italia centrale nel secolo XIII." *Collectanea francescana* 22 (1952): 225–50.

Mariano d'Alatri, P. *L'inquisizione francescana nell'Italia centrale nel secolo XIII.* Rome, 1954.

Marques, L. *La peinture du duecento en Italie centrale.* Paris, 1987.

Marrow, J. "*Circumdederunt me canes multi:* Christ's Tormentors in Northern European Art of the Late Middle Ages and Early Renaissance." *Art Bulletin* 59 (1977): 167–81.

Marrow, J. *Passion Iconography in Northern European Art of the Late Middle Ages and Early Renaissance: A Study on the Transformation of Sacred Metaphor into Descriptive Narrative.* Kontrijk, Belgium, 1979.

Martin, J. "The Dead Christ on the Cross in Byzantine Art." In *Late Classical and Medieval Studies in Honor of Albert Matthias Friend, Jr.* Edited by K. Weitzmann. Princeton, 1955.

Martindale, A. *Simone Martini: Complete Edition.* New York and Oxford, 1988.

Mathews, T. F., and A. K. Sanjian. *Armenian Gospel Iconography: The Tradition of the Glajor Gospel.* Washington, D.C., 1991.

Matthiae, G. *Pittura romana del medioevo.* Rome, 1965.

Maxwell, K. "Paris, Bibliothèque Nationale, Codex Grec 54: An Analysis of the Text and Miniatures." Ph.D. diss., University of Chicago, 1986.

Meersseman, G. G. *Dossier de l'Ordre de la Pénitence au XIII siècle.* Fribourg, 1961.

Meiss, M. *Painting in Florence and Siena after the Black Death.* Princeton, 1951.

Mellinkoff, R. *Outcasts: Signs of Otherness in Northern European Art of the Late Middle Ages.* 2 vols. Berkeley, 1993.

Meyer, K. "St. Job as a Patron of Music." *Art Bulletin* 36 (1954): 21–31.

Millet, G. *Recherches sur l'iconographie de l'évangile.* 1916. Reprint, Paris, 1960.

Millet, G., and A. Frolow. *La peinture du moyen âge en Yougoslavie.* Vols. 1–3. Paris, 1954–62.

Millet, G., and T. Velmans. *La peinture du Moyen Age en Yougoslavie.* Vol. 4. Paris, 1969.

Mitchell, C. "The Imagery of the Upper Church at Assisi." In *Giotto e il suo tempo,* Congresso Internazionale Assisi-Padua-Florence, 1967.

Mongan, A. and E. *European Paintings in the Timken Art Gallery.* San Diego, 1969.

Moorman, J. *A History of the Franciscan Order from its Origins to the Year 1517.* Oxford, 1957.

Moorman, J. *Medieval Franciscan Houses.* New York, 1983.

Moskowitz, A. *Nicola Pisano's Arca di San Domenico and its Legacy.* College Art Association Monographs. University Park, Pa, 1994.

Mouriki, D. "Palaeologan Mistra and the West." In *Byzantium and Europe.* First International Byzantine Conference, Delphi, 1985. Athens, 1987.

Mouriki, D. "Stylistic Trends in Monumental Painting of Greece at the Beginning of the Fourteenth Century." In *L'art byzantin au debut du XIV siècle,* Symposium de Gračanica, 1973. Belgrade, 1978.

Mouriki, D. *Thirteenth-Century Icon Painting in Cyprus.* Athens, 1986. Reprinted from *The Griffon,* 1–2 (1985–6): 9–77.

Mouriki, D. "The Wall Paintings of the Pantanassa at Mistra: Models of a Painter's Workshop in the Fifteenth Century." In *The Twilight of Byzantium.* Edited by S. Čurčić and D. Mouriki. Princeton, 1991.

Murray, A. "Archbishop and Mendicants in Thirteenth-Century Pisa." In *Stellung und Wirksamkeit der Bettelorden in der städtischen Gesellschaft.* Edited by K. Elm. Berlin, 1981.

Musto, R. "Queen Sancia of Naples (1286–1345) and the Spiritual Franciscans." In *Women of the Medieval World: Essays in Honor of John H. Mundy.* Edited by J. Kirshner and S. Wemple. Oxford, 1985.

Neff, A. "The *Dialogus Beatae Mariae et Anselmi de Passione Domini:* Toward an Attribution." *Miscellanea Francescana* 86 (1986): 105–8.

Neff, A. "A New Interpretation of the *Supplicationes Variae* Miniatures." In *Il medio ori-*

ente e l'occidente nell'arte del XIII secolo.
Edited by H. Belting. Bologna, 1982.

Neff, A. (as Amy Neff McNeary). "The *Supplicationes Variae* in Florence: A Late Dugento Manuscript." Ph.D. diss., University of Pennsylvania, 1977.

Neff, A. "Wicked Children on Calvary and the Baldness of St. Francis." *Mitteilungen des Kunsthistorischen Institutes in Florenz* 34 (1990): 215–44.

Neil, K. "St. Francis of Assisi, the Penitent Magdalen, and the Patron at the Foot of the Cross." *Rutgers Art Review* 9–10 (1988–9): 83–110.

Nelson, R. "A Byzantine Painter in Trecento Genoa: The *Last Judgment* at S. Lorenzo." *Art Bulletin* 67 (1985): 548–66.

Nelson, R. "The Byzantine Question." *Abstracts of Papers*, Eleventh Annual Byzantine Studies Conference, University of Chicago, 1985.

Nelson, R. "Illustrated Greek Manuscripts in the Italian Renaissance." Paper presented at the Dumbarton Oaks Symposium on Byzantium and the Italians, 13th–15th Centuries, May 1993. Forthcoming in *Dumbarton Oaks Papers*, 1995, as "The Italian Appreciation and Appropriation of Illuminated Byzantine Manuscripts, ca. 1200–1450."

Nelson, R. "Italian Art and the Levant," College Art Association 73rd Annual Conference, *Abstracts and Program Statements*, Los Angeles, 1985.

Nichols, S. *Romanesque Signs: Early Medieval Narrative and Iconography.* New Haven and London, 1983.

O'Connell, P. F. "The *Lignum Vitae* of Bonaventure and the Medieval Devotional Tradition." Ph.D. diss., Fordham University, 1985.

Offner, R. *A Critical and Historical Corpus of Florentine Painting.* Section III, vols 2, 5, and 6. New York, 1930–56.

Offner, R. *An Early Florentine Dossal.* N.p., n.d. [Florence, c. 1946].

Omont, H. *Évangiles avec peintures byzantines du XIe siècle.* 2 vols. Paris, 1908.

Ordoardo, G. "La custodia francescana di Terra Santa nel VI centenario della sua costituzione (1342–1942)." *Miscellanea francescana* 43 (1943): 217–56.

Os, H. W. van. "The Discovery of an Early Man of Sorrows on a Dominican Triptych." *Journal of the Warburg and Courtauld Institutes* 41 (1978): 65–75.

Os, H. W. van. "St. Francis of Assisi as a Second Christ in Early Italian Painting." *Simiolus* 7 (1974): 115–32.

Os, H. W. van. *Sienese Altarpieces, 1215–1460: Form, Content, Function.* Vol. 1: *1215–1344.* Groningen, 1984.

Ousterhout, R., and L. Brubaker, eds. *The Sacred Image: East and West.* Urbana, Ill., and Chicago, 1995.

Paatz, W. and E. *Die Kirchen von Florenz.* Vol. 3. Frankfort am Main, 1952.

Pace, V. "Pittura del duecento e del trecento a Roma e nel Lazio." In *La pittura in Italia: Il Duecento e il Trecento.* Vol. 2. Edited by E. Castelnuovo. Milan, 1985.

Pächt, O., C. R. Dodwell, and F. Wormald. *The St. Albans Psalter.* London, 1960.

Paliaga, F., and S. Renzoni. *Le chiese di Pisa: Guida alla conoscenza del patrimonio artistico.* Pisa, 1991.

Papi, M. D. "Santa Maria Novella di Firenze e l'Outremer domenicano." In *Toscana e Terrasanta nel Medioevo.* Edited by F. Cardini. Florence, 1982.

Pasztor, E. "Franciscanesimo e papato." In *Francesco, il francescanesimo e la cultura della nuova Europa.* Edited by I. Baldelli and A. M. Romanini. Rome, 1986.

Pelekanides, S. *Kallierges holes Thettalias aristos zographos.* Athens, 1973.

Pelekanides, S. *Kastoria.* Athens, 1985.

Pelekanides, S., et al. *The Treasures of Mount Athos – Illuminated Manuscripts.* Patriarchal Institute for Patristic Studies. Vol. 1. Athens, n.d. [1974–5].

Petkovic, S. *Arilje.* Belgrade, 1965.

Pickering, F. L. *Literature and Art in the Middle Ages.* Coral Gables, Fla., 1970.

Ploeg, K. van der. *Art, Architecture, and Liturgy: Siena Cathedral in the Middle Ages.* Groningen, 1993.

Poeschke, J. *Die Kirche San Francesco in Assisi und ihre Wandmalereien.* Munich, 1985.

Pokrovskii, N. *Miniatiury evangeliia gelatskago monastyria.* St. Petersburg, 1887.

Prehn, E. *A XIII-Cent. Crucifix in the Uffizi and the 'Maestro del S. Francesco Bardi.'* Edinburgh, 1958.

Prehn, E. "Il crocifisso N. 434 degli Uffizi e il 'Maestro del S. Francesco Bardi." In *Aspetti della pittura medievale toscana.* Florence, 1976.

Prehn, E. "Una decorazione murale del duecento toscano in un monastero laziale." In *Aspetti*

della pittura medievale toscana. Florence, 1976.

Radojčić, S. "The Judgement of Pilate in Byzantine Painting from the Beginning of the Fourteenth Century." *Srpska Akademija Nauka, Belgrad, Zbornik Radova* 13 (1971): 293-312 (in Serbo-Croatian, with French summary).

Ragusa, I., and R. Green, trans. *Meditations on the Life of Christ: An Illustrated Manuscript of the Fourteenth Century.* Princeton, 1961.

Rave, A. *Christiformitas: Studien zur franziskanischen Ikonographie des florentiner Trecento am Beispiel des ehemaligen Sakristei-schrankzyklus von Taddeo Gaddi in Santa Croce.* Worms, 1984.

Réau, L. *Iconographie de l'art chrétien.* 3 vols. Paris, 1957.

Reist, T. *Saint Bonaventure as a Biblical Commentator: A Translation and Analysis of his Commentary on Luke, XVIII, 34–XIX, 42.* Lanham, Md. and London, 1985.

Restle, M. *Die byzantinische Wandmalerei in Kleinasien.* Recklinghausen, 1967.

Rigaux, D. *À la table du Seigneur: L'Eucharistie chez les primitifs italiens (1250–1497).* Paris, 1989.

Rigaux, D. "The Franciscan Tertiaries at the Convent of Sant'Anna at Foligno." *Gesta* 31 (1992): 92–8.

Roma Anno 1300. Atti della IV settimana di studi di storia dell'arte medievale dell'Università di Roma "La Sapienza." Edited by A. M. Romanini. Rome, 1983.

Romano, S. "Le storie parallele di Assisi: il Maestro di S. Francesco." *Storia dell'arte* 44 (1982): 63–81.

Roncaglia, M. *St. Francis of Assisi and the Middle East.* Cairo, 1957.

Rubin, M. *Corpus Christi: The Eucharist in Late Medieval Culture.* Cambridge, 1991.

Ruf, G. *Das Grab des hl. Franziskus: Die Fresken der Unterkirche von Assisi.* Freiburg, Basel, Vienna, 1981.

Russo, D. "Saint François, les franciscains et les représentations du Christ sur la croix en Ombrie au XIIIe siècle." *Mélanges de l'École Français de Rome* 96 (1984): 647–717.

Sainati, G. *Diario Sacro Pisano.* Siena, 1886.

Sandberg-Vavalà, E. *La croce dipinta italiana e l'iconografia della Passione.* Verona, 1929. Reprint, Rome, 1980.

Scarpellini, P. "La chiesa di San Bevignate, i Templari e la pittura perugina del Duecento." In

Templari e Ospitalieri in Italia: La chiesa di San Bevignate a Perugia. Edited by M. Roncetti, P. Scarpellini, and F. Tommasi. Milan, 1987.

Scarpellini, P. "Iconografia francescana nei secoli XIII e XIV." In *Francesco d'Assisi: Storia e Arte.* Milan, 1982.

Scharf, A. *Byzantine Jewry from Justinian to the Fourth Crusade.* London, 1971.

Schiller, G. *Iconography of Christian Art.* Vol. 2. Greenwich, Conn., 1972.

Schmucki von Rieden, O. "Das Leiden Christi im Leben des Hl. Franziskus von Assisi. Eine quellenvergleichende Untersuchung im Lichte des zeitgenossischen Passionfröm-migkeit." *Collectanea franciscana* 30 (1960): 5–30, 129–45, 241–63, and 353–97.

Schultze, J. "Zur Kunst des 'Franziskusmeisters.'" *Wallraf-Richartz-Jahrbuch* 25 (1963): 109–50.

Schwartz, L. "Patronage and Franciscan Iconography in the Magdalen Chapel at Assisi." *Burlington Magazine* 133 (1991): 32–6.

Schwarz, M. V. "Zerstört und Wiederhergestellt. Die Ausmalung des Unterkirche von S. Francesco in Assisi." *Mitteilungen des Kunsthistorischen Institutes in Florenz* 37 (1994): 1–28.

Schwarzmaier, H. *Lucca und das Reich bis zum Ende des 11. Jahrhunderts.* Tubingen, 1972.

Schwarzmaier, H. *Movimenti religiosi e sociali a Lucca nel periodo tardo-longobardo e carolingio. Contributo alla leggenda del Volto Santo.* Lucca, 1973.

Seidel, L. *Songs of Glory.* Chicago, 1981.

Seidel, M. "Gli affreschi di Ambrogio Lorenzetti nel Chiostro di San Francesco a Siena: riconstruzione e datazione." *Prospettiva* 18 {1979}: 10–20.

Sesti, E. "L'arte francescana nella pittura italiana dei secoli XIII e XIV." In *Francesco il Francescanesimo e la cultura della nuova Europa.* Edited by I. Baldelli and A. M. Romanini. Rome, 1986.

Setton, K., ser. ed. *A History of the Crusades*, vol. 2: *The Later Crusades, 1189–1311.* Edited by R. L. Wolff and H. H. Hazard. Madison, Milwaukee, and London, 1969.

Ševčenko, N. "Vita Icons and 'Decorated' Icons of the Komnenian Period." In *Four Icons in the Menil Collection.* Edited by B. Davezac. Austin, Tex., 1992.

Simonsohn, S. *The Apostolic See and the Jews: A History.* Toronto, 1991.

Sindona, E. *L'opera completa di Cimabue e il momento figurativo pregiottesco*. Milan, 1975.

Smart, A. *The Assisi Problem and the Art of Giotto*. Oxford, 1971.

Smith, C. "Pisa: A Negative Case of Byzantine Influence." In *Il medio oriente e l'occidente nell'arte del XIII secolo*. Edited by H. Belting. Bologna, 1982.

Soteriou, G. and M. *Icones du Mont Sinai*. 2 vols. Athens, 1956.

Spence, R. "Pope Gregory IX and the Crusade." Ph.D. diss., Syracuse University, 1978.

Sta. Croce: Kirche, Kapellen, Kloster, Museum. Stuttgart, 1985.

Stein, J. "Dating the Bardi St. Francis Master Dossal: Text and Image." *Franciscan Studies* 36 (1976): 271–95.

Steinberg, L. *The Sexuality of Christ in Renaissance Art and Modern Oblivion*. New York, 1983.

Sticca, S. *The Latin Passion Play: Its Origins and Development*. Albany, N. Y., 1970.

Sticca, S. "*Officium Passionis Domini*: An Unpublished Manuscript of the Fourteenth Century." *Franciscan Studies* 34 (1974): 144–99.

Sticca, S. *The "Planctus Mariae" in the Dramatic Tradition of the Middle Ages*. Athens and London, 1988.

Stow, K. *Alienated Minority: The Jews of Medieval Latin Europe*. Cambridge, Mass., and London, 1992.

Stow, K. "Hatred of the Jews or Love of the Church: Papal Policy toward the Jews in the Middle Ages." In *Antisemitism Through the Ages*. Edited by S. Almog. Oxford, 1988.

Straub, A., and G. Keller. *Herrade de Landsberg, Hortus Deliciarum*. Strassburg, 1899.

Strehlke, C. "A Celibate Marriange and Franciscan Poverty Reflected in a Neapolitan Trecento Diptych." *The J. Paul Getty Journal* 15 (1987): 79–96.

Striker, C. L. "Crusader Painting in Constantinople: The Findings at Kalenderhane Camii." In *Il medio oriente e l'occidente nell'arte del XIII secolo*. Edited by H. Belting. Bologna, 1982.

Striker, C. L. and Y. D. Kuban. "Work at Kalenderhane Camii in Istanbul: Preliminary Reports I–V." *Dumbarton Oaks Papers* 21 (1967): 267–71; 22 (1968): 185–93; 25 (1971): 251–58; 29 (1975): 306–18.

Stubblebine, J. "Byzantine Influence in Thirteenth-Century Italian Panel Painting." *Dumbarton Oaks Papers* 20 (1966): 85–102.

Stubblebine, J. "Byzantine Sources for the Iconography of Duccio's *Maestà*." *Art Bulletin* 57 (1975): 176–85.

Stubblebine, J. "A Crucifix for Saint Bona." *Apollo* 125 (1987): 160–5.

Stubblebine, J. *Duccio di Buoninsegna and his School*. 2 vols. Princeton, 1979.

Stubblebine, J., ed. *Giotto: The Arena Chapel Frescoes*. New York, 1969.

Stubblebine, J. *Guido da Siena*. Princeton, 1964.

Stylianou, A. and J. "The Militarization of the Betrayal and its Examples in the Painted Churches of Cyprus." In *Euphrosynon: Aphierōma ston Manolē Chatzēdakē*. Vol. 2. Edited by E. Kypraiou. Athens, 1992.

Swarzenski, H. *Die lateinischen Illuminierten Handschriften des XIII. Jahrhunderts*. Vol. 1. Berlin, 1936.

Tafrali, O. *Monuments byzantins de Curtea de Arges*. Paris, 1931.

Tartuferi, A. *Giunta Pisano*. Soncino, 1991.

Tartuferi, A. *La pittura a Firenze nel Duecento*. Florence, 1990.

Taylor-Kelley, L. "The Horizontal Tuscan Panel, 1200–1365: Frame Format and Pictorial Composition." Ph.D. diss., University of Michigan, 1988.

Il Tesoro della Basilica di San Francesco ad Assisi. Assisi, 1980.

Thode, H. *Franz von Assisi und die Anfange der Kunst der Renaissance in Italien*. Berlin, 1885.

Thomas of Celano. *S. Francisci Assisiensis, Vita et Miracula*. Rome, 1906.

Timmer, D. E. "Biblical Exegesis and the Jewish Christian Controversy in the Early Twelfth Century." *Church History* 58 (1989): 309–21.

Toaff, A. *The Jews in Umbria*. Vol. 1: *1245–1435*. Leiden and New York, 1993.

Todini, F. *La pittura umbra: dal Duecento al primo Cinquecento*. Milan, 1989.

Tolaini, E. *Forma Pisarum: Problemi e ricerche per una storia urbanistica della città di Pisa*. Pisa, 1967.

Torriti, P. *La Pinacoteca Nazionale di Siena: I dipinti*. Genoa, 1990.

Toscano, B. "Il Maestro delle Palazze e il suo ambiente." *Paragone* 25, no. 291 (1974): 3–23.

Trexler, R. "Gendering Jesus Crucified." In *Iconography at the Crossroads*, Papers from the Colloquium Sponsored by the Index of

Christian Art, Princeton University, 23–4 March 1990. Princeton, 1993.

Trexler, R. *Naked before the Father: The Renunciation of Francis of Assisi.* New York, 1989.

Tschilingirov, A. *Christliche Kunst in Bulgarien, von der Spätantike bis zum Ausgang des Mittelalters.* Berlin, 1978.

Tuilier, A., trans. *Gregoire de Nazianze, La passion de Christ.* Paris, 1969.

Ubertino da Casale. *Arbor vitae crucifixae Jesu.* Venice, 1485.

Ulbert-Schede, U. *Das Andachtsbild der kreuztragenden Christus in der deutschen Kunst.* Munich, 1968.

Varanelli, E. S. "Le *Meditationes Vitae Nostri Domini Jesu Christi* nell'arte del duecento italiano." *Arte Medievale* 6 [1992]: 137–48.

Vassilakis, M. "Western Influence on the Fourteenth Century Art of Crete." *Jahrbuch der Osterreichischen Byzantinistik* 32/5 (1982): 301–11.

Vauchez, A. "Les stigmates de saint François et leurs détracteurs dans les derniers siècles du Moyen Age." *Mélanges d'archéologie et d'histoire* 80 (1968): 595–625.

Velmans, T. *La peinture murale byzantine à la fin du Moyen Âge.* Vol. 1. Bibliothèque des Cahiers Archéologiques, 11. Paris, 1977.

Velmans, T. *La Tetraévangile de la Laurentienne.* Bibliothèque des Cahiers Archéologiques, 6. Paris, 1971.

Velmans, T. "Les valeurs affectives dans la peinture murale byzantine au XIIIe siècle et la manière de les representer." In *L'Art byzantin du XIIIe siècle. Symposium de Sopoćani.* Edited by V. J. Djurić. Belgrade, 1967.

Verdon, T. "Christianity, the Renaissance, and the Study of History: Environments of Experience and Imagination." In *Christianity and the Renaissance: Image and Religious Imagination in the Quattrocento.* Edited by T. Verdon and J. Henderson. Syracuse, 1990.

Verdon, T., and J. Henderson, eds. *Christianity and the Renaissance: Image and Religious Imagination in the Quattrocento.* Syracuse, 1990.

Vikan, G. "Ruminations on Edible Icons: Originals and Copies in the Art of Byzantium." In *Retaining the Original: Multiple Originals, Copies and Reproductions,* National Gallery of Art, Studies in the History of Art, 20. Hanover and London, 1989.

Volpe, C. *Pietro Lorenzetti.* Milan, 1989.

Von der Osten, G. "Job and Christ." *Journal of the Warburg and Courtauld Institutes* 16 (1953): 153-8.

Waley, D. *Siena and the Sienese in the Thirteenth Century.* Cambridge, 1991.

Ware, A. K., and Mother Mary, trans. *Lenten Triodion.* London, 1978.

Warner, G. *Descriptive Catalogue of the Illuminated Manuscripts in the Library of C. W. Dyson Perrins.* 2 vols. Oxford, 1920.

Weiss, D. "Biblical History and Medieval Historiography: Rationalizing Strategies in Crusader Art." *Modern Language Notes* 108 {1993}: 710–37.

Weiss, D. "The Pictorial Language of the Arsenal Old Testament: Gothic and Byzantine Contributions and the Meaning of Crusader Art." Ph.D. diss., Johns Hopkins University, 1992.

Weiss, D. "The Three Solomon Portraits in the Arsenal Old Testament and the Construction of Meaning in Crusader Painting." *Arte Medievale* 6 (1992): 15–36.

Weitzmann, K. "Byzantine Miniature and Icon Painting in the Eleventh Century." In *Studies in Classical and Byzantine Manuscript Illumination.* Edited by H. Kessler. Chicago and London, 1971.

Weitzmann, K. "Byzantium and the West around the Year 1200." In *The Year 1200: A Symposium.* New York, 1975.

Weitzmann, K. *Die byzantinische Buchmalerei des X. und XI. Jahrhunderts.* Berlin, 1935.

Weitzmann, K. "Byzantium and the West around the Year 1200." In *The Year 1200: A Symposium.* New York, 1975.

Weitzmann, K. "The Constantinopolitan Lectionary, Morgan 639." In *Studies in Art and Literature for Bella da Costa Greene.* Edited by D. Miner. Princeton, 1954.

Weitzmann, K. "Crusader Icons and la 'Maniera Greca.'" In *Il medio oriente e l'occidente nell'arte del XIII secolo.* Edited by H. Belting. Bologna, 1982. Expanded as "Crusader Icons and Maniera Greca." In *Byzanz und der Westen.* Edited by I. Hutter. Vienna, 1984.

Weitzmann, K. "Icon Painting in the Crusader Kingdom," *Dumbarton Oaks Papers* 20 (1966): 51–83. Reprinted in *Studies in the Arts at Sinai.* Princeton, 1982.

Weitzmann, "The Narrative and Liturgical Gospel Illustrations." In *Studies in Classical and Byzantine Manuscript Illumination.* Edited by H. Kessler. Chicago, 1971.

Weitzmann, K. "Three Painted Crosses at Sinai." In *Studies in the Arts at Sinai*. Princeton, 1982.

Wharton, A. *Art of Empire: Painting and Architecture of the Byzantine Periphery*. University Park, Pa., and London, 1988.

Wharton, A. J. et al. "The Byzantine and Islamic Other: Orientalism in Art History." *College Art Association 80th Annual Conference, Abstracts and Program Statements*. New York, 1992.

White, J. *Art and Architecture in Italy 1250–1400*. 2nd. ed. London, 1987.

Wilk, B. *Die Darstellung der Kreuztragung Christi und verwandter Szenen bis zum 1300*. Tubingen, 1969.

Wilkins, D. "Early Florentine Frescoes in Santa Maria Novella." *Art Quarterly*, n.s. 1, no. 3 (1978): 141–74.

Wolff, R. "The Latin Empire of Constantinople and the Franciscans." *Traditio* 2 (1944): 213–37.

Wolfthal, D. "The Wandering Jew: Some Medieval and Renaissance Depictions." In *A Tribute to Lotte Brand Philip*. New York, 1985.

Wood, J. *Women, Art, and Spirituality: The Poor Clares of Early Modern Italy*. New York, 1996.

Wood, J. "Perceptions of Holiness in Thirteenth-Century Italian Painting: Clare of Assisi." *Art History*, 14 (1991): 301–28.

Xyngopolous, A. *Hoi toichographies tou Hagiou Nikolaou Orphanou Thessalonikes*. Athens, 1964.

Young, K. *Drama of the Medieval Church*. 2 vols. Oxford, 1933.

Zeitler, B. "Cross-Cultural Interpretations of Imagery in the Middle Ages." *Art Bulletin* 76 (1994): 680–94.

Zeri, F., with E. Gardner, *Italian Paintings: A Catalogue of the Collection of the Metropolitan Museum of Art, Florentine School*. New York, 1971.

INDEX

✠